THE PRESENCE OF THE
CASE STUDY HOUSES

THE PRESENCE OF THE
CASE STUDY HOUSES

Ethel Buisson and Thomas Billard

Birkhäuser - Publishers for Architecture
Basel · Berlin · Boston

Translated from the French by Jasmine Benyamin, California/Berlin

Acknowledgements

The authors are indepted to Paul Virilio for his support throughout the project, to Simona Edwards for her advice, and to Philippe Renoir, Patricia Pelloux and Antoine Billard for their patience.

The book would not have been possible without the assistance in Los Angeles of the AFAA, Thomas Cantaloube, Paulette and Victor Clafin, Neil M. Denari, Ana Henton, Stéphane Maupin, Juliette Salzmann and Marc Valessela.

The authors also warmly thank the many people – in particular the house owners and architects – who met with them:
Mr. and Mrs. Manuel Alvarado, Dr. Bailey, Mr. and Mrs. Jack Bevah, John and Carol Bowden, Demetrios Eames, George W. Fenimore, Albert Frey, Nana and George Gregory, Mark Haddawy, Don Hensman, Renee Riviere Ketcham and Franck Ketcham, Edward Killingsworth, Pierre Koenig, Mr. and Mrs. Marples, Leo and France Nathanson, Muriel Norton, Charles O'Wallis, Julius Shulman, Mr. and Mrs. Stahl, Karen and Ronald Van Wert, Kathryn and Richard Waltzer.

The photographs that criss cross from house to house were realized in light of recommendations by Georges Fessy and with the use of the view camera on loan from the University of Texas at Austin.

The research was both very successful and pleasant thanks to the resources made available by the Schools of Architecture at Princeton University and at Austin, and by the Charles Moore Foundation. In particular, the authors would like to thank Elizabeth Diller, Beatriz Colomina, Mark Wigley, Alessandra Ponte, Ralf Lerner and Joseph Bulbulia, without whom the theoretical reflections would not have found their way. And finally Andrew Vernooye, Kevin Alter, Mickael Benedikt, Larry Speck, Fritz Steiner, Jeffry Chusid, and Kevin Keim for their academic encouragement.

to Olivier

8 **Of glass and water – pluvial aperitif**

Military production during the war
The postwar process of armament
The Cold War
The Roosevelt-era ideology
Politics and architecture
The postwar house
The pioneer spirit
The city and the Americans
An urgent need for housing

12 **THE ANGEL OF THE CITY**

14 **Paper tiger – John Entenza**

20 **Cool magazine – Arts & Architecture**

26 **One vision – one man**

Los Angeles
Hollywood
Film during the years of the Case Study House
program
Homestead Act
The landscape of the single-family house
The scenario of the American family
Gardens and landscapes
Climate
Californian predecessors
The phases of the CSH program

32 **OBJECTS OF DESIRE, THE DESIRE OF OBJECTS**

34 **The inaugural projects – the 1945 season**
 CSH #1/7

58 **In the shade of the Eucalyptus**
 CSH #8 & #9

70 **Multiple prototypes**
 CSH #10/18

The beautiful American
Mobile homes
On the road
The mythology of metal
Heating
The Farnsworth House
The press
The fireplace
The plan and the kitchen
Furniture and the objects of the house
Second undertaking

98 **THE IMMEDIATE FUTURE**

100 **Exquisite corpse**
 CSH #1950

110 **Refined pavilions**
 CSH #16/18

128 **Missing – geometric abstraction**
 CSH #19

132 **Sacred temple – aged body**
 CSH #20

140 **Brutalist abstraction – Pierre Koenig**
 CSH #21 & #22

"Do-it-yourself"
The absent architect
Levittown
Platform framing

160 **ABSTRACT CLASSICISM**

162 **Classical contemporary – the triad**
 CSH #23

172 **A dreamed community of 260 units**
 CSH #24

178 **Classical vertical**
 CSH #25

Post-and-beam
Modernism and regionalism
Flat roof

186 **THE KING IS DEAD**

188 **Prolonging the dream**
CSH #26 & #27

202 **Renewing the dream**
CSA #1 & #2

210 **The bunker of the last gunshot**
CSH #28

220 **Ridiculous nostalgia**
Top-model model

222 **PAPER ARCHITECTURE**

224 **Role play**
226 Client-centered journal
236 Media house
242 Sponsors

250 **Archaeology**
252 Seductive images
256 The rules of the game
262 A model of grandeur
264 Model homes or case study?

266 **Today**
268 Past owners
270 Current owners
280 The Case Study Houses as media targets
282 Just a memory

284 Notes

288 **CATALOGUE**

314 Illustration credits
317 Colophon

OF GLASS AND WATER
Pluvial aperitif

It was raining that morning. Los Angeles was concealed as if by a uniformly wet filter. The water and drops gave the city a fantastical and unreal appearance, deforming it in a grotesque way. It was raining, and it had already been an hour that I had been struggling with the tight curves of the Hollywood hills, behind the grating windshield wipers of the Japanese rental.

I first noticed it from Sunset Boulevard, just above the red advertisement of the smoking cowboy. Fine and fragile as a leaf, it towered above this pile of mediocre construction like an abstract horizontal beacon. Achromatic amidst the grey, it existed despite it all, and was floating up there.

After several passes through the curves of Hollywood Boulevard, and passing in front of the Storer house designed by Frank Lloyd Wright – today standing colorless behind the macabre silhouettes of the eucalyptus – I tried anew a sharp bend to the right, rising towards the top of the hills and to Mulholland Drive, that mythic ribbon of asphalt hanging over the tide of houses below. The walls of the residential homes followed one another according to the rhythm of their "armed response" security signs, successively hiding the horizon of the valley, and depriving the driver – the architect that was driving – of all sought-after landmarks. Still drawn by the strange desire to see the fantastical and phantasmal object, the road was blocked by a gate, which was dripping wet much like the city.

I abandoned my little car in an instant and took my chances as a pedestrian. It was there, crouching somewhere along the black snake of the road. Rectilinear and perfectly horizontal, the house unfurls itself towards the exterior of the road's bend facing the neutral horizon. A wall protects and conceals the incredible and marvelous structure like a strand of camouflage today put in check.

I finally took it in as I climbed a little higher, noting with bitterness that it was no longer the last horse to vainly overlook the hills. Nonetheless, I comforted myself by granting it without the shadow of a doubt the trophy of sublimity already bestowed on it by Julius Shulman with his unreal photograph of the interior, a moment suspended in time floating above the city.

It was not a myth then, and I had the impression of touching the incarnation of an entire epoch, the ultimate icon of fifties modernism. Everything was flowing, and a feeling of perfection and justness brought me back to the silence of the scenery, and the sudden, incredible abstraction of the surroundings.

It was only a few days later that a friend – an immigrant to the City of Angels, the western capital of mega-cities – revealed to me the secret of those sheets of metal and glass suspended over the hills. There were others, and they were part of a program of experimentation code named CSH for Case Study House program. That which I had seen was assigned the number 22, and dreamed up almost fifty years ago by Pierre Koenig. There was even a book[1] that conserved the memory of that program. This friend presented it to me, grazing it deliberately between his hands, as if it were a religious icon. The book was dedicated to a certain Craig Ellwood, and an original, dense black drawing distinguished the beige canvas cover on which the name Esther McCoy appeared.

Settled into a Saarinen tulip chair under a patio-pool blue Monory canvas awning, with a vodka martini set on the low table, I embarked on the first leg of a return to the future.

THE ANGEL OF THE CITY

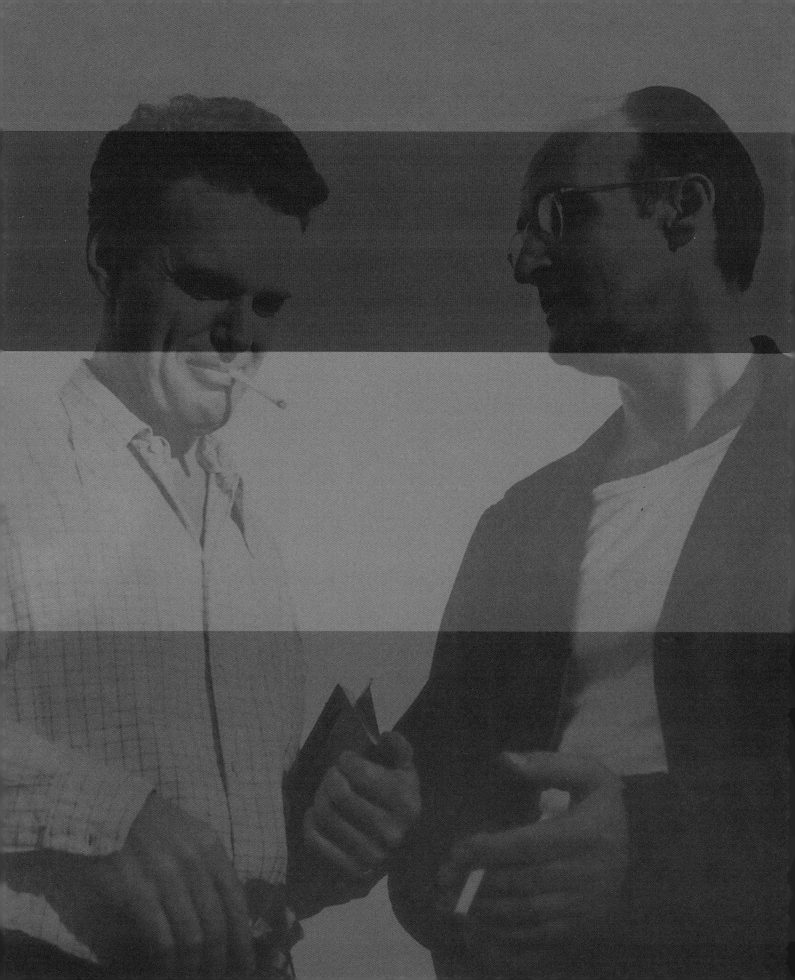

PAPER TIGER
John Entenza

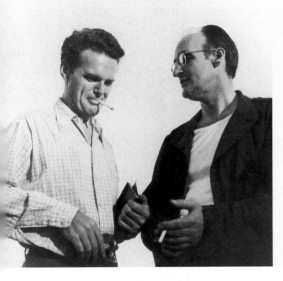

Charles Eames & John Entenza

The three letters "CSH" bring to mind very quickly the name of John Entenza. His face and his silhouette next to Charles Eames appear in a black and white photograph. The image plunges us back into the years of creative euphoria when John was running his magazine *Arts & Architecture*, to the time when this great editor and publisher played the typical Hollywood role of promoter and designer of a modern environment, while Charles designed the set.

Two silhouettes stand before an abstract background, two sworn partners. It is about two giants, Charles Eames and John Entenza. While the former is familiar to us, or at least not unknown with regard to the celebration of products by a designing couple, the latter does not engender an unbridled avalanche of images. Yet, while the first, alongside his wife Ray, became an inescapable design star of this century, a superstar both handsome and intelligent, the second was no less a producer, indeed a veritable artistic director who reformed the press. The greatest names in design, architecture and in the art world were born as they came to rest in the pages of *Arts & Architecture* during the months and years following the appalling conflict of 1939-1945.

Like two Fordist heroes designed by the dream factory, they seem to embody a certain American and specifically Californian ideal, with this terribly cool and casual attitude. In the print, the two giants rub shoulders with each other, two exceptional demiurges, a pope of design and a paper tiger.

Beyond the photographic anecdote, the two names merge with one another through numerous events in the forties. They would both be associated with the life of *Arts & Architecture*, with its image and its content. They would likewise collaborate in the production and development of plywood prototypes for the army, and most notably for the U.S. Navy and Air Force. With the Plyformed Wood Company, they put their convictions and their faith to the test with the research, fabrication and development of this new material, along with its numerous applications in the chaotic war industry.

Military production during the war

Faced with the rise of Nazism in Germany as well as Japanese hegemony at the outset of 1939, Franklin Roosevelt demands from the Congress an increase in the nation's defense budget. From that point on, the United States of America displays an active political role, and orients its efforts towards industrial expansion and military research. The bombing of Pearl Harbor would rock the country into war against Japan, then Germany in December of 1941. These efforts change in diverse ways distribution throughout the American territory. Quickly, economic shifts become perceptible; a reorientation of priorities as well as the moral and physical mobilization of the population engenders technological progress within the aeronautic and electronics industries. Leading industries proliferate with the integration of new materials and media. Technology would become the backbone of the country's eventual victory. The re-distribution of the population follows the specific needs for manpower within the country. Large steel production centers such as Chicago, Buffalo, and Michigan preferentially seek out the black population from the south, since they are even cheaper than immigrant workers. As a result, a decline in immigration is recorded during the war.

On the other hand, high tech industries establish themselves on the west coast, where they take advantage of inexpensive land in which a largely non-existent urbanism suggests the use of a generally non-unionized labor force. These industries seek out more specialized workers.

A child of the film world, Entenza ran the experimental department at Metro Goldwin Meyer (MGM) studios. His pronounced taste for contemporary architecture revealed itself when he entrusted the project to design his own house to Harwell Hamilton Harris. This house of a style more international than Californian with its white massing and curved entry is still nestled in the Santa Monica canyon, a few bends in the road from where he would build CSH #9 in 1949. Designating this second house to Eames and Eero Saarinen, Entenza affirms a way of life certainly closer to the architectural questions and preoccupations he develops in the columns of his avant-garde magazine. On the same terrain, the two designers will also build the emblematic CSH #8, the house and studio for Charles and Ray Eames, which toured the world through photographs as a manifesto of American modernity.

Esther McCoy whose name, like that of Entenza's, is indissociable from the CSH program (of which she would be the principal critic and narrator), reminds us that the editor and publisher had the genius to always be in the right place. After the two Californian houses of Santa Monica and Pacific Palisades, Esther McCoy recalls that he would settle in successively into the Strathmore terrace apartments of Richard Neutra, only to leave Los Angeles for Chicago in 1962 in order to join the management of the Graham Foundation and move into Mies van der Rohe's Lake Shore Drive Apartments. Finally, it is in a Mediterranean inspired house in San Diego's La Jolla where he would spend his retirement years. In some of his photographs from his time in Chicago, John Entenza appears often to blur with the silhouette of Mies, sporting a strict and somber suit with a straight cigar in his mouth. We are now, to be sure, far from the photo with Charles Eames, where the two accomplices were not yet the two institutions that one associates with their names today.

In 1938, Entenza purchases *Californian Arts & Architecture*, taking over the reins of this magazine in 1940 when he assumes the responsibilities of editor, publisher, and writer. It is as "guest editor" [2] that he would join the publication in order to replace Jerre Johnson. Retiring the word "Californian" from the title in 1940, he exhibits his ambition to lift the magazine out of its regional context, to open its pages to the world, and to dedicate it to the promises of tomorrow.

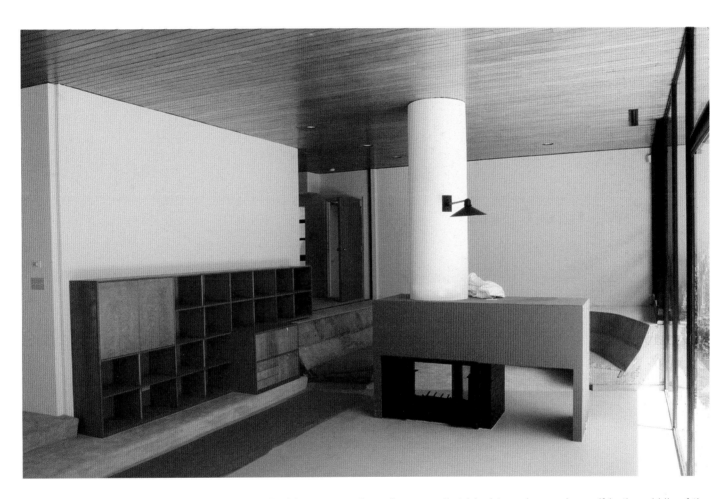

CSH#9, Charles Eames & Eero Saarinen

It had been two or three times now that I had turned around – as if in the middle of the Bermuda Triangle where one loses oneself among three lovers: CSH #8 by the Eames, CSH #20 by Neutra, and CSH #18 by Walker, all residing on the same promontory. CSH #9 was being renovated, retreating from the cliff facing the Pacific Ocean and the sun, as well as from the new house under construction that the owner was building for millions of dollars. CSH #9 would be the guesthouse for this large pistachio colored residence.

Intrigued by the little Japanese car often loitering about in the area, the owner comes out. Worried about the regular curiosity in the dead-end of Chautauqua Boulevard, he suggests a visit to his new abode, only once the words CSH #9 and John Entenza are uttered as if they are an indicative of a secret code. Under the crushing heat piercing through the eucalyptus, we enter the sanctuary.

We quickly leave the delicate pavilion aside in favor of the green confection on the crest of the cliff, the absolute pride of my host. It is a profusion of volumes overlapping of one another, colored with immense works of art hung on the wall, bathed in this Californian light that renders the walls too white and bright. The confection is decidedly the image of excess on this coast, overinflated with silicone and amphetamines currently en vogue.

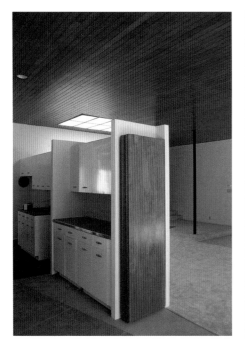

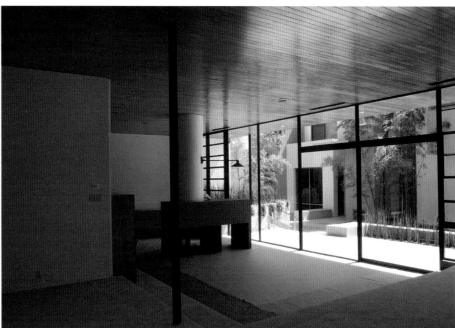

CSH#9, Charles Eames & Eero Saarinen

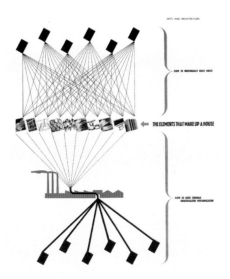

The postwar process of armament

The stimulation of the military industry allowed the country to restructure itself and increase its wealth without having to suffer, as such, the losses of a war on its own soil. After the conflict, peace occurs only at the price of continued support from armament. The efforts of the military industry find new sources for economic and structural development within the postwar reorganization of civil society. Initiated during the hostilities, the electronics research used in radar systems opens the door to computer-aided calculations; the latter would really prove itself, and thereupon be crucial during the perfecting of the H-Bomb in November of 1952. [1]

Facilitated by the machinations of publicity and marketing, military techniques and materials are rapidly converted to serve the everyday needs of the civilian population exemplified by the use of air conditioning, the implementation of large scale construction, prefabrication, the use of aluminum, plywood and plastic, and the development of the aeronautic infrastructure through the establishment of airports throughout the country. The Second World War and its consequences profoundly restructure the country both economically and politically, defining the broad outlines of the America of today.

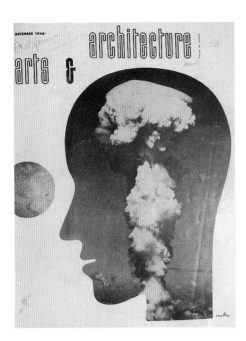

The Cold War

The Manhattan Project for atomic bomb research takes place between 1942-1946 at the Los Alamos National Laboratory in New Mexico. The first test of the bomb is launched on the 16th of July 1945, arming the United States with a ferocious weapon quickly dropped on Hiroshima on the 6th of August and on Nagasaki three days later, rendering a sinister conclusion to the Second World War.

On the 5th of March 1946 in Fulton Missouri, Winston Churchill summarizes the political situation between East and West by referring to "an iron curtain fallen on Europe." A striving towards an ever more significant military arsenal ensues between the Communist bloc and the United States, polarizing the world for many years in these two zones of conflict. The possession of the A-Bomb by the Soviet Union in 1949 marks the end of atomic hegemony for the United States, instilling in the latter an anxiety of enemy aggression on its own soil. Feeling that an ocean can no longer protect it from an atomic reprisal, the United States resumes its research into the H-Bomb, which succeeds in 1952, and is closely followed by the Russians in 1955.

McCarthyism destabilizes from within the political apparatus of the Democratic majority, rattling institutions. Certain Republicans use the witch-hunt for Communists as a demagogic and subversive force to encourage national paranoia. [2] Subsequently, this phenomena would be experienced as a troubling shadow cast over the government, only to be finally diffused four terror-filled years later, when McCarthy attempts to lay blame on the army. Exceeding the bounds of conformity, McCarthy is forced by the government to furnish proof for which he has none, and he is publicly disgraced.

When we leave the simulacrum, the owner leaves me at the entrance of the exquisite house, at the door of the white parallelepiped resting on the lawn and today surrounded by bamboo trees. An enormous glazed band spreads over the entire façade, open to the cliff, flooding an ample room with beautiful warmth, in which one notices a red fireplace dividing the volume in two. The fireplace resembles a library facing this magical contour, this immense sofa constructed and cast in the house. A glass cube on the left delimits the large room like a patio filtering the light while today leaving visible the angular and turbulent ventilation systems. Then, it was the shadow of an automobile that would come to haunt this expansive living room. The car and the loudspeakers, cult objects synonymous with modernity, had become furnished objects of the house, taking part in the manifesto of the California lifestyle. Apart from the stretched out living room along the fine glazed façade, the bedroom and study wind around freely. But it is with the living room that the expression of the house lives on, and reflects the spirit of its occupant; that magnificent socialite, an intellectual and an aesthete who embodied the emergence of the new Los Angeles of Wilshire Boulevard. If this CSH is different from the others, it is because it is designed not for a family, but for a bachelor who also happens to be the editor and father of the project.

The owner of CSH #20, Doctor Bailey, told me that Charles Eames and Eero Saarinen had taken care to maintain the meadow between the ocean and the houses, while they (the designers of the contemporary confection) were unabashedly resolute in placing their *oeuvre* facing the ocean frontally and proudly. At the time of the violent thunderstorms in February and March, the green project lost entire sections of its scenery many times over with the landslides, which partly engulfed the houses on the chewed up slopes. Yet an easy confidence by the owners of the pistachio house would accompany our relaxed conversation around the swimming pool, while we nibbled on some pre-made peanut butter sandwiches with the Chicano gardener, in the shade of the rectilinear terrace.

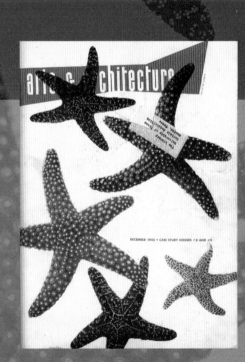

arts & architecture

PRICE 35 CENTS

DECEMBER 1945 • CASE STUDY HOUSES #8 AND

COOL MAGAZINE
Arts & Architecture

It was in the architecture bookstore Hennessey Ingalls[3] on Third Street in Santa Monica, an artificial pedestrian-only promenade, that I saw for the first time some copies of the magazine *Arts & Architecture.*

With this publication in my hands, I succumbed anew to the seduction of these houses, just as I had two days earlier in front of Pierre Koenig's glass pavilion above the city of angels. I had fallen as if under the influence of some illicit substance; the program and the houses soon made me sway with weakness, as much by the charm as by the rigor of thought established by Entenza, whose primary concern was to nourish, to renew, and to stimulate the curiosity of the reader.

To reach this object of desire, the strategies of seduction operate first in black and white glossy pages, then in the stitching of the canvas of Los Angeles.

Before leaving the bookstore, I decided to buy two other books, indeed two other indispensable guides: *The Case Study Houses 1945-1962* by Esther McCoy, and the *Thomas Guide*, the latter a veritable bible and dictionary of streets and continuous city maps.

The little car would aid me in criss-crossing the hills and the web of the city.

In contrast to the French and other European periodicals such *as L'Architecture d'Aujourdhui*, which are still known for their panoramic quality making them period anthologies, *Arts & Architecture* was a very slim volume, a monthly that recalled the format of fashion magazines. Its light and supple side endowed it with a freeness and ease that one finds also in the airy contents where, when it is a question of architecture, the black and white photographic plates prevail over a concise and precise text, always recalling the objectives, the program, the solutions, and the innovations retained. The image makes the real leap forward while the photograph transcends it, stimulating desire; charming photography, as it were.

Right away, the covers spark our imaginations by an aesthetic that still appears to us as innovative. Photographs, photomontages and drawings from Ray Eames to Hubert Matter are dressed time and again with renewed colors, textures and forms.

complete documentation—

MODERN CALIFORNIA HOUSES:

Case Study Houses 1946-1962

By ESTHER McCOY
Author of *Five California Architects*

Read—
the first book to provide a permanent record of the most unorthodox and influential building program ever attempted in the United States. Find complete reference material on the famous *Case Study Houses:* how they were designed and constructed, their suitability, and as time passes, their significance. Every phase of the houses and projects is considered from a technical, spatial, and aesthetic point of view — an analytical survey of innovations and designs that have set a pace in modern residential architecture for three decades.

"...the houses collected in this book will be a source of many concepts and details that have been endlessly used by others, but seldom so well carried out as in these prototypes..."—Thomas Creighton, Editor of *Progressive Architecture* Magazine.

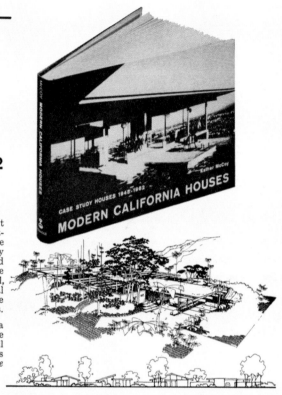

Through the editorial mastheads and the writer's reviews, one recognizes a garland of astute criticism surrounding Entenza, from Buckminster Fuller to George Nelson. Everything is contemporary, supporting the avant-garde image of the magazine. Comparing the issues from 1945 and 1966, the projects put through the critical mill and exposed to our eyes have indeed considerably changed and developed. However, they are revelatory of the thinking of their time, of the contemporary continuity evolving and advancing with John Entenza at the helm. The quest for the spirit of the times, and the particular context of Los Angeles as a new city without any specific artistic referents will put both the magazine and the place on an international level.

The thin journal, elegant and even precious, embodies the Wilshire Boulevard where it resides, an artery gleaming relative to the deposed downtown. It will be the target of numerous young architects and designers with the ambition to secure publication of their work. While today handsome and costly books are devoted to the likes of Craig Elwood, Pierre Koenig, Ray and Charles Eames and others, these architects and designers make up part of a generation, (along with the Australian Harry Seidler), of those architects who had their first publications in *Arts & Architecture*.

At the time of our encounters, Edward Killingsworth, the architect of three Case Study Houses would confirm to me the fascination among young architects of the time for this reference

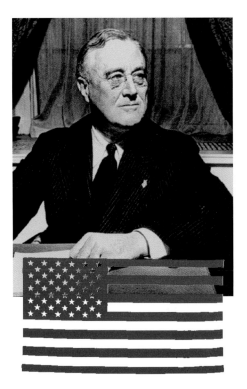

The Roosevelt-era ideology

Franklin D. Roosevelt, who was president of the United States from 1932 until 1945, helps the populace to cope with the crash of 1929. In proposing the New Deal – an immense development of public works that would restructure the economy through simultaneous measures against overproduction, devaluation and unemployment – Roosevelt organizes the country's infrastructure. He puts in place a process of building traffic lines rendering most of the states and territories accessible by rail and road. Then, a vast program would aid people in obtaining their own individual homes [3] through access to bank loans and to progressive reimbursements.

This process of change also becomes visible in the struggle for a more egalitarian society. Indeed, the Roosevelt presidency would be concerned with ethnic strife, providing support to the black population in its fight against segregation. After the death of president Roosevelt, his vice president Harry Truman continues the mandate and is re-elected in 1948 to remain in office until 1953.

Politics and architecture

The governmental body known as the Federal Housing Administration (or FHA) – installed since the New Deal in order to address the shortage of single-family housing – serves as a loan organization. In order to assure minimum financial risk, its criteria for intervention entail evaluating resale appraisals of a given property, as well its resistance to devaluation. [4] Following these criteria, the FHA ensures financing only for the houses conceived in a "traditional, colonial or ranch" style. It disparages flat roof architecture, and often refuses to subsidize metal construction it deems too costly. [5] Bomb shelters burgeon in the form of annexes throughout the country, occupying not only basements of public buildings and private homes, but also the subsurface of gardens. Ever-present in the American consciousness, the emergence of atomic energy inspires a new formal and design language.

journal. He would confess that, as a draftee on the old and broken continent during the end of the conflict in 1940, he eagerly awaited the delivery of his mail, and in particular, his issues of *Arts & Architecture*.

Entenza transformed his magazine into the official window onto creative production in contemporary California. With the inauguration of the Case Study House Program in January of 1945, he turned his journal into a propaganda tool of the California model disseminating his new ideas regarding a new style of life, promoting a "domesticity," [4] which would rapidly cease to be experimental and rather become the concrete, immediate future.

Driven by a kind of Puritanism, the elegant journal took on at that time the look of an instruction manual, tempered into a factual magazine, oscillating between CSH projects in theory and in practice, from construction documents to drawings and photography.

Publisher, editor-in-chief and writer, John Entenza slides on his hats of innovator and promoter, demanding access to modernity for everyone.

The depression years saw in the American press the birth of the concept of the "low cost house" capable of satisfying the people of the time, and of coming within range of materials available at lower cost – a concern for most people that stemmed from the economy of the crash. The fall of manufacturing costs provoked by the industrialization of construction will reach its apogee with the installation of the war industry, transforming Los Angeles into a

Designs for postwar living, Eero Saarinen & Lundquist,
Arts & Architecture, August 1943

The postwar house

The idea of the postwar house is envisaged during the war, more precisely towards the end of the conflict, since it is at this time that the wish to see the return of the heroes from the front becomes more present. Critics and journalists alike debate the possibilities for the house and the desirable built environment for these soldiers who had become the very incarnation of civilization against barbarism.

The single-family house has always been viewed in the United States as one of the greatest opportunities for the flourishing and freedom of the family unit. With the conclusion of the war, it is viewed as an industrially produced commodity like the automobile. If industry and technology participated in the country's victory, they would become viewed from this moment on as those factors and vehicles of modernity

that could offer ever-new freedoms to be conquered.
We note the direct transference of the war effort; from the optimal supply and arrangement of everything from airplanes to soldier's pant pockets, to the domestic space, where the first studies of the postwar house (an *Arts & Architecture* competition) are replete with closets and zones of storage.

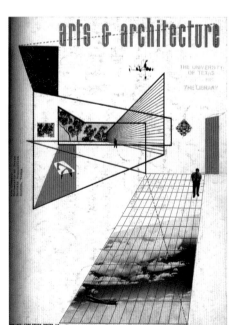

veritable laboratory for research in aeronautical engineering, and, more specifically, into a giant factory for combat planes. Richard Neutra's plywood and aluminum houses, along with Schindler's concrete work, will both be abundantly published in the magazine. Frank Lloyd Wright and other American architects will be invited to participate in the exercise of putting into form this low cost house, breaking with all stylistic conventions.

Through investigations like "What is a house?" and others, the magazine develops reflections on the house of today and tomorrow, introducing all the while the notion of the "postwar house," which prefigures the CSH program. In this article, Entenza develops the idea of the house as a tool of man's fulfillment, capable of satisfying physical as well as social and intellectual needs. As the GI's return after the war, *Arts & Architecture* presents them with the most favorable solutions – both high-performance and comfortable – of which to make use, on par with the equipment and armament that society provided them in order to fight and eradicate barbarism. This return of heroes allows Entenza to anticipate the enormous need for houses after the years of recession and war. He sees in this return as well the possibility of hurling the war industry towards a peacetime industry dedicated to the individual, to construction, and to progress.

The war effort revolutionized industry and catapulted it into a mass enterprise. The article on prefabrication provides the editor and his team with the means to reveal their fierce optimism in the creation of a space appropriate to an idealized industrial society that is innocuous and democratic. Efficiency, economy, and health are indissociable from prefabrication, and contribute to the enrichment of man. In illustrating this article, the eloquent photomontages support the examples as if they were propaganda images.

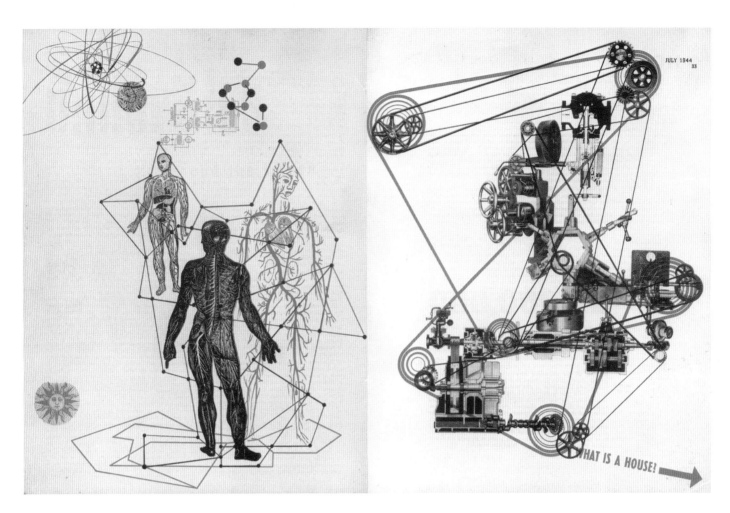

HAT IS A HOUSE!

What is a house?, Arts & Architecture, February 1944

The CSH program also serves to call into question past standards of living, a questioning with the desire to reformulate the house. In this light, Entenza reintegrates the architect, engineer, designer and user into the thinking and making process of the dwelling object. He places them above "process" and elevates them to the rank of good designers who synthesize numerous disciplines from research to production – the veritable heirs of the war effort's best heroes.

ONE VISION
One man

The blue of the January 1945 cover of *Arts & Architecture* almost makes us forget that the conflict in which the world is plunged is not yet over. The CSH program is announced on the cover as the highlight of the issue. For the editor, it marks the success of numerous and still recent reflections and experiences, like the "designs for postwar living" house competition organized by the magazine in August of 1943, among whose winners were Eero Saarinen, I.M. Pei and Raphael Soriano.

Having apparently written the program alone, John Entenza synthesizes the visions developed in his magazine since the beginning of the forties. His announced objective is to end speculations about the postwar house by putting it directly to work and offering it on a platter for the critics and for the public.

Asserting an Anglo-Saxon pragmatism, the editor decides to produce eight house projects, and entrusts them to eight architecture firms from California. This declaration reinforces the idea of having results as the first priority of experimentation, as the only means to validate the proposals.

The shift from paper architecture to built architecture appears to be the necessary condition for convincing the readers, manufacturers and architects to invent or invest in the concept of the postwar house.

Of the eight architects and designers included, only Richard Neutra at the time can claim an international aura, relegating the others to a more national status. [5] Their contract with the magazine is simple: They must propose a house that offers the best conditions of life to an American middle class family. This quest for an ideal environment for all recalls an idea of architecture as a social art at the service of its contemporaries. The program is a rule of the game to which all eight men must submit.

Furthermore, it is imperative that these architects take on choices for spatial solutions, and for specification of materials and products that are reserved solely on their merits, their quality, and their specificity. The solutions and materials could draw on old sources or from new innovation.

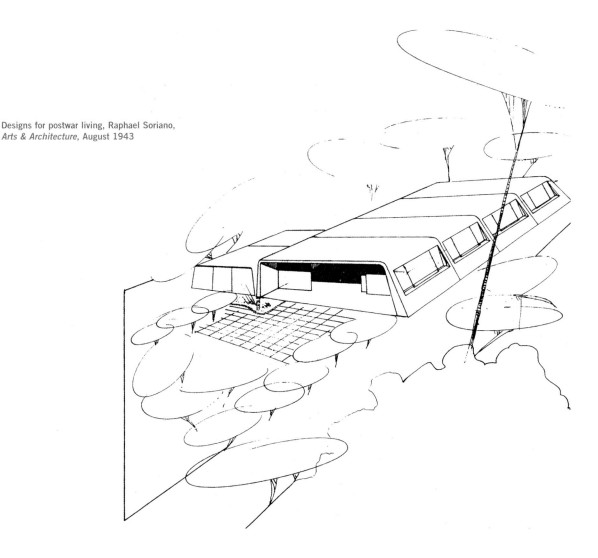

Designs for postwar living, Raphael Soriano,
Arts & Architecture, August 1943

The pioneer spirit

The Americans have a distinctive spirit, that of
the pioneer and of eternal renewal. To change
one's life, one's name, one's job, to move, to
divorce; all quite commonplace, thanks to a
single language, to the media, to road and air
transportation. The United States is a relatively
homogenous country, despite its size and ethnic
diversity. Craving for the ideal and simultane-
ously ready to conquer, cultivating the myth of
the pioneer, blessed with a communitarian though
not socialist culture and favoring ghettoization, a
kind of intolerance among different communities
develops in the country. Parallel to this phe-
nomenon, mutual aid and charity rub shoulders,
and become identified with a social and moral
act. The community, and likewise corporations
play the role of the thinking body among a
group of adherents.

Entenza specifies that all the projects must be buildable at a low cost, while keeping in mind
the specific climate of California. He promotes the nuclear family as the American model,
and proposes that his contemporaries grab hold of the present and the future, tame it and
understand it.

The eight appointed architects must take into account that the magazine appears as the sole
client of the project demands, and becomes as such a sort of referent for the reader as well
as for future consumers of architecture. In January of 1945, John Entenza puts in place a
model that proposes a kind of technical, practical and economic value grid.

With his demiurgic and totalizing demands, the editor offers to supply these houses with
furnishings and fittings, since they are also recognized for their relevance. He launches a call
to manufacturers and designers to join him in the effort to search for this domestic ideal.

The selected materials and fittings would be the objects of news reports and numerous
advertisements, boasting their merits and thereby propelling a desire for newness. This
desire would also be evident in the field of gardens and landscapes invested in by the client-
magazine, promoted by the domestic space as guiding principle. In order to convice and
ensure dtrict adherence to this principle, *Arts & Architecture* produces work so that the potential
owner may sense this reality and plunge himself finally into this modernity so near and so
bright. The houses would be open to the public and exposed to critical view, as material

J. R.

dAVIDSON (designer) studied in Germany, England, and France. He came to the United States in 1923 and established private practice in 1925. He is recognized for the first modern designs of stores, restaurants, offices, simple and multiple residences and interiors in Los Angeles and Chicago. He has been instructor at the Art Center School in Los Angeles since 1938. In 1937, he received recognition from the Royal Institute of British Architects; first prize winner in the Pittsburgh Glass Competition in 1938. His work has been published in Deutsche Kunst & Decoration, Moderne Bauform, Nuestra 'Architecture, Architectural Record, The Forum, Arts & Architecture, and House & Garden.

Hella

Park

SUMNER **S**PAULDING, architect and city planner, was born in Ionia, Michigan, June 14, 1892. He attended the University of Michigan from 1911 to 1913, and received his Bachelor of Arts degree from the Massachusetts Institute of Technology in 1916. He has traveled and studied in Europe and in Mexico. He is the designer of many country estates; the Catalina Casino for William Wrigley Jr.; the men's campus at Pomona College, and he is chairman of the American Institute of Architects for the designing of Los Angeles Civic Center. He also worked with John C. Austin in the designing of the Los

Angeles Municipal Airport. He has taught architecture the University of Southern California and at Scripps He is a fellow of the American Institute of Architects.

n

RICHARD J. **n**EUTRA was born in Vienna, Aus 1892 and came to the United States in 1923 after having in the practice of architecture in Europe. He has been Angeles since 1926. Member of American Institute of Arch He has practiced in California, Oregon, Texas, and Illinois. elected as the first American delegate of Les Congres nationaux d'Architecture Modern and is now president world-wide professional organisation. A city planner, pert and consultant, he is now architect and consultant Planning Board of the Insular Government of Puerto Rico.

EERO **S**AARINEN of Saarinen and was born in Kirkkunummi, Finland, in 1910, to the United States in 1923. Attended art Paris (sculpture), Yale School of Architecture Scholarship to Europe.

From 1936 to 1939 he did extensive city planning research and other architectural work. From 1939 to 1942 he was associated with Eliel Saarinen and Robert Swanson, building Crow Island School, Winnetka, Illinois. When associated with Perkins, Weiler and Wile, Tabernacle Christian Church, Columbus, Indiana, and Centerline Housing Project, Centerline, Michigan, were built. He has competed in several competitions, including the Smithsonian Gallery of Art Competition in which his entry was awarded first prize and first prize in Arts & Architecture's First Annual Architectural Competition. Now working for the Office of Strategic Services, Washington, D. C.

Sturtevant

W

AM WILSON **W**URSTER, of Wurster & Bernardi, born in California, 1895. Educated in the public schools of Stockton, later entered the University of California, spending his vacations working in the office of an architect. After travel abroad he returned to New York, working with the architectural firm of Delano & Aldrich. Returned to California in 1924 and entered private practice. In 1943 Mr. Wurster closed his architectural office in order to devote his time to war and postwar architectural problems, doing special research on Urbanism and Planning. Carried on this research at Harvard as a Fellow in the graduate school of design. Now Dean of the School of Architecture and Planning, Massachusetts Institute of Technology.

e

CHARLES **e**AMES, born in St. Louis, Missouri. Studied architecture in St. Louis and Washington Universities. Travelled abroad. Practiced architecture and industrial design in the Middle West. Developed the Experimental Design Department of Cranbrook Academy of Art, working with Eliel Saarinen. Won two first awards in the Museum of Modern Art's Organic Design Competition. He is identified with the war effort through the development of his process for moulding wood and the design of essential items and the techniques for their manufacture.

r

RALPH **r**APSON was born in 1915. He spent two years at Alma College, Alma, Michigan, and three years at the College of Architecture, University of Michigan. He received a scholarship at Cranbrook Academy of Art and studied architecture and civic planning under Eliel Saarinen. Co-winner of first prize for Festival Theater and Fine Arts Building for William and Mary College Competition. Prize winner in Ladies Home Journal Small House Competition; Owens-Illinois Small House Competition; Owens-Illinois Dairy Competition; Kawneer Store Front Competition; 1938 Rome Collaborative. He was co-designer of the "Fabric House" and the "Cave House." His work has been chiefly in the residential field and in housing. He is now head of the Architectural Department at the Institute of Design in Chicago. Member of C.I.A.M. In addition to architectural practice he is also designing furniture for several manufacturers.

29

The city and the Americans

If the Americans denigrate the city and flee from it as if it were a disaster, this sentiment is accompanied by a moral desire to be able to live in the calm of nature. As a result, the home in the middle of a garden becomes the model of the familial ideal[6]. Since the nineteenth century, the train has been the means of transport appropriate to the early suburbs that developed along the roads laid out to open up the countryside. In 1930, the road network followed by the housing assistance put in place by Roosevelt provides the first impetus to leave the city for the residential suburbs, while the urban centers would continue to ensure tertiary activities, as in the "downtowns" of today. Due to the overall use of the car, cities by the fifties are emptied of almost all their inhabitants, and progressively all their cultural, commercial and economic activities as well; indeed, everything is decentralized in favor of the suburbs. Made possible by the automobile, but also by the fear of an eventual war in the homeland, the idea of a better life in the suburbs favored their expansion. Dissemination is seen as a deterrent from bombardment.

The economy of the countryside can be summed up as follows: The residential suburb is often located near a similarly decentralized business park. A city in which activities take place downtown becomes totally vacant after office hours, while the urban zones are hemmed in and populated by minorities whose purchasing power is extremely low, by those who can no longer attain knowledge in the absence of a local culture or economy.

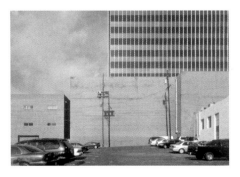

evidence, thus catching up with the modern European prototypes and models displayed in all the exhibitions and fairs of this immense territory.

The eight chosen "Californian" designers constitute part of a family of modern architects in which the aesthetic of their work casts a legacy onto the present, and onto the particular context of Los Angeles. Richard Neutra and Julius Ralph Davidson are the emblems of this generation, resolutely Californian and descended from a European culture in which practice had left its mark on an architecture influenced by regionalism. Extending the work of Frank Lloyd Wright to the west coast – with which both Neutra and R.M Schindler would be associated – this generation develops a kind of writing during the years of crisis, instigating prototypes that combine contemporary forms and technologies.

If the gamble of the CSH program is a daring one, it takes place at the end of the war at a moment when the social, political, and economic structures are most affected by the war and where the Americans are perhaps the most capable of understanding and appreciating the advent of new standards of living shown by the magazine.

The CSH program becomes the war arm of the magazine, a catalyst thought to hurl the average American into the immediate future.

The program poses as an ultimate limit, a benchmark of good taste and progress in face of a surge in the consumer market for single-family homes, carrying its share of mediocrity, eclecticism, and speculation. If the program is the guarantor of good taste for the readers, it quickly becomes a means to educate them to accept the modern forms that the magazine displays with each new issue.

An urgent need for housing

Right after the war, the military industry ceases, in part, to exist, leaving 10 million people henceforth unemployed. The 20 million women who had worked during the conflict must give back their jobs to the returning soldiers. While positions in the employment market are limited at this time, the government must also face a shortage of single-family housing that is exaggerated by the inefficient resumption of civilian construction since the crash of 1929, and aggravated by the conflict. With the onset of war, domestic construction concentrates on military barracks to house workers, large numbers of whom were mobilized in new labor centers in Los Angeles. Such short-term employment goes hand in hand with its precarious housing. Construction is distinctly military in aim, and is perfected through the rapidity and efficiency of its completion. Enriched by the pragmatic methods used at the time, industry is in a position to respond to the needs of the postwar civilian population and to adapt its efforts to the incomes of the average American. The government plans the immediate construction of 5 million homes, with 12.5 million more to be built in the years to come. [7] For the veterans, this dream of home ownership is made possible by the institution of the GI Bill of Rights, [8] cover the entire payment without the need for an initial contribution.

For the civilian population, the government – through the intermediary of the FHA – favors the acquisition of single-family homes by the exemption of certain taxes, and allows for real estate loans.

Nonetheless, the FHA does not grant loans to everyone, nor does it grant loans to all real estate ventures. It limits itself to a homogeneous population made up essentially of whites yearning to live in the suburbs. The FHA even advises promoters to focus on a particular market based on age, income bracket, and ethnic group.

OBJECTS OF DESIRE, THE DESIRE OF OBJECTS

rts & architecture

SEPTEMBER

PRICE 35

THE INAUGURAL PROJECTS
The 1945 season

CSH #1/7

The CSH program is portrayed in *Arts & Architecture* as if it were a television serial. After the test trials through the pages of the magazine, the project is framed and established in a durable way by the editorial staff and its advertisement through publication.

Arts & Architecture finally reproduces the portraits of the principal actors of this fiction as if to complete the credits of the series, which would sustain the American – and more specifically Californian – dream for more than twenty years.

The year 1945 would be the most prolific and steady towards the advancement and systematic establishment of this saga of eight projects, soon to be nine. The scenario for this year remains constant; a new plan appears every month with its author. The latter develops a script for a hypothetical family, a sketch of the preoccupations amd solution ultimately chosen, built up through numerous drawings and a few models. All this is adorned with some advertisements for those products and materials to be used for the project's completion. Then, not unlike a popular magazine that contains an adventure in installments, the following month carries, apart from another plan, further details regarding the design of the preceding house, whether in the form of interior layouts or zooms onto particular moments, from the kitchen to the heating system. This first CSH season witnesses the birth of architectural projects that oscillate between a domestic reality that is innovative and restrained; CSH #1, #2, and #3 formalize methods never before envisaged, while CSH #4 and #5 reveal spatial or technical experimentation that comes directly out of this program's magnificent laboratory. More tempered and modest projects, CSH #6 and #7 make use of techniques and materials that are more simple and local; they precede CSH #8 and #9, two projects that are visionary in both their design and built form.

Only six of the nine plans would be built, a result whose score nonetheless appears honorable today, attesting to all the tremendous will to create on the part of Entenza and his team assembled around *Arts & Architecture*. Of the nine projects from 1945 that can be discovered in the pages of the magazine, six can be found traveling through the sharp bends of the Hollywood Hills and onto the freeways dotting the city. Mulholland Drive, Chautauqua Boulevard, Sunset Boulevard, the 10, 110, 415, and other arteries would lead me to one of its detours, to one of the soon-to-be familiar profiles of a California dream-turned-myth.

Los Angeles

Nothing destined this natural site to become one of the great metropolises of the twentieth century. It is an important geological depression near the San Andreas Fault, and surrounded by mountainous barriers isolating the numerous outlying deserts. Neither a notable port nor a remarkable fluvial setting, this valley is not a strategic site. Nevertheless, the climate yields the depth of its agricultural calling, despite difficulties in the water supply. The citrus capital of the last century and the cinematic center of the turn of the century, along with the oil, petrochemical, and soon the aeronautic industry all contribute to metamorphosing the countryside and the city that was opened up by the gold rush.

From 1,610 inhabitants in 1850, the megalopolis composed of several cities successively passes population thresholds of one hundred thousand in 1900, and then a million before 1930 to total 1,970,358 at the outset of the fifties. The postwar boom reflects the predominance of the aeronautic industries, as well as the vast expansion of automobile use. By 1990, the city accommodates 3,485,390 inhabitants, and assembles 8,779,944 people in its county. [10]

36

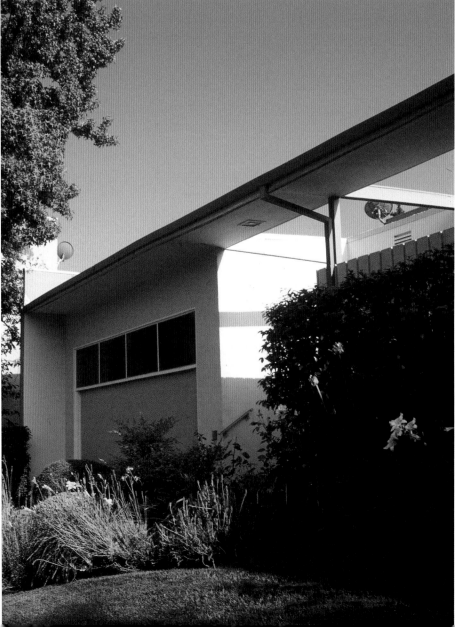

CSH#1, Julius Ralph Davidson

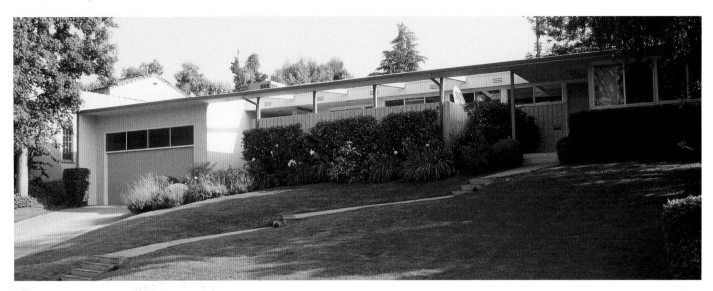

Hollywood

One can schematically identify three entities in the United States: The first is political and located at the White House in Washington D.C., the second is financial, located on Wall Street in New York, and the third is in Los Angeles at the Hollywood film studios. It is the studios that put into images the national symbols that would subsequently be emulated. [11] One must differentiate Hollywood from Los Angeles, [12] which lives according to another rhythm. The studios are regarded alongside the New York stock market on Wall Street, and not Spring Street, the financial center of Los Angeles.

It is at the end of an afternoon, behind the Warner Bros. Studios flanked by giant posters of television serials, that I see the first house of the program, code-named CSH #1. Resting on a mound of synthetic green, it offers its long horizontal silhouette for view, white and slender at the end of an undulation of white concrete. A woman as discreet as her house invites me inside with a strong Yugoslav accent and this look on her face as if amused to meet the architect who had sent word to the house a week earlier. She did not know the history of the house, having herself only recently arrived from Europe, a Europe wounded by the Balkan conflict. Without knowing it, she revived the editor's utopian ideal of offering through the project a new sense of comfort to the war veteran, as well as the promise of a better life.

While the house has lost many of the elements unique to the initial published design, such as the second story and long horizontal windows facing the road, it nonetheless has retained its original interior constructed around a large living area open onto the garden and embellished by a fireplace, multiple storage arrangements and a built-in screen, all marking the elaboration of this first study. Far from being the first to be built, this house would not see its day until 1948 in a second version that was lightened by war-time restrictions through the reduction of approximately 110 square meters, and the limiting of the choice of materials. But it is with his first design that Julius Ralph Davidson concentrates his hopes for the postwar house. At the time of its inception, it was designed across two floors – a rare element of the program – isolating as such the guest quarters and making them independent from the rest of the "machine for living." After its first publication in 1945, the architect proposes from March onwards a supplementary edition where he would unveil perspective views of all the domestic spaces, most notably of the storage arrangements, making of this house a model of spatial economy for daily use by the family. The virtuosity of the fit outs and of the integration of space is evident, recalling Esther McCoy's comment which revealed that the architect had undergone his early training in the designing of English yachts and luxury boutiques in Chicago.

Davidson, the pioneer of the program, would introduce plywood as a material suitable for the fabrication of walls, concrete with colored cement finishing for the floors of all living areas,

a flat roof within the framework of the trellis for large spans, and generous sliding elements that would be both quiet and practical, projecting the Californian family towards both its outer and private Eden.

With this first house, the equipment becomes a witness to progress. With its 73 power outlets, the house is amply fitted with electrical conduits. The amenities that seem commonplace today were at that time synonymous with the innovation invested in, and supported by, the domestic space. The automization of the garage door as well as the presence of plumbing taps activated by the feet or knees are only a few signs of the novelties. The house asserts its media-embedded nature by the provision of perforated wall openings in numerous rooms in order to encourage better communication. The integration of the television screen illustrates the commitment to change, a commitment that extends to the presence of a screen above the piano for silent home movies, a nod to the dream industry. Technology becomes the ally of familial comfort, reducing effort while incorporating new media.

The serving hatch, the angled stone fireplace, the recessed lighting, the finely worked screen separating the entry to the living area, the low furnishings, the compact kitchen, garage and service yard along the street, the large expanses of horizontal roofing, the transparent façades, the day-night divisions, the openings onto the garden, and the integration of diverse

CSH#1, Julius Ralph Davidson, *Arts & Architecture*, February 1945

38

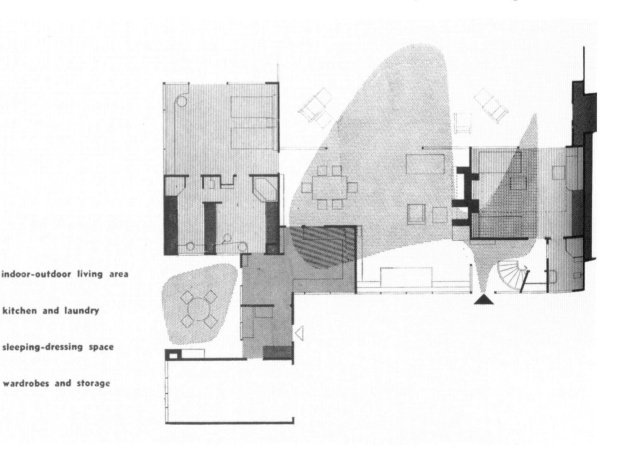

indoor-outdoor living area

kitchen and laundry

sleeping-dressing space

wardrobes and storage

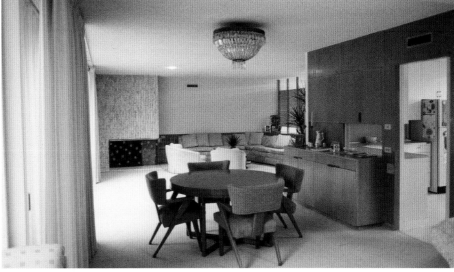

CSH#1, Julius Ralph Davidson

technologies are as much characteristic signs of the houses of the CSH program as they are generalized references of modernity that have indeed gone well beyond the bounds of the program in order to become new domestic standards, as well as the probable legacy of John Entenza.

What remains of these delicate intentions in the 1948 version? The guest area, now back on the same floor, glides along the side of the house, and the garage is widened. These are the only notable differences in the evolution of the project. The magazine does not elaborate on the new plan in detail, nor does it devote more than a single article to it, while its portfolio of images would never appear in the magazine's pages.

I finally take my leave of the house. The strange blue-tinged light of this particular dusk extends the house's horizontal profile and the image of a David Hockney painting now becomes clear and obsessive, as with the reflection of the light in the blue of the pool, and of the palm trees in the rear.

This image of the painting did not leave my mind, but rather imprinted itself anew on the vision of CSH #2 and its new pool at the end of a street in Pasadena. The owner of this house had a Mexican accent while his wife Barbara had none. They were also flattered and proud to have someone write about their house. They had lived there for about ten years and seemed to know nothing about their home's past, apart from a vague rumor coinciding with an exhibition at the MOCA Los Angeles.

The architect Sumner Spaulding designed it in March 1945 for a family of four – a classic scenario for the program. His concern was to offer easy maintenance and low cost to its occupants who would have no housekeepers, unlike most other families, such "that domestic services will be rendered by the family itself."[6] This concept motivated the architect to devise simple rooms that were pleasantly distributed around a clear plan.

In its first iteration, a distinctive design approach is brought to work and utility spaces such as the kitchen, laundry center and bathrooms, which are, as with the garage, claimed as pieces

SOLUTION: This, the second house in the Case Study Program, is designed to achieve low maintenance cost and still provide the elements necessary for the relaxed, expanded living that hitherto has been possible only for families of considerable means. We have assumed that the servant age is past—that domestic services will be rendered by the family itself—that cooking, cleaning, and allied tasks requiring household skills must be accomplished with an economy of energy and convenience—that space ample for a family of four or five is desirable—that a large part of the active living of the family will take place out of doors—that flexibility in use is essential to the main living areas—that the bath should be as generous and pleasant as any other room in the house.

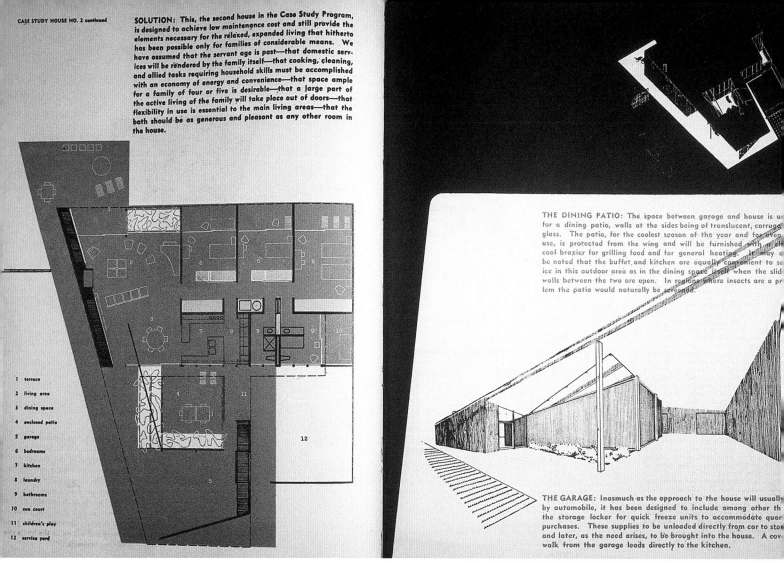

THE DINING PATIO: The space between garage and house is u for a dining patio, walls at the sides being of translucent, corruga glass. The patio, for the coolest season of the year and for ev use, is protected from the wing and will be furnished with a h cool brazier for grilling food and for general heating. It may be noted that the buffet and kitchen are equally convenient to s ice in this outdoor area as in the dining space itself when the slid walls between the two are open. In regions where insects are a pr lem the patio would naturally be screened.

THE GARAGE: Inasmuch as the approach to the house will usually by automobile, it has been designed to include among other th the storage locker for quick freeze units to accommodate quar purchases. These supplies to be unloaded directly from car to sto and later, as the need arises, to be brought into the house. A cov walk from the garage leads directly to the kitchen.

1 terrace
2 living area
3 dining space
4 enclosed patio
5 garage
6 bedrooms
7 kitchen
8 laundry
9 bathrooms
10 sun court
11 children's play
12 service yard

CSH#2, Summer Spaulding & John Rex,
Arts & Architecture, April 1945

of a larger whole. Under a large sloping roof designed to anticipate the snow (present sometimes in this hilly region) CSH #2 seems to favor its orientation towards the mountains with its glazed façade. The house is designed in three bands in which the middle one separates daily and nightly activities. Within this arrangement, the car takes on an essential role with its large garage nearby, which has at its disposal significant accommodation for various storage units including a deep freeze. The wall-sized cupboard – a distinguishing element of the project – facilitates the transport of groceries directly from the trunk of the car to the chest of the house. The pivotal kitchen is a model of efficiency, while the dining nook serves as a reference for all subsequent houses of the program by doing away with the idea of a dining room – a model deemed too bourgeois for this new post-atomic American family. The kitchen furnishings are lightened by their metal structures, around which both high and low pieces are placed. No longer a mere technical requirement to be hidden, the kitchen opens onto the rest of the house. This opening accompanies the emancipation of the woman. [7] Indeed, the active woman of the house takes on a full role and blossoms in the fluid space: "When guests are present she can be with them and still have close supervision over the preparation of food." [8] CSH #2 is the second house of the program to be built. However, it is built at two different times. In its first temporal mode, it paves the way for a "contemporary" modernity as stated by the program, by introducing basic concepts and governing rules. Heavily modified in October 1946 and completed in 1947 by Spaulding and his new collaborator John Rex, this project nevertheless retains an extraordinarily flexible quality with its spaces and with a simple and efficient organization of the living and service areas. If the basic concepts find their architectural reality in the first design, the second, on the other hand, looks to validate them.

It rectifies the constructive givens by responding to the demands for a reproducible and low-cost house in a country given over to inflation. The house divides into sixteen modules the measurements of which are based on the sizes of materials used. While the first design orients the house as a whole towards the mountain, the second arranges the openings along three sides and privileges the double orientation of the living room, then isolating the terraces from one another.

A curved brick wall snakes its way from the outside to under the roof. This curious object separates the car from man, finally rendering the latter a pedestrian, and returning him to the joys of domestic breeding. Soon, we enter the house alongside the wall with the owners. Now, we are seated on the long settees to talk over avocado sandwiches, in the square of the unencumbered living space open to nature from one side to the other, which separates the bedrooms from the service areas. This square is furnished with a fireplace and television box typical of the time, and scattered over with a multitude of plants and South American sculpture, giving the whole space a "cool" side that had already characterized the project half a century ago. The lines of the furnishings are more vague and well-to-do, demystifying somewhat the postwar modernity of this country's west coast: Both rigorous and demanding, yet at times disparaged and paradoxically relaxed. Remodeled after a few years, the glass façades are extended to align with the edges of the roof, lending a certain elegance and horizontality to the project alongside the blue of the pool and its brand new pavilion. The parrots and the

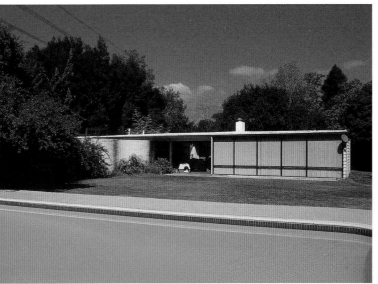
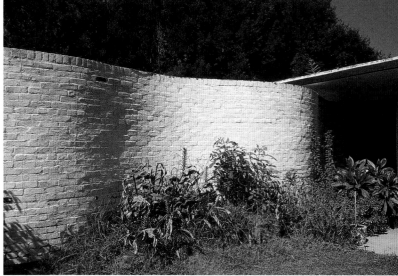

CSH#2, Summer Spaulding & John Rex

small monkeys populate the exterior and as with such foreign animals, they remind their owners of the presence of Central and South America in their decorative objects, without ever cluttering the interior.

After having left the brick support of CSH #2, I decided to visit the owner of CSH #7, from whom I had yet to receive a reply to my letter. This absence of response, and indeed of any sign of interest, had sharpened my curiosity. Had it been abandoned for a vacation, or for good? I stopped in San Gabriel, where this project was designed by the architect Thornton Abell in November 1945 and brought to life in 1948 after numerous modifications.

As it brought the pool of black asphalt to an end, the monochrome façade of the modest sized villa stretched out only to offer the visitor a garage door and an entry hidden underneath a pergola. The owner's dog was being decidedly more talkative than his master who obstinately refused to open the door, barking like his faithful friend and threatening to call a patrol of the local militia, a group that the stranger did not particularly want to meet face to face.

This visit only gave me information regarding the color of this project, since one could not guess it from the photographs from *Arts & Architecture* in 1948. Indeed, the house would take on all the nuances of green tones largely evoked in the portfolio published in July 1948. An analysis of the coloration as elicited by the pages would seem to want to imitate nature in all its shades. A great success according to the large audience that studied the project from July to September of that year, CSH #7 appeared as one of the most persuasive and probing responses to the questions and preoccupations put forth in the original CSH program from January 1945.

CSH#7, Thornton Abell

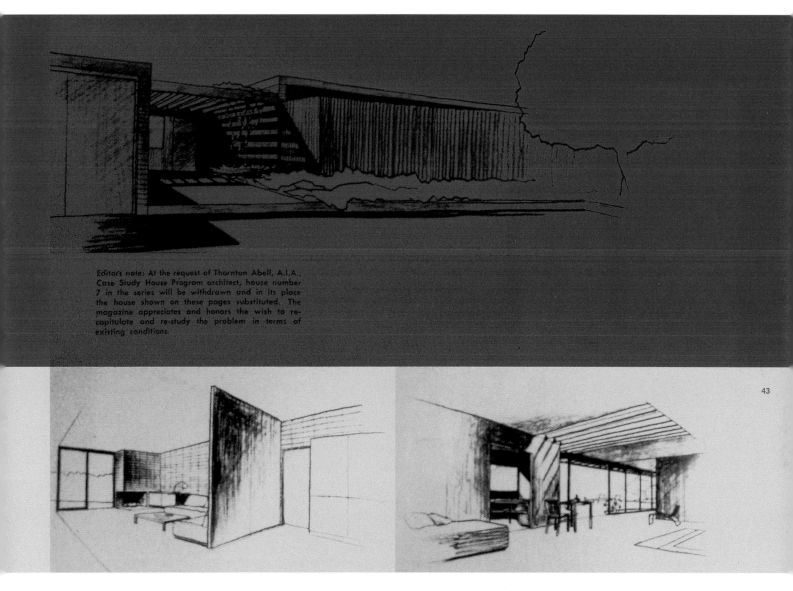

CSH#7, Thornton Abell, *Arts & Architecture*, April 1947

Articulated around its living room and creating a space able to accommodate all the activities of different members of the family, this living area allows for simultaneous isolation and socializing, by articulating a conversation zone near the fireplace and outside of the main circulation area, while providing a study zone near the kitchen and allowing for other activities in the living room. The living space separates night areas from work areas. The plan of this project focuses on two parallel bands that take advantage of the V form of the initial, more space consuming design from November 1945. Each room is connected to the outside; the bedrooms have their patios, the service areas their lath house, the activity areas their large garden.

Constructed on a concrete slab, the choice of the four-foot modules, the wood used for the structure, and the forced air central heating are dictated by economic concerns. The choice of concrete block is unique in the range of CSH materials. Designed following the principle of an ideal project that anticipates future modifications, the first version is exposed in the pages of the magazine in order to attract potential sponsors or buyers. Modest in both its program

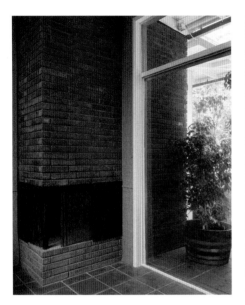

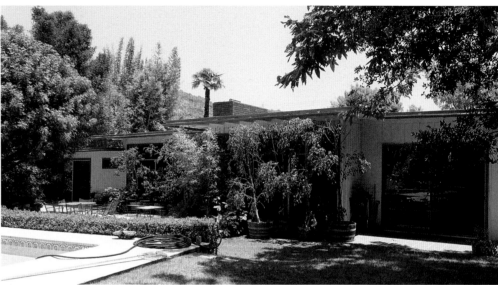

CSH#3, William Wilson Wurster & Theodore Bernardi

and form, this comfortable project subscribes fully to the lineage of projects designed by Richard Neutra, in its sensible vision for a modernity that would be sensitive in its writings and formulations, by the use of green panels and robust materials like wood and brick.

Edited in June 1945, CSH #3 would be built, then opened to the public in April 1949. This house responded perfectly to the expectations of the program that now boasted three projects. Based on a simple, clear and rational design, the architects William Wilson Wurster and Theodore Bernardi defined it as adaptable to their imaginary standard clients. The cost of construction lies at the center of their preoccupations, prioritizing pragmatism ahead of architectural heroism. Exceeding all criteria shared by all the production of the first season, the project explores a new spatial system and defines an intermediary space without any distinctive allotment designated to it. The plan of the house is similar to an H, in which the central bar resembles an atrium containing the entry. Day and night spaces are laid out on either side of this central space which bathes in direct sunlight and which is largely open to the garden. The slots of light multiply all throughout the project and come to animate the hall, the master bedroom, and the combination workroom-laundry. Given that the separation of day and night is implacable, the childrens' bedrooms are oriented towards the street in order to be protected from the audible nuisances brought on by their parents' parties on the patio. As with the numerous projects of the first season, the plan of this house opens itself widely to the exterior with the use of terraces. It also conceals numerous cupboards and compact storage spaces. An interior perspective drawing reveals the classic laundry next to the kitchen, which doubles as a workshop reserved for the father's manual activities, such that he can complete his model-making studies while the mother irons. Leisure is devoted to the heart of the house and no longer solely to the garden or the garage. Concerned with the effects of architecture on human behavior, the architects define this area, allowing the parents to be occupied without being separated: "The joining of the two areas will preserve that companionship that is sometimes lost by one member pursuing a hobby too hard." [9]

Arts & Architecture, August 1943

son we show furniture is to keep our drawings of the interiors from looking barren. Of course, in spite of what we have been saying we do have ideas about furniture types and arrangement. To use a dangerous phrase we know what WE like. In relation to such likes we have put a great deal of thought into the scheme. All of us tried to put our thoughts into it, which is by way of saying that it may have some of the qualities that a "family" might bring into it. We don't like to think of the furniture arrangement as too fixed—we have several ideas and later we might feel inclined to do something different. In fact, we would invite our readers to churn the furniture around and see how they would like to live in the house.

The furniture is thought of in terms of use rather than for its own sake. Therefore, everything is kept as much below eye line as is consistent with comfort. By this we mean that we hope not to have any of those low-backed chairs that hit you in the small

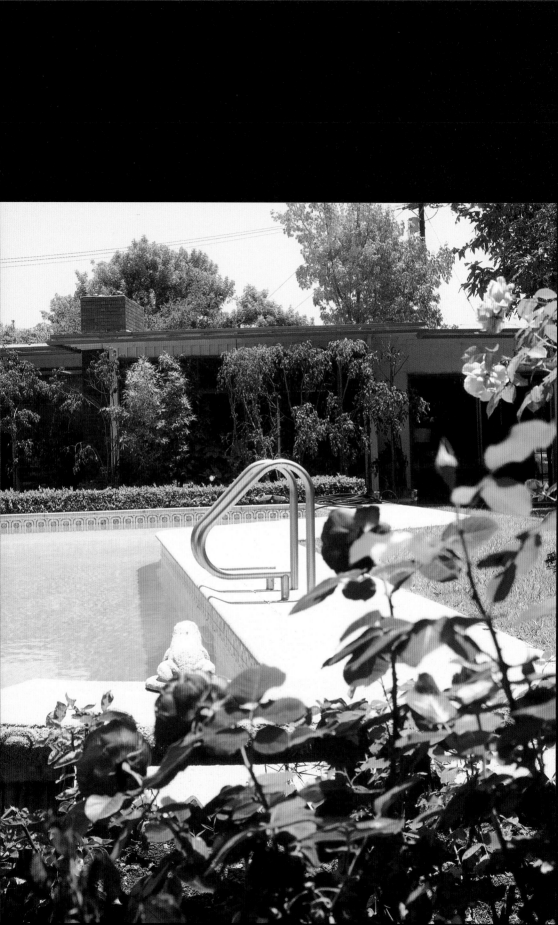

CSH#3, William Wilson Wurster & Theodore Bernardi

Contrary to Davidson who regretted not having been able to build CSH #11 in 1946 out of a metal structure, Wurster and Bernard content themselves with the traditional dimensions of 2x4 wood framing. The pursuit of repetitive and modular elements is strong in this project, where for example, one notices on the exterior sheets of aluminum covering the wood structure of the house. On the interior, glass and plywood panels inundate the vertical partitions and bath the house in an impeccably natural light. They would love plywood for its "cheap" quality: "although plywood costs more than plaster, we like it better because it looks cheaper." [10] Used as much for its newness as for its performance, but most of all its aesthetic quality, this material would flood the projects and designs, the wall sections in the dressing rooms, as well as the decorative panels padding the roof. An advertisement expressly placed in the magazine on behalf of the plywood firm, the George E. Ream Company, announces in 1943 "Plywood for war…later for peace." [11] Pierre Koenig would be one of the rare architects of the program to bring it into play in the CSH, as much for its economy of means as for its perfect and abstractly pure surfaces.

It would be the direct lighting of the atrium that would provide this project its identity, diffusing a soft light through the adjusted brise-soleil, creating an inside-outside space. Today, this central area of the house has retained all its charm, with its concrete paving stones and the slats of light in the hall.

It would be one of few occasions where the actual user would ignore everything around her to the point of rumors, with her cat and dog more voluminous and heavier than me. The plans and the copies of the prints from the magazine that I would give the owner during a second visit would produce for her the mirage of destined celebrity.

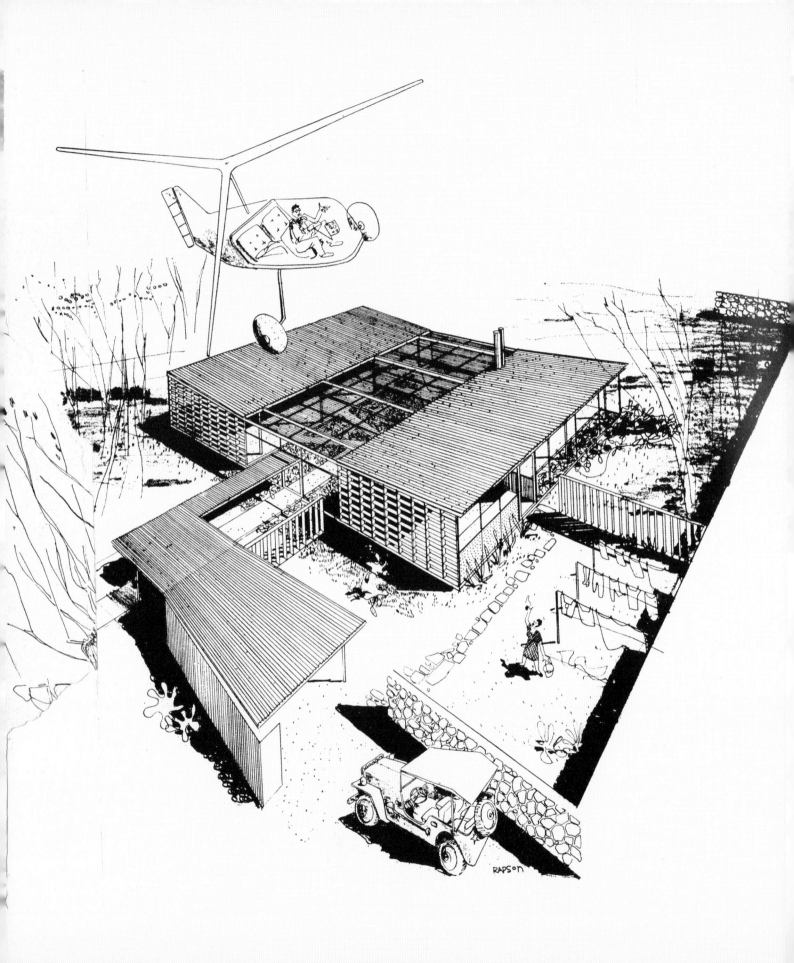

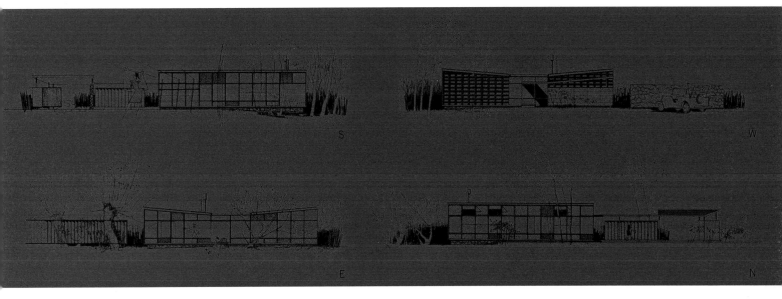

S

W

E

N

CSH#4, Ralph Rapson, *Arts & Architecture*,
August 1945

Fulfilling the category of the most radical and innovative projects in terms of way of life, CSH #4 and CSH #5 seem to signal a complete break with the standards of the time. While their subtle graphics along with their lack of constraint are today seen as mythic elements of the program, it is nevertheless a fact that their principles continue to challenge formal norms.

Named by its author "Greenbelt," CSH #4 is brought to our view from the sky, where a man who is the owner of the house or perhaps a close friend of the family, gazes down upon it from a helicopter and greets his wife or friend standing in the courtyard. The Jeep has replaced the classical automobile, and the three-banded house is contained within a rectangle. Other vehicles, other habits, other houses, other lives – that is what Ralph Rapson, the designer of this UFO, seems to be suggesting to us.

After a more sophisticated and complete reading of the articles from 1945, we discover that CSH #4 develops on either side of an interior central garden, in an area of transition between the public/daily and the private/nocturnal side of living. The captivity of nature forms an integral part of the house; the vegetation is an object of decoration, of life as preservation, and of culture. The author appears to want to reconcile man with his primary environment, that which had seen him born and blossom.

Beyond the gently sloping butterfly form of the roof, the sheet metal roof deck, the adjustable louvers under the central wire-glass roof, and the repetitive skeleton (devised by the architect in wood and metal according to price and availability), accommodate modular panels of glass, plywood and vivid colors, all anticipating the Eames house. The typical Californian question of the relationship between inside and outside is also posed by this case study.

The "Greenbelt" comes close to a term belonging to urbanism,[12] seeming to imply the inclusion of this house within a network that is larger than that of the single-family house. In fact, the house is conceived not in the context of a residential suburb, but rather in the city. It is designed in such a way as to create its own environment and to adapt itself to restrictive exterior locations by privileging the view towards the interior.

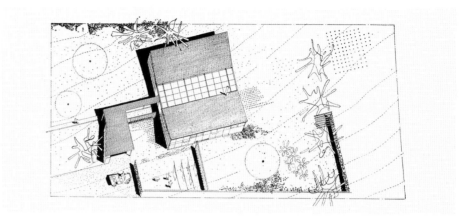

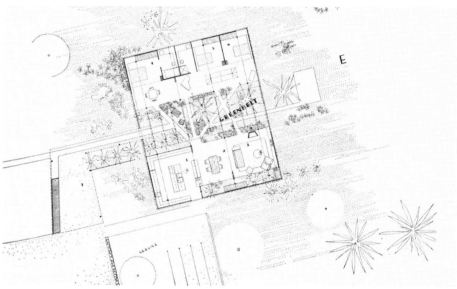

Back on the ground and in the midst of CSH #4, Rapson, a designer in his home state, invites us with his trademark perspectives to taste the garden and the house in which the transparency of the interior and the fluidity of the spaces take us by surprise. In the project, the gaze of the visitor lets itself in and loses its way among the volumes in which the lines blur the borders between inside and outside through this tamed yet savage nature.

Apart from this *Mise-en-abyme* of standards already experimented by Rapson in another project – a cellar house published in the April 1943 issue of *Arts & Architecture* – the author dissolves barriers in a definitive manner such that the living areas are reduced to a minimum to profit from the void of the garden, which resonates like a call to nature and meditation; indeed a sort of eco-friendly, New Age Californian reading well ahead of its time.

The house recedes with the aid of a structure that is industrial in both making and vocabulary, a cheap and efficient greenhouse, a tool devoid of all formal and decorative preoccupations. This desire to break the limits of the domestic object in order to bring it to other fields of conceptual order would be the principle reason for the abandonment of the project, a decision that was motivated by the fear of leaping into the void, into a future unknown and unlikely for most.

SEPTEMBER 1945

PRICE 35 CENT

arts & architecture

INTERIORS
CASE STUDY HOUSE # 4

CASE STUDY HOUSE #
WHITNEY R. SMITH, A.I.A. 5

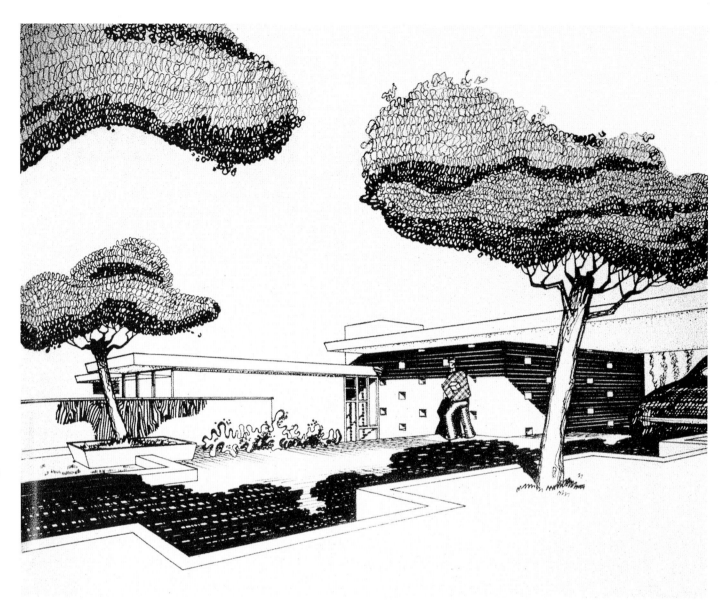

52

CSH#5, Whitney R. Smith, *Arts & Architecture*,
September 1945

Like its previous sister CSH #4, CSH #5 has never been realized. It also explores a house model that relies on a newly urban, experimental mode of living, unfortunately left undiscovered, but through the subtle features of its author's delicate drawings.

The different rooms of the house as discovered through the perspective drawings and plans are scattered and quasi autonomous from one another. The architect Whitney R. Smith defines them as "islands under one roof," [13] which are reconnected and unified under a large horizontal rectangle, thick and sloping at the edges.

The loggia, kitchen and sitting room that form the central space are separate, but can be joined together with the deployment of sliding glass partitions. The hallways are abolished in favor of fostering connections with the outside, in which the open loggia – again a space without any real affectation – is punctuated by these programmatic blocks.

The entry has disappeared and becomes multiple, the exterior becomes part of the inside like a void placed in the midst of solid material textures, marking a strong originality, as well as a break with the aesthetic of the program houses. The freestanding rooms are made of powerful and imposing masonry, fabricated from adobe bricks and armed with a metal structure, shattering the model of the traditional house.

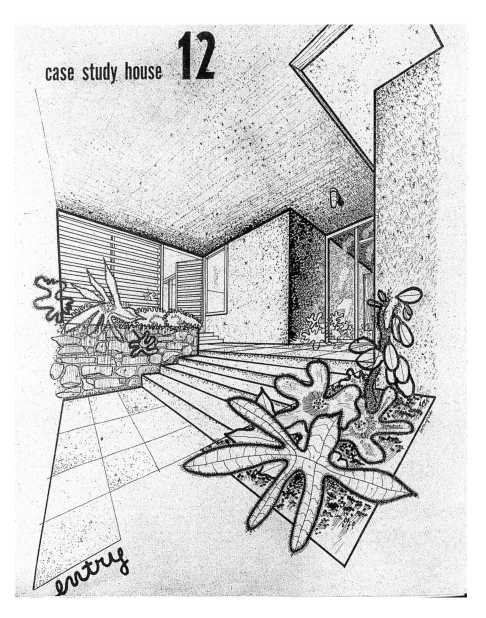

case study house 12

entry

The questioning of standards is reinforced by a brilliant utilization of rustic and diverse materials lending an additional sense of independence to each living space, as well as a unique coloration to this stunning and self-evident project. On the floors, the bricks are scattered throughout the exterior spaces, while cork covers the bedrooms and the kitchen. The articulation of the modules creates a landscaped and regional dimension.

CSH #4 would dissolve into nature with its interior greenhouse. CSH #5 would dissolve into the landscape with its earth wall and its red brick floors compressed around a fluctuating buffer zone, an unspecified and adaptable threshold. In these two projects, the outlines of domestic space are melded with their environments. The organized voids are left at the margins of the construction. The house is erased in favor of its use, and the desire to live otherwise.

Six months later, in February 1946, Whitney R. Smith would produce again for the magazine, namely CSH #12, but this time he abandons his beautiful loggia concept in favor of a plan more convincing for the public: An X form where day spaces dedicated to social activities cross with intimate and private night spaces. The idea of an independent island would only remain in the guest area, projected beyond the garage under the large overhang of the latter's roof. This project, even better than the earlier one, would also never see the light of day.

hope, will be added in the future. Meanwhile, the "water hole" with its hose-spray and "sunning beach" will do well; it lies between and separates the social and the sports court. This sports court has its vital connection with the house: the children's shower, wash-and-toilet room. To have these facilities so handy to the outdoors is a trick to reduce house-dirtying and thus house cleaning.

The last of the courts, C-4, may be called the practical operations and all-purpose service court. Deliveries come in here, laundry is dried, the smallest child plays in the sun or in the shade, right in view of the kitchen window. Its playroom—an enlargement of the bedroom which can be segregated by a fold away fabric door, to yield quieter afternoon naps—broadly and under a roof overhang opens out on Court Four. Family meals are informally taken on the upper level at a table under the roof projection and the Chinese elm tree. A vine covered trellis protects this outdoor nook from the external view.

The general layout has been sufficiently described. In particular we may note, that the living room has a music bay with piano and score cabinet. There is further a "visual and occoustical appliance" cabinet whence the electronic fireworks may originate and where apparatus for television, radio, music reproduction and color picture projection finds its place. The opposite living room wall is treated as a glass bead screen and projection plane. The ceiling slopes up to it.

The spacious sitting corner of fitted-in seats with sponge rubber cushions needs only the supplementation of a few easy chairs to harbor a good sized party, which will with ease extend through the wide opening of the sliding door to the patio under the big tree and about the fireplace.

The dressing room and bath of the master suite also will serve visiting guests. The utility room is very centrally located, to supply heated water to lavatories, showers, tubs, sinks, and circulates hot air through short ducts into the subfloor plenum space, to make the entire floor a radiating panel.

Dining space and kitchen communicate through a wide porthole as well as a walking opening, but at will can also be segregated.

The bedroom of the two older children has its desks and library shelves; the youngest one sleeps in the lower of a two story bunkset. The Omegas believe in the educational value of a child guest, visiting and boarding with the family for a couple of days—a shining example of table manners and a stimulus to new modes of playing through the long day.

Less demonstrative than the two earlier projects of the program, Richard Neutra's CSH #6 would also be abandoned.

With this case study, Richard Neutra extends the exploration initiated by his predecessors, even though the experimental form of the design seems to elude a design that is rather marked with a certain banality. Further, by seizing this opportunity for reflection, the architect surprises us by showing himself capable of raising his hands high to accept the challenge launched by the hypothetical clients of whom he is the principal author and inventor, by avoiding the heroic architectural act in favor of a prudent design.

The architect presents himself in the October 1945 issue with what he announces as a double project: CSH #6 "Omega" and CSH #13 "Alpha" for two couples who had acquired two adjoining lots. Like the lots, the two couples are as imaginary as their improbable names. In his presentation, Neutra has them intervene and develop their program from vignettes of his work. This use of auto reference is unique in the program. As such, dialogues "reproduced" in the magazine are juicy, and underline the maturity of this architect who is capable of putting himself in the position to face his clients.

"We would like you to pioneer with moderation, this time." Indeed, it is the triviality of the real into which the architect plunges us in order to show his qualities as a designer. He has the clients later add, "we need the place *now*, you see, in the midst of what I should call the

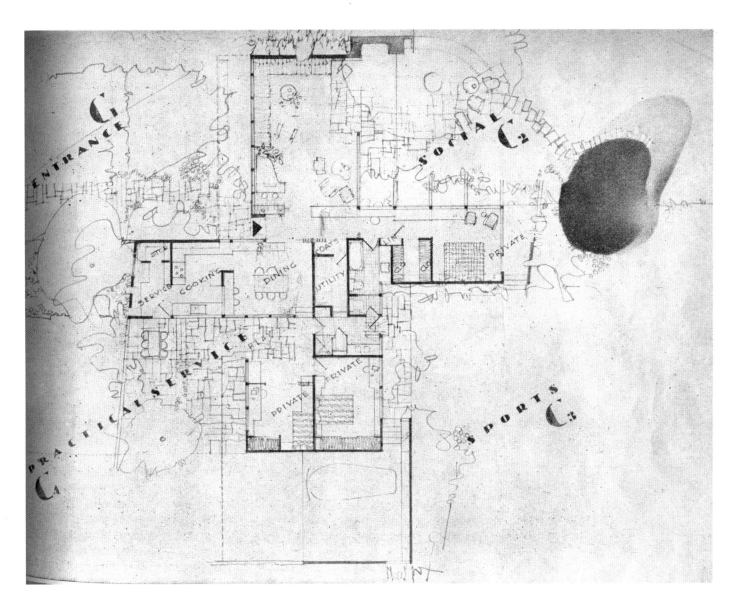

On the image: ENTRANCE C₁, SOCIAL C₂, PRIVATE, SERVICE, COOKING, DINING, UTILITY, COATS, PRACTICAL SERVICE C₄, PRIVATE, PRIVATE, SPORTS C₃

CSH#6, Richard Neutra, *Arts & Architecture*,
October 1945

transition period, where things are still less available than in the pre-war. And whatever may
be novel in the bracket of 'Availables,' – please go and test only a few of them on me, not
all!" [14] By announcing the client's point of view and by putting forward their reasons, Neutra
justifies his orientation to a regional modernism, and retreats openly from the International
Style of which he was the leader on the west coast. With his projects, he must finally bring
himself to take into account the limitations of materials, even though, he portrayed during the
long years of the war wood window mullions in metal in order to sell a modern image. The
dialogue ends with this maxim: "Take us seriously, if you please," as if irony had been all
along the only engine of the interview.

His project, which ensues from this demand for a wise modernity, is, at first sight, a discreet
house. The innovations are mainly contained in the great number of materials sheltered
under an expansive roof without forgetting the formation of a modular structure.

The metal runs alongside the stone and the sliding doors – details as typical of the architect
as the legendary overhangs of his roofs that extend his rooms to the exterior. While the materials
are set in advance in order to reassure the clients and to lend a temperate vocabulary to the
architect's simple and modern writing, the great modernity of the projects CSH #6 and
CSH #13 results from the X plan for Omega and L plan for Alpha.

This arrangement of the plan interprets in a critical manner the duality of the program, that is, the day and night spaces so dear to our European architects from the beginning of the 20th century. The zoning of the cross plan for CSH #6 separates the day-night/social-private functions, and allows for the designation of four courtyards in each corner, extending as many spaces towards the exterior. Four courtyards with four functions follow after the entry, dissolving in the slippages and fluid passages of the materials for the flooring, the wall, and the projections of the roof from inside to outside.

Rectilinear and modern with its separation of functions, the house and its relation with the environment become Californian, soft, user-friendly, and contemporary. The architect carefully masters artificial lighting in order to favor a reading of the inside and outside. The natural ventilation is an important element favored by the fluidity of air from one wing to another, by the windows and the doors. Furthermore, the white materiality of the roof that reflects the sunlight is composed of a hollow casing able to harness the breeze from three of its sides, facilitating the cooling of the roof by air flowing through this thick demarcation layer. The overflow towards the exterior and its gentle capture stem from the delicate articulations for which Neutra possesses a "savoir-faire."

When CSH #13 is placed on a hypothetical lot adjacent to CSH #6 in 1946, the sense of integrating the two houses while protecting privacy provides two new challenges. The Alpha family has three children that play with their Omega first cousins. The sports court of CSH #6 is thus open onto the corner of CSH #13, and the mountain view is possible from both houses. In announcing these two points, Neutra attempts to lend the rules of life a taste of communality by encouraging respect and exchange between neighbors.

The details of these two houses are omnipresent in the architect's delightful drawings, and they echo the catalogue of photos as a point of departure and reference for the work. Finally, while these two projects are never built, one finds these details in numerous other creations by Neutra.

Of the nine projects of the program's first season published in 1945, six are built, marking the fierce and obstinate will of the *Arts & Architecture* team led by John Entenza to succeed with its investigations and deliver the postwar house, which had become 'today's house' with the end of the conflict.

While the major events of these first investigations rest with the Eames and Entenza houses – CSH # 8 and CSH #9 respectively, which would see their day in 1949 – the four other built projects do not lack in interest in terms of their aesthetic performance and modes of living first projected, then constructed and practiced by two or three different generations. Also, because of the trials and tribulations associated with the montage of operations, there remain nevertheless exemplary sites, of which the most probing and complete is perhaps that of CSH #3, where the gap between conception and completion is one of the shortest.

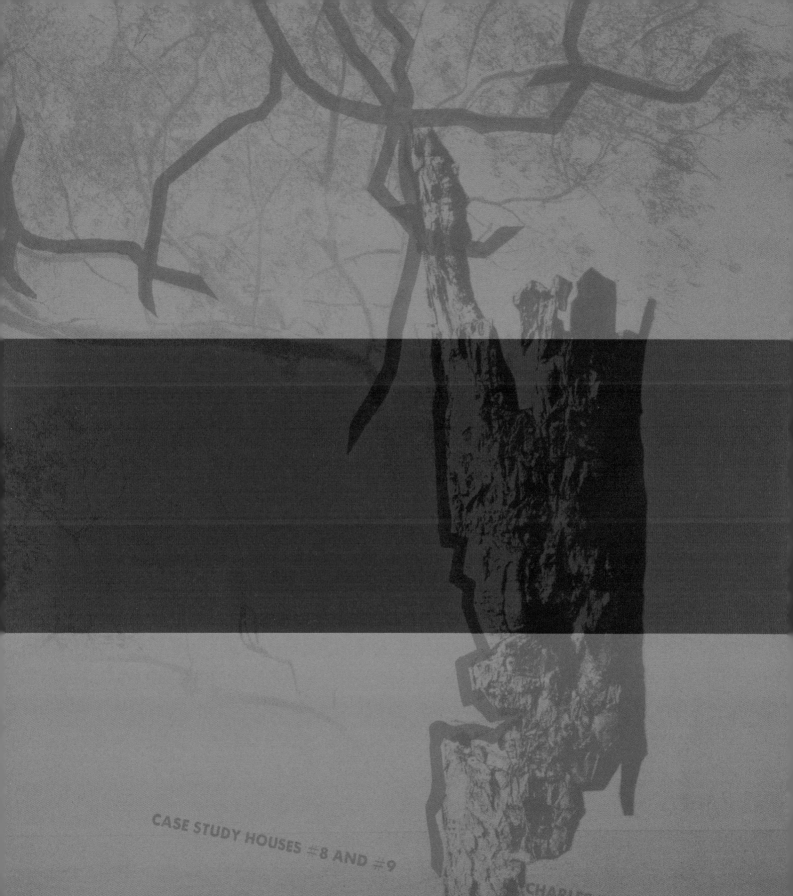

CASE STUDY HOUSES #8 AND #9

CHARLES EAMES AND EERO SAARI

IN THE SHADE OF THE EUCALYPTUS

CSH #8 & #9

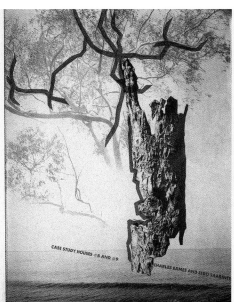

Far from this notion of getting the idea of modernity across through a writing acceptable by everyone, the publication of CSH #8 and CSH #9 in December 1945 would mark the first point of acceleration of the program.

While the first seven projects were for the most part conceived during the war years, and thus with restrictions on primary materials, the established peace would allow architects to deepen their desire to make use of previously lacking metal, and by the same token to explore the premise of industrializing the construction process. The prefabrication of construction elements that was introduced in 1944 appeared through these two projects within the perspective of a new context of peace, as a way of successfully offering a maximum of good design to the most people.

In December 1945, the readers of the magazine discover the Siamese projects CSH #8 and CSH #9 as designed by Eero Saarinen and Charles Eames, appearing behind an enigmatic page showing the sprawling bark of a tree. Having both taught at the Cranbrook Academy of Art [15] where they met and worked for Eero's father Eliel Saarinen, they realiz together the design of molded wood and plastic furnishings that garner much attention, and are awarded even before 1945 [16]. Creators and design partners after the war abandon the furniture in order to dedicate themselves to the question of space under the watchful eye of John Entenza. On a site in Pacific Palisades facing the ocean, and in the shade of the large eucalyptus trees

8

The house is built between two trusses. The floor and ceiling help to stiffen the top and bottom cord of the truss, and together with the truss form a box beam. The end walls keep the box beam from collapsing sideways. The structure rests on two steel supports, these being set in so that the end of the box forms a cantilever. This shortens the span and develops a negative moment over the support which makes for a more economical truss. Cross bracing between the steel supports gives added strength.

9.

Object to enclose as much space as possible within a fairly simple construction. The four columns in the middle are so placed to allow for cross bracing as well as continuity. Most of the joist load is transmitted to the outer rim of the rectangle and all carrying members inside carry a fairly light and equal load. Because of this the ceiling does not need girders projecting below the joist but is a simple flat slab.

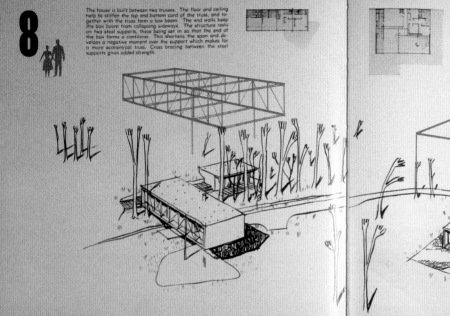

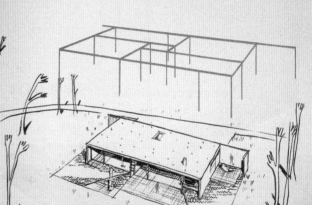

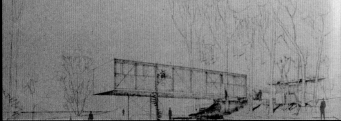

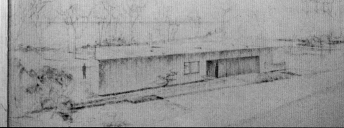

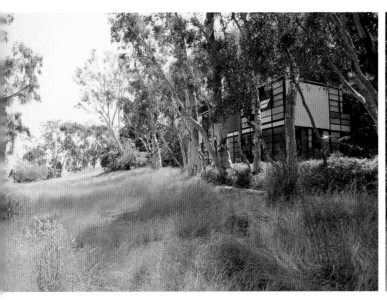
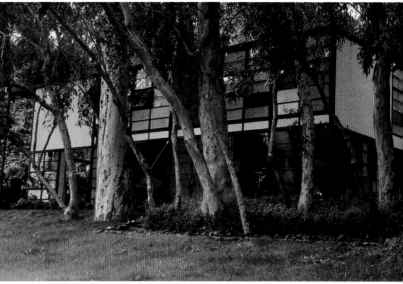

CSH#8, Charles & Ray Eames

planted by the founder of Venice Abbot Kinney, the two side by side projects claim their differences right away, appearing as two distinct answers to specific needs and requirements. The reader is no longer amidst the realm of the standard, but rather of the experimental, a realm demanded by the particular clients of these two projects who appear in the pages of the magazine as in a Chinese shadow play, surrounded by the logos of objects from their daily life. Entenza and the Eames couple are presented surrounded by an idyllic plot of land in which they will invest. Siamese projects since their first iteration, the two houses explore two abstract and minimal models contained in two distinct parallelepiped forms, in which the first is a cantilevered beam leaning perpendicularly against the slope, and the second is a sort of flat cube almost perfectly contained in the center of the lot.

The two objects that rest on a common site do not look at each other, but rather open themselves towards the ocean, in order to better respect the privacy of each.

Apart from this difference in form making – through fragmented beam or contained cube – these two projects are brothers. Their edges and skins define them, white and perfect for the one, and by the demarcation of vast horizontal façades carved out by panels of glass or opaque planes for the other. As in Cinemascope, the two panoramic façades offer the ocean as a distant horizon to their future owners.

Above the silhouettes of the owners and the simplified plans of the projects, space is allotted for sketches of the houses and for the expression of their metal structures as a summary and central point of these buildings.

Two views toward the ocean close the composition, recalling the importance of this preexisting natural landscape to the projects.

While the pedagogic emphasis to explain the plans and the specific solutions to the clients' requirements is always present as in previous projects through the clearly annotated sketches, the newness is immediately rooted in the explanation of the structure, as if the essence and means of accomplishing the function of the program has finally found its expression of contemporaneity in this dreamed modernity.

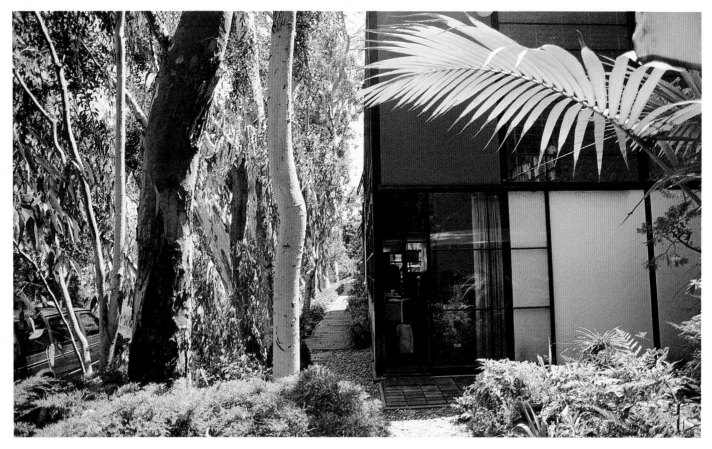

CSH#8, Charles & Ray Eames

The CSH program is a product of the war, and the Eames and Saarinen projects stand as the incarnation of this era of technological development and new techniques. The simple constructions of CSH #8 and CSH #9 are made possible by an efficient elaboration of performative and economic structures. In the grand tradition of modernity and of the International Style, the structure liberates the plan and offers new perspectives on developing new standards of living.

Paving the way for a light metal structure that was standard to industry to be used for domestic architecture, these two houses would be courageous prototypes. Yet, the reality of this future would not arrive until January 1949 with the beginning of construction for CSH #9.

Indeed, the two projects reappear in the magazine in January 1949 in a split manner. No one really knows why Saarinen and Eames abandon their cooperation on CSH #8, which is subsequently finalized and redesigned by Charles and Ray Eames. While CSH #9 is announced as being under construction and its skeleton is photographed as proof of its existence and its progress, CSH #8 would take on renewed importance, becoming "Case Study House 1949," a generic house for the year and for the program. It is in an article published in that same month that Entenza names the Eames house as such, like a ringing of the New Year's first result. Reviewing the past four years, he recalls the nine designed projects and the five under

PREVIEW OF SOME PRODUCTS MERIT SPECIFIED FOR 1949 CASE STUDY HOUSES

Above: Left to right
Sunmaster Clothesline
Altec Lansing
Hercules Safe
Flush Wall Radio

Right: Left to right
Kohler Sink
Alexander Smith Carpet
Squared Circle

Right: Left to right
Herman Miller Clock
Robeson Magnetic Cutlery

Above: Left to right
Case Lavatory
Shopsmith
Blackstone Dryer
Blackstone Washer

Right: Left to right
Blo-Fan Ventilator
Heatilator
Payne Forced Air Unit
Payne Forced Air Unit

Film during the years of the Case Study House program [13]

The forties turn towards propagandist film, in which patriotism and anitnaziism are noticeable in such films noirs as *Casablanca* and *Mission to Moscow*, in sharp contrast with movies of the same genre of the thirties. Escapist film remains with the Western, which produces iconic actresses such as Rita Hayworth. During the fifties, the production houses endure censure, becoming eminently Manichean; and oppose independent film such as that produced by the Actor's Studio. The benchmarks of a redemptive American culture are set down with war films that "dramatize the heroic exploits of American soldiers, new defenders of liberty." The Cold War is marked by propagandist film, but also by science fiction movies that depict the fear of an atomic war as well as enemy invasions. Escapist film divides what is left of the market between the genres of Musical Comedy and the Western, which "profit enormously from the subduing of Hollywood, as with the new techniques of panoramic images and Technicolor." Marilyn Monroe symbolizes the star of this class of films.

American film in the sixties is deeply affected by the shock of European cinema, which influences its production. The Western adopts a crude violence, and the modern "whodunit" marks its appearance with *Bonnie and Clyde* eclipsing the classic Western, the musical comedy, and the melodrama, along with such fetishized actors as Clark Gable and Montgomery Clift. A renaissance of "art film" that is engaged, political, and critical of the Hollywood super productions is born out of the dissolution of political censure.

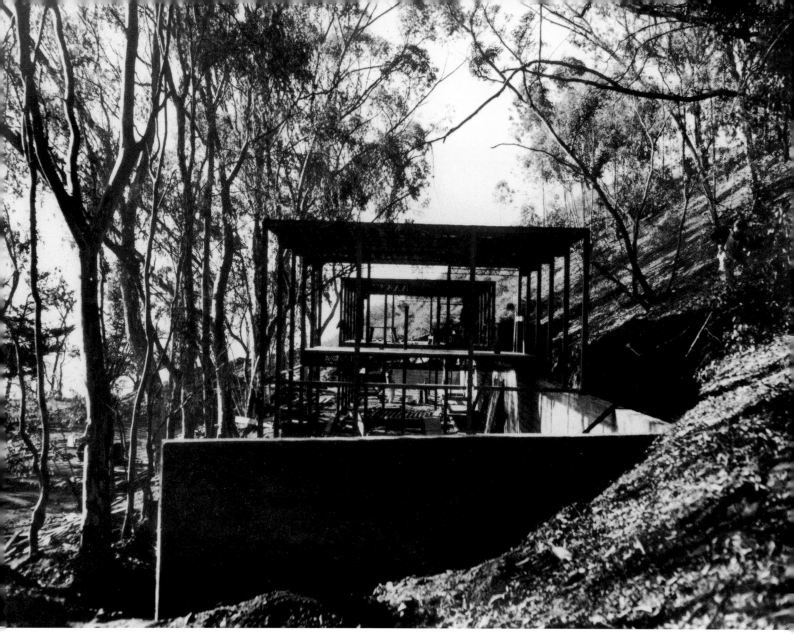

CSH#8, Charles & Ray Eames

construction. Fourteen vibrant projects are presented as incontestable proof of the ambitions of the program as announced in January 1945, and finally come to fruition with the reorganization of the market and the return of a certain prosperity, stamping out in a definitive manner Depression years and war that had witnessed nonetheless the genesis of the project.

After a tribute to the architects, and an analysis of the market in a state of total reconstruction, Entenza proposes sponsoring one single house per year, after having proven and detailed the soundness of his program.
With fewer projects on view, more attention would be brought to these annual productions that would become in turn the serial of the season. As such, a new temporality would be put in place, giving a rhythm for several years to come.
The article dedicated to the construction of CSH #9 in the January issue projects us immediately into the second period of the program, which is marked by metal structures, a generic element marked by the "savoir-faire" and elegance of three great California architects: Craig Ellwood, Pierre Koenig, and Raphael Soriano.
From the first study, we deduce the main body of the house, which recalls the structure of a bridge of beams diagonally cross braced and leaning on the hill on the short end, then carried on two columns on the other. Behind the field of vision, opening to the south and

Homestead Act [14]

In 1785, Thomas Jefferson organizes the parcelization of the territories following a north-south pattern. By favoring the grid and cartographic fragmentation, Jefferson can sell or exchange the parcels of land in order to reimburse debts incurred by the state accumulated during the revolutionary war. Anticipating the surveyed courses, Jefferson privileges the rural over the urban, and protects the country against the centralization and densification of the city, which he views as disastrous. [15]
The surveyed lines imposed by the Land Ordinance Act of the same year initially generate the formation of seven states, a (sometimes difficult) division which denies topographical circumstances. The unitary measurement is defined as six miles on a side and constitutes a single township. This same unit is then divided into 36 plots each measuring one square mile. The latter is further subdivided into so-called "quarters." The quarter constitutes the parcel allotted each settler upon arrival into the country, with whom lays the responsibility and the obligation to cultivate the land within five years of acquisition. This action is known as the Homestead Act and encourages the country to populate its remote territories, accessible by the infrastructure, e.g. the railways, [16] as well as planned and encouraged by the state.

laterally on the ocean and separated from the main house, one finds the more modestly sized work studio against the hill. With the length of the main house composed of eight bays in 1945, then seven in March 1948 [17], daily activities and services are rejected along the last bay, which now allots the pleasure of the panorama for calm and convivial activities. The bridge takes on the role of a carport, which is situated below it. A spiral staircase allows access to the apartment from the parking area. It is in this way that the role of this habitat defines itself, calling for simple maintenance and an urban character of the apartment, despite its siting in nature [18]. One can also read this desire as a nod to and extension of the vocabulary of the motel, an essentially American model.
In a publication devoted to the work of the designing couple, Beatriz Colomina explains that the abandonment of the bridge house concept occurs after Charles Eames' 1947 visit to the Mies van der Rohe retrospective at the MOMA in New York [19]. Bringing back astonishing and spectacular photographs from the exhibition that he had taken from ground level for *Arts & Architecture*, Eames also brings back with him the memory of an image from Mies' sketch for a project at the summit of a hill dating from 1934.

In 1948, the second version is conceived with two parallelepipeds perpendicular to the first project and separated by an exterior patio. The principal view towards the ocean is no longer frontal but rather becomes oblique, and is filtered by a row of grown eucalyptus that is reflected on its fine skin, which is partly made of glass encased in two colored boxes. The meadow would become over the years of waiting a picnic and play area for the Eames family, which, by virtue of its connection to the house, would be generally maintained.
While the plan of the second version would not be changed enormously, its engagement with the ground and its orientation are called into question, as nature, more than the view, would be source of the house's form. Esther McCoy [20] recalls the pains that Eames went through to minimize the extent of the project's luxury. He leaves the delivery of metal destined for the

CSH#9, Charles Eames & Eero Saarinen

first study in the garden, in order to redesign a more humble and measured solution. Then, he launches into his "Erector Set" game, using all the metal sections; he adds only one, then doubles the usable space by leaning the whole project against the hill; the retaining wall thus becomes a landscaped anchor. The ludic aspect of the project – a methodological trait of the Eames couple – governs the central part of the creative design process. Most of the elements from the first version are found again as a kit of parts in the last version: The framework, the stair, the metal, and the structural system. The studio also affirms itself and augments its presence. It lies along the hill as a continuation of the main body of the house, giving to the work its own identity. Color is considered as a structural game as it becomes more and more articulated, playing between the scale of the site and the scale of the furnishings. This remarkable project would highlight the influence of the landscape on the object of industrial design, and, as witnessed by the disappearance of the bridge, the progressive camouflaging of the house, much like a refined pavilion amidst its vegetal casing.

Despite the fact that the structural elements of CSH #8 and CSH #9 are similar, and impart the same elements of their black and white skeletons in the pages of the magazine, their perception in the two projects is radically opposed, lending the two houses their generic quality. Saarinen and Eames conceal the fragile structure of CSH #9, subtracting it from the construction of the façades in favor of planar and ordered surfaces, while Eames decides not to clad his structure but rather to inscribe it as a principle technical element of the living and work spaces, and as such approaches the idea of the "machine for living," whereby the machine becomes a technological instrument conceived to accommodate and serve man.

Abundantly published, the metal structures of these projects would know two destinies; one hidden, the other magnified by a fine, playful and colored skin, taking on the empty or filled modules as an abstract assemblage of painting. This idea of assemblage would be taken up again by the numerous furniture projects of the Eames couple, as in the case of the storage units produced by Herman Miller in 1950, or the latter's showroom design – their second architectural project in Los Angeles. The studied object is made even more sensitive as Eames decides to leave the cross bracing inscribed on the exterior skin of the façade. Technique also becomes an aesthetic, one of finesse and legible performativity within a structure of industrial lace.

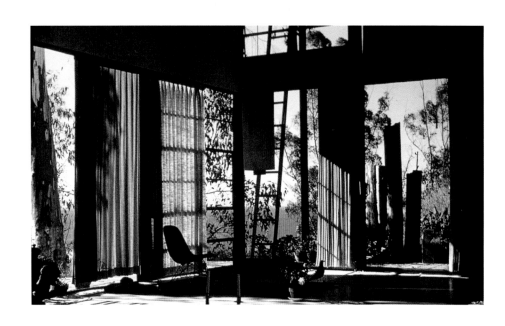

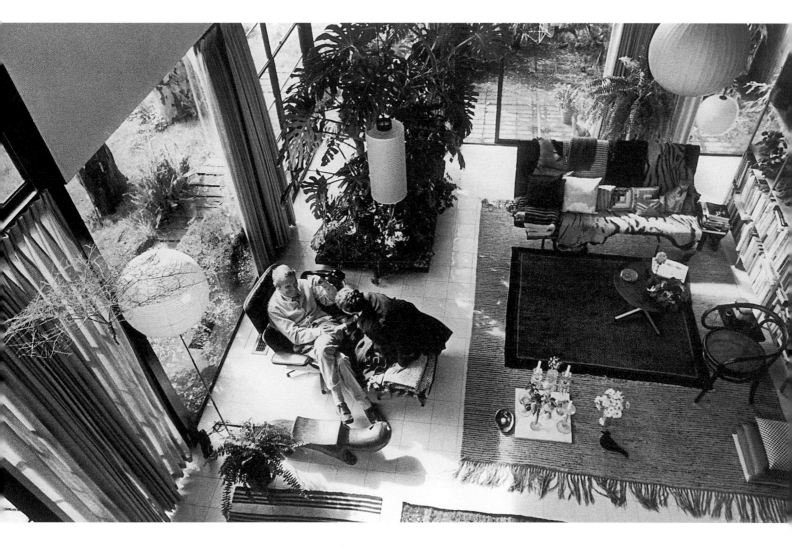

CSH#8, Charles & Ray Eames

Large format black and white photographs display the remarkable interiors, furnished with the latest object creations as well as furniture designed that year. Magnificent, the Eames house is presented as the culmination of the program, a masterpiece where domestic and professional lives are finally fulfilled thanks to the techniques ushered in by mass production and by the elevation of industrial standards. Beyond this, the ideal is transcended by the relationship of the house to its marvelous environment facing the ocean and under the eucalyptus, where the Eames' had their radiant idea of coiling up and concealing their studied object.

MULTIPLE PROTOTYPES

CSH #10/18

CSH#10, Kemper Nomland & Kemper Nomland, Jr.

It was a Sunday morning, and I was leaving the immense pool of black asphalt encircling the Rose Bowl, which I passed on the off chance that I would see CSH #10 after paying a courtesy call to Frank Lloyd Wright's Alice Millard House. Far from the hive of fleas where one enters under the amused and murderous gaze of O.J. Simpson – god of the stadium and demon of the city – I rang the doorbell to the house, which was hidden like Wright's aforementioned "La Miniatura" behind the thick camouflage of long and perfumed leaves. A woman of around 60 years of age opened the door for me, surprised at my intention to visit the walls of her peaceful retreat. In order not to appear coarse and not to further spoil the overrated reputation of my good European education, I arranged a meeting to come back on Wednesday, allowing me the glorious prospect of a sunny afternoon along the Venice Beach Promenade, which was only a few shady bars and cafes away.

CSH #10 and CSH #16 open a new season of John Entenza's venture, and appear as two unique and isolated cases in their additions to the original program. Their recognition by the publisher as products that would be able to endorse and promote the values of the CSH project would advance them from the status of notable to exemplary buildings.

This season of project additions also marks the entry in to the scene of three new architects: Kemper Nomland and Kemper Nomland Jr. for CSH #10, and Rodney Walker for CSH #16, 17, and 18.

CSH #10 would appear in the pages of the magazine in August 1945 without being stamped with the CSH label. Nevertheless, in 1947, in recognition of its achievement, the publisher would add the stamp to the previous projects, and as such, justifies the qualities of these designs as being expressive of his 1945 manifesto. It is a house project for a family that is none other than the architect's own. Its low cost and innovative solutions such as its heated floor system that flows like a finished floor in a simple slab of concrete, and the use of industrial materials such as plywood, corrugated wire glass, the modern and fluid layout of spaces, as well as the provision of large openings to the outside, are qualities that are justification enough for Entenza to bestow the label "CSH" for this project.

It just looks AWFUL.

The landscape of the single-family house

Beginning in 1850, the first suburbs develop along the rail tracks. They reproduce the characteristics of pastoral landscapes, where myth and reality are subtly intertwined. Green year-round, the lawn gives the illusion of a peaceful haven protected from urban crime and savage lands. Frederick Law Olmstead plans one of the first landscaped suburbs named Riverside, west of Chicago. In order not to interrupt the enchanting quality of nature, he allows the tone and style of the site to remain rural,[17] does not design barriers between properties, and sets back homes from the edge of the road. The bends in the roads recall the meanderings of a river, while the streets adopt the names of flowers and plants reminiscent of the bucolic qualities so beloved by the Anglo-Saxons.

72

CSH#10, Kemper Nomland & Kemper Nomland, Jr.

73

The Wednesday of the following week, I returned to CSH #10, protected as always from onlookers and weather alike by the thick foliage, which was bathed in end-of-summer light. Situated at the hollow of a bend's long contour, the shallow sloping roof was the sole visible element of this house from the street, where the little Japanese car waited patiently.

The owner whom I met on Sunday opens the door for me, this time accompanied by her husband. They are not the original owners, despite their retirement age (indeed, the architect and then his son, the designer, had successively left their wood shell). I proceed quietly toward the house in order to go through it, taking a corridor perpendicular to the slope and running alongside a fragile panel of corrugated glass towards the living room steps. The sheet of glass that is underscored by a line of fluorescent lighting in its stainless steel casing, delicately separates the bedrooms from the day spaces. The shadows glide along in a pale light toward their obscurity. Towards the foot of the stairs, the living room and kitchen unfold towards a terrace and its transparent sliding glass doors that is punctuated by a fireplace, and which is open to a vibrant nature offered on a veritable platter of generous paving stones. Accentuated by the panels of glass resting lightly on the ground, the limit between interior and exterior is called into question. With its generous and varied usage, the glass characterizes this house as it dissolves quietly into nature. The large picture window retracts itself in its entirety behind the fireplace – a detail that would be impossible today. The house appears suddenly as a

Arts & Architecture, April 1948

simple shelter, a single large roof covered in bleached plywood that still runs over the walls and furnishings installed there. The owner reinforces this feeling of continuity by the evocation of the primary furnishing as one single element, prefabricated in the studio and installed with a crane. If the sliding window panels, the corrugated glass, the lines of indirect lighting, and the plywood still maintain this nostalgia for a fifties style, it is in the architect's old studio towards the uppermost part of the house – with its distinctive patio – that the atmosphere of *Arts & Architecture* magazine is most palpable. On the walls, the presence of lamps made by the General Lighting Company and "merit specified by the CSH Program," casts us back into the advertising images and black and white photographs. Modified and cluttered with style-less and at times useless objects, the spaces that fit together present a simple plan and building that play delicately with the landscape and gently sloping site. Despite the curtains and other effects concealing from view the all too near neighbors who arrived after the house's construction, CSH #10 has not lost its soul – it is only dozing under the trees and hiding at the hollow of a gentle curve.

The scenario of the American family

The American dream does not come into being immediately or spontaneously. Rather, it is manufactured through a succession of publicity campaigns and statistical analyses, progressively putting into place the concept of the "middle class American" [18] after the Second World War. Before the war, many families lived under the same roof, having difficulty accessing property. While the American dream derives its sources from Jefferson's Homestead Act, this dream presents formidable economic stakes. Urged to acquire land, a house, a car, a television, kitchen appliances, as well as machines and household appliances of all sorts, the emerging domestic consumer society constitutes an economic pillar in its own right.

The traumas endured by the soldiers having just returned from the war are softened by the idea of the family unit. Young couples in 1950 are wealthier than their parents, not having faced the Depression of 1929. A large effort is put forth by the media to relieve people of their guilt and make them tempted to buy. An idea that is both moral and civic will be born out of the perceived benefits of consumption: Each consumer participates in helping to support the country's economy.

The publicity campaigns surrounding the theme of consumption most likely have consequences on the roles assumed by women at that time. Having relinquished their jobs to the returning soldiers, they disavow all but their roles as consumers [19] and procreators. The suburban community becomes the cradle of the demographic explosion, and the originator of the Baby Boom.

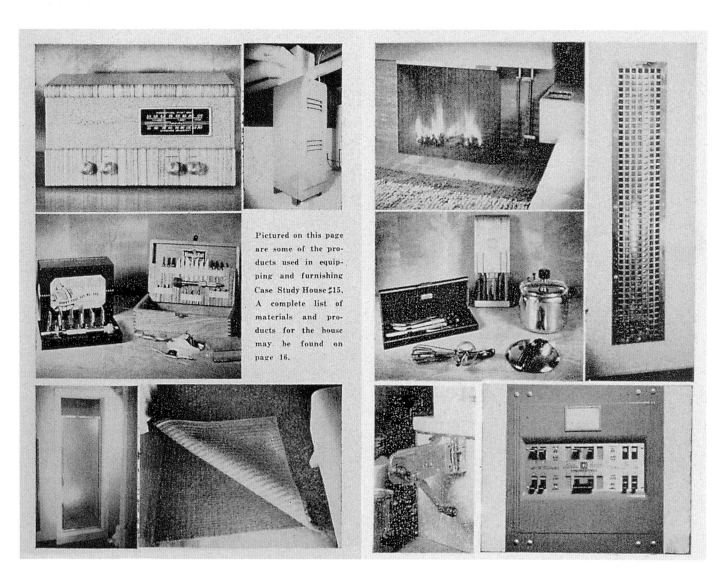

Pictured on this page are some of the products used in equipping and furnishing Case Study House #15. A complete list of materials and products for the house may be found on page 16.

CSH#15, Julius Ralph Davidson, *Arts & Architecture*, January 1945

It is today in the La Cañada tract north of Pasadena, that I must go to see CSH #15, the twin sister of CSH #11. Having since disappeared, CSH #11 was the first house of the program to be constructed. These first two prototypes that were erected in 1946 and that propelled the program into a quantifiable reality, were the work of the architect Julius Ralph Davidson. CSH #11 arrived in the tangible world thanks to two of the contributors to *Arts & Architecture*, with the architect taking the risk to build it and the advertising agent taking the risk to live there. The architect himself would allot a piece of the site on which he would later erect his studio and residence. The desire to achieve a prototype for the returning GI's mobilizes the magazine and the manufacturers, but foremost the will of Entenza's circle and his protégés, all of whom have invested – more than in name only – in this adventure.

The project for the house is modest, in keeping with the wishes of the authorities during this period of restrictions. In a area of approximately 110 square meters, Davidson achieves a veritable tour de force in designing a prototypical dwelling with neither an entry nor a hallway, whereby each surface is exploited to its maximum potential. The service areas are situated as buffers against the street, thereby protecting the life beyond. All the rooms have access from the inside to the garden, projecting future owners towards a supplementary space reducing the surface area of the rooms.

CSH#15, Julius Ralph Davidson

Today, one can still measure and appreciate the subtlety of Davidson's simple, efficient, and economical plan with CSH #15, which still exists, wrapped by additions that coil around the original core. On this site, Entenza would toy with the dream of a CSH colony, but in vain, since only one was built there. In light of the slight bitterness on the part of the architect, one still notices his regret over the abandonment of the metal structure – a mythical objective of the program's pioneers – in favor of a wooden one.

In the sitting room that has taken the place of the original patio, I show the surprised owners that traces of this prototype in its first iteration can still be read. Having been transformed for the moment into an archaeologist of postwar Californian modernity, I redraw with my uninformed hosts – as far as they could pursue it – the routes taken by the two contributors to *Arts & Architecture* more than fifty years ago.

The contained plan of the project demands respect because of its exciting optimization of spaces, whereby each moment of transition becomes the basis of a program and of an intelligent articulation. There are no more circulation spaces: only dressing rooms, storage areas, a corridor kitchen, and a bathroom. Secondary functions are invested in the interstitial zones of the house.

Above and beyond the simplicity and sobriety of materials, as well as the numerous objectives achieved by the house including its low construction cost and its efficient response to

77

SPACE FOR LIVING

Gardens and landscapes

With the vision of creating both an ideal and global environment, the Case Study Houses include in their programs both gardens and bridges indistinguishable from the exterior context. These gardens are conceived by the designers as interiors outside, and contribute, on par with the furnishings, to the fame attributed to the CSH. The young landscapers arrive at the gardens with the same motivation and determinations as their designers, breaking from the traditional pastoral model of the garden.

A great formal diversity and a succession of spaces and moods characterize these innovative projects, often influenced by abstraction and pictorialism. Their modest scales lend a delicate touch to the domestic landscape. In addition, research into the local species of vegetation and of the indigenous plants of California brings to these spaces a particular exoticism that is far from Hollywood standards, from the palm trees and other species imported from South America.

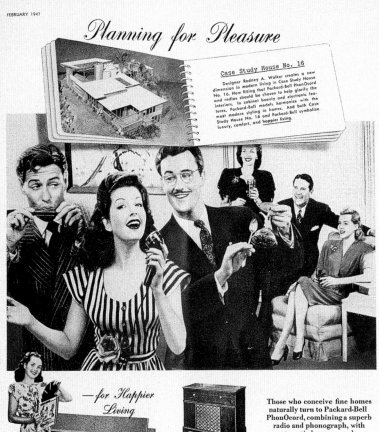

CSH#16, Rodney Walker, *Arts & Architecture*, February 1947

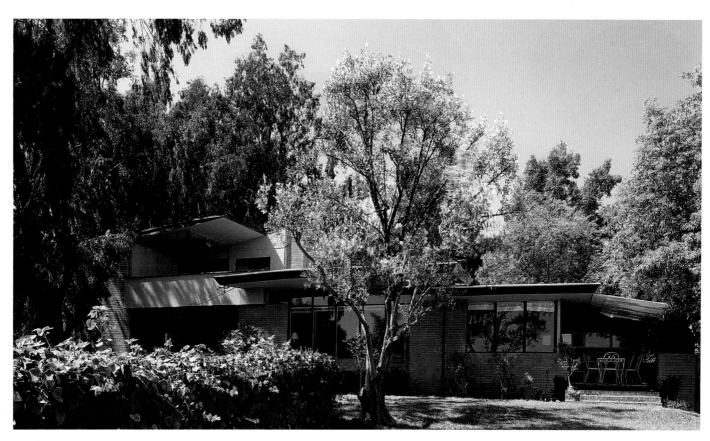

CSH#16, Rodney Walker

contemporary needs, the project signals a positive marker for the program in that, despite its modesty, it is the only example to have been reproduced four times elsewhere.

The collaboration with the architect Rodney Walker begins with CSH #16 and lasts through two other consecutive houses, of which one is located next to the Eames icon on a quiet plateau in Pacific Palisades. He embeds these two houses on exceptional sites: The first on a hill in Beverly Hills, and the second, facing the ocean. While CSH #18 benefited from the 1995 earthquake by getting a perfect face lift, and, in turn, a second chance at youth that it undoubtedly deserved, CSH #16 bears the wrinkles of time's passing. CSH #17, the most modest of the three projects, is located in the hollow of a canyon flowing with cars on Mulholland Drive. In contrast to its two sisters, it was not preserved in good condition, and today suffers from multiple awkward graftings that deface it completely.

CSH #17 is one of the rare examples of a project whose construction cost is revealed to the public: Ten dollars per square foot, or approximately eighty-six dollars a square meter. This low figure is explained by the rigorous design of a 140 square meter house. Three bands succeed one another under the minimal, raised rectangular roof. The first band houses the garage, entry, and living area, the second, circulation, kitchen at one end and the laundry facility on the other, and the third three bedrooms (traditional number for the program), and bathrooms. The day-night distribution and the service band in the center are not the only

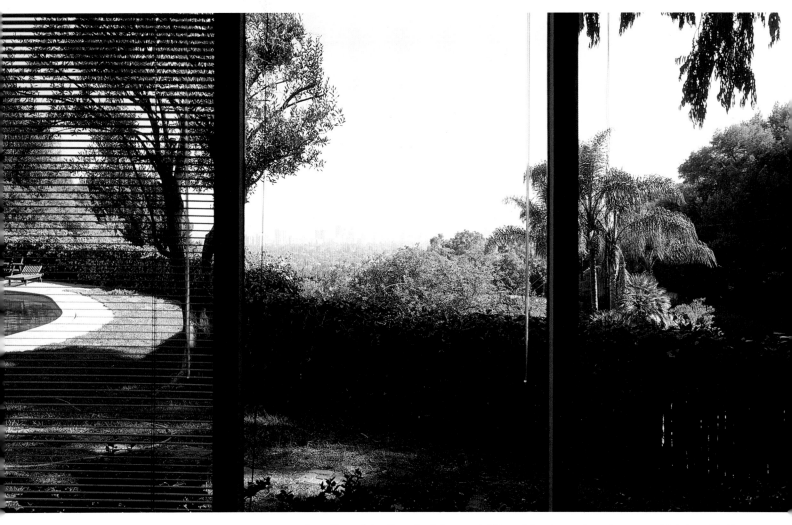

CSH#16, Rodney Walker

noteworthy points; the orientation and lifting of the house by a terrace, which benefits the bedrooms in the rear, the orientation of the living and reception spaces towards the street and the walkway to the garage, remain isolated cases within the program projects. Nonetheless, the materials common to numerous CSH are still in abundance. Plywood, Plexiglas and bricks compete for both the vertical and horizontal surfaces without creating complex compositions as such. The covered terrace serves as an extension to the living room, while the S shaped fireplace in the center accommodates fireplaces on both its curves – one inside and the other outside. A curtain on discreet slide channels encircles the fireplace and the view, thereby eluding all dictated geometries by isolating a space for the rest of the family activities.

I return to Beverly Hills to see CSH #16 as it stauds today. At a pass above a sharp bend of black asphalt and amidst the large trees, CSH #16 comports the air of a bragger, the oblique profile of its second-storey enclosed by walls. In 1947, this roof that seemed ready for takeoff had been an open terrace protected by a pergola. It offered to its inhabitants a clear and magnificent view towards the valley and the ocean through a second living area open to the California sky. A veritable room for living complete with fireplace, a barbecue and kitchen sink along with banquettes for starry nights, this summer lounge was provided with all the equipment necessary to pull off incredible parties, with its dance floor and installation of loud speakers used to diffuse music throughout the house. This terrace, today enclosed, does not

CSH#16, Rodney Walker

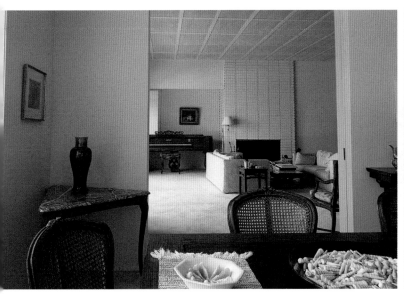

Climate

Between the ocean and the deserts, the city of Los Angeles benefits from a dry climate, warm yet tempered in an exceptionally soft way such that only two dry seasons succeed one another in any given year. The influence of the ocean is felt throughout the valley region, protected as it is by the mountains from the heat of the deserts. The Mediterranean climate is more temperate on the coast and in Santa Monica, whereas Pasadena suffers from heat waves due to its distance from the seaside and the presence of the arid Rocheuses Mountains. Pollution threatens summer days and often shrouds the city.

fail to bring to my mind the rooms of the R.M. Schindler house at 833 North Kings Road – a vestige of an architecture where man aspired to live outdoors, breathing in the soft and not-yet-jaundiced Los Angeles air.

Leaving this place dedicated to the entertainment and pleasure of happy and stylish bourgeois Angelinos by gliding along the cantilevered stairs which are covered today, I go back by the entrance called "la loggia", a double volume breaking from the traditionally horizontal spaces of the other Case Study Houses in a unique manner. Covered with tinted glazing that previously allowed the penetration of a refreshing green light, "la loggia" is the obligatory passageway for each room in the house. The garage is removed from the rest of the house but connected via a porch configured in a protective L form. The garden, designed by Garrett Eckbo, Royston and Williams, presents a terrace to the south alongside the living room, in which the edge was framed by a pergola [21], a detail that like numerous other traces has since faded.

This house seems to have been conceived of as a glazed cascade, striving to seduce and honor each view. To the north, the more intimate and secret view is hidden from the eyes of the street, to the south the ocean, to the east the city, and to the west the hill and its large trees. It is on the ground floor that the house reveals its charm, now outdated under the thick filter of dust and time that rest on the striated plaster walls, and on the remaining woodwork, repainted now with less subtlety. The living area originally articulated itself through many

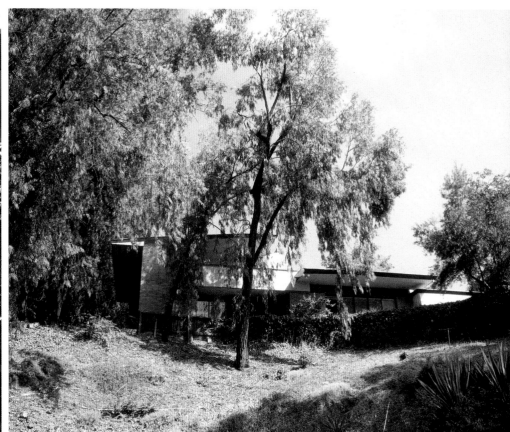

CSH#16, Rodney Walker

alcoves using its mobile partitions, both sliding and accordion, embracing the breadth of its view. The automation of the house is uncovered by the abandonment of the internal perforated wall openings [22], its wild cinematographic equipment, and its radiant heating located in the ceiling.

The presence of 4"x4" [23] posts at 3 foot intervals [24] sets the rhythm for all the openings and plane surfaces of the building, allowing for woodwork readily available on the market to integrate itself within the framing without adding to the size of its footprint. The framing of these projects by a repetitive wooden structure affirms the will to rationalize the construction within the perspective of reproduction. It is through the exteriors that the resemblance between the two houses is most striking, if one abstracts the heavy striated blinds that weigh down the glazed bays of the elegant Beverly Hills home. And at the end of this particular morning, they are left largely open onto the misty valley dissolving into the ocean and the white of the sky.

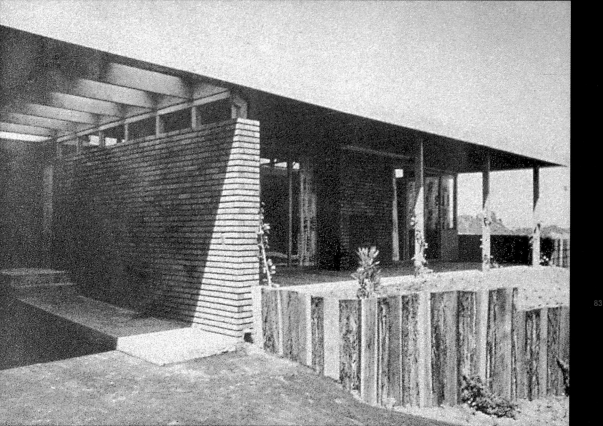

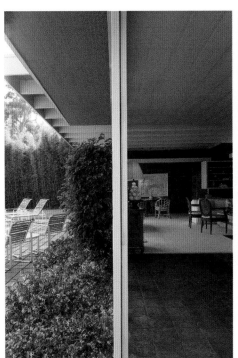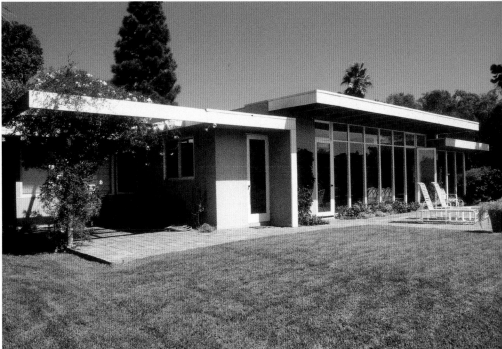

CSH#18, Rodney Walker

I am treated again to a panoramic shot in CSH #18, this time with the ocean about 100 meters or so down below after the beach. Despite having already paced up and down it these last few days, the site is still amazing, green and calm with its eucalyptus shuddering in the breeze. We are at the edge of the Eames and Saarinen property, and in two hours, I would cross the street to see again Doctor Bailey and his house designed by Richard Neutra, CSH #20. If the Cemetery of Elephants were to still exist, then the Pacific Palisades CSH would have been – without a doubt – a lovely illustration.

From the entryway – where the owners invite me in with a pride that is altogether American – I discover a new and entirely re-done interior, since they had lost everything because of the earthquake in 1995. Face-lifted according to the laws of restoration, the house presents for me the good fortune of seeing this residence in conditions almost identical to those which the onlookers originally drawn to the site would have known. Only the furniture does not represent the taste of the period, and the eclecticism by which it is characterized today tells us that the desire for the immediate future is not that of the occupants. A foundation helped the owners with the renovation and reconstruction of this west coast monument, a reputation which they were ignorant of at the time of their settling in, having only been attracted to the house by the stunning view at the time of its purchase.

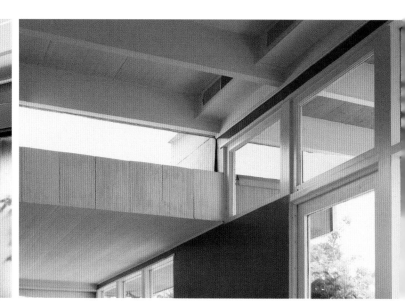

CSH#18, Rodney Walker

The interior bathed in light lends color to the wood panels, to the collapsed fireplace, to the luminous stripes, and to the confined furnishings, creating a quasi-immaterial reality, as if they are objects floating in a magical and supernatural atmosphere. The light is omnipresent and sharp, coming from this filmic façade onto which all the rooms open up, but also from the bands of delicate glass clearstories slipping between the roofs that glide over each other. The shift in ceiling height is often accompanied by a change in flooring material, lending an impression of largeness and breadth.

As in the projects by Davidson, each articulation supports a specific programmatic element, making one forget the corridors while legitimizing residual spaces. Experimentation is an integral part of Rodney A. Walker's projects, improving, for example, the heating systems with each new project. For CSH #18, he would use ceilings ventilated with hot air, radiating with heat.

The house opens onto an imposing landscape, hiding its secret from the roadway behind some brick walls, a frosted glass panel, and an insignificant garage door, all of which are demarcated by a sand-grey concrete slab, opened up by two palm trees with oblique trunks. The U plan of this CSH is subtle and concise like that of CSH #17. Less radical and severe than this last project contained under a simple rectangle, CSH #18 exploits a remarkable site with panache, and deploys with great elegance its glazed bays reminiscent of classical colonnades, which are emphasized by the overhangs of the straight roofs.

This strict design of an abstract frame facing the ocean is highlighted by the monochrome green of a British lawn on which the domestic object becomes a pure object, as if dreamed up by David Hockney – absent pool, bright light.

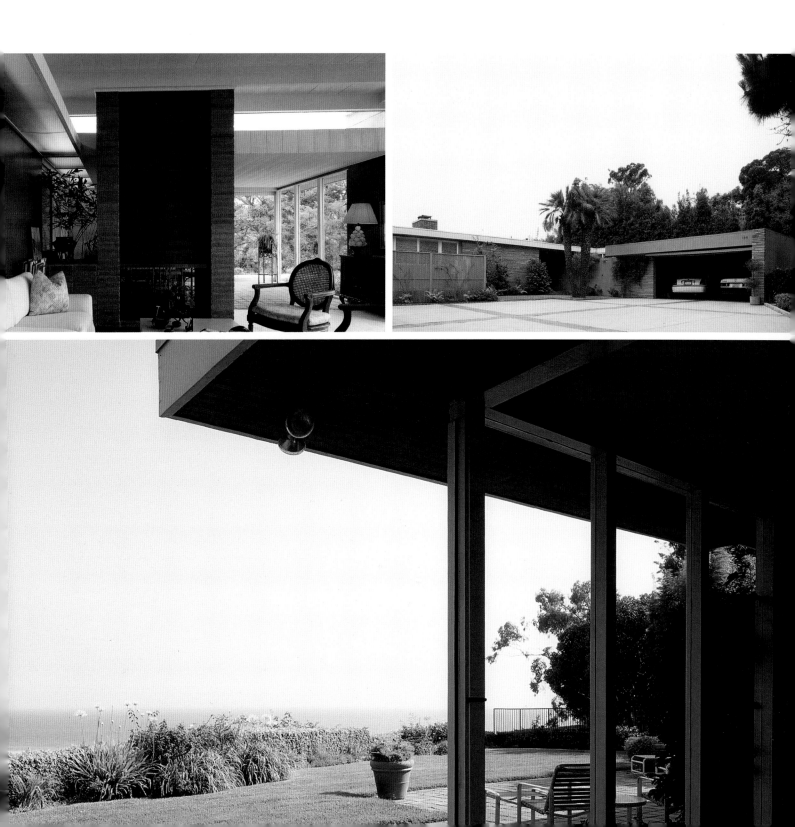

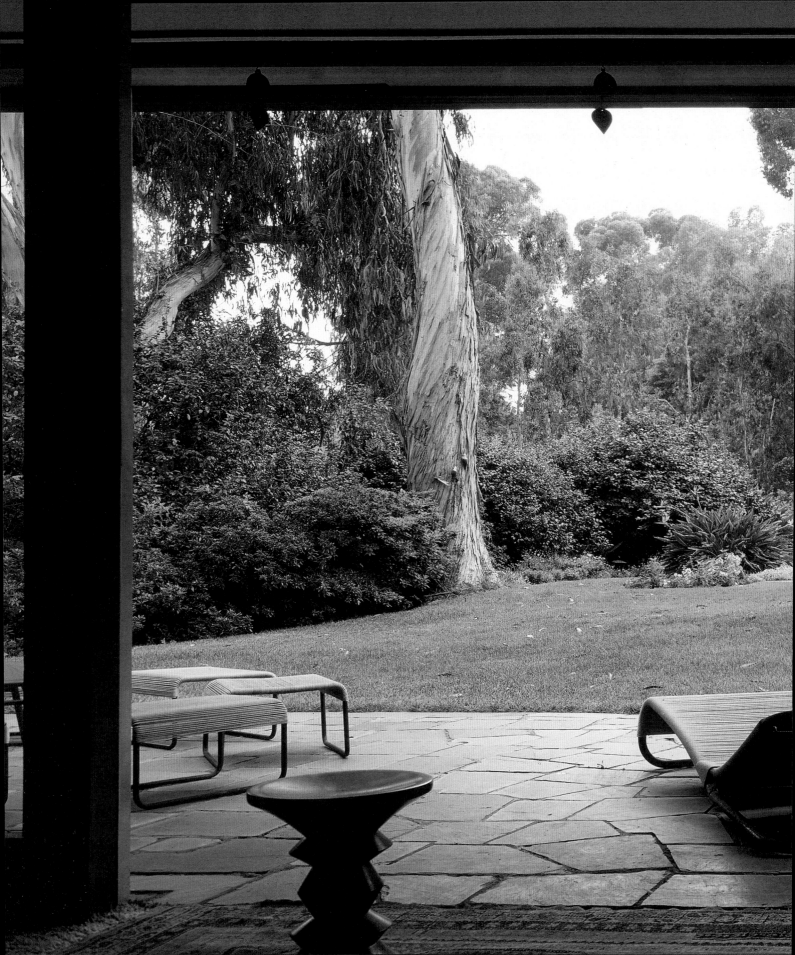

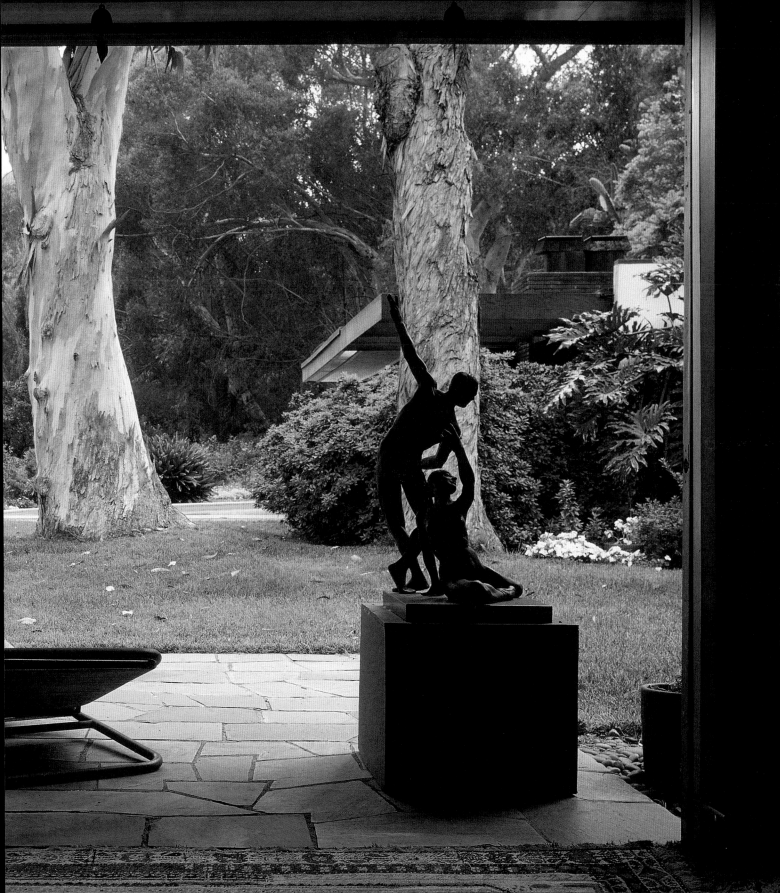

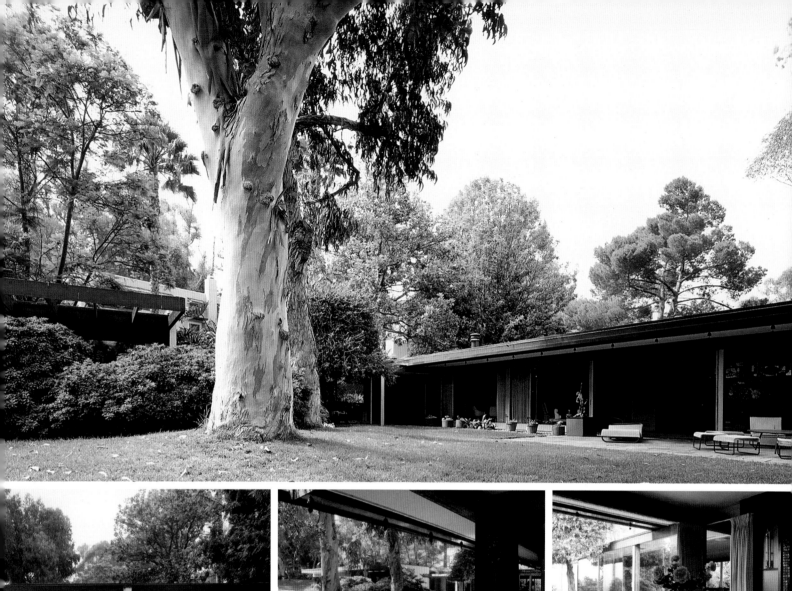

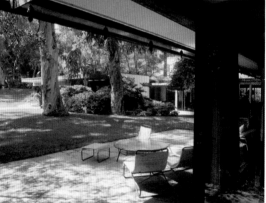
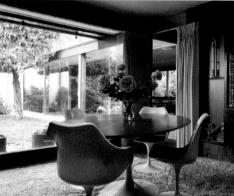

CSH#20, Richard Neutra

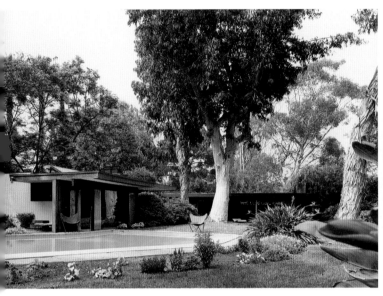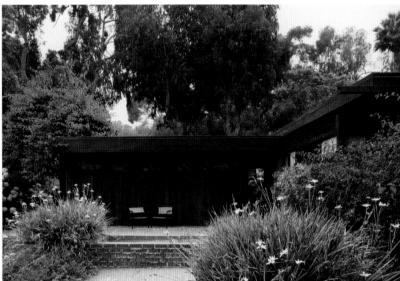

Californian predecessors

Few cities can, like Los Angeles, boast about having welcomed as many highly renowned architects; modern masters such as Frank Lloyd Wright, Rudolph Schindler, Richard Neutra, Raphael Soriano and many others. They rediscovered the pioneer spirit of the West, along with an audacity to cling to the modernity of the times.

These two generations of California architects proved that domestic architecture can be conceived with inexpensive materials, that a dining room is less important than two bathrooms, that its design should be comprehensive both exterior and interior, and that a house should be planned along the tenets of hygiene, making the sun and natural ventilation fundamental elements of the design. They also introduced other urban elements such as aligning the façade to the street in order to disengage an interiorized private garden. The traditional outlines of house plans vanish with the institution of the modern mode of living turned towards leisure, and towards functionalist rigor.

Leaving the frontal and dramatic sight of the Pacific horizon, I go back up towards the end of the Chautauqua cul-de-sac, to the right on a slight bump. The freshness of the eucalyptus and the rustling of the leaves create an ambience that is more calm, tempered and serene. Moreover, the morning mist along the coast is always present. After the bend, the car port spreads out, demarcated by some soft plastic vertical strips lending a quasi-seaside atmosphere to the place, along the lines of the Côte d'Azur – really dolled up…. to be sure.

It has already been three times now that I have come to this house, CSH #20, which the happy host of the premises decided fifty years ago to have built by Richard Neutra, and to have it enrolled in the CSH Program despite all the implicit and explicit constraints linked to this type of experimentation. Was Doctor Bailey not the ideal guinea pig, representing, along with his family, the middle class model of his era?

Stuart Bailey knew this area well, since as a student he would come here and have picnics with his friends under the trees facing the Pacific horizon. Interested in the discounts given by construction firms and material manufacturers – the sponsors of the program – our young doctor adopted the aims of the magazine to participate in the construction of a domestic model.

He chose Neutra in order to ensure the design of this house, which was pioneering and discreet like its owner, doubtless remembering that illusory request that it be formulated "to pioneer with moderation."

This house is as horizontal as it is measured, built with care on the site such that the trees are respected. Apart from the delicate details and their connections, the strength of the architect lies in creating this domesticity that is refined and clearly studied, without ever being bombastic. Of course, the doctor willingly talks about the architect as a problem child, who refused to let his client choose the color at the bottom of the fireplace, never hesitating to threaten him not to approve the plans if the client overruled his decision, or even to make unannounced visits to judge the state of his work, such that the ageing and maintenance of the house matched the architectural production.

It was the only house of the program, and the only one among Neutra's work that, in its design, anticipated the changes in lifestyle and growth of the family. From an original size of 114 square meters, it would double in size after two extensions. The principle of the expandable single family home is a promising and sellable concept, but one that was too little exploited by the magazine, which would never subsequently publish extensions designed by the architect. In its initial form, the house consists essentially of a large living room extended by a bedroom and a rectangle split in two, gliding along its long end. The two rooms are surrounded by a glass wall, whereby the large sliding doors create a staggering permeability with respect to the terrace and the garden. The corners of the rooms are disengaged and transparent, automatically extending the spaces beyond their limits.

The practical heart[25] of the house is constructed around a prefabricated technical sheath that accommodates all the home's fluids of the house, as well as its ventilation. The kitchen and the bathroom are connected at the periphery of this organ, wedging the living area towards the street. Above and beyond this volume, the strips of plastic float above the doctor's car and partly outline the service courtyard. The extensions that begin with the first bedroom are arranged as autonomous pavilions on the mowed lawn of the garden. They are, so to speak, rhizomes that stem from the main house. The first extension, executed in 1951, is composed of two bedrooms and a bathroom, which are linked by a slender bridge corridor. That same year, a pool is added to the L-shaped house. Later, a playroom is placed next to the corridor and serves to complete the final arrangement of the house as one can see it today.

In the lounge and seated on a comfortable and heavy settee, I am seized by the feeling of reduction. I am jammed up against the long open band of the garden, and I have the feeling that the lounge is wedged in like me, attentive to the outside, rested on the brick wall behind me, and supported by a large fireplace to my left. The contemplation of the garden would appear to be the ultimate programmatic element of this living area. In fact, there is no need to go outside. A painting framed by the extension of the roof and its shadow reaching the floor, flaunts itself in front. The few steel tube deck chairs with shadows of their threads stretched to the limit by the light accentuate and amplify this system of looking.

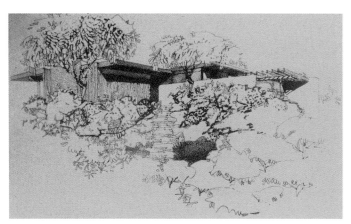
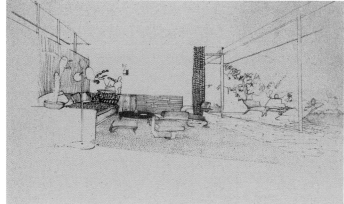

CSH#20, Richard Neutra, *Arts & Architecture*,
November 1947

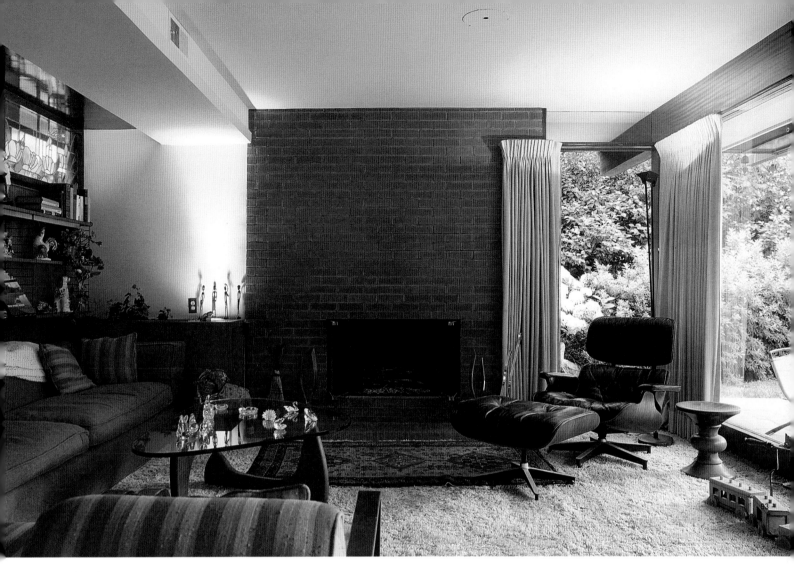

CSH#20, Richard Neutra

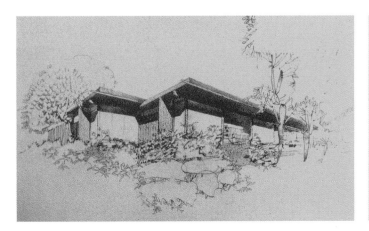

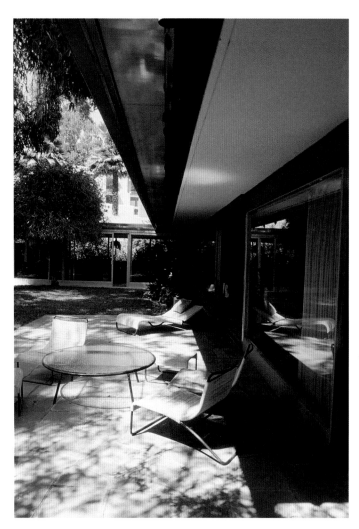
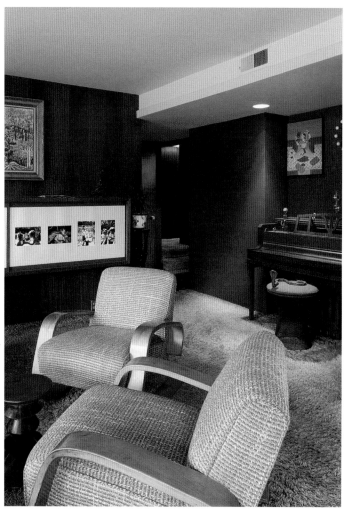

CSH#20, Richard Neutra

Experiencing CSH #20 perhaps resembles a kind of vertigo where the transfer has proven useless. I have the feeling of ultimate precision with respect to the scale of the house and the landscape: A house hidden away under the immensity of the trees.

Although he includes this house among the vignettes from his first studies for CSH #6 and 13, Neutra seems with CSH #20, far removed from his experimental production of the preceding decade. Apart from the materials of brick, wood, and glass that are present in much of the production of the first two seasons, it is indeed to the maturity of the architect, as exemplified by the resolution of CSH #20, that one must pay tribute. The architect exceeds the aesthetic of the experimental and enlists his production in the service of an almost banality, abandoning a certain arrogance in favor of a domesticity that is rigorous and tame. Sitting in the large deckchairs with aging threads designed by Van Keppel and Green, the discussion with the doctor soon slows down and we both soon relish, like two amateurs of good wine, savoring the delicate fragrance of this contemporary regionalism, indeed of this tempered yet exotic modernism. Without a doubt, the original furniture by Aalto, Saarinen and Eames participates in the feeling of plenitude.

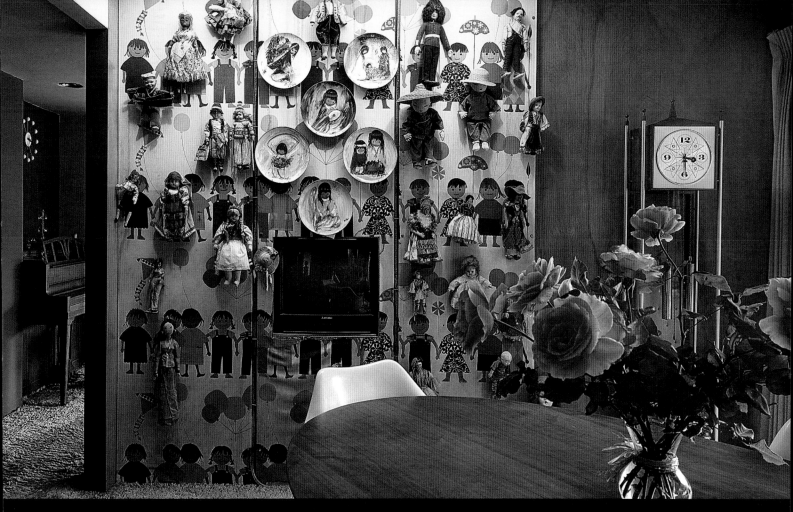

CSH#20, Richard Neutra

The phases of the CSH program

At the time of the CSH program, that is, in the period between 1945 and 1964, four different phases follow one another in succession.
The first phase constitutes the establishment of the program in 1945, and its announcement and proposal of nine projects, which are presented to criticism. These first houses would hold the attention of critics not for their structural innovations owing to the shortage of materials after the war, but for the inventions within the bounds of the plan, and the maintenance of their particular rapport with the exterior. The turning point towards the second phase occurs with the metal frame construction of CSH #8 and CSH #9.
This second phase is elaborated between 1950 and 1960, an episode marked by the research and use of metal structures. An aesthetic and structural rigor underlines a new rise in production as with the inaugural project by Raphaël Soriano. Craig Ellwood and Pierre Koenig will pursue this research and develop new modular structural steel systems. A remarkable desire for design research pervades the projects from this period, of which the end is announced by the return of wood structures and the generic post and beam system of Los Angeles revisited by Calvin Straub, Edward Killingsworth and their associates.
The projects from the third phase will orient themselves towards the production of houses in large numbers, resuming the idea of community settlements abandoned at the time of the first projects.
Lastly, the final episode opens with the departure of John Entenza from *Arts & Architecture*. The imbalance between the single-family house promoted by the magazine and the house produced by the property developers is flagrant.
The house as product now takes to the arguments of cost-effectiveness above all.
The program then suggests to architects to pursue their investigations with the creation of apartment blocks.

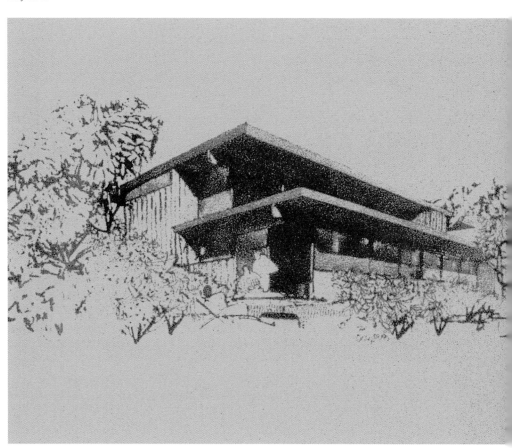

In his quest for the banal, Neutra would continue his research with a last CSH study, bearing the number 21. CSH #21 was planned within the continuum of the three preceding opuses by the architect, under the same eucalyptus trees, profiting from the ocean breeze and materials similar to those used for its little sister. Its anonymous owners, called Mr. and Mrs. 21, were young and had a young son and daughter, a family not far from that of Doctor Bailey's.
Their difference lies in their use of the house, since the young couple intend to exercise their activities as screenwriter and sculptor. Differing from CSH #20 in both function and form, CSH #21 is composed of two volumes that slip over each other, offering two distinct programmatic levels. The lower level would accommodate the bedrooms – two smaller ones along with a more important third with a dressing area and a bathroom for the parents. The volume above, largely open, would service the daytime spaces dedicated to the life of the family. This level would extend into terraces above the garage, where the mistress of the house could devote herself to her sculpting. A small studio would slip in between this terrace and the kitchen, transformed according to the change in activity of the young wife [26]. The higher level would also benefit from a view to the west and onto the ocean, which would be projected on to the glass sliding doors, effacing the façade.

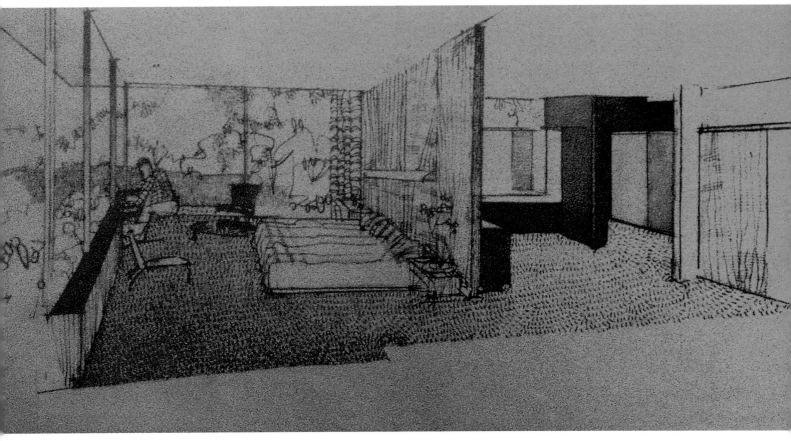

CSH#20, Richard Neutra, *Arts & Architecture*,
May 1947

The husband's activities would be confined to three different spaces: His writing alcove open onto nature, the patio, and the utility area next to the kitchen. The childrens' quarters, as with the parents' area would benefit from exits onto the garden and into the shade of the old eucalyptus. This surprising spatial system of horizontals gliding on top of each other evokes the fusion of the project, putting its site and its geographic context in relief. The two slabs would project the contours of the floors in which they were embedded, allowing for the house to disappear a little more.

Neutra's drawings would erase the limit between construction and landscape, allowing the flat slabs of the roof to emerge onto a groundcover thickened by luxurious vegetation. In the architect's pencil drawings, the interiors that are protected under large roofs are bathed in dense shade, allowing us to imagine both their intimacy and coolness. The precise features of the horizontal roofs and beams meet each other without ever colliding, the light massing of the fireplaces, the partitions, carpeting and other vegetation without precise contours are invited into the graphical composition. This house, like many others, would escape construction, but not the eyes of the well-informed readers of the magazine. Before its disappearance, along with the hopes of it being constructed, the television man – the presumed owner of this project and friend of Dr. Bailey – would be made to discover the site. Today, a two-storey house is located on the premises, and casts its shadow onto the program.

THE IMMEDIATE FUTURE

1950

Case Study House 1950 is now in that tenuous and hopeful state of coming together that includes the putting of things in their proper place and trying to find places for the proper things. We show here a few of the many excellent products chosen for the house with the reasonable assurance that they will be integrated into a living pattern that will fully justify everyone's efforts. Too often, in these projects, there is a strange maladjustment of schedule. While kitchen cabinets are not yet in sight the landscaping is already beautifully done, and the lawn well sprinkled; the paneling is installed, and doors hung and painted and complete with handsome hardware, but the bathrooms are bare. And so, in these last few weeks, people will be waiting for hooks while others busily saw the eyes; and the delivery of lamps will unaccountably be accompanied by a last minute installation of cement. There is, of course, no reason within the realm of sense why it should be so, but it is an unhappy truth that only wonders and miracles can make a house come together in the end. At least, we, who love them, will have to continue to lean heavily on patience and a stony stubbornness until we can find a better way to beat a path to a better mousetrap. Soon, then, we hope to be able to show, with exhausted pride, a beautiful small house.

OBJECTS SELECTED FOR THE 1950 CASE STUDY HOUSE BY RAPHAEL SORIANO, ARCHITECT

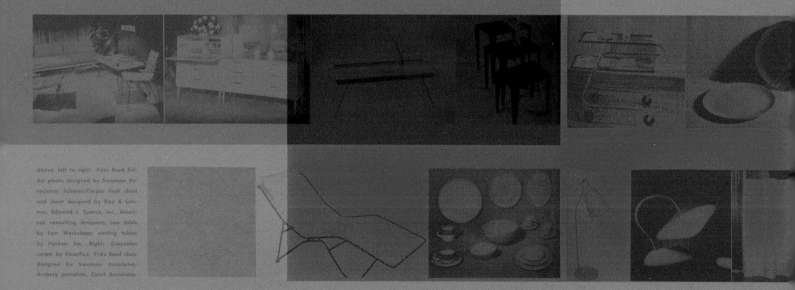

Above, left to right: Ficks Reed Sol-Air pieces designed by Swanson Associates; Johnson-Carper desk chest and chest designed by Day & Latimer, Edmond J. Spence, Inc., American consulting designers; low table by Lam Workshops; nesting tables by Heskon, Inc. Right: Greysolon carpet by Klearflax. Ficks Reed chair designed by Swanson Associates. Arzberg porcelain, Court Associates.

EXQUISITE CORPSE

CSH #1950

The corpse had been mutilated in the image of that which belonged to a young woman, James Ellroy's "Black Dahlia," unrecognizable and amputated of some of her limbs. The site was no vague terrain as in Ellroy's novel, but a suitable and convenient one located in a Pacific Palisades canyon, not far from the Cemetery of Elephants. By its history and the image it had generated, this first exquisite corpse brought me back to the Black Dahlia and her young corpse, to a young woman whose ambition had been to become a star, soon to be crushed by some filthy hands in the nights of Los Angeles. Elegant much like Ellroy's young heroine, CSH #1950 had been that, all the while performing a star role in John Entenza's output. It was decorated in the same way as the Dahlia, and knew the same tragic destiny, run over in the nothingness and banality of the Californian metropolis, mutilated by unscrupulous owners who disfigured the sublime object while propelling it into oblivion and into this annoying eclecticism against which it was built.

It was there, standing like a phantom under a pile of jumbled white that was densely walled-up, having finished by choking it and making it disappear. The first time, I hardly had noted the place. I had been warned by David Gebhard's book, census taker of all the marvels that were drowned in all the parking lots in the middle of style-less objects merged into one another amidst the bends of the freeway: "Almost invisible now, this is the first of the pure steel-frame Case Study Houses sponsored by *Arts & Architecture* magazine. It has been extensively remodeled." [27] – worse than recast: Mutilated.

Nonetheless magnetized by the corpse, I went back many times because of photographs I discovered in the library of the elegant project, an elegance of which I tried in vain to find traces or signs of survival in the pile nestled in the canyon in Pacific Palisades.

CSH #1950 follows CSH #1949. It marks an important stage in the program by breaking from the thirteen other houses that had been built with a certain effervescence and disorder. The ambition exhibited by Entenza is announced with December 1949 issue of the magazine; satisfied with the path undertaken, the publisher clarifies the rules of the game by proposing the planning and construction of one case study per year, the first chapter of which he

The beautiful American

The house and the car are intimately connected. While the car extends domestic space, the house is the technical and industrial engine, whose motor is the kitchen. This analogy can be easily confirmed in the Ford Museum in Dearborn, Michigan. In addition to cars, fixtures related to everyday life are also on display; from the deadly presidential limousine of John F. Kennedy to the interiors of kitchen layouts from 1700 until 1930, to the reconstruction of Buckminster Fuller's Dymaxion house. The museum also houses a reconstructed village of single-family homes from the United States of various eras and building types. Private life extends from the house with the car, giving it an essential place in the house as mediator between the interior and exterior.

entrusts to Raphael Soriano, the Californian architect of Greek origin, and Neutra and Schindler's collaborator. His work is marked by research into glass pavilions,[28] as well as into the use of simple and reliable metal structures. The project is confirmed for a family of four, and the publisher highlights the metal structure capable of resolving questions of cost and, in so doing, embodying this pragmatism and desire for modernity borne by the magazine and reinforced by the two last built projects.

The program is renewed with the idea of a model house with an average habitable surface area of 150 square meters, constructed on a generic site and inscribed in its California environment. Here, Entenza is touching on an idea of regional modernity dear to Colin Rowe, which poses an alternative to that dogmatic, international notion of modernity, which strives to convert all the cities of the world into a similar style.

The series anticipates a new addition for each month, and with each issue, the reader would be informed of the progress in real time of this work, arising out of the particular context of the end of certain recessions, and marking the entry of the program into its emblematic phase – that of projects and houses composed of pure metal structures dressed with glass skins. Further, this episode is punctuated by the almost systematic use of standard industrial materials. The quest for the industrialization of the house is as obvious as its possible reproduction; as such, it sustains the promises of the program from 1945, as well as the existence and the availability of this domestic immediate future, ready to be consumed by all.

Raphael Soriano's work exceeds mere technical demonstration by bringing in a more personal aesthetic eye. He wins critical praise, knowing by experience that potential habitants of a single-family house are not generally very fond of the industrial aesthetic. More traditional materials like brick and more bourgeois materials like stucco make one forget the mechanical side of the building and distance it from the preceding episode. The beautiful objects and care that are dedicated to this second work would merit the house to receive an architecture prize awarded by the American Institute of Architects[29].

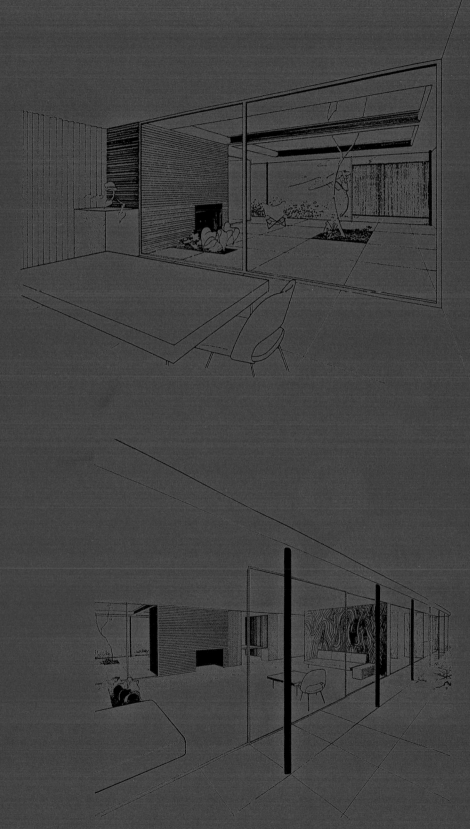

CSH#1950, Raphael Soriano,
Arts & Architecture, August 1950

FABRICS

(986) Artists' Concepts: Exceptionally well prepared and illustrated 24-page brochure showing work of Estelle and Erwine Laverne, Alvine Lustig, Ray Komai, Zahara Schatz, Juliet and Gyorgy Keppes, and Alexander Calder in fabrics and wall papers, and of William Katavolos, Douglas Kelley and Ross Littell in furniture design and ceramics; artists' concepts uninhibited by "what the public will buy" approach; this brochure belongs in all files.—Laverne Originals, 225 Fifth Avenue, New York 10, N. Y.

(79a) Bamboo Drapery Materials: Information, samples Higo inside core bamboo drapery material; imported from Japan; natural or matched to color samples; also fine narrow outside peel in deep natural; comes taped with riveted-in hooks ready to hang; good product, merits consideration.—Rattan Stylists, 1145½ North Las Palmas Street, Los Angeles, Calif.

(97a) California Fabrics: Information line of California fabrics selected for 1950 "Good Design" exhibition Chicago Merchandise Mart, Detroit Institute of Art's show "For Modern Living", A. I. D. exhibits sponsored by Los Angeles County Museum and Taft Museum, etc., "Design for Use, U.S.A." now being assembled by Museum of Modern Art for exhibit principal cities in Europe and Great Britain, merit specified for CSHouse 1950; information available to architects, designers, interior decorators.—McKay, Davis & McLane, 210 East Olympic Boulevard, Los Angeles, Calif.

(955) Contemporary Fabrics: Information one of best lines contemporary fabrics, including hand prints and correlated solids for immediate delivery;

Textura by Testa, consisting of small scale patterns creating textures rather than designs; reasonably priced; definitely deserves close appraisal.—Angelo Testa & Company, 49 East Ontario Street, Chicago 11, Ill.

(987) Reed Fabric Drapes: Information Sun Reed fabric drapes, shades; imported from Southwest Germany, made from selected hearts of Black Forest fir; loomed from slender reeds 36" to 136" long into rolls of same width and up to 120" feet long with 11 reeds to the inch; reeds straight, uniform, without nodes or breaks; stitched solid in 1" or 2" widths at top with recurring stitches ¾" across width of material; can be cut at any point without additional bindings; hangs in graceful fold; merit specified for CSHouse 1950.—Decorium, Inc., 420 Market Street, San Francisco, Calif.

(988) Silks: Information Scalamandre silk fabrics; wide range patterns, designs, colors; one of best sources of information.—Scalamandre Silks, Inc., 598 Madison Avenue, New York, N.Y.

FLOOR COVERINGS

(89a) Carpet Strip, Tackless: Full color brochure detailing Smoothedge tackless carpet strip: Works on curtain stretcher principle; eliminates tack indentations, uneven installations.—The Roberts Company, 1536 North Indiana Street, Los Angeles 63, Calif.

(989) Custom Rugs: Illustrated brochure custom-made one-of-a-kind rugs and carpets; hand-made to special order to match wallpaper, draperies, upholstery, accessories; seamless carpets in any width, length, texture, pattern, color; inexpensive, fast service; good service, well worth investigation.—Rugcrofters, Inc., 143 Madison Avenue, New York 16, N. Y.

● (7a) Rubberized Waffled Rug Cushion: Brochure, folders Allen Rubber-Loc Rubberized Waffled Rug Cushion for all types of contract installations; pure rubber, durable fibers; non-slip, provides comfortable walking, preserves rugs, carpets.—Allen Industries, Inc., Leland and G. T. R. R., Detroit 7, Mich.

● (961) Rug Cushion: Leaflet on Spongex sponge rubber rug cushion; greatly increases carpet life, provides luxurious comfort underfoot, creates no dust or lint, easily vacuumed or damp-wiped, has no dirt catching crevices, moth and vermin-proof, never mats down, made of natural rubber, long lasting.—The Sponge Rubber Products Company, 335 Derby Place, Shelton, Conn.

● (309) Rugs: Catalog, brochures probably best known line contemporary rugs, carpets; wide range colors, fabrics, patterns; features plain colors.—Klearflax Linen Looms, Inc., Sixty-third Street at Grand Avenue, Duluth, Minn.

● (990) Vinyl-Cork Tile: Brochure with color chart on Dodge Vinyl-Cork Tile; combines advantages of cork with toughness of vinyl surface; bright, permanent colors, including several remarkably good plain colors; resilient, quiet, safe to walk on, long wearing; good insulating, sound deadening qualities; resistant to fire; requires no waxing; cleans with soap and water; inks, grease, acid, mild alkalis do not mar; merit specified for CSHouse 1950.—Dodge Cork Company, Inc., Lancaster, Pa.

● (62a) Woven Cut-Pile Rugs: Full color literature Wunda Weve loom woven cut-pile cotton carpets, rugs; tough, durable cotton yarns pre-dyed for color penetration, evenness of tone;

pile loom woven through back and double locked for durability; wash without fading, matting; clean with any vacuum; wide range good plain colors; available by square foot or in fringed or unfringed standard sizes; merit specified for use CSHouse 1950.—Belrug Mills, Inc., Greenville, S. C.

FURNITURE

(104a) Contemporary Collections: Information one of most complete, articulate, collections contemporary items; includes fabrics by Salvador Dali, George Nelson, Ray Eames, Edward Wormley, Abel Sorenson, Bernard Rudofsky, and Freda Diamond; lamps by Paul McCobb, Arno Scheiding, David Wurster; furniture by Hosken; accessories by Ben Siebel, Higgins; dinnerware by Russel Wright; clocks by George Nelson, Richards Morgenthau Company, 225 Fifth Avenue, New York 10, N. Y.

● (923) Contemporary Furniture: Brochure, folders remarkably well designed line commercial contemporary furniture; features strong construction; clean, simple lines; selected pieces merit specified for CSHouse 1950.—Sterling Furniture, Inc., 1611 West Cortland Street, Chicago 22, Illinois.

(85a) Contemporary Furniture, Daybed: Information new retail outlet good lines contemporary furniture, accessories; includes exceptionally well designed Felmore day bed; seat pulls forward providing generous size single bed; 4½" thick foam rubber seat, fully upholstered reversible seat cushion, permanent deep coil spring back; frame available in walnut, oak, ash, black; legs aluminum or black steel; reasonably priced, shipped anywhere in

104

CSH#1950, Raphael Soriano,
Arts & Architecture, December 1950

CSH#1950, Raphael Soriano,
Arts & Architecture, December 1950

Mobile homes

The house as object of consumption is a finished industrial product that is bought like a car. Manufactured in forty minutes on an assembly line, these shelters correspond to 10% of postwar housing production. [20]
The form of the mobile homes is determined by the specifications of their transport. Likewise, mobile home parks are often situated near roads. In 1940, the mobile homes look more like trailers, but, little by little, they take on aspects of the house with a pitched roof, and zealously seek out kit assembly and industrial design. It is possible to have two mobile homes situated back-to-back or on top of each other. Mobile homes are sold completely furnished, down to the curtain details. They are not adapted to any particular site; rather, it is a question of occupying an in-between, or an incessant ubiquity between here and elsewhere.

FROM CARROLL SAGAR & ASSOCIATES

the best in contemporary . . .

everything for the contemporary home, office and store. The latest and finest in modern furniture, lamps and accessories.

Architects: Let us help you and your clients with your interior problems wholesale to the trade

interior consultants for Case Study House 1950

105

The elegant project unveils itself in February 1950 by small strokes through three diagrams of possible organizations of volumes, and of possible access by car to the site – scenarios that are envisaged and put to the test in reality allowing the perception of the multiplicity of simple forms that articulate themselves according to the framework of Soriano's structure. Finally, he designs a fourth version, published and already equipped with "merit specified" products and accessories that had been introduced at the time of its first publication, and which propell the project into commercial reality.
In CSH #1950, life is organized under a flat rectangle, delicately posed on a network of slender columns. This abstract geometric limit is held by a skin of glass and inhabited by rectilinear volumes with accentuated and solid textures. Under the roof there is life – a life permeable to the exterior environment, which penetrates its limits. A tranquil life under a resolutely fluid arrangement. The views glide along Soriano's first evocations and wander throughout, allowing the viewer to imagine the circulation and the spaces, the simple articulations of the rooms that open onto each other in a row, or which are separated by enclosed patios within the limit of the flying roof that unifies all the emerging objects. I see you, you see me.

These eleven quartets stand apart from other twentieth century chamber music by an extraordinary inventiveness and variety of new technical devices. They do not break with the tradition, or like the single quartet by Webern reduce it to its **ultima ratio.** They enlarge the conception of a style for four instruments by adding to it the full weight and extension of the late-Romantic symphony. To a considerable extent this enlargement has been the consequence of accepting at full value the polyphonic implications of the extended melody of Liszt, Wagner, and Bruckner, out of Schubert, which so upset the classical unities of later nineteenth century symphonic style. String quartet is a more useful polyphonic medium than the symphony orchestra; but the polyphonic use of such extended melodies played by four distinctively heard instruments will impose upon the harmony an increasing amount of dissonance, if the parts are not to be lost in such a warm chromatic bath as that of Strauss's **Domestic** Symphony—or for that matter Schoenberg's early string sextet **Transfigured Night.** Polytonality may be an adequate solution for music in two or occasionally in three parts. In four parts polytonality must be capable of four distinct divisions, or it will inevitably come down again to two. This is the problem of Milhaud. For further example one need only consider the four short isolated movements for string quartet by Stravinsky, among the most dissonant of his compositions.

The attempt to impose on string quartet an even contrapuntal style, resembling that of Bach's keyboard music, has brought both Hindemith and Harris to disaster. The four parts, though equal in value, are very different in quality; they must combine by contrasts, avoiding the continuously uniform registration of multi-voiced keyboard style. Mozart explored this medium by adapting several of Bach's fugues, but the **adagios** he composed to accompany theses translations are better suited to the quartet idiom.

The first quartet by Schoenberg is the best example of melody as songlike as that of Schubert, polyphonically compounded and elaborated with all the inner working of a rich symphonic art. The first development section follows closely that of the first movement of Beethoven's **Eroica** Symphony. The several distinct but continuous movements are joined into a single enlarged Lisztian sonata-

On the road

The American population is singularly mobile, facilitated by a single language and currency, and a national television. If the obsessive ambiance of movement is what one takes away from Jack Kerouac's "On the Road," it is with this characteristically American idea of east-west crossings that the cinematic genre of the "road movie" is born. The roads, straight as a die, follow the undulations of the hills they cannot bypass, delineating a radical carving of the land. The road network elaborated in a first phase by the great works of Roosevelt's New Deal and then with Truman in 1956 [21] would provoke significant expansion favoring a mass increase in automobile usage, propagating the American suburbs. From then on, one can imagine that the acquisition of a car represents an element of economic growth, by itself and by the consumption of fuel that it requires; in this way, gasoline becomes a determining economic factor.

CSH#1950, Raphael Soriano,
Arts & Architecture, November 1950

Begun in April 1950 and presented to the critics in December of that same year, it brings back the image of a minimalist classical temple to the magazine's readers. A shelter built in a few days whose metal structure the editor of the article lauds, for it is less expensive than wood and much more contemporary and close to this époque.

The purity of the design magnified by the photographs, reinforces the restrained delineation of the house, situated in a rectilinear manner, facing the canyon. The floor – absent in the drawings and the photographs – contains except for the base a great number of technical networks related to electricity or heating that are submerged in the smooth concrete. Open to the street and to the view, the principle façade offers the horizon to both the bedrooms and the lounge, as such breaking in a radical manner with the habit of hiding intimacy behind the kitchen, and with the separation of night and day zones. The service areas relegated to the rear form a band of space along with their patios that capture the natural surroundings and indeed the outside in the permeable roof.

The brick fireplaces, the wood panels and partitions, the soft curtains, and the accordion doors enrich the delineation of structure and skin. The walls have disappeared from the architect's vocabulary. The twenty-four columns are totally visible and exposed in the structural system.

The report of December 1950 is a veritable production, highlighting the house and transfiguring it into a lantern in the middle of dense blackness. It reveals its secrets and unveils the riches of its spaces and furnishings through its façade, which, through the lens of the photographer, has become a large display window and an ideal frame for the expression of good design to be consumed. A veritable organized mirage, the final report is a kind of catalogue in a desirable environment, and, what's more, it is real and built very near Hollywood with its illuminated scenery – the ultimate magic lantern of trends.

It is on a detour from Mulholland Drive and on Woodrow Wilson Drive that Julius Shulman had his house and photography studio built by the same Raphael Soriano. Having been born the same year as CSH #1950, I approach the myth and the image of the deceased by the image of its sister and the maker of dream images.

Shulman, indissociable from Richard Neutra, from American and Californian (most notably Los Angeles) architecture, entrusted the design of his dwelling universe to Soriano, and the conception of his garden to Garret Eckbo. Although the dwelling is a true Case Study House, it does not take part in the program. Today, it stands on the hills as a beacon and witness to its age.

Truly timeless, the architect's opus breaks with its closely-knit environment, situated in a patch of savage and exuberant greenery, cutting with care and brilliance the neat and well-kept gardens in the summits of the city's chic hills. Outdated, the house is covered in a layer of

CSH#1950, Raphael Soriano,
Arts & Architecture, October 1950

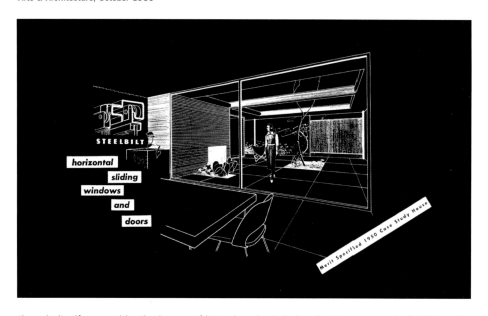

time, in itself covered by the leaves of intrusive plants belonging to an uncontrollable jungle, planted in times past on nothing, in order now to become this nature that has taken back its right over man-made things. Shulman asked me to come into his studio where every square centimeter and every piece of furniture is covered with black and white prints, all in a disordered jumble, like the leaves outside.

I try in vain to reconstruct the views from the photographs of the house, like the unforgettable screen patios sitting there, or the steel structure immortalized on its platform that has today disappeared under the branches. I stitch together the clues, trying to find out what Soriano's unique CSH could have resembled.

The Case Study Houses were well ordered for their photo sessions and embued with the desire to exist singularly in these suspended moments. And then, finally after an instant, I see the slender columns, the strict design of the roofing and of the almost absent flooring, the fireplaces of brutalist stones, the thick cupboards that absorbed the partitions and, above all, their transparency, and along with it, this fluidity of spaces lived by the photograph – spaces that do not hold their position, but rather disappear and reappear perpetually.

Excited by my interest in the program, the octogenarian is ready to proselytize on behalf of the program, all the while remaining a fierce critic of its author and his true influence. Apart from the collision with the dream maker, that morning on the Hollywood Hills I had brushed against the sensations – that is, the mirage – of CSH #1950.

A few asphalt bends away from Soriano's "beautiful American" lies CSH #16, a distant cousin of the mutilated one, itself the older sister to two other sad – still exquisite, but otherwise cold – corpses.

In his magazine, John Entenza reveals an unknown who has come to Hollywood to become an actor, but who would become one of the great architects of the postwar period. The publisher would entrust three house projects to this young designer who would cross paths with the program at the time of the construction of CSH #8 and CSH #9. [30] Along with Pierre

This is the frame for a steel-framed house

The mythology of metal

Metal profoundly fascinates the Californian architects, as much for its technical abilities as for its industrial origins. Metal represents the opportunity for designers to achieve the idea of the standardized domestic object, produced and sent directly from a factory. Beyond the myth of being the modern material *par excellence*, metal is highly performative when tending towards the use of new structures, freeing the plan completely from the congestion of walls, designing the promised vision of a glass pavilion. It also allows for a response suited to sloping ground and earthquakes, which have to be considered in California.

While the war effort convinces architects and the public – however belatedly – that the mass construction of houses can be achieved by the industrialization of this production, and of the necessity of using metal, the manufacturers of this material and structural steel pay little attention to this market that is too insignificant in their eyes. Furthermore, numerous construction firms reject metal, since its use often requires considerable skill and precision.

Koenig, Craig Ellwood (whose real name is John Burke) personifies the sublime period of the CSH prefigured by Charles Eames then opened up by Soriano – a classic period materialized by pavilions of glass.

In entrusting three projects to Ellwood and two others to Koenig, the publisher bets on new inspiration for the program by choosing enthusiasm and ambition over qualifications in order to expand the program with audacious and unknown architects. At a time when the magazine no longer seems to have difficulties convincing readers, with its numerous houses and with the re-publication of photographs of CSH #1950 in many international magazines, *Arts & Architecture* could allow itself to take the risk of youth.

With this new chapter, the program enters into a period when private promoters and well-informed owners see their demands taken on and promoted by the magazine. Indeed, Entenza discovers already commissioned projects that share similar values with his own. The magazine is no longer the client-innovator, but it remains the guarantor of the "CSH" label allocated to the projects that carry its aspirations and ambitions.

REFINED PAVILIONS

CSH #16/18

It has been called "the new case study house" since the time of its publication… Begun in 1952 after a year without any new CSH, then announced in July 1954 as being the sixteenth house to be presented, [31] it becomes CSH #16, thus taking over the name of a project by Rodney A. Walker. This new achievement by Craig Ellwood is the only one to survive of the three conceived by the architect and produced by the magazine. The two others were mutilated almost immediately, disfigured into confections with neo-Pompeian colonnades in the case of the first, in the case of the second an insipid hodgepodge, no less colorful. Indeed, they were both very beautiful, like the CSH #1950 and the black dahlia. Then, their steel flesh was bruised, their delicate and transparent glass skin torn, defaced by the "good" taste of others, and by the changeable and obsolete merits of their owners at the time, at pains to seem and appear. One must pass through the gates of Bel Air – the high security neighborhood reserved for the genteel society – in order to reach the sole survivor, protected and secluded on her rock, not unlike that sad principality of the French Riviera. Having passed the Rococo portal, I follow the soft sloping ribbon of asphalt under the eucalyptus and other large shady trees, concealing palaces often reflecting the cheapness of their owners. The trees follow one another and definitively blacken the city, mingling with the foliage's uncertain mist. Around the summit of the hill that has been paced up and down by car, the vegetation becomes suddenly hazy along the turning of a bend. Something blurry appears, framed, flooding the natural surroundings with a perfect abstraction. There it is, with its glass walls that capture nature, fiercely preserving its privacy behind this uncertain boundary; this fragile, yet effective and provocative fortification. The wall turns over in wood, under the roof that flees beyond its bounds, a car is stationed, parked there like the solid wall of bricks separating the entry of the carport.

As with CSH #10, it is a thin and fine lady of a certain age that lets me into the delicate edifice. She has been its owner since the first day, the day when Henry Salzman, property developer and former patron to Craig Ellwood, sold it to her for 36,000 dollars after having delivered it to the visitors and readers of *Arts & Architecture*. The lady's silhouette is slight

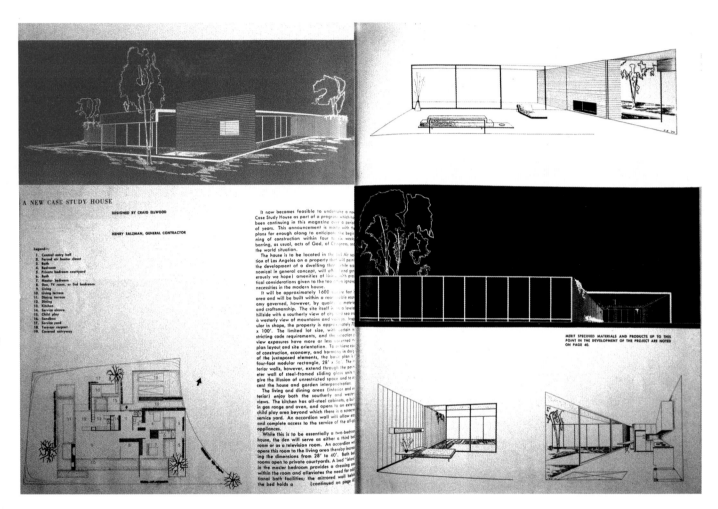

CSH#16, Craig Ellwood, *Arts & Architecture*,
April 1952

and perfectly presented in a kind of amazing grey unitard. I remain in this interior only for a moment; a group of Japanese students have damaged some trinkets, confirming the patience of my host who glides along like a mouse in this intact space, similar to something appearing in the décor of "2001 A Space Odyssey." Like the ceiling, the white, joined vertical panels are composed within a frame that is the color of wine, dividing the vast living areas where the furnishings float as if suspended from nerves. In 1953, the architect describes his choice in the final portfolio: "To provide visual freedom and to maintain definition of the architectural elements, the roof slab is floated over the vertical wall planes and the walls are lifted from the floor slab with a black recess base… each element is articulated as a separate unit."[32] A block of matching stones surrounds the fireplace at an angle and catches the vessel at the base like the brick walls gliding under the white slab of the roof. A terrace of greenery enclosed by a brick wall opens out onto the kitchen in the rear. Conceived as a landscaped exterior element by Eric Armstrong, the surfaces of the brick walls are spiked with steel bars, in which the shadow plays are as important as their fictional function as gymnastic devices. The landscape and the earthworks conceived from the beginning of the project favor a choice of regional plants that function to camouflage the house.

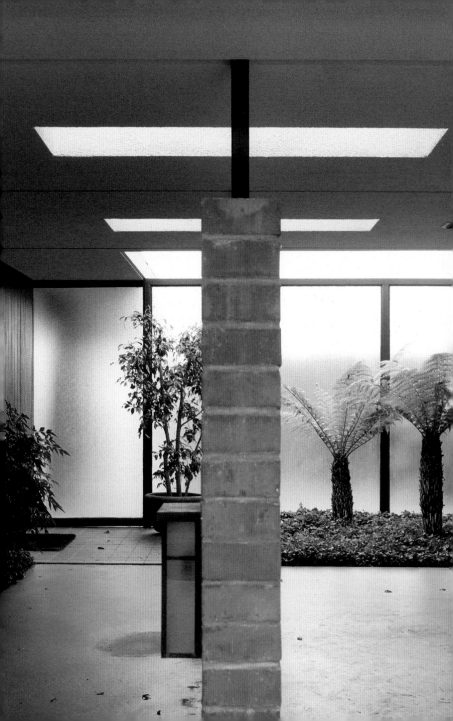

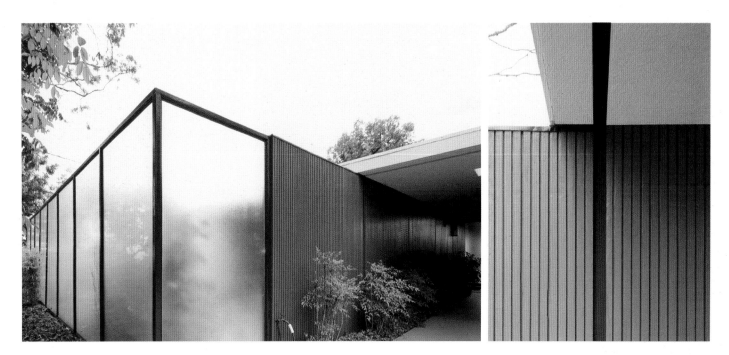

CSH#16, Craig Ellwood

Each room is produced with its corresponding exterior in mind. In the bedrooms, wood paneled walls slip outside, extending the limits of the nocturnal spaces, until which point they are restrained and protected by glass walls woven in black yet delicate metal, much like the strict and abstract patterning of the interior. At once protective and soft, this paradoxical limit is the most eloquent homage of an architect to the natural exuberance of California, and indeed to its most beautiful spatial thread that captures light and transcends its textures by means of an improbably subtle focus. One view – only one – is controlled as such: That which recedes from the living room into the city and the ocean. A second, turned towards the interior, is framed by the small television room situated adjacent to the living area.

The terraces and patios that are delineated by translucent glass, brick, and the horizon are of small size highlighting the reduced dimensions of the sliver of space on which the house has taken refuge.

CSH #16 is based on a framing module of 4'x4' [33] and utilizes structural tubing of 2.5 square inch sections. [34] By virtue of the sectional dimension, these tubes allow for their clear articulation vis-à-vis other structural elements and their materials, as with the I beams that are used for the roofing in which the individual members have sections also reminiscent of the tubes. The posts are arranged along the module and half module. While Raphael Soriano revealed his structure using round posts, (as in the classical columns used in his CSH of 1950) and placed them according to the dictates of the roof while being clearly removed from the exterior glass skin, Craig Ellwood conceives his metal structure within the logic of the building as a whole, and only reveals it through a play of colors applied to the frame, thereby submitting to discoveries only offered by the apprehension of these visual moments. The differences in approach by the architects are also reflected in the way in which the walls are defined and

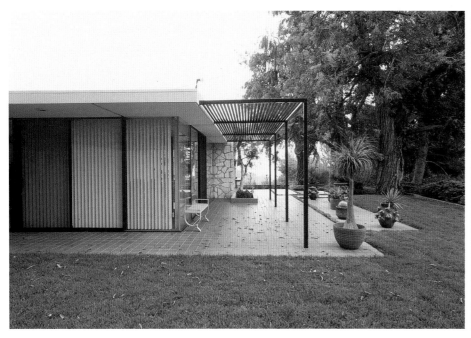

CSH#16, Craig Ellwood

treated. Soriano strives to use them as programmatic elements, defining them as ordering surfaces. Ellwood assimilates them as both planar elements and screens floating within the structural grid. Likewise with the furnishings, they were to be light and mobile. Apart from this divergence, the expansive overhangs and the stretching of the interior partitions that capture the exterior so dear to Richard Neutra, and likewise the large bays of sliding glass and aluminum indicate the search for a similarly performative and economic use of a metal structure that binds the two architects with proximate preoccupations.

This first experience with the Case Study program marks the beginning of a long collaboration between Elwood and the journal, which he would soon rejoin as an influential member. Indeed the readers of *Arts & Architecture* would discover in September of 1954 perspective drawings highlighting the designers' production to follow. From first glance, one understands the reasons for which the editor had taken pains to announce two months earlier that budgetary concerns would no longer serve as a prime objective for the two projects to come.

Indeed what follows is a vast residence two times larger than the preceding house, which stretches in the form of a Y around a sumptuous swimming pool and occupies the entire breadth of the rectangular lot, with the house to the north and the tennis courts to the south. The program retreats from the promises of the "low cost houses" – now already a dream for more that ten years – and as such moves away from the middle class American family. Craig Ellwood designs the project for Doctor Hoffman, [35] his wife, their four children and their servants; the latter, a necessary addition that infringed on the program guidelines set in 1945.

A perfectly self-enclosed studio space grafts onto the U shaped building, demarcating the entry on the middle bar. This central space is home to the life and light of the domestic unit and embraces the pool with its vast façade of glazed sliding doors. Reserved for those daily activities undertaken by the entire family, the lateral bar is surrounded on either side by two

Case Study House No. 17 is now well out of the ground with the steel structure virtually complete and a large part of the hollow clay block walls in place. In the August, September, November, 1954, and March, 1955, issues of the magazine we have shown the developing plans of the house and the final project for the landscaping. Here, we illustrate the utility core with some details of the equipment to be installed. In subsequent issues we will present the house during various stages of construction until it is complete and ready to open for public showing. By way of direction for those who might care to see the project in progress, the location is in the general Beverly Hills area; by proceeding north on Coldwater Canyon road, it can be found at 9554 Hidden Valley Road.

the case study house

DESIGNED BY CRAIG ELLWOOD

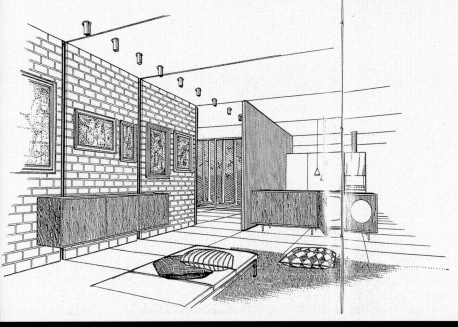

Case Study House No. 17 is the latest in a continuing series designed and built for the magazine, ARTS & ARCHITECTURE. It has been the purpose of this project to correlate the best of modern building techniques with existing and newly developed materials in an attempt to create logical contemporary housing that is a stimulating and provocative contribution to the thinking in this field.

SPECIFICATION NOTES

All kitchen appliances in the new Case Study House will be built in. The individual Westinghouse refrigerator and freezer units were selected for their many construction and design features. These include vapor sealed wrap-around construction for strength and rigidity, Laminar Fiberglas insulation, double self-sealing door gaskets, plastic sliding crisper doors, adjustable shelving and Thermocycle defrosting. These units carry five-year warranties. The exterior finish will be brushed chrome.

The built-in ovens are Thermador's new oversize units. These units are completely automatic with Timer Clock and Teleminute Minder. Features include visual and audible signals to assure accurate temperature and timing, automatic control of bake, broil, and pre-heat, heavy insulation, vapor deflecting visor and no exterior vents. The eight-position oven racks and pan are easily removable or adjustable, and the stippled white porcelain interior is acid-resistant with rounded corners for maximum cleaning ease. The specially designed aluminum broiler tray produces excellent infra-red charcoal-type broiling results. The generous size "Masterpiece" oven is 18" high, 18" wide and 19" deep, and yet fits into standard 64" cabinet. It is finished in stainless steel.

For complete cooking ease, the Thermador cooking top will include a griddle and the Duo-Cooking unit. The griddle is made of heavy aluminum, heavily ribbed on the underside for even heat distribution, and has a neon-type "heat-on" indicator with a five-heat switch. Flush-mounted handles allow easy removal for cleaning. In addition to all the conveniences of a deep well cooker, the Duo-Cook is readily converted to a fourth heating unit and is equipped with a five-quart cooker pot and French fry basket. A safety high temperature switch prevents overheating. A Thermador warming drawer is provided in the cabinet work adjacent to the barbecue unit. This will be used to keep food at the proper temperature without drying out or overcooking, and will also provide a means for warming rolls, plates, etc.

The barbecue cabinet unit is custom designed and is to be constructed of black and stainless steel plate. This unit is designed for the Rotir electric spit which includes 9 stainless steel skewers with wood handles, stainless steel spit, crank adjustment and gear head non-radio-interfering

(Continued on Page 30)

CSH#17, Craig Ellwood,
Arts & Architecture, May 1955

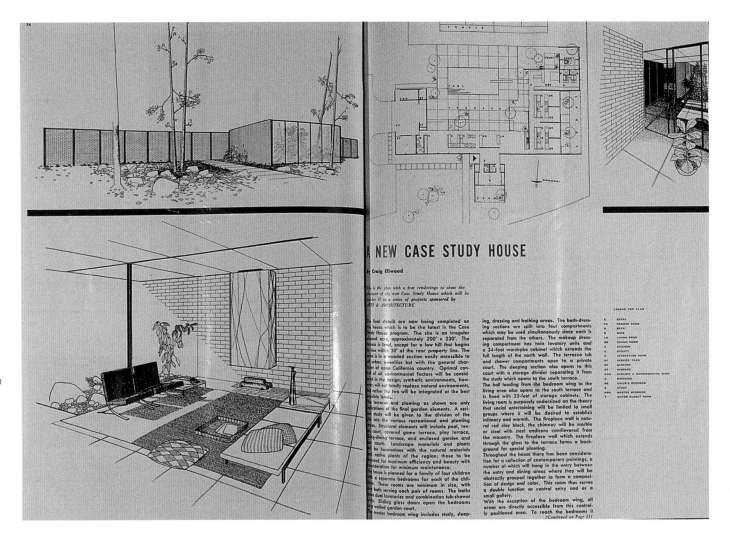

(Continued on Page 33)

CSH#17, Craig Ellwood, *Arts & Architecture*,
August 1954

solid blocks. To the east, it is contained by bedrooms, and to the west, by the garages and storage areas. The bedroom wing accommodates the parents on the south and the children on the east. All the interior spaces extend beyond the delicate structure, to the intimacy provided by the enclosed gardens, or to the relaxation and entertainment offered by the pool. The deliberately small living room is designed as such according to the request of the client in order to enhance intimate conversation and general sociability. The servants' quarters are placed in immediate proximity to the entrance. Conceived as a satellite peripheral to the main body of the house, this wing preserves its sense of intimacy through a courtyard demarcated by bricks and glass, a direct echo of Ellwood's previous production – the secret garden that was CSH #16. As in this previous house, the landscaping is envisaged as one that celebrates the regional vegetation in order to produce – albeit in an accelerated fashion – the effect of an ancient grove. On the other hand, the patios have various species of tropical and semi-tropical plants. [36]

The house is situated on a slab of concrete and surrounded on all sides by a slightly alternating rectangular border of bricks, glass and wood ordered within the abstract grid of the steel posts and woodwork. The sectional tubing employed by Ellwood in his previous *opus* is abandoned

Heating

The architects of the CSH particularly favor the appearance of postwar central heating. Rarely being thermally isolated in California, the houses would thus be heated in different ways. Under floor heating is prescribed for almost all the houses. If the houses are constructed on a concrete slab, the slab is cast with traversed pipes of hot water (CSH #10, 22, 26). In the case of solid foundations, the space is sufficient for under floor ventilation (CSH #16, 17, 18, Craig Ellwood), or fitted with ventilation in the ceiling, which is easier to solve in case of a change of level (CSH #9). In addition to liberating the walls from large water heaters, the under floor or ceiling heating will not use radiators in order to complement the open plan and to add to the purity of the spaces. Each room being now heated, the activity of the house is (thus) distributed in an equal way, thus fulfilling a multiplicity of tasks.

here in favor of the dominant H profiles of the steel sections. The receding and thickened brick appears on both its faces as an important and rugged texture that performs alongside the smooth panels of glass and the verticals that are adhered and structured by the billowing floor to ceiling façade paneling.

Few details and spatial moments are needed to put in focus this new model for dwelling. The articulations between elements and materials, as well as the subtle play between the structure and infill are remarkably studied and conceived. The later "high tech" Anglo-Saxons would replay this same economy, but certainly, one could argue, without the same elegance. The revealed structure is treated as an element that is both rhythmic and tectonic, in which the rigor of the module favors what Ellwood would describe as "a complete harmony of structure, plan and form." [37]

Beyond providing a sense of security, the brick walls imbue the façades with an unusual solidity. Indeed, the pavilion enacts the oppositions of the seeming frailty of the interior sheets of transparent glass and the masses of steel and masonry in the rear. The interior walls of the living area are conceived in monochromatic and neutral materials in order to accommodate the doctor's collection of contemporary painting. The furnishings would be chosen according to their sculptural qualities. Metal appears in its share of important welded work including the fireplace mantel, the solid anchoring of the childrens' beds, as well as the fittings for the built-in furnishings of the living room. In light of all the gadgets and technical innovations, the house is also fitted with newly irrigated perforated wall openings since the telephone which is situated at different stations is accessible from the pool. The dissemination of media continues in the living room where both a hi-fi stereo and a television with remote control are incorporated.

121

CSH#17, Craig Ellwood, *Arts & Architecture*,
March 1956

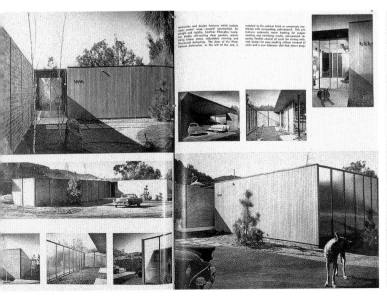
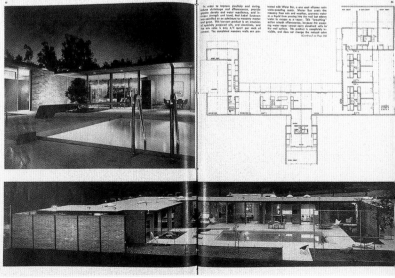

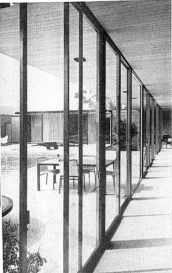

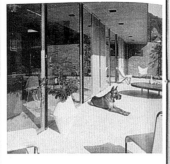

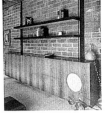

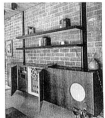

This system allows the entry and service doors to be answered from several stations within the house. Also children's bedrooms may be monitored in several areas, including the master bedroom, kitchen, living-room, nurse's room and the hobby shop.

Provisions were made with the technical cooperation of the Pacific Telephone and Telegraph company during the design stage for several telephone stations. Telephone outlets are included

mite damage. Modular rigid frames of 4"-H-13# columns and 5"-I-10# beams are designed to carry all vertical and horizontal loading, thus all walls, interior and exterior, are non-bearing. 2" x 6"s @ 16" c/c span between beams and the roof sheathing is 1" x 6" fir, laid diagonally for diaphragm action against seismic forces. The finish ceiling is 1" x 4" tongue-and-groove vertical grain Douglas fir boarding. The fascia is 5" steel channel. All steel, the columns, beams, fascias and miscellaneous steel is U. S. Steel, manufactured by the Columbia-Geneva Steel Division. The slightly higher cost of steel framing was offset by a savings in lumber: the steel system allowed the use of 2" x 6" ceiling/roof joists, and to maintain the same architectural detailing, equivalent wood beams would be 10" x 10"s, requiring 2" x 10" ceiling/roof joists. Additional savings were effected in the masonry wall panels between columns: steel reinforcing was minimized because the steel frame is designed to withstand all vertical and horizontal loads, including seismic forces. The steel frame is integrated with the design, all steel columns throughout the building are exposed to become the basic element of the architecture. This exposed steel is painted black to contrast crisply with the natural terra cotta color of the clay block. Room partitions occur on the module, or mid-module, so that the rhythm of the frame is reflected in the division of space and again in the vertical elements. Thus there is a complete harmony of structure, plan and form.

The masonry panels between the steel columns are Davidson 6" clay block. This unit provides all the advantages of kiln-fired masonry for the same price-in-place as concrete block. Besides the natural beauty of burned red clay, these advantages include high density for strength and weatherproofing, and modular dimensions for ease of design, detail and construction. Davidson 8" clay block is used in the fireplace wall.

on the pool terrace and tennis court, and consideration has been given the future installation of a separate telephone for the children. The telephone instruments include the new color design.

The structural framework of the house is entirely steel. Steel was selected because its use insures permanence of form, minimum maintenance, and it is not subject to moisture and ter-

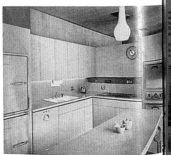

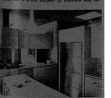

CSH#17, Craig Ellwood, *Arts & Architecture*,
March 1956

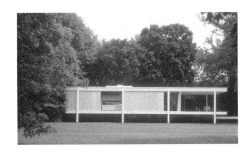

The Farnsworth House

The Farnsworth House is like a temple, indeed a holiday villa isolated in its container of greenery. The CSH projects put in perspective the Farnsworth House within the field of domestic space. As the architects of the program pursue the work of Mies van der Rohe, they confirm the master's preoccupations with aesthetics, fluidity and the metal frame. They invent other models at their disposal, enriched by progress those that are lighter and more technical, and in essence more acceptable for the broader public. These new models appear to be based within their particular context, as much technical as natural. Without a plinth and by their size, they come closer to Laugier's primitive hut.

As with the concrete paving stones and the monolithic fiberglass roof, the steel structure is designed to withstand seismic deformations while simultaneously maintaining the house termite-free. The designer distances himself from the finesse of his earlier CSH by embracing an absolute aesthetic that privileges modularity and multiplicity, thus seeming rather to lean towards an architecture of the highest order.

Of the pure design and construction of the Y plan, its elegance and its singularity, nothing is left but the photographs and commentaries with which the pages of the magazine would be inundated. In fact, it is by reading these advertisements that I discovered CSH #17. They reproduce the photographs of the building site, touting the merits of the sliding glass, the steel beams and other remarkable structural features, as well as documenting the participation of numerous workers at different stages of this adventure. The overflowing roof, the glass capturing the reflections of the basin's perimeter and the immediate surroundings, the taut beauty of its surfaces, the reflections of the pool water, and the broad and profound perspectives that blur the inside with the outside and vice versa, all these marvelous devices would be devoured only a few months after the completion of the work by a disastrous design.

Its delicacy absorbed by stupidity, by the vision of a decorator who bought the house from the doctor, the jewel would be transformed into an indigestible meringue, bringing the fragile citadel of modernity to naught. The set designer would cloud the empty shell with the derisive cloak of a Roman villa, catapulting the modern pavilion into a Roman one, worthy of the Rococo and ludicrous décor illuminated by the splendors of Hollywood peplum. His third project would experience the same tragedy and the same unworthy ending, suffocated by absurd kitsch and banal pompousness.

Ellwood's third house (CSH #18) would be an ultimate model of mastery and of design, of marvelous innovation making it one of the jewels of the program.

CSH#17, Craig Ellwood, *Arts & Architecture*,
March 1956

Published in February 1956, the first perspective drawings show a furnished house contained in a rectangle, presenting viewers of the journal with numerous glazed bays on the south façade, that like its sister, CSH #17, open onto an enticing swimming pool. Paradoxically, the north façade outlines a rectangular profile, protecting the automobiles and dissuading indiscreet glances from wandering toward the intimacy of the inhabitants, with a carport to which the glass canopy gives the prototype the allure of a bird. The drawings confront us with the reality in advance of the photographs to follow.

Its domestic model supports the claims of reproducibility as well as adaptability to each user: "More and more the increasing cost of labor is forcing construction into the factory. Eventually the balloon frame – the conventional system of framing houses – will tend to disappear, and within possibly 10 or 15 years houses will be built from pre-cut and prefabricated components manufactured for fast assembly. Catalogs will offer a choice of metal, wood or plastic structural frames which will be easily and quickly bolted together…" [38]

To achieve its ends, the designer picks up from the teachings of CSH #16, by, in particular, making use of the prefabricated tubular structure filled with simple, manufactured panels. The structure of CSH #18 would be in 2' tubular sections along with contrasting rectangular beams of the same sectional dimension on the short side. Between the steel tubes of the skeleton, sandwiched panels are introduced, a new notion invented by the model's designer which he conceives of as similar to the skin of the project. These laminated panels hang on to the metal frame according to a method that resembles a curtain wall. This means of assembly will determine the rapidity of mounting this prototype as well as the fastening of the structure preassembled in the workshop. This fabrication asserts an aesthetic that presents the skin and the fine structure as fundamental and distinct elements.

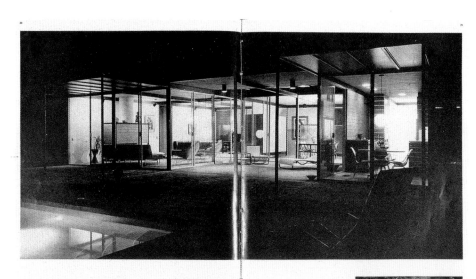

CASE STUDY HOUSE 18 BY CRAIG ELLWOOD

CASE STUDY HOUSE 18

BY CRAIG ELLWOOD ASSOCIATES

This house featured as a project for a Case Study House in 1956 is now under construction. It was necessary to work with certain rather difficult problems peculiar to the site. These problems now solved, we are able to proceed as previously announced.

The site is situated in a natural canyon watercourse and was filled 25 to 30 years ago during construction of the subdivision. The fill is 8 feet to 41 feet in depth and is not compacted, thus it was necessary to consider a system of caissons or pilings to carry loads to natural earth. Poured reinforced concrete caissons and power-driven steel piling were both considered. A boring investigation of the soil revealed the fill consisted of decomposed granite and granite rock and rubble with voids. Since the presence of rock and voids caused cave-ins and soil shifting during boring operations, the power-driven steel pilings were selected as the most economical solution. These piling are 8"-WF-32# steel beams on a grid of 16-foot centers, power-driven to a 30-ton bearing capacity. 14" x 24" reinforced concrete girders span between steel piling and a 7" thick reinforced concrete slab spans the girders.

The 18' x 36' pool will be "floated" on compacted fill. The soil in the pool area will be excavated and replaced with compaction to a depth of 19'. Compaction will be to 90% of optimum density. This solution, engineered and designed by Anthony Bros. Pool Company proved to be much less costly than placing the pool on steel piling.

The house structure is 8-foot modular: 2" x 2" square steel tube columns, 2" x 5½" rectangular steel tube beams. This is the first use of rectangular steel tubing as beams and is probably the first application of a modular steel frame with prefabrication methods.

All wall panels for the house are prefabricated and are faced with 5/16" "Harborite," a Douglas Fir marine plywood with resin-impregnated overlays. These overlays provide a smooth, hard, grainless surface that eliminates grain-raise and checking, and takes paint well.

Roof decking is Fenestra "Holorib" steel building panels spanning 8 feet beam to beam. The design of these high-strength panels provides maximum bonding area and the telescoping lap joints and interlocking side laps allow quick and easy installation.

Eleven "Steelbilt" steel-framed sliding glass units are specified to integrate the interior with the garden and enclosed court yard. Floor throughout will be quarry tile, except in bathrooms, where Granitex Mosaics will be used for floors and walls. Mosaics will also be used on all countertops. All tile will be manufactured by The Mosaic Tile Company. The kitchen work area will feature eleven Westinghouse built-in appliances.

One of the first purposes of this house is to show how good design techniques can be best applied to prefabrication. The usual and standard procedure is to disguise the construction method and pretend that the house is job built. Here nothing is hidden and the system used is emphasized in the design. Frames and panels are strongly defined to become the basis of the architectural expression. In an early issue we will feature the steel piling, the structural steel frame.

P. E. PHILBRICK CO., BUILDERS

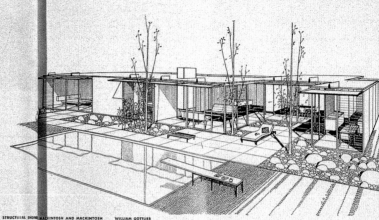

STRUCTURAL ENGRS. MACKINTOSH AND MACKINTOSH WILLIAM GOTTLIEB

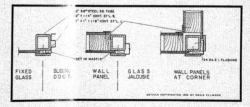

FIXED GLASS | SLIDING DOOR | WALL PANEL | GLASS JALOUSIE | WALL PANELS AT CORNER

DETAILS COPYRIGHTED 1956 BY CRAIG ELLWOOD

With this system, detailing has been minimized. One connection applies to all exterior wall conditions: panels, glass, sash and sliding door units connect to structural tubes in the same manner.

19

125

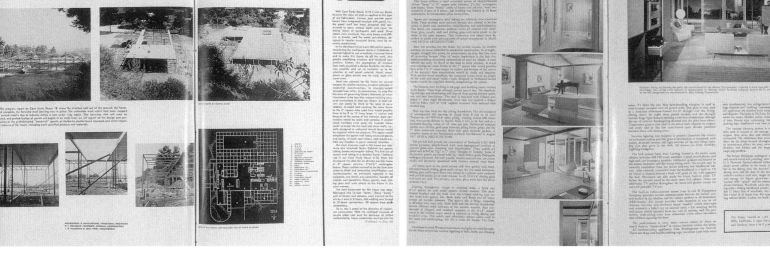

Craig Ellwood would tout the benefits of prefabrication [39] throughout the two years of dialogue with the readers of the journal, as if to acclimate them to this industrial phenomenon. [40] He states: "If we can continue to find inventive structural forms to suit these materials and techniques, this will be the means to prevent stereotyped architecture." [41]

The simple details promised by Ellwood are put to the readers in April 1957. We shift slowly towards the real and the tangible with his three-dimensional sectional prototypes published in March 1958. They bring into play the sectional profiles of the steel, the panels filled with plywood, and the fine sheets of glass. These panels and sheets are articulated with the tubes according to the same finishing details, giving the ensemble a perfect cohesion.

The final photographic documentation in May 1958 does not betray the perspective drawings from the debut publication. On can imagine Dr. Field's family with his two daughters, all music lovers and art collectors, passing tranquil days and evenings to the sounds of the rehearsals that Mrs. Fields, a professional musician, performs on her piano. The architect has not forgotten to install a powder room in the couple's bedroom for those days when the mistress of the house appears in public. [42] The media presence in the house manifests itself through the outlets connecting a portable television to various locations including the garden enclosure, not to speak of the fixed appliances and the television remotely controlled from bed. The fluorescent switches turn off the lights a minute after their activation. [43] Finally, one notes a built-in vacuum system accessible from six different inlets. The over-equipping is also found in the kitchen, with its two ovens, two refrigerators and an integrated robotic mixer.

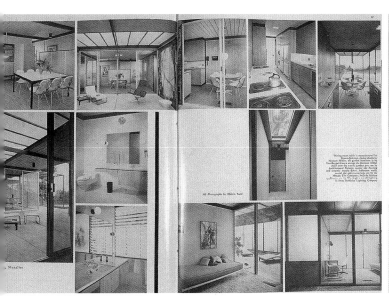
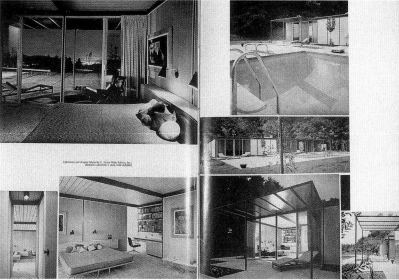

CSH#18, Craig Ellwood, *Arts & Architecture*, June 1958

The press [22]

Since 1846, the house is reported in the media, sold by mail order like a common product. The houses appear in the pages of the women's press, the architect's plans are sold by mail order for a few dollars. Frank Lloyd Wright sells his "blue prints" by mail order in the *Ladies' Home Journal* from 1895 until 1920.
John Entenza would breed a small revolution by shifting the model house of the womens' press to the art and architecture press, and in particular to the domain of criticism beyond mere presentation.

The obsessional enthusiasm for talking evidenced by the loudspeakers inundates even those areas that seem so mute in their photos. Numerous furnishings chosen with care occupy the floors, which are this time clad with baked tiles alternating with thick rugs.
Night photography reveals the secrets of the south façade and its interiors, while the rear façade's daytime images reinforce the design, the automobile parked under the roof, and the composition that is impeccably framed by the structure. The black and white of the photographs will not show the blue applied to the steel frame, nor the blue-tinted glass of the canopy, which extends the color as an echo of the pool and the sky. The photographs reveal to our eyes this aesthetic of modularity, this lightness of the plans and panes of glass, the mad flow of the spaces and reflections, the axes of reduction. We are projected into a modern yet terribly traditional space, with its Asian and Japanese accents, reminding the European of the proximity of the Pacific.

MISSING
Geometric abstraction

CSH #19

In the issue on CSH #18 in May 1957, a new chapter of the program slips into the magazine, giving birth to CSH #19. With this new episode, John Entenza proposes an alternative to Craig Elwood's minimal response, one conceived by the architect Don Knorr of Knorr-Elliot Associates, in which the separation of activities and functions through different buildings flaunts itself as a founding principle. While everything seems to set these two visions of domesticity against distinct geographic situations – in this case Los Angeles and San Francisco – the reading of the architect's plans and descriptions reinstates attitudes and points of view that are most contemporary and Californian. Unfortunately for CSH #19, the project would not know the same outcome as CSH #18, namely its opening to the public; it was forgotten and rejected, having at last disappeared and faded from view in Atherton, a suburb south of San Francisco. Had the project been built? and if so, did it still exist? And why did the magazine not follow the building's construction?

Nevertheless, the alternative developed by Knorr through the drawings appears to be a track not yet explored by the program despite certain similarities with CSH #15, namely with the isolation of functions and the choice of materials, like unfinished brick.

Conceived for a young couple and their son, the house produces an environment where each programmatic element is devised in an independent manner, and introduced as a piece of a puzzle in the play and composition of a distinctive spatial sequence, all the while dressed in materials and textures that emphasize this succession of ambiances and places.

On a square podium called the "mat," [44] the designer arranges three separate volumes that are linked by pathways. The garage and the service areas for the pool form the first block at one side of the plot; a second block houses the children's wing that is low like the garage, accommodating within its masonry volume two bedrooms open onto two terraces. Facing this wing, a two-storey block in steel, glass and brick is sited, where the family activities, the parents' bedroom and balcony coil up in the large volume.

CSH#19, Don Knorr, *Arts & Architecture*,
September 1957

The landscape architect Richard Haag designs a network of pathways, of translucent glass screens, of taut bridges, gravel and stone terraces laid in sand, [45] a grass carpet, and a pool that binds all the constructed elements in such a way as to create a geometric composition. The plot stands out perfectly against a thick sea of bamboo, the "mat" seeming inaccessible, as it is protected by this green coating.

The atmosphere of the walkways and gardens – moving from the stone Zen garden, to the collection of cacti, to the grass dunes – slips in between the buildings and enriches these interstitial spaces. The wish to sequence and arrange surprises and discoveries takes on its full magnitude with the composition of the programmatic elements: The visitor arrives at the center of the H formation, through the narrow sliver between the bedrooms on the left, and the double-height bar on the right, the latter hiding a box-within-a-box with its sleep deck, facing a wall of books and a strange fireplace that floats in this tall space like a sculptural water drop. Similar to a Russian doll, CSH #19 puts into tension and links program elements much like a collection of objects and impressions. It offers a particular and colorful environment on a framed plateau, as well as an ordered, amazing and structured lifestyle, which is sequenced and cut like a precise movie.

Greek in its travertine floors, Asian in its scenery, and Hitchcockian for its suspense of discovery, this project has a Technicolor ambiance and views and trajectories in Cinemascope. Unfortunately, as with many other celluloid masterpieces, the film has disappeared, burned in the pages of the magazine and has subsequently been forgotten.

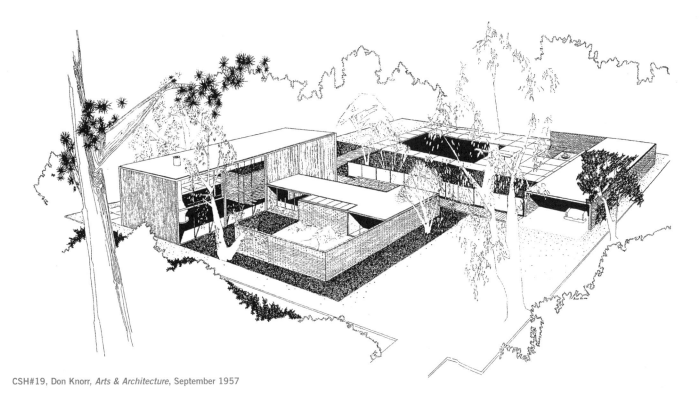

CSH#19, Don Knorr, *Arts & Architecture*, September 1957

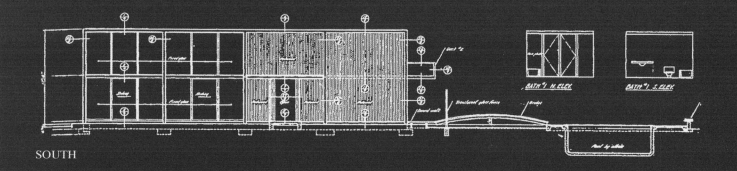

SOUTH

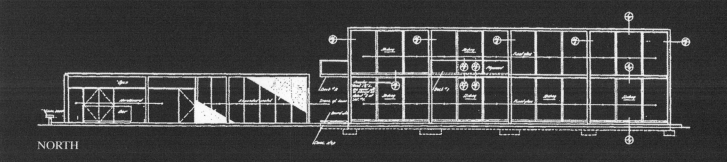

NORTH

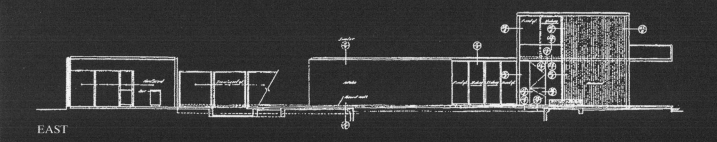

EAST

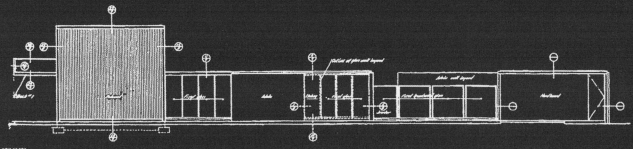

WEST

CSH#19, Don Knorr, *Arts & Architecture*, August 1957

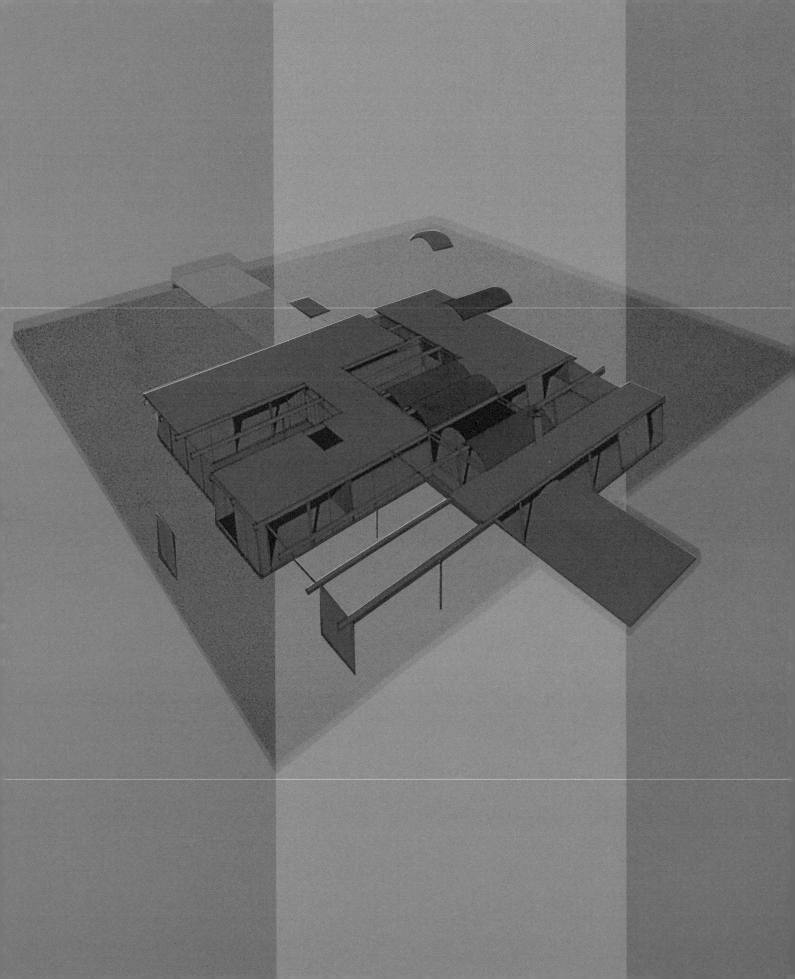

SACRED TEMPLE
Aged body

CSH #20

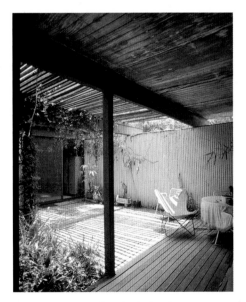

CSH#20, Conrad Buff III, Calvin Straub,
Donald Hensman

Like a drowned body that resurfaces in a pool of water or in the neighboring Pacific, the skin of CSH #20 slowly loosens from the bones of its emaciated structure, under the white light of this heavy and hazy afternoon.

Hidden away under the disquieting profiles of tall trees, its large body stretches out amidst the foliage of the Sierra foothills. In this plot's unkempt jungle, which is open onto its gaping carport and the road to the east, the impression of time suspended is striking. The images of the Statue of Liberty on the beach, toppled over and covered in sand cross my mind as a hardly academic flashback of the spectacle before my eyes. Cataclysm or time's sabotage, the house and its immediate surroundings appear abandoned, in a state of advanced dilapidation and of unprecedented jeopardy. The Sleeping Beauty has not awoken, and her Prince Charming lives silently on the premises with his little dog.

While gently opening the door, and apologetic for not being able to show his treasure crowned in the glory of yesteryear, he invites me to stroll around at length. The house reveals itself with each stride, behind the traces of an aged body that is tired yet dignified, on which its loose and rough skin hangs, dulled over time by the sun and rain, leaving one to imagine a great and serene beauty that was.

I enter the forgotten temple – the modern sanctuary in its miniature jungle – as if entering an Inca or Khmer ruin, surprised that everything remains despite the erosion of time.

A plywood alternative to the investigations and steel modules of previous CSH, the network of posts and beams still lies today over more than half of the site, allowing the trees and the shrubs in the courtyards and patios to blossom within this regular and at times voided frame. With its hollow beams and plywood panels, the wood structure suffers from the skin's detachment and its corresponding vertical members of horizontal vines made of thin strips of wood, in which their former regularity and geometric rigor have gradually blurred. Nature has once again become wild and unrestrained, and the house merges with the scraps and piles of leaves and vines and mingles in with the de-pigmentation of its surfaces whose limits have become uncertain. Entering from the right of the folding screen, I plunge into the foggy

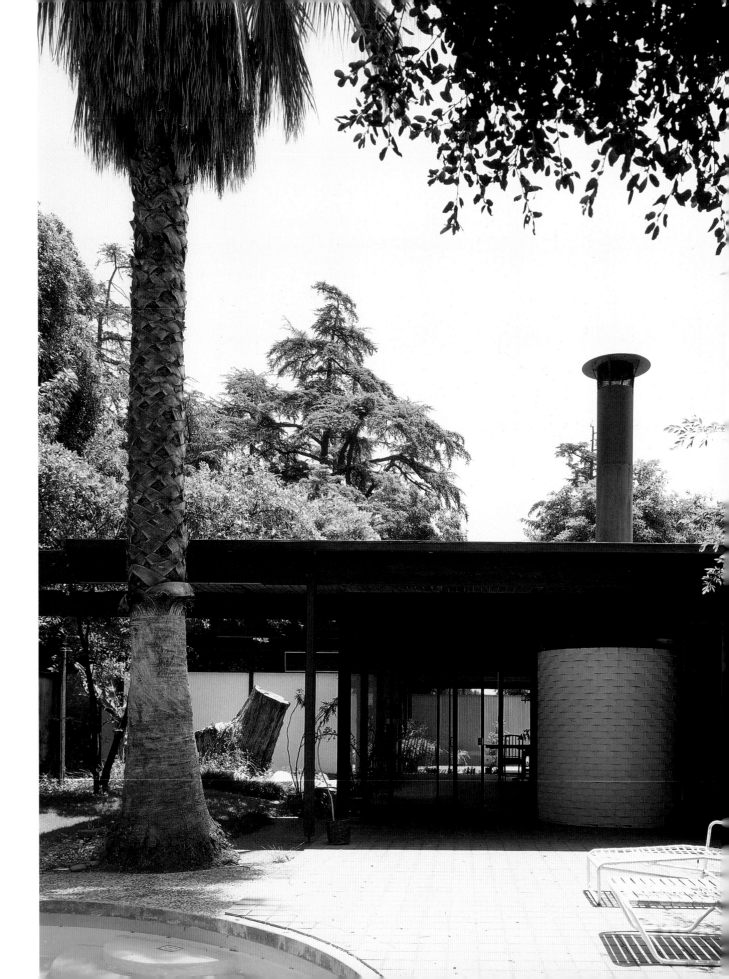

The fireplace

While the fireplace is not essential for heating the climate of Los Angeles (especially if one already takes into account central heating), it appears in almost all of the CSH. Used on holidays, or temporarily, to heat only the living room, the hearth is inseparable from the idea of the family unit. Whether against the wall, in the center, two-sided, or sculptural, the fireplaces of the CSH introduce simplified, geometric and refined forms. Only houses #8, 21, and 24 have no fireplace, the heating of the first two resembling mechanical and light machines. For those fireplaces that are embedded, most have simple openings to the stripped wall, removing the flue (CSH #2,3). Certain fireplaces, like a screen, are tightly abutted to the landscape (CSH #23), or against an interior garden (CSH #4). They are doubled as a barbecue on the exterior face (CSH #16), or with another fireplace if the flue is placed on the interior (CSH #10). Its mantelpiece may be sculptural, enveloping and modeled, much like a found object (CSH #19, 20). At the center, it would flaunt itself like a unique object, either open on two sides (CSH #9) or all around (CSH #22).

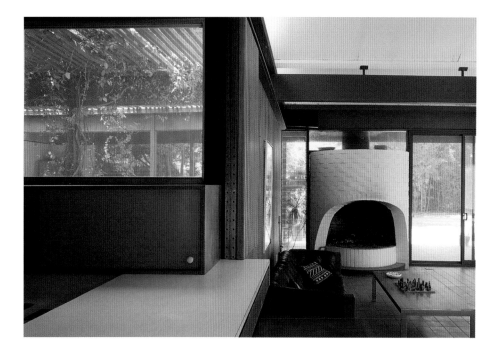

135

CSH#20, Conrad Buff III, Calvin Straub, Donald Hensman

atmosphere, having as my only point of reference the tiled floor on which I walk cautiously. Having been conceived originally by its owner-designer Mr. Bass, the squares of the earthenware floor and the entry screen are today covered in the same surfaces, also sometimes of earth, recuperating the land previously lost, like a wave of sand discharged by the wind. This gridding on the floor then, would have been traceable from the entry to the end of the garden by a pathway, punctuated by the fireplace where the social activities would take place. I leave the studio – a remnant of the first owner – and then the parents' bedroom separated by a patio that today has lost its splendor and enter the living room, where at last I discover the icons of this house: Slender curved wooden vaults. There they are, stretched over the solid brick fireplace painted a thick white, round and dirty, veritable heart of the temple. A formerly red colored conduit, today faded, escapes from above the mantelpiece, crossing the vaults and floating on the roof like an object as arrogant as it is incongruous. The paneling still exists on the walls, but is often covered by a multitude of objects that clutter its vertical surfaces.

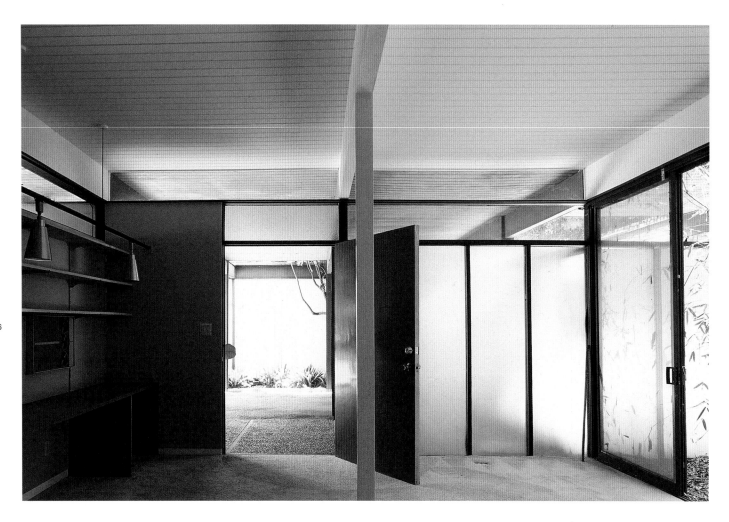

CSH#20, Conrad Buff III, Calvin Straub,
Donald Hensman

The structural network extends, like a rhizome, and empties itself outside of the foyer, stretching out over the pool in the form of a pear, so difficult then to grid. [46] The curved and straight lines of the garden designed by Garrett Eckbo remain, or rather re-appear, as one passes over them unexpectedly. One distinguishes the floor since its entirety is treated as a scenic and autonomous element with its own hierarchy. While the vinyl flooring is widespread in the circulation and service areas as well as the studio, the high pile carpeting is found confined to the bedrooms and pebbles cover the patios and the contour of the pool. With the same distinct sense of joinery, the partitions always demarcate the structure one way or another, whether hollowed or in relief, leaving an opening. Time has left a thick grey layer on all the surfaces. Since everything persists in an advanced state of lethargy, something essential appears to have been lost – the soul of the place, perhaps. Only a diagonal approximately 1 meter in height tears itself away from the ground, a primitive stump marking the effaced presence of the giant that had leaned over the fragile, geometric network. The marvelous

The plan, the kitchen [23]

Since the 1920's, the plan has dictated the appearance of the house's exterior, favoring an interior/exterior reading. A visual opening then dominates the plan, and helps to lend a feeling of space that is essential for the resolution of those constraints associated with the diminutive scale of the houses. From the 1950's on, techniques concerning the opening and transparency of the façade make significant progress in liberating their designs. While the plan of "modern" house is open and places itself within the heritage of Le Corbusier's free plan by no longer isolating rooms from one another, the fifties expose the kitchen to the dining room, as well as to the sitting room. Until this time, the kitchen has always been isolated to the rear part of the house, and often adjacent with the servants' quarters. By its plan and its amenities as well as with the emergence of industrial design, the kitchen appears at the center quite naturally, making of it a symbol of America's relaxed modernity, proposing an informal life in which the rules of propriety are softened. Defined as the motor of the house, the kitchen allows the hostess to participate in the rest of the household activities and to receive guests, all the while attending to her domestic tasks. The amenities are no longer limited to an oven, refrigerator and sink. They are emancipated to the status of an integrated kitchen that now includes in its inventory a dishwasher, a waste disposal, a ventilation hood, freezer, washer and dryer. The work surfaces and primary storage spaces are opened on both sides, permitting the passage of dishes and allowing for their rapid service. Compared to the traditional, partitioned plans with as many activities as rooms, the open plan offers an alternative: While the spaces interpenetrate, they distinguish themselves from one another by the intervention of autonomous furnishing-partitions, by the central fireplace, or by the changing of surface materials. In addition to the open plan, the notion of zones of activity is borrowed from urbanism and now applied to architecture. Often separated into activities such as nighttime and daytime, noisy and calm, public and private, or into zones of service, humidity, etc., the plan resolves the idea of zoning through the distinguishing of elements from one another, using an X plan, an L plan, a T, an H, etc.

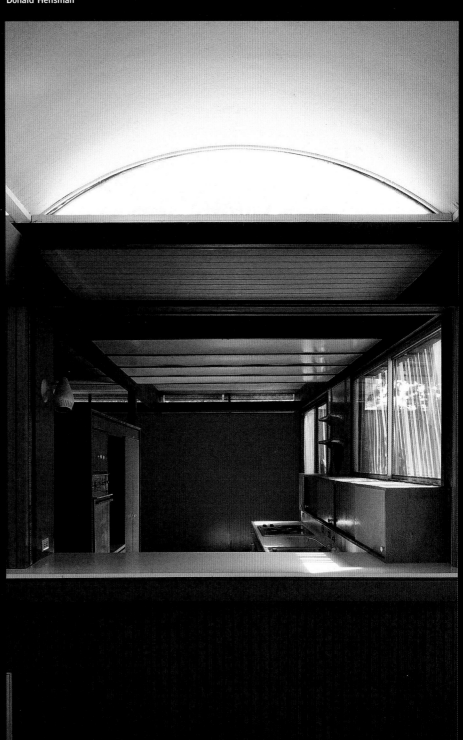

137

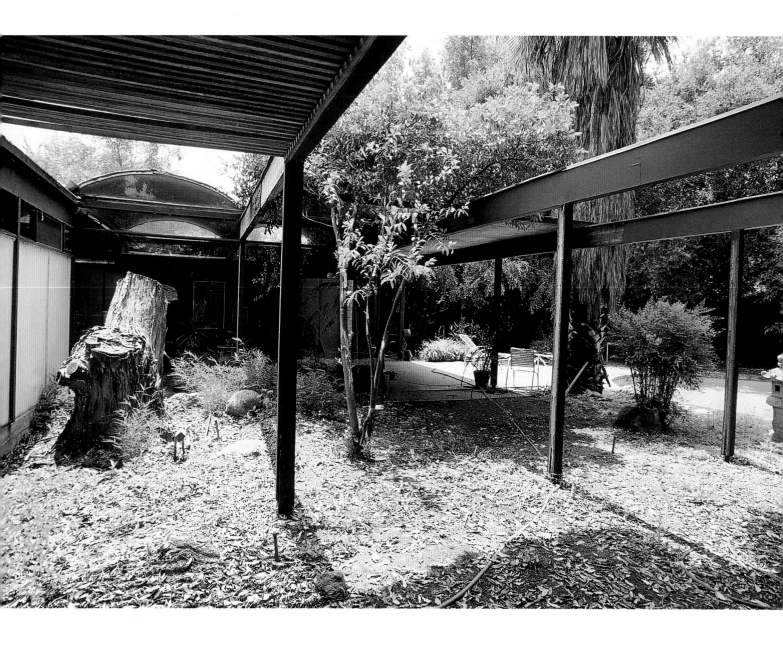

CSH#20, Conrad Buff III, Calvin Straub,
Donald Hensman

pine tree, like an umbrella over the delicate frame, has been broken off above the vaults. Threatening the roof, it was cut down a few years ago, and with it, Julius Shulman's iconography disappeared. An orphan, CSH #20 is now a bit more wounded, and the nature that embraced it then and that devours it today follows the same direction as when it appeared pale between the voids of the vaults. Buff, Straub and Hensman had conceived CSH #20 in the image of an archipelago of pieces within a frame regulated by the size of the plywood panels,[47] treating the voids where nature captures it and roots itself in the structure like a giant pine tree that has become an architectonic element. The economy of materials, with the choice of a wood structure and plywood infill, does not lack daring, especially when compared with the solid steel projects of the previous episodes. With the sponsorship of two plywood manufacturers,[48] this desire for rupture is born from the same wish to use prefabricated components, all the while privileging the traditional hierarchy of wood. This latter material and its panels are enriched and diversified, thanks to contemporary techniques of the time: "Lamination, pressure gluing, and plastic impregnation give a new significance to this traditional material"[49] and indeed a new presence and relevance in the building industry.

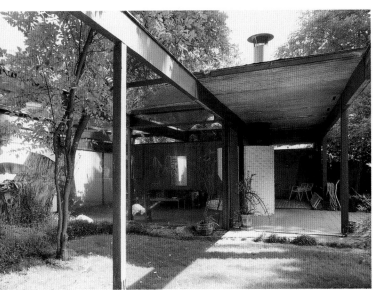
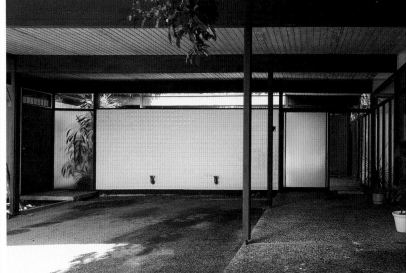

The ambition of the architects is to participate in a type of construction familiar to a majority of the potential clients or Californian readers, while at the same time integrating the forms and styles of modern life with a material that they come to see every day.

The use of load bearing vaults insulated with fiberglass that would motivate many refusals of construction permits and the cylindrical central fireplace are other remarkable points, whereas the flat roofs and rectilinear designs remain dominant features of the Case Study House program.

BRUTALIST ABSTRACTION
Pierre Koenig

CSH #21 & #22

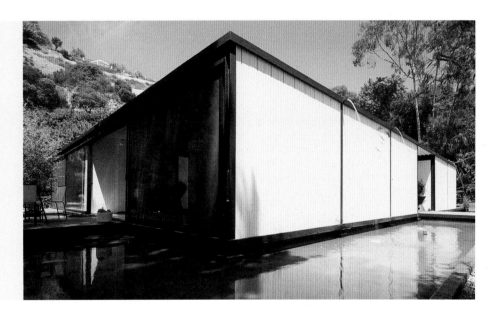

The return to the world of the living and to built refinements finally takes place with the meeting of the following constructed models: CSH #21, #22, and #23, as present as their designers Pierre Koenig (who passed away in 2004) and Edward Killingsworth. With these projects, the black series finally comes to an end.

The two Californian grandfathers had previously followed quite different career paths. An obstinate monk, Koenig had only built his radical watchmaking marvels in steel, while Killingsworth, in partnership with Brady and Smith, had built hotels and commercial fittings throughout the world, photographs of which still paper their Long Beach office, which was recently converted into a museum.

Pierre Koenig lived a few miles northeast of Santa Monica, in an immaculate white house of steel and glass hidden by sumptuous vegetation. A man with hair as white as his sneakers invites me into his double height volume. Across the street from the grey band, an incredible sampling of vinyl records multi-colored on their fine slices are at the music lover's disposal. Besides my clothes, the furnishings contemporary to the CSH and a totem in Plexiglass are the only colored elements in this monochromatic space that is the architect's giant and peaceful cell.

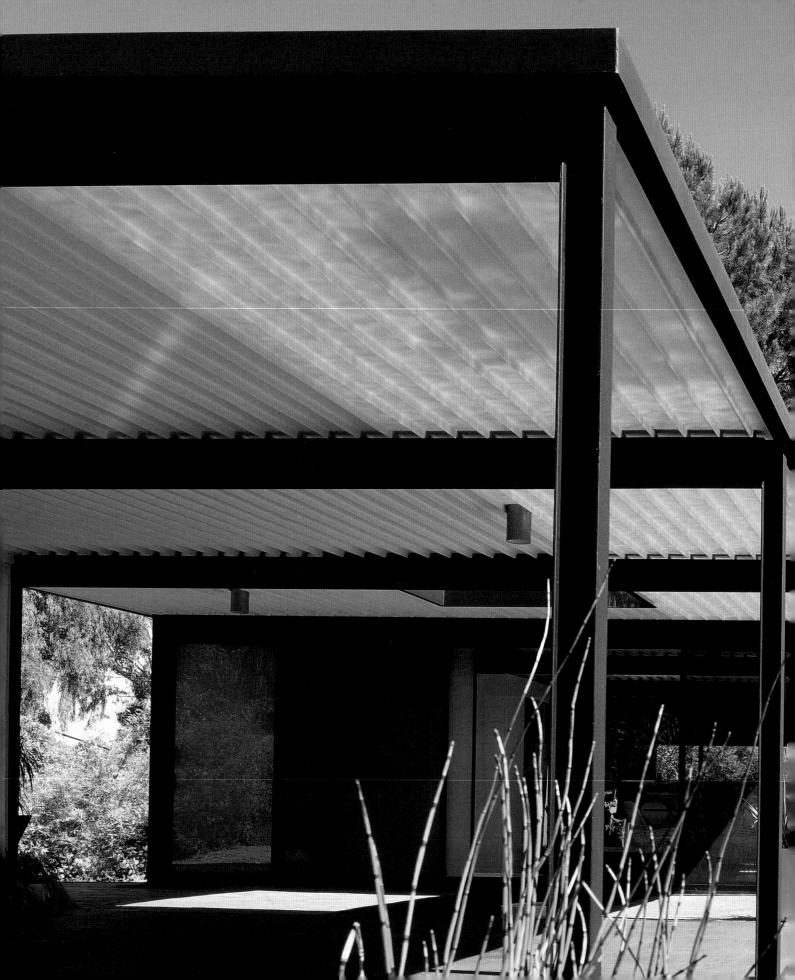

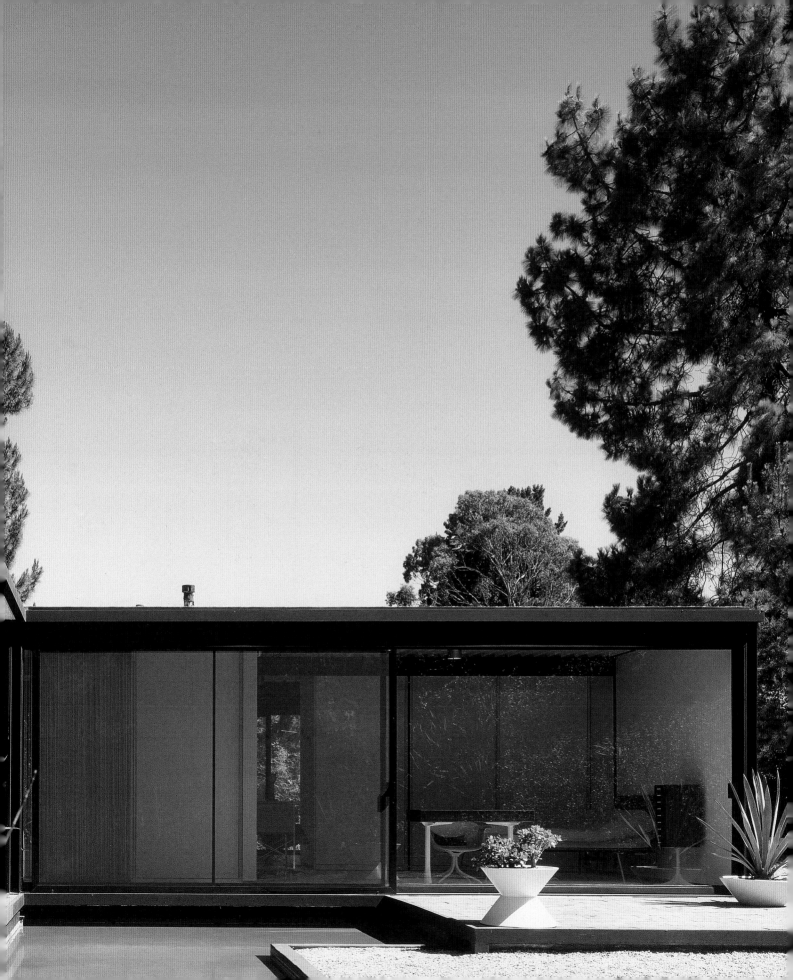

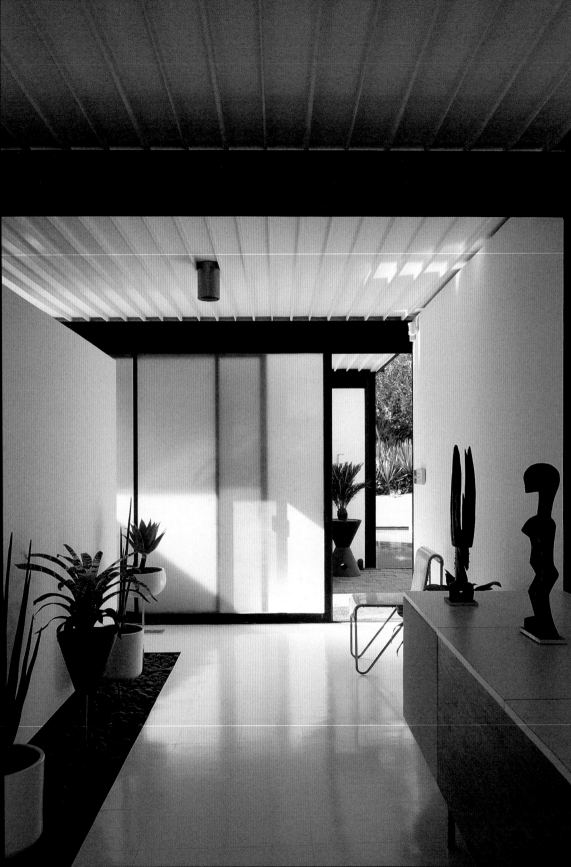

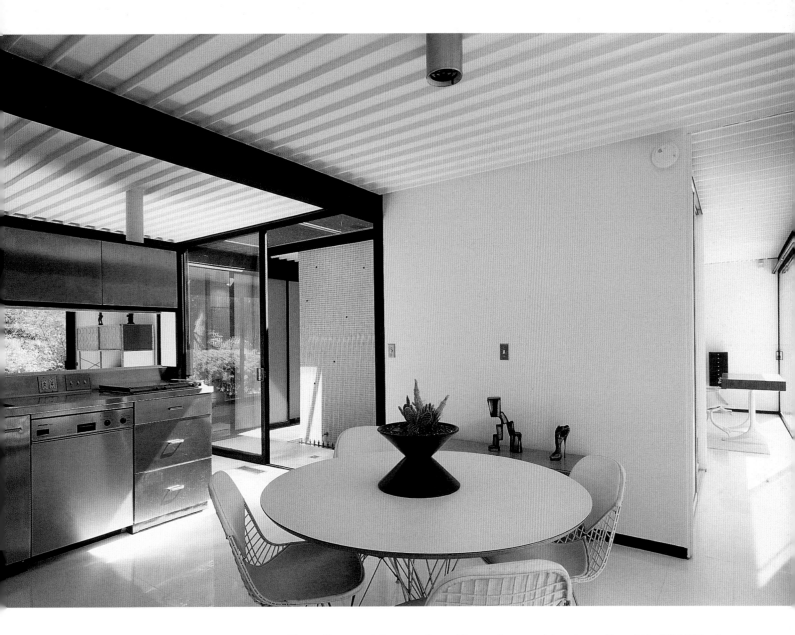

CSH#21, Pierre Koenig

The solitary monk is currently working on the complete rejuvenation of his CSH #21, about which he speaks to me at length after having eyed me up and down from my hair to the soles of my shoes.

Did Pierre Koenig live outside of time? In any case, he had not aged one bit. A Californian Hibernator? It is the question I was asking myself while listening to his plans for CSH #21, in view of his total engagement with the present, with the persistent desire to construct an environment even better than the last. The renovation and conservation of the object designed in 1958-59 interested him only as a chance to bring into play current techniques and materials in order to make up for the shortcomings or absence of earlier methods. Thus, the architect was about to install an air conditioning system responding to the comfort and requirements of the new inhabitant. The kitchen, also redesigned, offered the latest high-performance equipement; an Inox kitchen was about to replace the original yellow General Electric one.

CSH #21 was born out of the choice and desire for modernity, hygiene, practicality and innovation. With its second youth, it would renew this same desire and image of freshness.

Contrary to Craig Ellwood who developed his CSH prototypes and his rigorous construction and assembly details through the lens of prefabrication, all the while putting into play elements to be industrialized, Pierre Keonig creates with his projects a construction based on existing

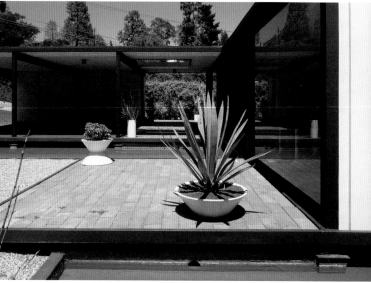

industrialized, standard elements within the perspective of mass-produced construction. The two approaches – the first more global and the second more pragmatic – put the two architects in opposition to each other, giving birth to two different aesthetics. The former, refined and consistent, with beautiful rooms designed and articulated among themselves, the latter, more radical in its confrontation with elements from industry. In his analysis of the Koenig pavilions [50] entitled *The Modern Steel House*, Neil Jackson aligns the architect's attitude with that of Charles Eames and with the latter's CSH #8, which proposed a clever assemblage of the standard object ready to be used. This attitude would produce two kinds of prototypes of grand and stately structures – one fragile, the other solid.

Ellwood's and Koenig's paths crossed each other with John Entenza's project; they shared common origins, namely with their involvement in the São Paulo Biennales of 1954 and 1957. Further, the first publications of their projects were both displayed in the glossy pages of *Arts & Architecture*. Always on the lookout for new talent, Entenza picked Koenig for the construction of his first steel house in 1950, whose structure – with its cylindrical posts – recalled the connection to Raphael Soriano, whose office in Los Angeles our still-student designer visited that summer.

In marked contrast to the habit and reflex of rejecting metal in domestic building, Koenig still sees this material as "a way of life." He magnifies the presence of steel in the structure by making the decision to leave it visible. He reduces it to its simplest expression and exacerbates it by painting it dark.

Nestled in a canyon situated in the Hollywood Hills, CSH #21 lies almost at the end of one of those narrow, twisted, and steep dead-end roads. The project is L-shaped, and its rectangular living space is designed for a childless couple. The walls of the house, which are parallel to the road, are windowless and describe a white silhouette to which a rhythm is given by the structure.

CSH#21, Pierre Koenig

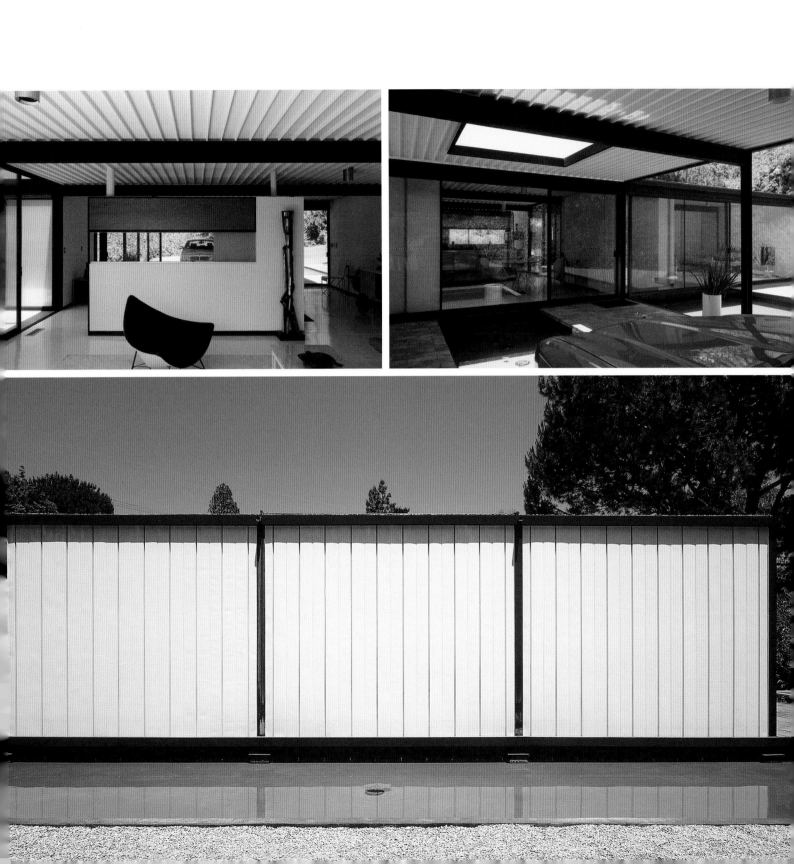

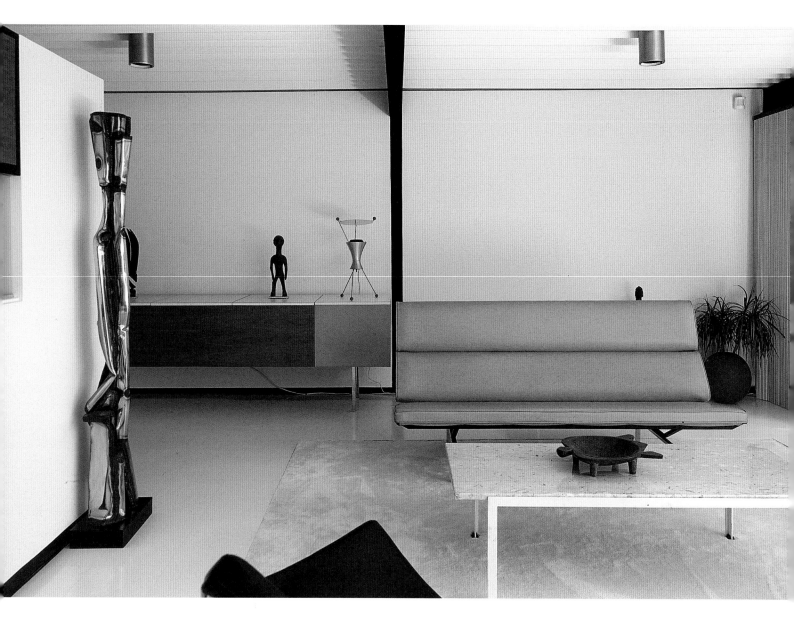

Furniture and the objects of the house

Having found its voice in prefabrication, the furniture of the "moderns" leaves the universe of the artisan and enters factory assembly. The war accelerates manufacturing and the use of new materials such as polymers, plywood, and fiberglass. On the whole, these new materials allow for less bulk and an even solidity. Inheriting the principles of exterior furnishings designed by Eileen Grey, the sense of both visual and physical lightness emerges in new creations. Easy to transport from interior to exterior and from one room to another, the furniture is designed essentially with metal rods, curved to avoid thick metal tubes. Furniture continues to be designed in wood. The massive wood bases are turned out and often end up cone-shaped, with the plywood cleverly molded thanks to adhesives. The techniques of stuffing armchairs that are now devoid of springs and of horsehair fillings

are replaced by foam and rubber. They are in decreased numbers, and in sizes more contained, they are interchangeable and sometimes modular.

The furniture produced after the war becomes plentiful, democratic and less costly. Transportation favors its expansion and economic importance. Easily lifted, stacked or even in kit form, it traverses borders. Scandinavian furniture is transported in kit form from its country of origin, or manufactured on site with permits. Carpets are chosen in wool, and placed in those rooms with hard floor surfaces. Few curtains are visible in the CSH, and if there are soft furnishings, they display abstract motifs designed by artists. The table covers would be out of stainless material, easy to maintain, organic and sculptural, with the addition of a placemat sufficing for both everyday and festive occasions.

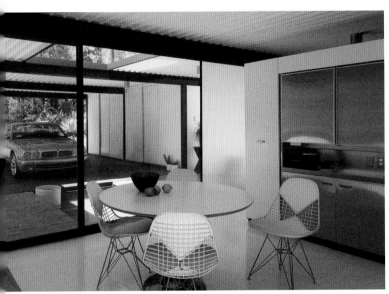
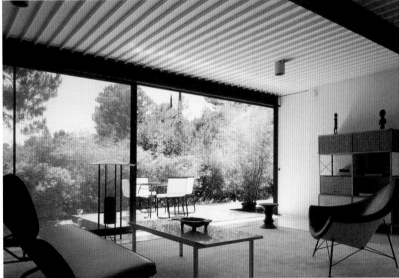

CSH#21, Pierre Koenig

The architect treats himself to two large, pure glazed façades that open onto the valley and a terrace to the south situated on a car platform, as well as a private terrace to the north. The steel posts and beams of CSH #21 are not overturned, but rather outline large performative porticos, thus differing from Ellwood's refined pavilions. Between the framing members, the large white surfaces unfold, ribbed on the exposed steel roof decks, and smooth on the plaster panelled walls, the latter reflecting on the shiny floor flooding the living surfaces and echoing the similarly reflecting pools of water that surround the house. The exposed steel skeleton receives a skin of glass and other standard elements that glide along the north and south façades, as well as metallic weatherboarding on the outside of the east-west façades. For economic reasons and for the margin of its anchoring in the ground, the house is not covered by a roof overhang to the house, but rather sheltered with mobile solar screens. [51]

The elimination of windows in the bathrooms occurs through the installation of a core of bathroom units, a device situated in the center of the house and open to a patio, which thus permits natural ventilation and lighting. The house is cut-through and transparent on two sides, the kitchen presents itself as a practical and playful object staged in the large void of the living area, a space that is revived and exaggerated to the same degree as the automobile placed on its glazed platform behind the sliding panels. A veritable object of heightened technique, the urban race car finally finds its place in the domestic space, as its silhouette had already

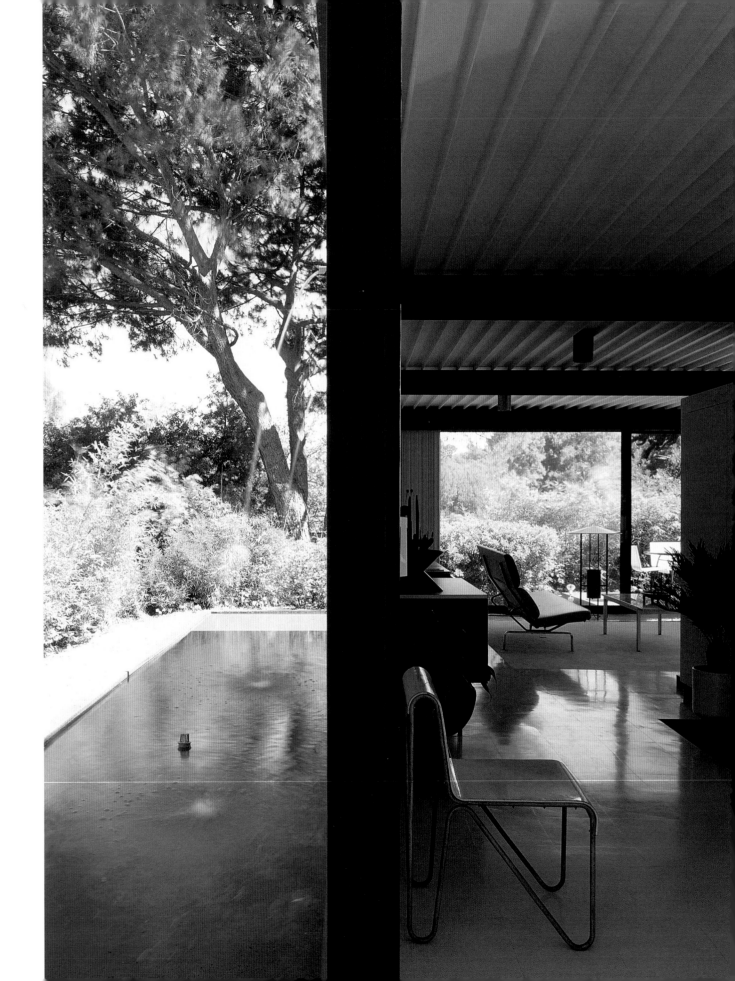

CSH#21, Pierre Koenig

been found in CSH #9. A brick terrace and a pool of water demarcate the limit of the plane, while still duplicating the round and dynamic forms of the vehicle in the other horizontal planes. As it is for Killingsworth, water for Koenig is used in part to enlarge and double the house. On the other hand, water is also a natural source of coolness and pleasure, its movement in this project is assured by a hydraulic pump that accelerates the flow of the water.

The minimal image of CSH #21 corresponds to the subtle design of the garden that consists of brick terraces and simple pools. With their roughness the bricks suggest the only texture that is to be asserted, balancing with its discreet striations the metal panels that are arranged in the black frames. In August 1958, Koenig would publish two details of the project, marking in a significant way his capacity to simplify a project. He makes of Mies' adage "less is more" an axiom of design in addition to an axiom of aesthetics.

With CSH #21, the architect delivers the height of domestic efficiency and sobriety. Undoubtedly a sublime house to live in, the fluidity of the spaces is highlighted by the numerous transparencies and views, and the simplicity of a writing that is ultimately not technical and voluntarily absent gives the program a new identity. The quintessential model of minimalism for the program, it would appear to be the project to most closely reflect the vision outlined in January 1945 – even closer than the iconic CSH #8, since it was without a doubt more universal and generic.

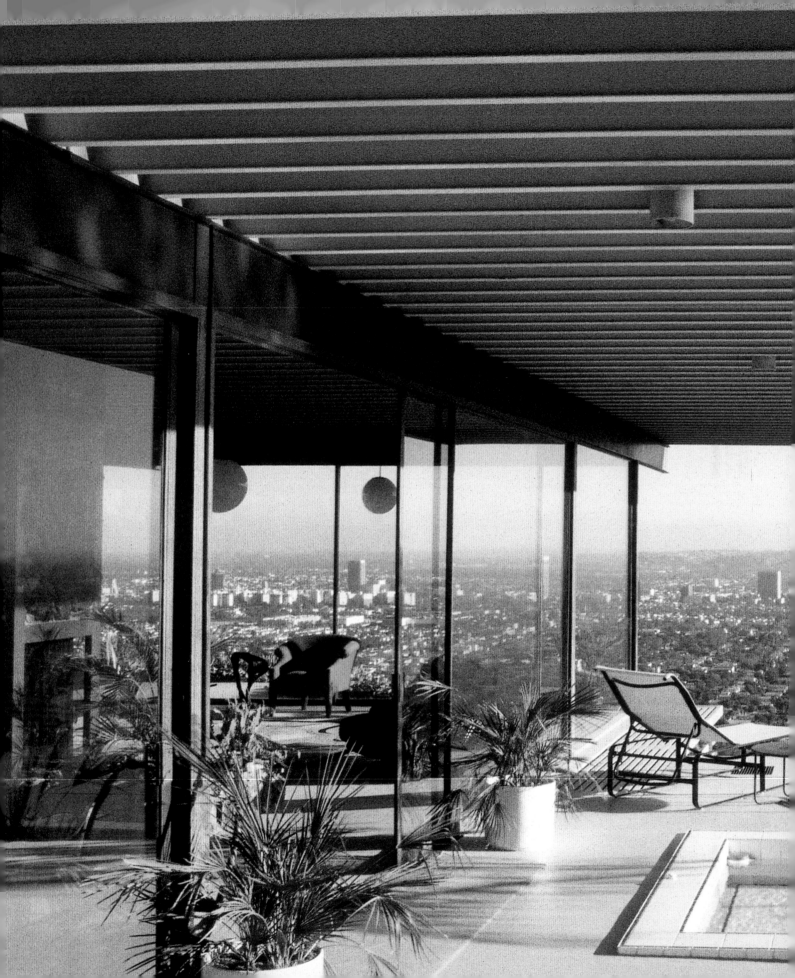

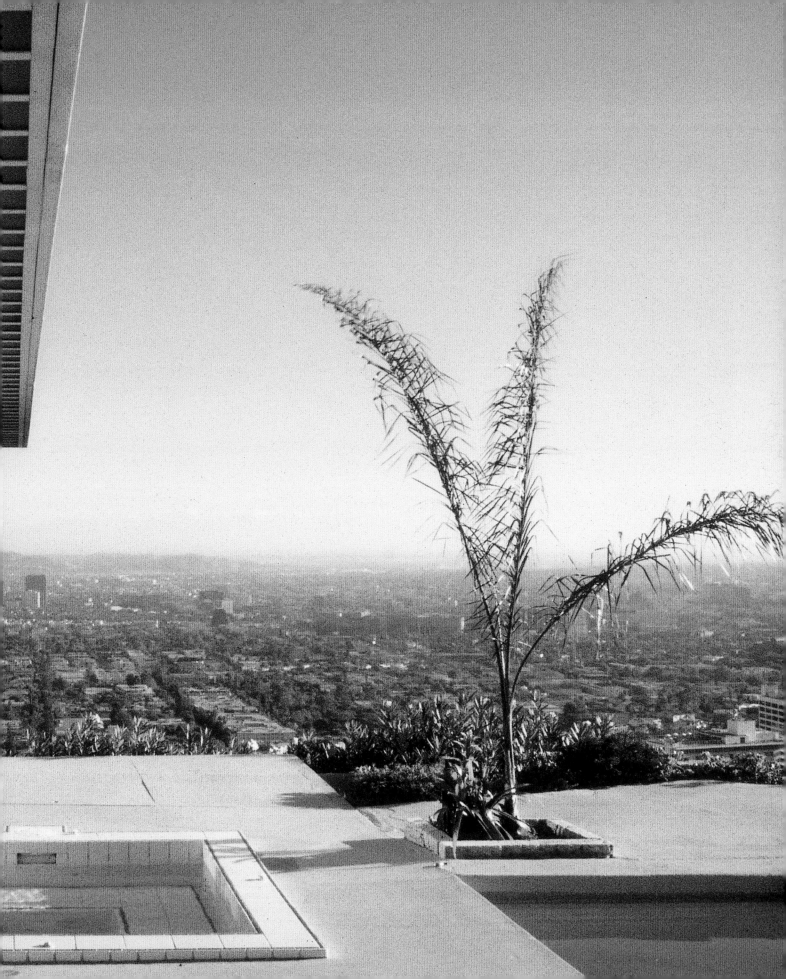

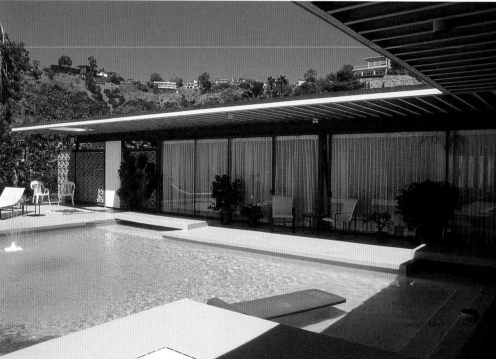

CSH#22, Pierre Koenig

Faced with this success as much for its budget as for the speed of its construction, the publisher John Entenza proposes to Koenig to publish a new CSH, presenting the architect with an opportunity to design another prototype. The opportunity would soon present itself, and in May 1959, a few months after the delivery of CSH #21, its younger sister CSH #22 would spread out its L form in the pages of the magazine.

Two perspectives delimit by their fine features the exteriors of the new pavilion on the same hills of Hollywood that its little sister had just acquired. The L-shaped plan cantilevers over a cliff bordering the hilly terrain to the south. The mineralized landscape, also small-scaled, is covered in multiple terraces and a pool straddled by footbridges, a garden of concrete and blue water.

The site is not a common field, but, as described by the architect, an eagle's nest whose panoramic view of 240 degrees he would preserve – a view palpable to both one's eyes and entire body. The view reveals the expanse of Los Angeles, its flat profile only bristling up by the towers of the downtown and along the fault of Wilshire Boulevard extending to the ocean, which laps up the beaches of Santa Monica, there amidst the fog flooding the city. Only a perfectly transparent glass pavilion such as this is able to allow the distance to expose the surface limits of the living room and other dwelling spaces. The project searches for the annihilation of limits and their initial dematerialization. The outside is everywhere inside.

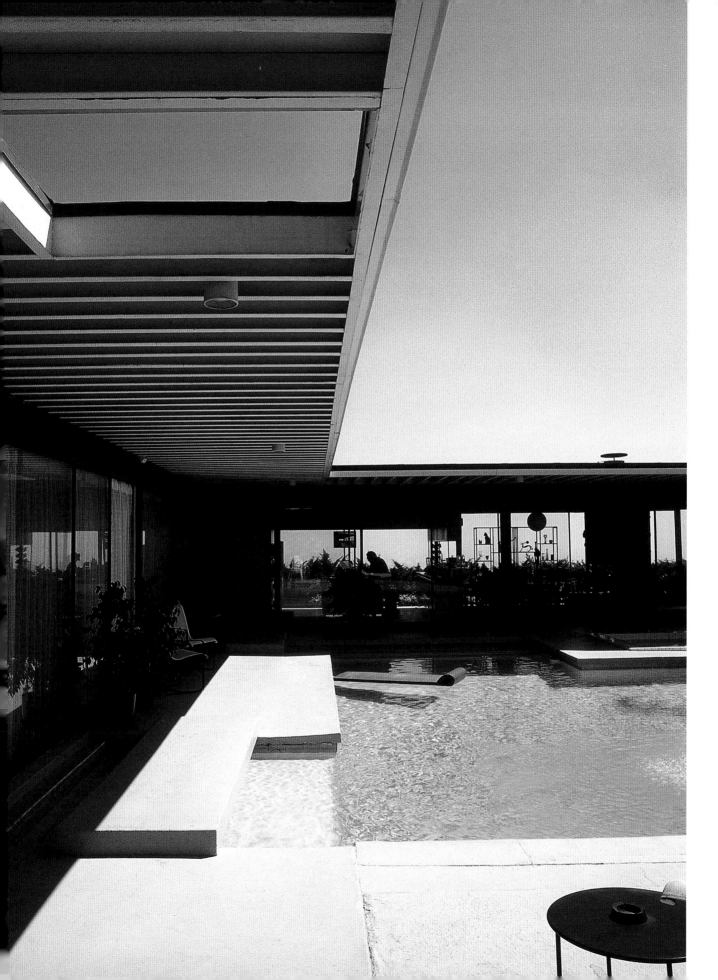

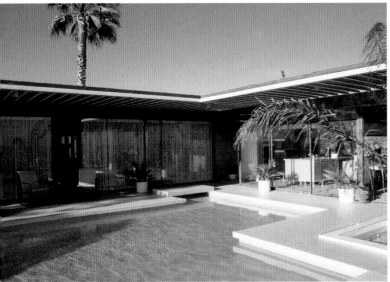
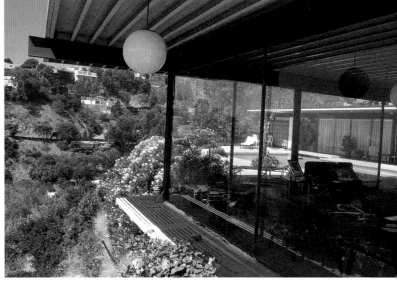

Second undertaking

Distancing themselves from the clinical aspect of the houses from the twenties, the CSH adopt a whole range of natural and synthetic materials. A pleasure derived from the use of texture and abstraction appears as a nod to the influence of contemporary art. A concern for contrast is present in the multiplicity of material choices, as the differences between the soft, glossy, rough and matte are highlighted in the same room (up to three materials are used for the wall surfaces). Among the natural materials, some are deliberately used from the interior to the exterior in order to achieve the feeling of continuity, coherence, durability, and an absence of maintenance. This applies to wood,

brick, and stone, which are applied as a facing on isolated surfaces like walls, fireplace mantels, or plinths. Abundant in the American market, wood is used in all its forms; as floorboards, paneling, or plywood, for floors, walls, ceilings, and furnishings. From the sixties on, it is more commonplace to see brick veneer on all surfaces. Other natural materials are used such as slate, ceramic, glass paste, terracotta, rubber floors, cork, jute and coconut cloth, along with wool carpets.

Among the synthetic materials present is PVC for the floors, Formica, plastic and vinyl. The surfaces that are covered in this way are easy to maintain and are used in humid or large areas.

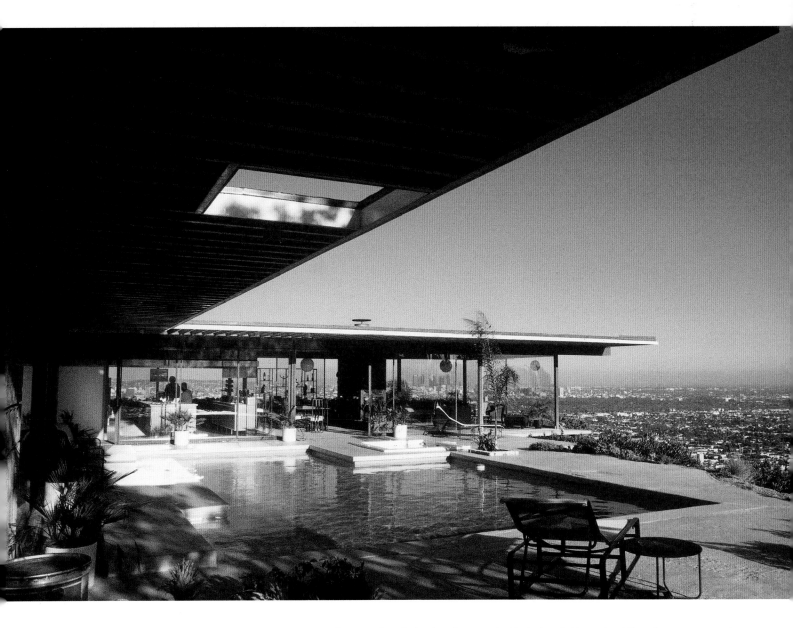

CSH#22, Pierre Koenig

A vast roof covers the whole glass box created to look outside and not the other way around, capturing and directing the gaze of the spectator towards the inside; the captives become contemplative and the neighbors are far away. All in all it is a delusionary box, a machine for only viewing the horizon.

This roof tensed in an L form, this eagle resting on the fragile posts is published in February 1960 in a photo essay where, as the only visible built element, it floats sublimely over an absent horizon. The rigor of the design is accentuated by the use of beams, on which lie the roof's factory-manufactured undulations. Seeming overscaled, the beams exceed the roofing, thereby adding a supplementary force to this brutalist horizontal structure that slices the sky.

Resting on a window-less wall, the branch of the L-shaped roof accomodates the bedrooms and allows the perpendicular roofing of the living room and the kitchen to stretch beyond the void above the city. Alone amidst the glass pavilion, the fireplace floats along with parts of the kitchen, both extensions of the building oscillate between the furniture and the steel structure, provoking gravity as well as attracting the distant gazes of others. Even though it is thickened out by adhered stones and even though the opulent furniture seems to ignore the

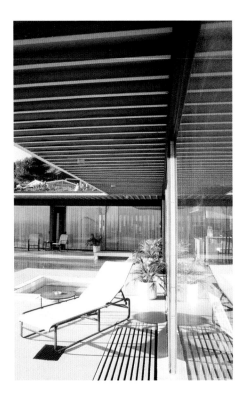

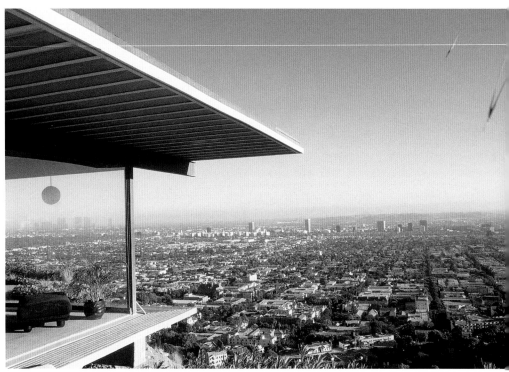

CSH#22, Pierre Koenig

heritage of 1960, the charming retirees who still occupy the suspended object of elegance accept its whims that have since become icons of both the city and an era, and accept the danger both sublime and provocative, of the alltogether Hollywood madness of showing oneself in the light. The terraces defining the beautiful box have thickened over time, no doubt more comfortable. The exchanges between the rooms are made by the terrace that has become a bridge connecting the bedrooms. Shelter to a minimun. The architecture becomes absent and humble in a certain way, revealing the landscape as a mirroring of daily life, more so than even its principle of existence. The architecture serves the view and is served by the view in order to become an absent everyday object.

The models inhabit the house for the photographers, just as the furnishings and models did before for Julius Shulman. Those same spindly models perhaps now leave for Palm Springs, where the roofing over Albert Frey's boulder also takes over the décor – also an unreal house and guardian of a desert.

Pierre Koenig would refuse Entenza's invitation a third time. He reminds me of the great Albert Frey who told me one day that an architect should not accept too many projects in order to realize the ones he accepts well. One project per year suffices, says Albert Frey; a sage in this desert haunted by Elvises both real and fake, and by other fortunes on a golden holiday.

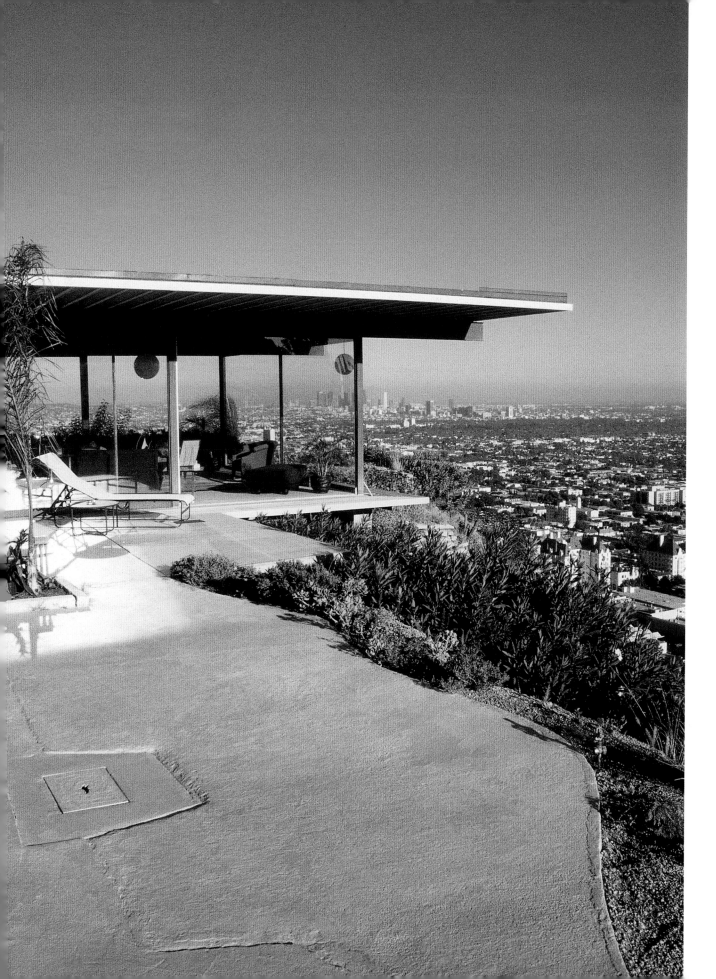

ABSTRACT CLASSICISM

CLASSICAL CONTEMPORARY
The triad

CSH #23

It was not the same horizon that now keeps a grip on the urban tumult that I am contemplating at the moment, serene and Mediterranean, this horizon defined by the ocean. It was also no longer the same gathering, no longer this silhouette of Mr. Stahl – the impressive medieval lord of the castle CSH #22, strong, proud and, unfortunately, for whom my only average English seemed incomprehensible. It was not even the same martini glass, the one from that time being a bit more flared. It was surely not the same interior, the metal having now disappeared nor the same furniture, but those oh-so-high ceilings. Besides, it was no longer the same city.

I was north of San Diego, in the hills of La Jolla, a pretty chic area that provokes the ocean from its hillsides that witness the birth of the sublime Salk Institute for Biological Studies by the great Louis Kahn, which is perched facing the immensity of light from the setting sun.

The house is also different; code-named CSH #23, it is posed in contrast on a panoramic view, like the preceding *opus*. Its location overhanging the horizon is perhaps the only point of commonality between the projects if one excludes their mutual filiation and the abundant use of transparent bays. The mythic metal is abandoned in favor of wood and the classic Californian post-and-beam structure. The brief stipulates beams of glued laminate timber and other wood assemblages. Only for cross-bracing do posts of metal remain, assuring the maintenance of the structure and its anti-seismic dimension. The splendor of the program years persists nonetheless with the refined and precise assembly of the wood members.

Also, exceeding this conformity to a popular and widespread structural model, this new chapter through CSH #23 – so-called the "Triad" – opens a field of research not tackled for more than 15 years, namely that of erecting a community of contemporary houses.

Industrialization implies mass construction and the duplication of a model. At the end of the fifties, the program seems obliged to take part in and verify the soundness of integrating several models originating from industry within a coherent ensemble. Particularly in the United States, this idea of community is a banner under which individuals share the same

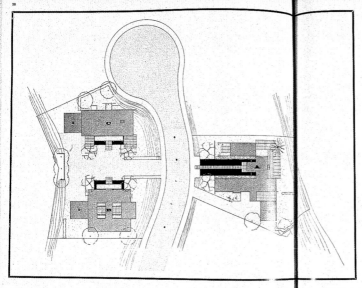

WITH THE AMANTEA COMPANY, DEVELOPERS

THE NEW CASE STUDY HOUSE PROJECT TRIAD BY KILLINGSWORTH, BRADY AND SMITH, ARCHITECTS

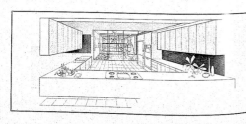

Throughout the development of the Triad stress is being placed upon the inter-relation of the three houses. Each house must have its own definition yet be closely tied to the others. To achieve this careful attention is being given to materials which compliment the axial siting and the simple form of the structures. Exterior materials selected to date are redwood vertical boarding and texture 1-11 Douglas fir plywood. Paving will be precast white concrete pavers, and quarry tile. All three reflecting pools will be of concrete with integral black mix and a black vinyl coating as a surface treatment. The pools will be 3" deep and the black bottom will provide mirror-like reflections. Each pool will have a circulating pump to keep the water fresh. Interior materials which are common to all three houses are as follows: Ceilings will be of acoustic tile. Wall surfaces where not covered by decorative woods will be of gypsum board. Framing throughout will be products of the West Coast Lumbermen's Association. The glue-laminate beams will be of Douglas Fir. Arcadia sliding aluminum doors will provide the indoor-outdoor relation so necessary in this fine climate. Thermador appliances are used exclusively in the kitchens. These will include the Masterpiece—the bi-level Bilt-in oven, Bilt-in refrigerator-freezer and Bilt-in cooking top. Kitchen and other exhausts fans will be by Trade-Wind. Pittsburg paints will be used throughout the Triad project for interior and exterior paint and stain.

Progress on the Houses

House A

The problem of relating the material used for the stepping stones over the pool and that of the entry has finally been solved by the use of white pre-cast concrete in both areas. These slabs will be finely textured and laid butt joint in the entry. They will be in 24" x 24" module thus making the stepping stones 24" x 48" rather than the 20" x 36" originally planned. The primary solid wall in the entry will be faced on both sides and ends with Mahogany Sculpture wood shaped in a fine vertical linear pattern. This will provide an excellent background for a good piece of furniture. Materials for the living room are so simple that it was felt best to keep the fireplace in the same character. Thus it is of simple concrete block with socked joints and paint. The master bath has been changed slightly in that there is only one tile step to the sunken tub rather than two.

Another decision yet to be made is whether the ceiling should be dropped or left at the 10'-0" height. This will be determined by the selection of the lighting system. It is probable that the ceiling will remain the same with a light soffit set at an 8'-0" plane. Both baths will feature Gladding McBean's new Hermosa Triangle Tile. In the kitchen it was found with study at a larger scale that general storage for the house was inadequate. For this reason a small wing has been extended toward the garage. This area will contain service facilities and a large catch-all closet. Another development has been the dropping of an 8'-0" ceiling over the whole of the kitchen area. This was done to retain an intimate quality to the house.

(Continued on page 35)

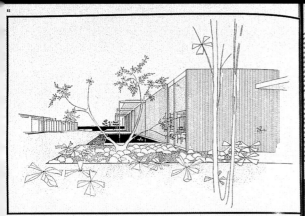

roof framing. Budget being another consideration of the program, exposed roof framing has been eliminated in most cases. The exterior wall surfaces will be covered with resawn redwood boarding or Douglas Fir vertical boarding. Interior walls surfaces will be drywall in selected hardwoods in various forms and gypsum board. Ceilings are of acoustic tile, and aluminum sliding doors will be used throughout. The kitchen areas have walnut cabinets with white plastic laminate tops. The floors will be vinyl, the heating system will be forced air.

The maximum enclosure of space was the primary consideration of the individual plan. The ceiling height is set at ten feet with the horizontal dimension in all primary rooms heightened by a focal point or open glass areas to distant or intimate vistas. All three houses are designed for family living with so-called perfect circulation; that is, access from a central entry to each room of the house without crossing another livable room. Each house has a combination family-dining room with snack bar facilities. The children's areas are related to the play yards so that the children's treasures may be accessible with the least amount of confusion to the

(Continued on page 32)

The products from the companies listed below have been merit specified by the architects, and the use of the materials will be noted in subsequent issues during the progress of the building program; others will be added as the specifications are developed.

Gladding, McBean and Co., West Coast Lumbermen's Association, The Mosaic Tile Company, The Douglas Fir Plywood Association, Arcadia Metal Products, Palos Verdes Division of Great Lakes Carbon Corporation, Trade-Wind Motor Fans, California Redwood Association, Thermador Electrical Manufacturing Corporation

B

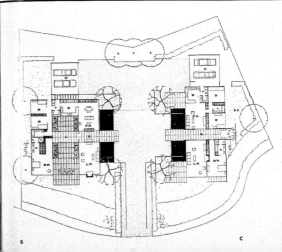

C

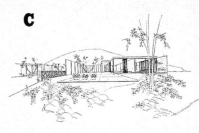

values and the same skin color; a ghetto identified, recognized, and preserved by others, a clan whose membership is affirmed to a class, and sometimes to a cult.

In August 1959, Edward Killingsworth and his associates present an ensemble of three prototypes, each named by the first three letters of the alphabet; an embryonic community with which the promoter of the operation, the Amantea Company Developers (and friends of John Entenza) nurse the ambition of building 82 modern houses, which would enjoy the aura and publicity of *Arts & Architecture*. Only the three houses constituting the Triad would be built, energetically criticized by the residents of La Jolla for their flat roofs that were seen as discordant with the landscape.

I mused over Esther McCoy's words for a few moments, and I imagined John Entenza's pleasure in taking advantage of this tranquil environment of the La Jolla hills for his retirement. Quickly seized by this feeling of comfort and retreat not far from the desire on the part of many white-haired individuals from the French Riviera, I took the time to look anew, paying a bit more attention to the structure of the house, and I was surprised again by the high ceilings under which I had entered almost an hour ago.

All throughout house A of the Triad, there seemed to be a translation of a feeling of serenity and blossoming echoing the Mediterranean panorama, which is equally cinematographic. My host, the architect, greeted me at the edge of his garden, where I busied myself with finding Julius Shulman's photographic vantage points. At the time of my visit to his bungalow in the middle of the Hollywood jungle, Shulman had referred to the shots taken of the Triad in 1961 as a surprising memory of his collaboration with the program.

Edward Killingsworth expected from him photographs that were taken along the axes of his buildings, like the compositions and drawings that appeared in the magazine. Unmotivated by this kind of construction of shots, the photographer nonetheless approached the architect's axis lines while revealing others, on one side of the central path, capturing a reflection of the door in a pool. Finally, he submitted to the vision of the designer and shot the views head-on.

DIY "do-it-yourself"

Since the beginning of the twentieth century, homes have been buildable in kit form, inducing buyers to transform themselves into well-informed handymen. In the case of Levittown, future owners could choose the option of a garage or else a rough attic, allowing them to buy the house at a reduced cost. The level of finish could vary, and was also exemplified with furnishings left unpainted.

The principle of the kit of parts and the notion of "do-it-yourself" are phenomena visible in 1920 with Buster Keaton's burlesque comedy *One Week*. In twenty minutes, from the time of a young couple's marriage to the construction of their dowry house, we follow the journey through the house's assembly, which the couple undertakes in seven days. The house is folded and unloaded by a truck in small numbered packages, while Keaton and his wife carefully follow the construction manual and start putting the house up. A jealous impostor however reverses the numbers on the packages, complicating the house's assembly and rendering it impossible. The film synthesizes the founding values of a mobile America under construction.

CSH#23 A, Edward Killingsworth, Jules Brady
and Waugh Smith

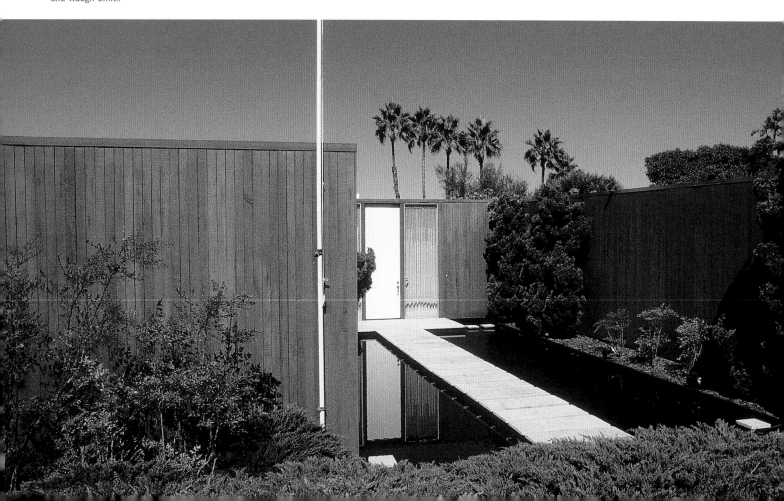

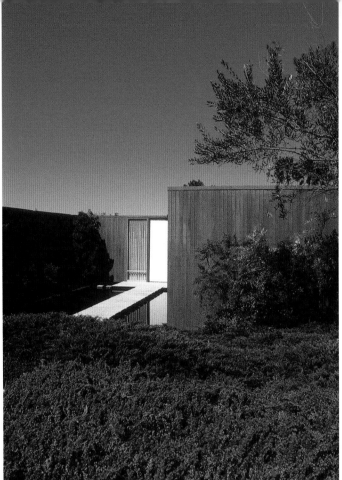

CSH#23 A, Edward Killingsworth, Jules Brady and Waugh Smith

The absent architect

The pioneer, the immigrant having just landed in the New World, obtains his tract of land – his famous "Quarter" alotted him by the government in exchange for the occupation and exploitation of this virgin territory. He constructs his shelter out of materials that he finds, and assembles his work with fast and easy techniques. If he lives within proximity of a forest, he comes to be known as that mythic woodcutter, the "Lumber Jack," erecting his structure with logs, a techinique now commonly known as "timber construction." This phenomenon sheds light on a custom anchored in North American culture, in which constructive habits privilege efficacy over the arts and crafts, revealing a notion of democratic construction that by virtue of its pragmatism does not call on the building trade. Perhaps for nostalgia's sake, Frank Lloyd Wright uses logs for his first houses. Wood has remained in this part of the world the most frequently used material for functional and low cost construction, one that responds to the frequent movement of its inhabitants. Wood defines the house with its quality of immediacy.

In the photographs, a woman – the architect's wife – contemplates her image in the pools of water, this image being the only evolving element in all the photo documentation of the program, if one omits the enigmatic dog that appears in the prints for Craig Ellwood's CSH #17. A top model of the era within the large void of composed perspectives composed by the architect, this silhouette retains a surprising presence for Julius Shulman, as if he wanted to construct isolated perspectives from the reflections of the water. Indeed, the houses of the Triad seem to extend inexorably towards an outside.

It is through the plane of water in the photographs that I gain entry into house A, with the permission of my host. Like the prophets, we walked on the black water and along the principal axis of the architect's composition. I had not been able to notice it before since I had crossed it with my white Japanese car, in order to park on the large racket at the end of the hillside road. The racket echoed the plan of 1959, and I was gripped again by this voracious nature that devoured the views and the houses.

Totally vanished under this jungle that is maintained by the Hispanics crossing the near and porous border, an army of fortune in the shadow of the eucalyptus and palm trees gather at the end of the boulevards each morning and are rejected, exhausted, each evening, with no promise of a tomorrow. As one arrives by car, house A, which is located slightly below the street, is quickly recognizable because of its pool, while houses B and C, raised slightly above grade, are more difficult to see under the asymmetric nature that shrouds them. Finally, the outline of these two houses facing the dark walls of house A reinforce the exchange and reading of the ensemble. House A would be covered in grey paint, similar to the bark of a tree. Developed by the interiors consultant Stanley Young, this color would become the color of reference for Killingsworth's work then and now; it is called "Bark Killingsworth." [52] The wood sponsor wanted his weatherboarding visible, but the architect's will was saved, since he criticized the heterogeneity of the lot supplied for the house, briskly refusing it and only accepting it covered with this bark-like film.

CSH#23 C, Edward Killingsworth, Jules Brady
and Waugh Smith

Levittown

Levittown [24] is a city that comprises 17,331 houses built in Long Island at the outbreak of the war, through a business venture undertaken by the property developer Levitt. Experienced through his two military construction projects erected under the pressure of emergency conditions, Levitt studies and perfects a kind of construction that is efficient, and he takes greater interest in the performance of its implemenation than in architectural success. In doing away with the basement, and in building the house on scaled-down foundations, he simplifies its typology. The roads are drawn following a networked massing plan that allows for the access and distribution of material in front of each site, every twenty meters. By redeveloping the structure, and by specializing each construction crew with a specific task, Levitt favors an assembly line construction that approaches the Fordist model. By limiting the intervention of specialists, by completing in advance the difficult sections, by being the first to employ the assembly line production of wood, of nails, and of transport, by refusing employment to unionized workers, and by paying them per task and no longer per hour, Levitt conceives of a business model that through its functioning reduces the breakdown of responsibilities, and as such avoids all delays liable to bring about its demise. Encouraged by competitive prices and houses payable by credit with a 100-Dollar initial contribution, the success is immediate. Since the houses have four to five rooms, the garage and the attic are laid out under a pitched roof. The integration of the television and the washing machine helps one to forget a little the reduced dimensions of the plots – 20 meters by 64 meters – allotted to each house. This peaceful haven of democratic virtues stages a latent discrimination: Open to the veterans as a matter of priority, it is closed to blacks. Women are confined to domestic tasks and no longer really leave their neighborhoods, reversing their active place in society acquired during the war. These great developments herald the debut of suburban life, making ghettoization commonplace.

CSH#23 C, Edward Killingsworth, Jules Brady
and Waugh Smith

The door of house A towers like a white stele, embedded in the smooth and windowless façade of the edifice at the end of a path above the pool of black water. It is erected in the center of two blades of glass that are today obscured by some shades – blades that are as vertical and sharp as the door itself. Once the threshold is crossed, a vertical mirrored wall returns our image and stops us in our tracks. We glide along this wall then behind the reflection and my host invites me into the sitting room that, to my surprise, projects me to the landscape of the bay. It is as if I had found myself in a cool and dark cave, with this glass façade that had embedded in it a fireplace dedicated entirely to the view. The fire from the hearth during the star-lit void of the night must be incredible.

The long reception and living rooms extend themselves with their thin, fragile structures to surround the terrace. The tall brown walls direct from both sides of the pool to the parents' and childrens' apartments. The ceilings appear even taller since the architect had the delicate care of never cutting the rooms with transoms above the doors. There remains only one line between the floor and the ceiling: The line of the horizon is the only cut and reference element among the vast glazed bays, allowing no vision in from a stranger outside. All the built elements seem then to float between this high and low line. The patios attend to everyone's privacy and protect their secrets in a colored vegetal nest. Today's furniture has no weight in this extended space, and it is relegated to a lower scale, taking into account the significant ceiling height and the absence of landmarks; indeed, it eludes verticality. The crystal luster does not seem incongruous in this house, since the classical furniture that was demanded at the time of the project's construction came from antique stores.

I feel as if I am weightless, gliding along the smooth surfaces, looking at the picture window like an astronaut looks at the earth, so far yet so close. I leave this address between the sky and the land, having acquired this experience and think of extending this feeling to the two other sisters, fake twins that are sited a bit higher and emptied of their occupants. I turn around and a similar vertigo resumes, standing before the glass façades that isolate nature, the structures and the landscape of the Pacific.

169

CSH#23 A, Edward Killingsworth, Jules Brady and Waugh Smith

The architects would take care with the voids and solids, the surfaces and the volumes, the interstitial and programmatic spaces. Used as notation, the patios, doors, ceiling, and frosted glass partitions modulate themselves to infinity, happily varying the plans of the three houses: A U-shaped plan for house A, an H for house B, and an O for house C. The alphabet is soon exhausted. Each house would be unique, a part of the whole. Houses B and C face each other, confronting their views of fragmented façades, replying with reflections cast on the planes of water and panels of glass. House B would be covered in a white and snow-blue skin in order not to interrupt the sky seen from the patio, while house C would be the color of bitter chocolate, standing against the mountain and its color. More compact than its alter ego, its plan is composed in the form of concentric rings, with its screens shedding to form a patio, lending it a clarity and the status of "favorite" among the architects of the time.
I return to Los Angeles, embracing Louis Kahn's figures and façades, which suspend time like nothing else, comparable as they are to the ruins of an ancient city.

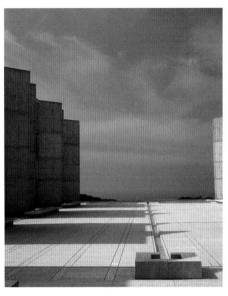

Louis Kahn, Salk Institute, San Diego 171

CSH#23 A, Edward Killingsworth, Jules Brady
and Waugh Smith

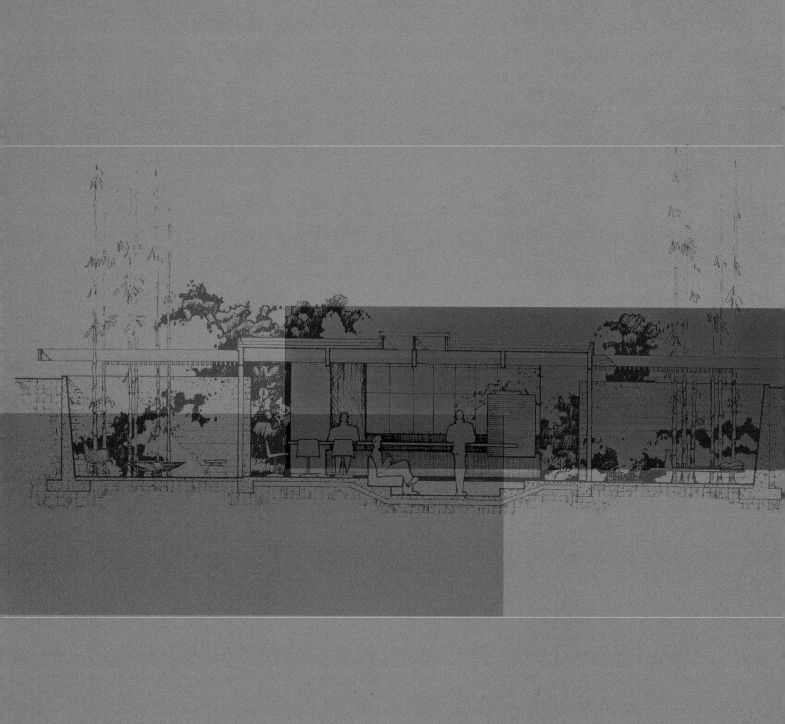

A DREAMED COMMUNITY OF 260 UNITS

CSH #24

The dream of conceiving a contemporary community, offering 260 units as the possibility for a shared better environment, came to rest in the pages of *Arts & Architecture* in July 1961. The ideal was promised by the architects A. Quincy Jones and Frederick E. Emmons, through the realization of a housing project in the San Fernando Valley for Eichler Homes, an enlightened promoter and a superstar of modernity in numerous issues of John Entenza's magazine. A defender of modern architecture since 1949, he envisages the construction of 260 houses over 148 acres [53] of an old, generously wooded ranch. The architects plan the communal spaces for activities such as swimming and horseback riding, for barbecues and leisure areas along with commercial centers connected by green paths. The price to be paid for this equipped community is the reduction of each lot from 20,000 square feet to 11,000 square feet. The designers then develop for the magazine one single house of the five to be reproduced. The whole of the project would be ultimately rejected by the authorities, [54] because they would not accept the collective character of the communal spaces.

Through their establishment of a simple principle and of a remarkable conceptual purity, the architects are champions of this collectivity. This principle allows for the management of an assemblage, where the unique landscape of eucalyptus trees is maintained, where the interaction and the borders of different lots are respected and enriched, where the privacy of each house is protected from the others and from the street, where each family can blossom in its cocoon, and where domestic life and leisure occupy multiple spaces.

The basic principle of the design for the living unit and its garden is its integration with the site and the surrounding landscape. The large rectangles broken in the site and between the trees are isolated from one another by the vegetal mounds that separate them. This audacious device assures an acoustic and visual isolation from the neighbors, all the while providing thermal insulation of the houses during the cold season where the embankments temper the off-peak season. The insulation during the hot season is regulated by the presence of a surface of water on the flat roof of the CSH, thus alleviating the summer atmosphere below their strange reflections that literally float on the vegetal mounds.

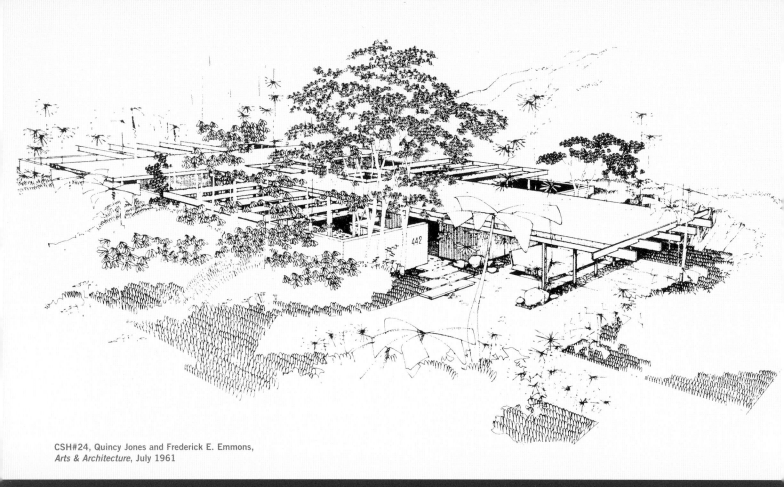

CSH#24, Quincy Jones and Frederick E. Emmons,
Arts & Architecture, July 1961

The T-shaped roof extends itself to the street, greets the cars, and, with its blank walls that slip into the ground, outlines the unique façade of this remarkable Case Study House. A veritable aeronautic canopy, it covers the rectangular excavation, allowing the structural beams to appear at the periphery of the orthogonal contour as bony limbs that delimit the gardens.

With this project, Jones and Emmons extend their work, which is already rich with experimental prototypes in metal. They alternately produce their own homes as well as the X-100 house in 1956 for Eichler Homes, following the work of another architect enlightened by this material, namely Raphael Soriano.
Constructed with the support of Joseph Eichler, X-100 successfully explores the incredible freedom of architects to have vegetation penetrating into the house, to conceive of a light fluidity of spaces, and lastly to display their capacity to create steel structures that disappear into the domestic environment.
In September 1961, our two architects deliver their design of the house interior, which focuses itself on the central living core, a literal pivot of the T plan regrouping the kitchen and living room. Between this core and the carport, a room whose use is unrestricted and unaffected – an office, a studio, and guest room – comes to insert itself in the space, creating a distance between living and the automobile's nuisances. Almost half the house surfaces are devoted

to the garden, which is divided into compartments like a check pattern. If the preparation of meals is a central preoccupation of the magazine *Arts & Architecture* in September 1961, it is also clearly affirmed at the center of the house plan, which is composed of two kitchens. The first "public" kitchen is contained within the central rectangle, and opens itself onto the living room. The line of the bar separates the kitchen from the living room, both of which are embedded even more into the multi-level floor of this edifice. The furniture replaces the dissolving partitions and façades, which lie in a unified, lived-in void whose limits have evaporated. The refrigerator is autonomous and accessible from multiple sides, a true hinge in the living space. It has substituted in some way the fireplace as a symbolic object of consumer society.

The banquette still exists, and is rooted in the floor, delimiting a perfectly cozy place for discussion and exchange – a site maybe of resistance, as a last defense against the television. More discreet, the second kitchen called the scullery is a closed-off service space, which can be used by someone else, or for the preparation of meals that have smell-related annoyances. Since the house has no servants, the scullery is a token of bourgeois reminiscences recaptured by the American dream.

CSH#24, Quincy Jones and Frederick E. Emmons, *Arts & Architecture*, December 1961

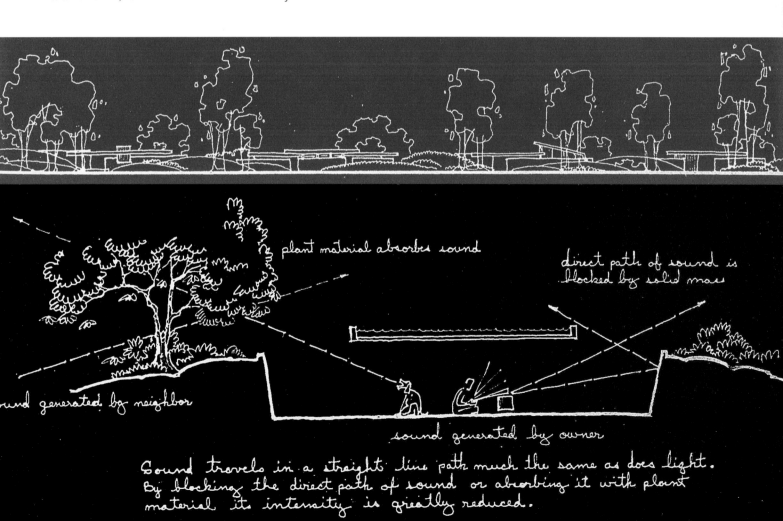

plant material absorbs sound

direct path of sound is blocked by solid mass

sound generated by neighbor

sound generated by owner

Sound travels in a straight line path much the same as does light. By blocking the direct path of sound or absorbing it with plant material its intensity is greatly reduced.

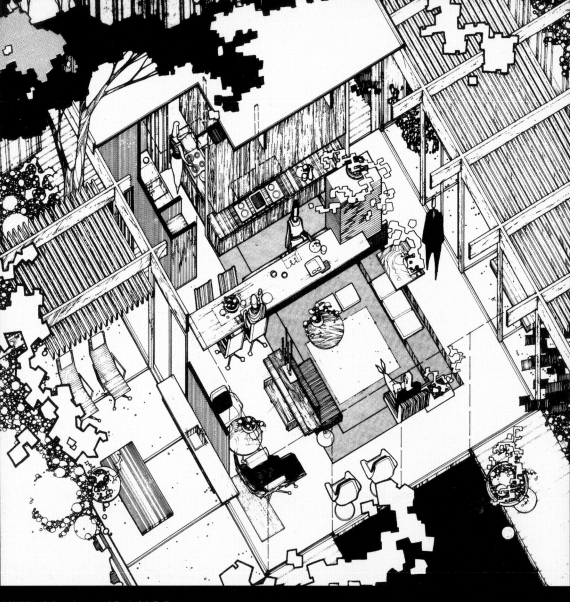

CSH#24, Quincy Jones and Frederick E. Emmons,
Arts & Architecture, September 1961

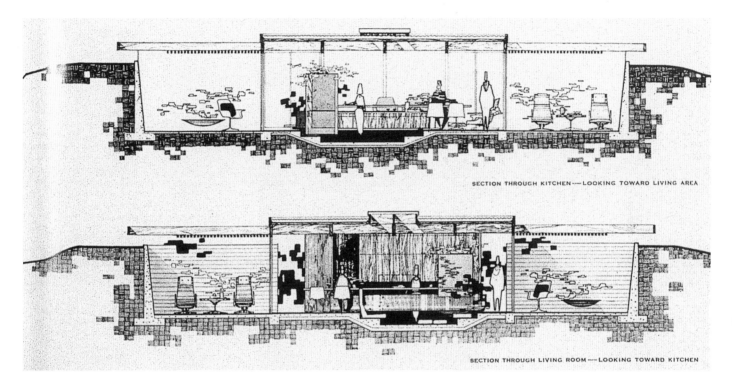

SECTION THROUGH KITCHEN——LOOKING TOWARD LIVING AREA

SECTION THROUGH LIVING ROOM——LOOKING TOWARD KITCHEN

CSH#24, Quincy Jones and Frederick E. Emmons,
Arts & Architecture, **September 1961**

The rigor of the design separates and stages the chores without hesitating to confront them or superimpose them in order to suggest other uses. The minimal living room spreads out over two terraces and the gardens, reducing its surface in order to take advantage of the mild Californian climate. The pool of water tempers the atmosphere and separates the day zone from the bedrooms that are organized at the head of the T and extend themselves along a transversal garden sheltered under the flying posts. Forming a grid on the strict excavation, these same posts reveal themselves in a model reproduced in the magazine in December of that same year. The information contained in this last article seems to me to be a plea for the privacy of each of the units, and for their integration into the existing natural site. A conceptual sketch illustrates again the principle of embedding and its performances of acoustic and visual isolation. A profile of the ensemble proposes the vision of a community in harmony with the site.

In vain: This dream would remain at the drawing stage, and would not succeed in fusing architecture with nature, doubtlessly marking the ultimate limit of this Californian practice embraced by numerous architects.

CLASSICAL VERTICAL

CSH #25

Platform framing

Techniques of construction are standardized. Originally called the "balloon frame," this type of wood structure is the object of lethal fires, which drives its replacement by a similar type of assembly called "platform framing". The latter implements the separation of the ground level from the second floor, such that flames are unable to spread from one storey to another. It is through a series of two by fours, wood sections of 2' x 4' (length 6" and more) that, when assembled, constitute the construction module for the fabrication of posts and beams. Spaced at a maximum of 2" on center, these sections define the arrangement of the walls and partitions. They then extend to the roofing as a system of lintels that do not rest on a primary structure. [25] Today, houses are always built following this assemblage of wood elements that can then be altered, whether through extension or cutting. When metal is used in the single-family home industry, the 2'x4' technique of assembly is imitated. It is these flattened metal U sections that take on the name "cold metal framing studs."

That morning I had a meeting in West Hollywood, located below Sunset Boulevard, in one of those apartments that opened onto a patio. No swimming pool there; a journalist friend was waiting for me. He was coming back from zone 51 in Rosewell, where they had just celebrated the fiftieth anniversary of the flying saucer accident. I had suggested to him to go look at an extra model about which I had spoken to him for several weeks, a model that was more than just a spaceship never seen and only fantasized. We drove toward the direction of Long Beach and the beaches of Manhattan Beach where the large crashing waves interest the surfers, those shearers of foam with their surfboards. We lost ourselves in the Naples district, which was urbanized until the twenties – a kind of Californian Port-Grimaud with its share of canals and little kitsch houses, with boats parked in the front and cars in the courtyard. No landmark was possible in this concentration of garden-less dwellings. Then, having taken out our simplified visitor's plan from 1962 published by the magazine, we finally located ourselves in this flooded labyrinth. Abandoning the white car in order to be more efficient, we went in search of the bright parallelepiped designed by Edward Killingsworth. Facing a platform alongside the bridge, its profile is revealed against the light, like a rectangular mass planted on the ground, with common floors and party walls. CSH #25 presents itself now a few meters away, restored eighteen years ago and maintained like new by a couple in love with the house's strict volumes.

Access to its principle façade is made by boat or on foot, while its opposite side is accessible by car. The site is deep and narrow. The rectangular mass is divided into two parts, the first is windowless and cut into three vertical bands, outlining the entry that is highlighted by a black bottomed pool of water above which float sheets of concrete. The second part of the composition is very balanced, a superimposition of two glass volumes along the canal and protected by an olive tree, which provides an uncertain natural filter. At the sound of the bell, the guardian of the place opens the door for us, a door that evades the façade with the entirety of its vertiginous height. Bluffed by the immense aluminum airplane wing-cum-door, we fall into what appears to be a sanctuary of light dedicated to a dazzling modernity.

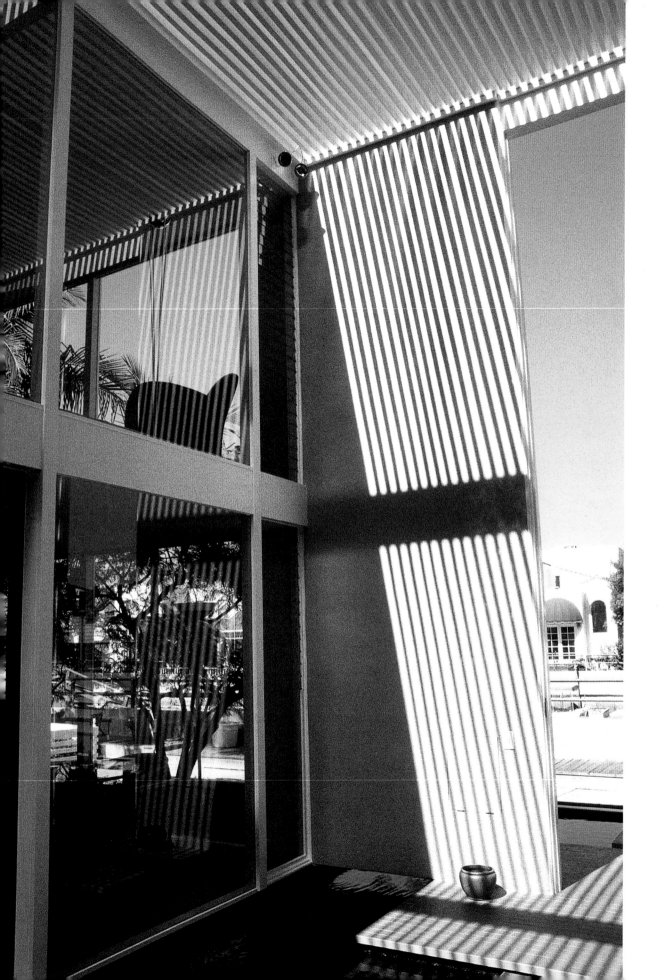

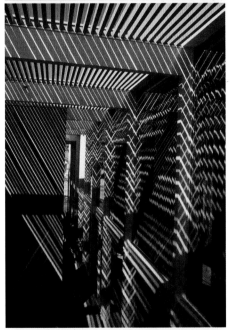

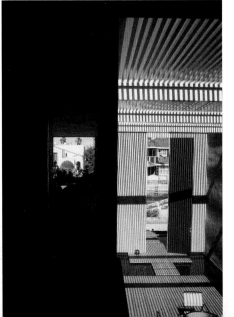

CSH#25, Edward Killingsworth, Jules Brady
and Waugh Smith

CSH#25, Edward Killingsworth, Jules Brady and
Waugh Smith, *Arts & Architecture*, January 1962

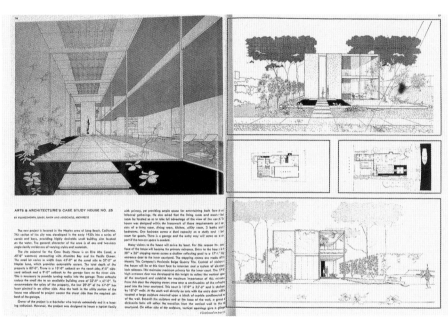

Two volumes associated with and surrounded by the tall slender walls hug the patio, a double height void bathed in air. The water demarcates a private terrace in this patio, where a vertical plane responds to the symmetry of the door that extends to the entirety of its height. A silence settles in on its pivoting, enclosing us in a fishnet of vines that slice the projected light like the blades cast on the wall. We are just at the edge of the urban world, in a tiny pocket of light. The privacy protected by the tall walls disappears along the large sliding bays that adorn the immaterial façade of the double glass pavilion, endangering its view on the canal.

I find in this project a scheme close to that of the Triad, where the separation of day and night is carried out by the superimposition of two bands open onto a void, which in this case are shafts of filtered light. This surprising device solves the terrible dilemma of a tight lot, and with the owner's need to open out his living room and kitchen onto the canal. The architect would do it with audacity, proposing a two-storey house model rarely studied in the course of the program. Killingsworth invests the whole of the site and protects the privacy of the domestic space by high walls, on the inside of which nature has disappeared in favor of a monastic void.

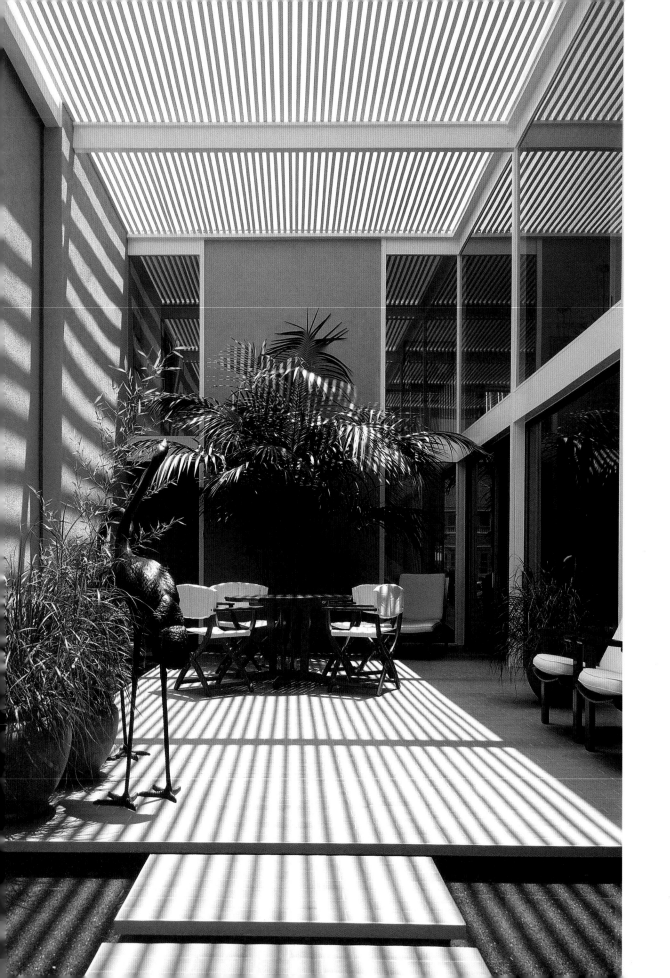

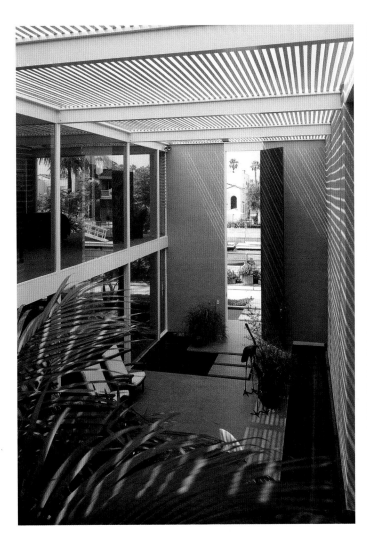

CSH#25, Edward Killingsworth, Jules Brady
and Waugh Smith

The owners tell me about the house's incessant demand for maintenance, which regularly involves the cleaning of the pools and the application of white paint on the woodwork. In walking through the site, I note the same elegance of the vertical doors from the Triad, and in this minimal treatment of the bathrooms, where only a horizontal piece of furniture covered in dark and precious wood floats. The linkage of the rooms that are stretched along the glass façade accelerates the perspective from the stairs until the frame on the canal that cuts the landscape behind the vegetal filter's timid leaves.

An impression of fluidity and calm persists in the void and the humid air that covers the fish net penetrating the rooms whose limits are now impalpable. A light vertigo seizes me as I stand at the edge of the too slender floorboards, forgetting as I do for an instant the site's minimal geometry.

The visitor from zone 51 confirms his impression of floating in this distended space. Only the perspective from the outside, suddenly dismembered by the calm, brings the visitor back to the reality of the context.

A house to traverse, a museum house that reveals its rooms from the patio and exhibits its furniture and its vertical functions, a transparent house composed of a classical and surreal modernity. The architect realizes the paradox of a small building with an intoxicating and dazzling range.

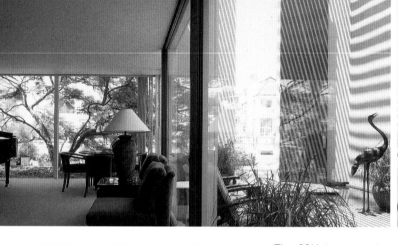
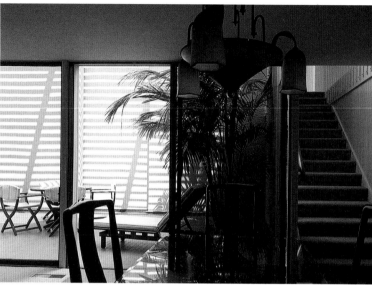

184 CSH#25, Edward Killingsworth, Jules Brady
and Waugh Smith

The CSH was conceived and built for the furniture manufacturer and distributor Edward Frank, who was familiar with the program and was the promoter of numerous interiors stamped with the CSH seal. The architect Edward Killingsworth developed a composition for this model, in which the patio would be the culminating point, with a contemporary sculpture planted across from the front door. By this gesture, and by this will to have art enter the domestic space, the architect extends the program and offers it a new field of research. The art then becomes a discipline that can even encourage a better environment promised to all. Like good design, art too has its place in the program!

This sculpture is not the first art object to enter the CSH. In fact, one discovers among the published images numerous works of photography and paintings, most notably on the walls of CSH #8 and #9. But the object here is the first to appear, like the furniture, under the "Merit Specified" label. In this way, the art becomes an object absorbed and available in the same way as an ordinary object, and sealed by the architect alone. The architect would confess to me that his first preoccupations in his early years had been sculpture and painting, and that, in the intervening time, he had re-purchased the sculpture from CSH #25, which, from that moment on, had held a place of honor in the entry to his office.

We took leave of our hosts after these few delicious instants, moments that were still in a state of weightlessness. Very quickly, our feet were brought back to earth, and back to the reality of banal objects in this Venice of the angelic suburbs.

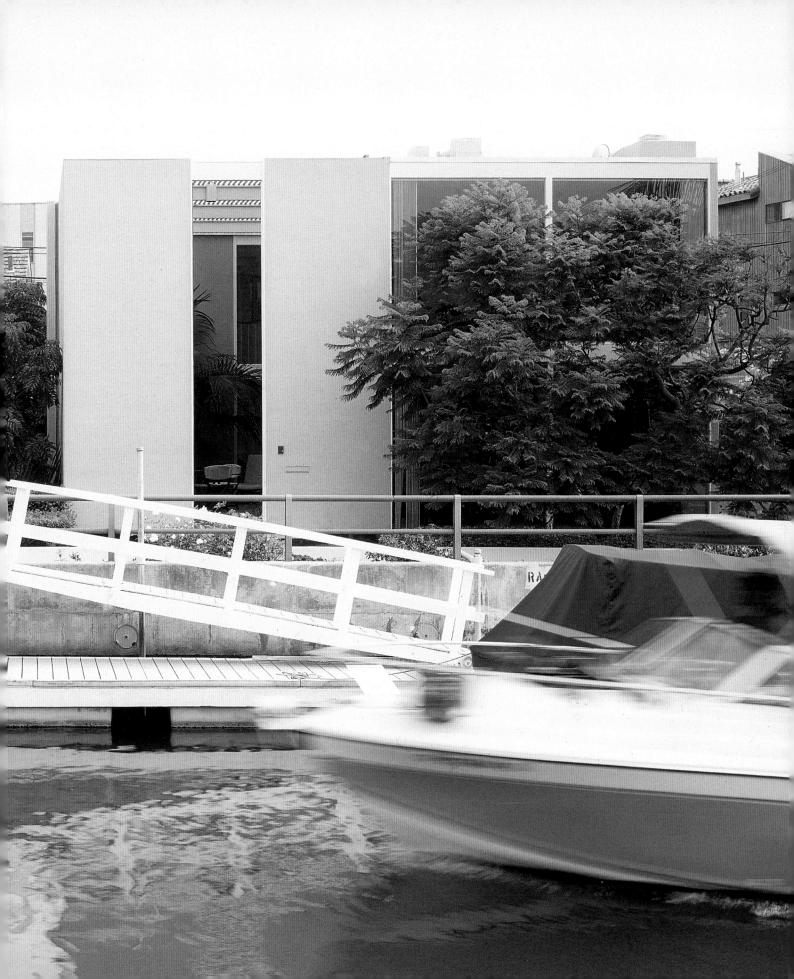

THE KING IS DEAD

PROLONGING THE DREAM

CSH #26 & #27

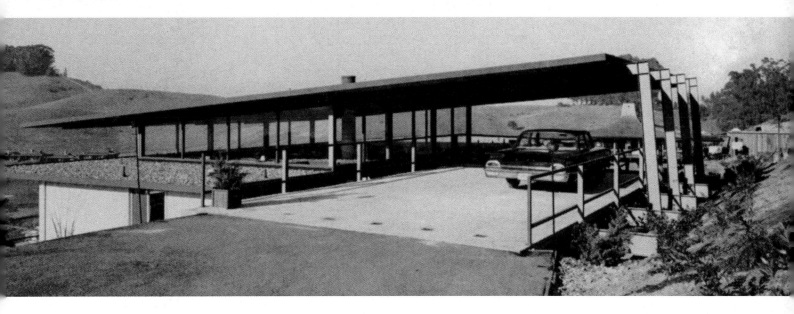

CSH#26, Beverley David Thorne,
Arts & Architecture, January 1963

David Vincent was quite alone in this incredulous world surrounded by American citizens protected in a bubble of prosperity, who ignored the presence of "invaders" all over the country. He alone knew of it and he struggled to inform the world of his extraordinary visions, with revelations and promises of invasions in motion delivered to him. We know little about this man, above and beyond the heavy secret impossible to relay. Yet we recall he worked as an architect, and his office was turned upside down when he returned late one evening driving along a small road…

That day, south of San Francisco, in San Raphael, the memory of David Vincent and his clear blue and distraught look would never leave my mind. No, I did not see the invaders along Highway One running between the two west-coast cities along the abrupt and wild cliffs of Big Sur, despite the state of fatigue from which I was suffering, much like our architect from television.

I gazed at the house at the end of this road, on the hills scorched by the heat and the sun. High conifer trees stood guard on either side of the asphalt ribbon. The engine idled. I took a few moments of repose before parking on the immobile platform that was unsettling because it was too empty.

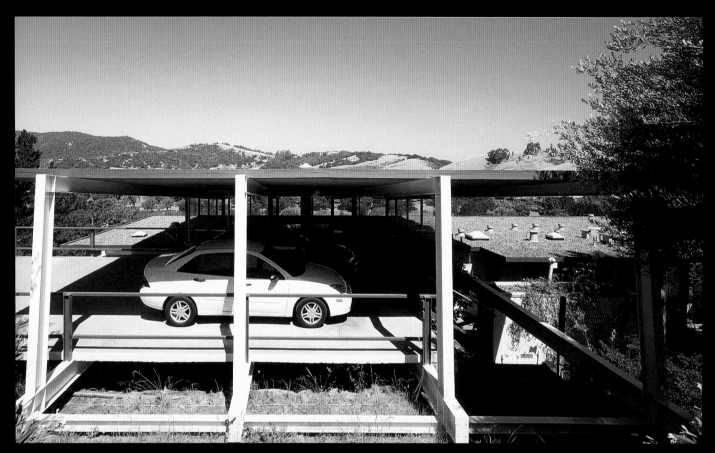

CSH#26, Beverley David Thorne

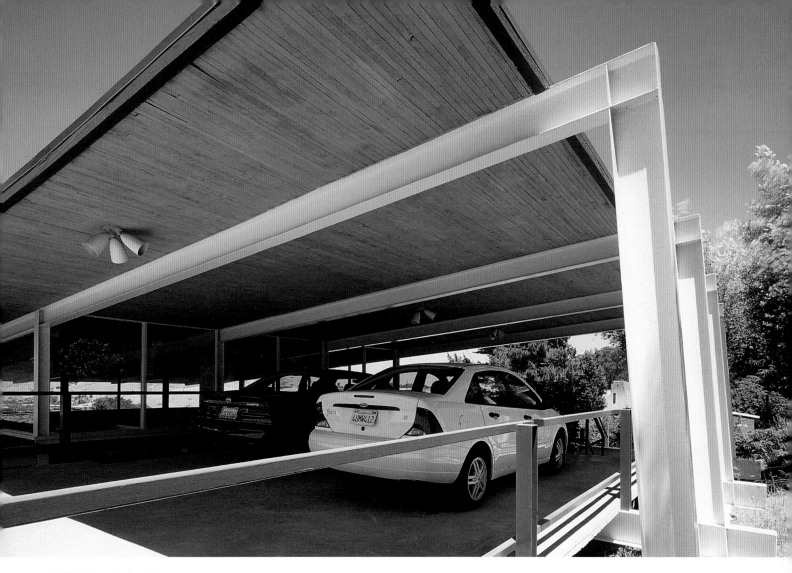

CSH#26, Beverley David Thorne

Only the schizophrenic architect David Vincent could project such an object, or live in it. A smooth platform rests on the slope, like others that had already done so further to the south. But here, the house is tucked away under the road, under a landing strip for large engine cars from the fifties, those extra flat and slender vehicles. Behind the steering wheel of my little Japanese car, I land poorly and without fanfare on this large strip of dreams. What a feeling indeed of an irrational and sensational vertigo produced by this sliding under the thin oblique of the roof plunging towards the void. I slip into the shade and stop my timid engine. The shadow projects the perfect rectangle of the roof, which rests on the long structures of sharp steel.

It is Beverley Thorne, distinguished by a prize awarded by the American Iron and Steel Institute, and not David Vincent, that is the architect who designed CSH #26 as a platform for living, planted on the hillside. He claims a ferocious will in his detachment of the domestic space from an everyday work area too stressful for its occupants. A first slab delimits the parking and appears to extend itself like a table above and beyond the fault line that lies on the horizontal body of the building. In the rectilinear crack, the rear façade with its service areas lies below. The house, now visible on the platform, is a rectangular pancake of approximately 200 square meters. With its four bedrooms and two bathrooms, the program extends a bit more the first prototypes of the CSH saga. The horizontal parallelepiped is extended by

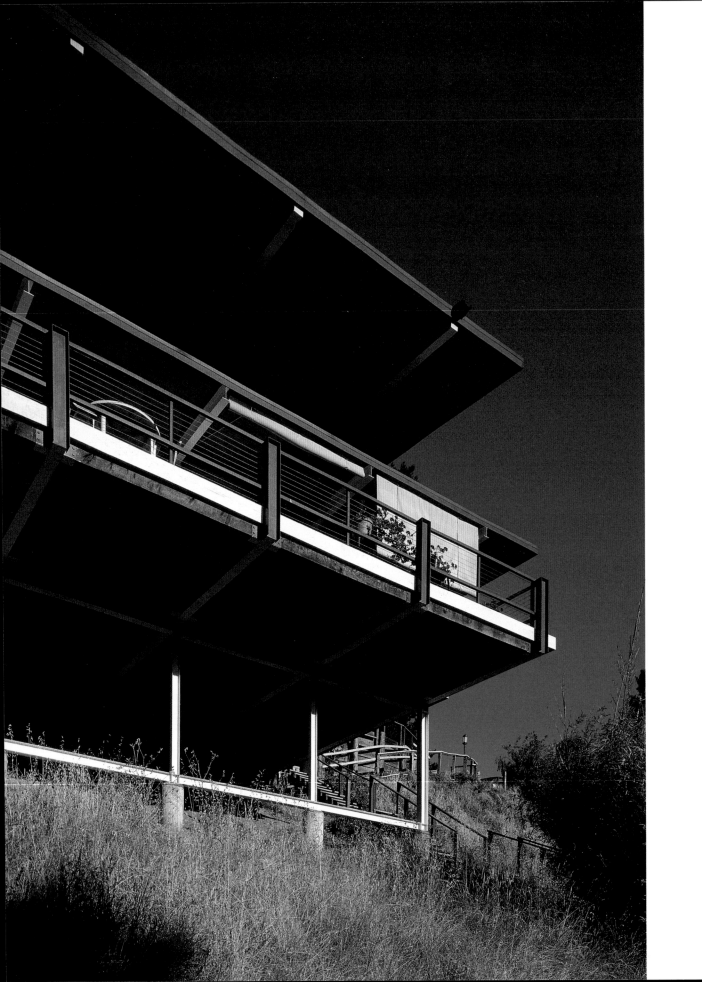

Post-and-beam

Architects make final refinements of structural and assembly details such that they alone would be capable of creating a unique aesthetic. The question of detail and process becomes central to the project and remains in evidence during its production. Architects do not hesitate to show the techniques of house design, by dividing the spaces following the rationalism of posts and beams, in contrast to the modernists of the first wave, who created smooth ceilings that are detached from all apparent structural difficulties by hiding the structural system.

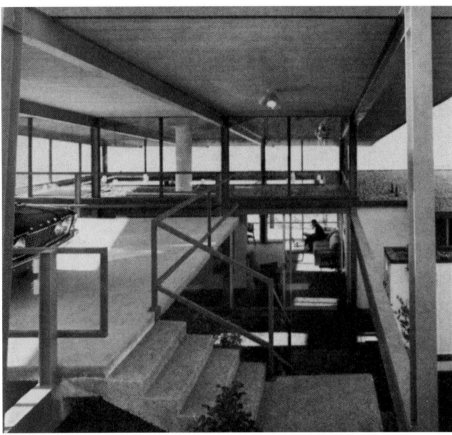

193

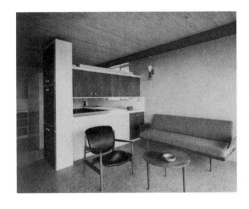

CSH#26, Beverley David Thorne, *Arts & Architecture*, January 1963

a cantilevered element of 80 square meters, a panoramic element sweeping across the landscape and outlining a continuous band of sliding glass from the interior. The house that was hidden from my view since I arrived by car reveals itself now, beyond the prints in the magazine, in the shade that I had traversed by an awkward staircase in the hollow space crossed by the rough steel of the white beams. Nobody would respond to the doorbell ringing, and I would have to content myself with the prints from 1962, and with a tour of the unusual and monolithic object within the turbulent geography under the intense light of this region of northern California, under the Yves Klein blue sky spun in white wool. Edging my way along the crack, I take the steep stairs and look vertiginously at the horizontal planes of CSH #26 that jut out of the hill in defiance.

While there was not a specific owner identified at the time of the house's introduction, the architect had in contrast two employees and their wives participate in the narration of a program. Produced by 20th Century Homes and the Bethlehem Steel Company who were accustomed to collaborations with the program, CSH #26 was imagined as model of construction that was adaptable to the numerous hilly and uneven sites in California. The economic factor is taken into account in this project, since the architect has to demonstrate his capacity to design a metal house on a difficult site for the same price as a traditional

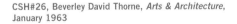

CSH#26, Beverley David Thorne

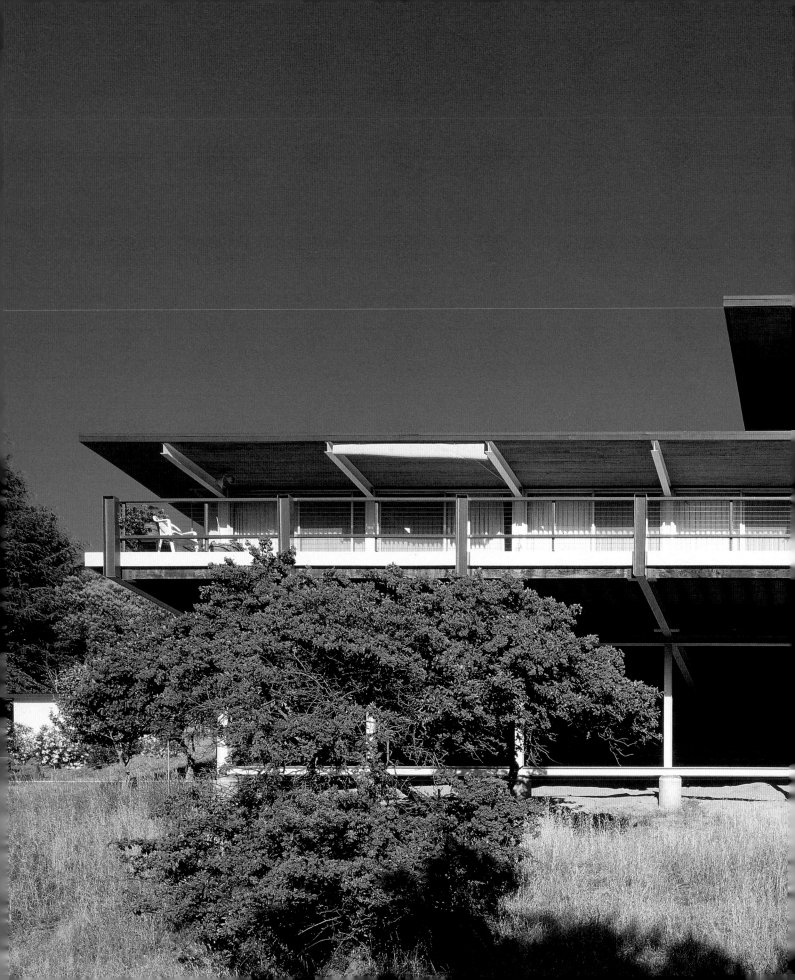

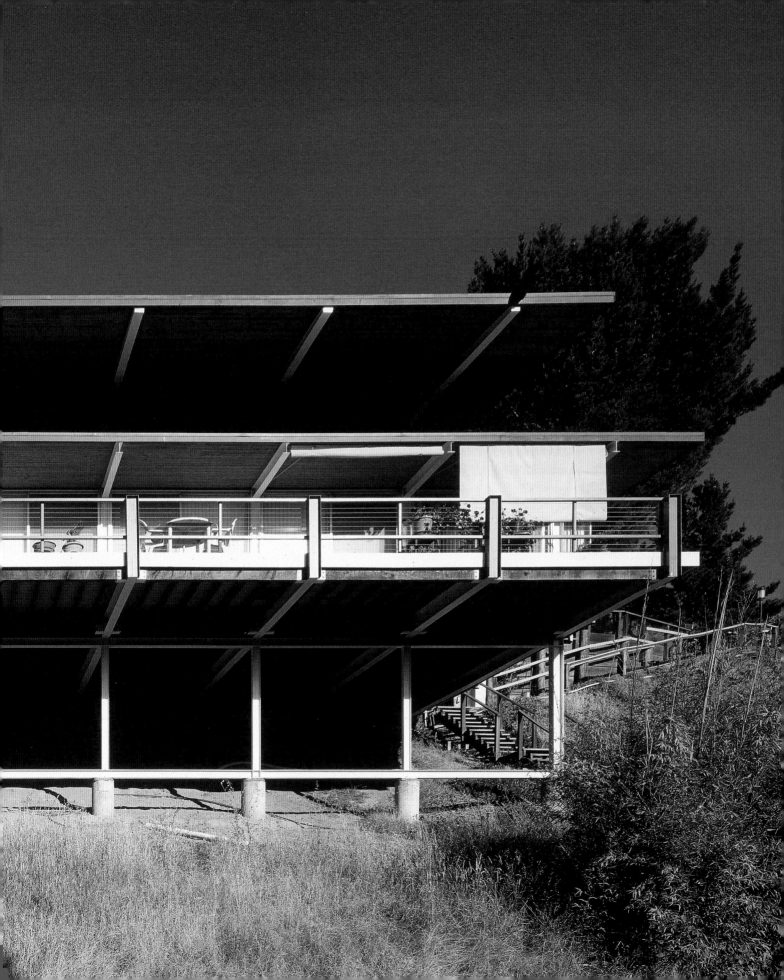

construction. The architect resolves the question of the slope with the platform principle, recuperating the one-storey American house model. The building rests on the hill, on top of a line of steel posts. Everything is conceived and calculated for an optimal efficiency; in fact, it took only eight hours from the time of the installation of the cranes on the site to the erection of the steel frame. The images published in the October 1962 issue of *Arts & Architecture* allow us to catch a glimpse of the lightness and modular character of the whole structure. Neither excavation nor stripping or filling of the hill would be necessary for the building of CSH #26. The landscaping intervention by Eckbo, Dean and Williams was designed with the same restraint and discretion. The land would remain untouched in its entirety, only to be inhabited by a thin vegetal coating. They avoided all demarcation from the neighboring lots, respecting the local rules concerning the absence of barriers. To the west and to the north of the site, they chose plants from the existing ecosystem of the chaparral. To the east, between the house and the mountainside, and on almost flat ground, they decide to plant a garden utilizing traditional techniques – a garden that is imagined as a green room planted with small-scaled trees. Under the carport, the fault line is covered by potted tropical plants. Finally, to the south, the landscape designers play the game of oppositions through the presence of dense plants and tall fragile grass, which faces the rectilinear superstructure. Like the sharp steel

CSH#26, Beverley David Thorne

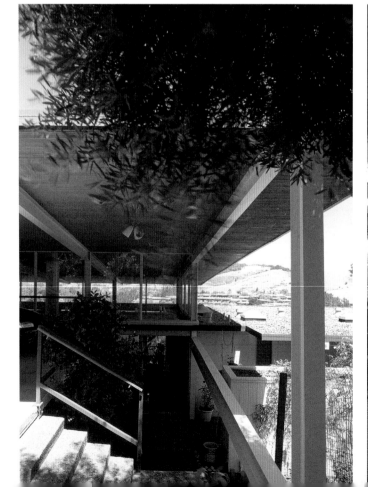
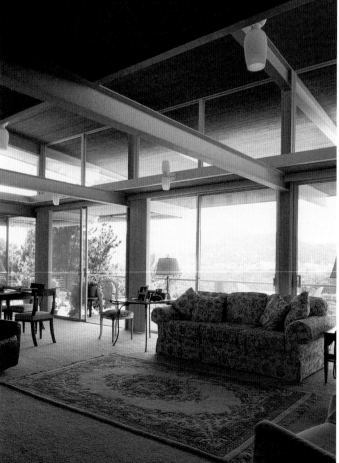

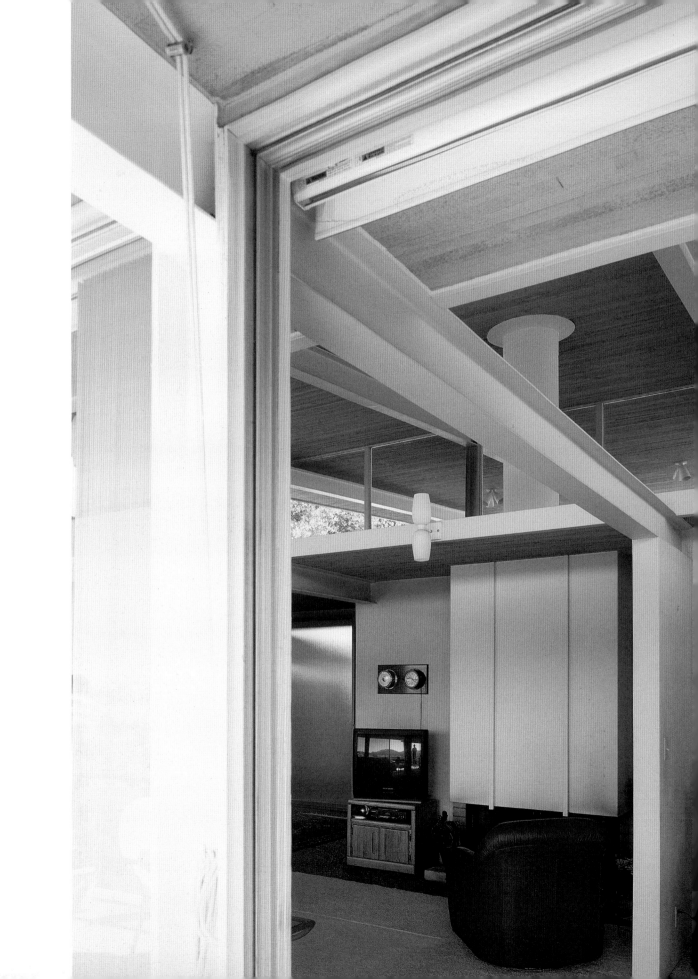

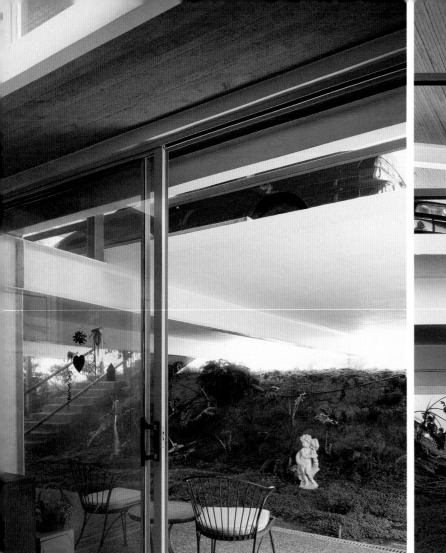
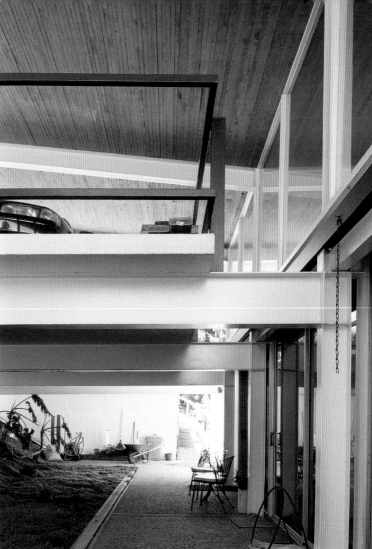

CSH#26, Beverley David Thorne

skeleton, the precise and fine furnishings stand out in the images from 1963, against the light of the undulating landscape, a full screen projected onto the void. Symmetrical lamps adorn the living room posts and create the mirage of a reflection in the glass lantern.

John Entenza would view the prints from this new episode differently, indeed from the vantage point of a reader and subscriber. The father of the CSH retired from the magazine in 1962, leaving the subsequent creations to others, and leaving the choice of a follow-up he would no longer dictate. Like an inheritance indissociable from the magazine, the show would go on until September 1966 with the publication of CSH #28 – the last of a prestigious series. The modes of living proposed did nothing but extend those that were already in existence; if anything, they only questioned the building envelopes within a more and more conventional vocabulary.

I returned sometime later after having arranged a meeting, and I was greeted by Renée. As my host for the weekend, she would recount at length the life she led there with her husband and their four children, owners from the first day, now thirty-eight years ago. A new coat of white paint now covers the whole of the structure, and she let me in on the long and painful renovation of the wide balcony. The little room prepared by my host was projected in the night lit by a full moon and a full sky. I tried to imagine what had urged on Renée's husband – at that time an airline pilot – to choose this house and to push three of his children to also become aviators.

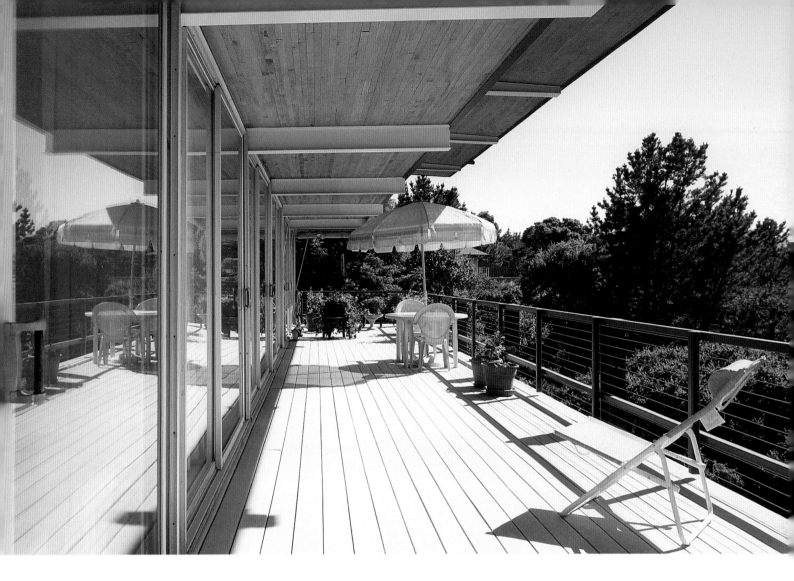

Modernism and regionalism

Colin Rowe interprets modern architecture from the fifties as distinct from the modern movement of the twenties. According to him, this earlier period distinguishes itself from rationalism and accords itself with "the spirit of the times," lending to each key architectural project [26] an authenticity governed by spontaneity and modernity. These projects exhibit a will to transcend symmetry while affirming a well-balanced composition. Thirty years later, this phenomenon would reappear in the United States not due to the brightness or brilliance of the times, but rather, according to Rowe, thanks to regionalist architectural elements that would unify, as such, a notion of architecture suitable to America. [27] The subtle games that would exist between interior and exterior spaces through their layering and interweaving, followed by the integration of the car in the plan of the house, as well as the use of local materials and techniques such as wood or stone, would make of American architectural modernism more than a replica of its European predecessors. Rowe then poses the question of membership in the national modernist movement belonging to the second wave. The cutting edge of the American movement includes Gropius, Mies, and Breuer.

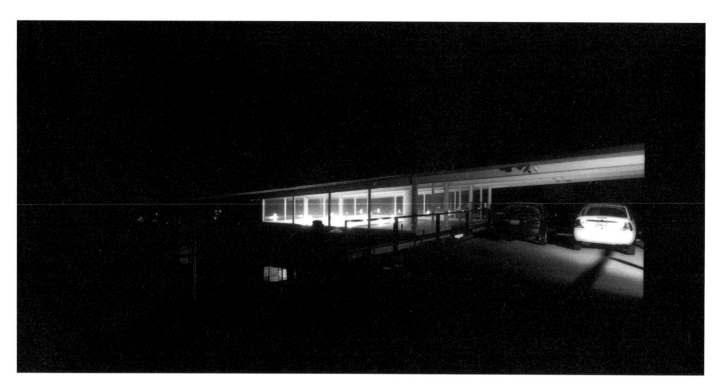

CSH#26, Beverley David Thorne

Edited in June 1963, CSH #27 is for many an accident of the program. Paul Virilio defines the concept of accident as the obscure side of all inventions and all industrial objects, from the Titanic for the sea, to the Concorde for civil aviation. Surely, CSH #27 is the most significant accident of the program that Entenza bequeathed to his successors.

Conceived for the east coast and thus voluntarily uprooted from California, it is exported to the uncharted territory of New Jersey. The use of a multiplied unique module of prefabricated concrete lends a surprising quality to this production, and distances it from the rest of the CSH Program production. CSH #27 is an assemblage of heavy modules or improbable clones, connected only by their resemblance to each other. A campsite of tents put in play by bourgeois rules lacking in a foundation, from which the Californian landscape and lifestyle are absent. The pioneer spirit is also absent, as if it had become dependant on a market study that tended to target a potential buyer who himself was out of context. Export is deadly to the CSH program, especially if it is not accepted and claimed as the desire and quest for a contemporary lifestyle, lending an aspect of both utopia and reality to numerous CSH.

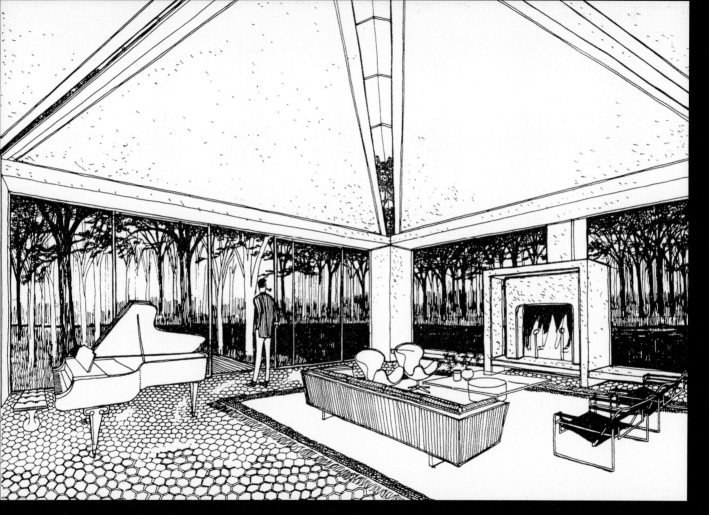

CSH#27, John Carden Campbell, Worley Wong,
avec Allen Don Fong, *Arts & Architecture*, June 1963

RENEWING THE DREAM

CSA #1 & #2

Nearly twenty years after the first exposure of the program, a new direction is taken under the impetus of the magazine's team that succeeded John Entenza. Losing momentum, the program repositions itself towards the mass production market, more in relation with that of the American property developer, and as such in contrast from the postwar years.

The CSH logo becomes CSA, for "Case Study Apartments," affirming the shift of preoccupation from the isolated domestic object to that of the piled-up ensemble. This shift, already foreseeable with CSH #23 and #24, really takes off in the fall of 1964 with the confirmation of investment in a site where an upsetting mediocrity already reigned supreme. The will displayed in wanting to renew the object of study by passing from the house to the apartment with the same tools that were introduced at the outset of the program in 1945, continues and is anchored in its construction and completion. The desire to conceive of a dignified and elegant architecture constitutes a veritable battle that is taken on by the architects, in a context that differs from that of the individual property. In addition to its location, the apartment is often charged with a negative, even pejorative connotation. However, the architects determine that the respect for this form of dwelling – until then neglected by the program – can be attained by the respect for good design.

Once the new intentions of the program are solidified, the magazine manipulates the financial arguments and a technical vocabulary, proving in a certain sense that the banks and investors are to be convinced as much as the readers. The magazine insists on financial results above initiative.

During the Entenza years, this aspect does not play a central role in the content of the program, nor in its story. With the advent of the CSA, domestic space is a rentable investment as much as it is a model of life. Entenza's dream seems to evaporate a bit more. The three points of Vitruvian architecture are now eclipsed by an economic concern at the service of this prime interest in the United States. Modernity becomes almost a sales argument, a chic and promising aesthetic that produces reliable returns.

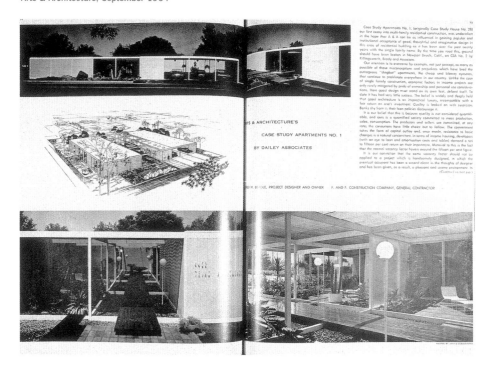

Initially called CSH #28 and then CSA #1, the project is built in September 1964 and exported to Arizona under the pretense of photographic reportage. The project is a rectangle composed of six squares, each approximately 84 square meters. Three of these rectangles accommodate the apartments. The two in the center are destined for communal spaces, while the last at an angle is dedicated to parking.

A distinctive perspective shows a view onto a generous volume surrounded by two parallel bars reconnected by a frame that captures the trees in a garden. With a horizontal view printed on the same page, the street façade displays itself impeccably, and allows for the revelation of the minimal post-and-beam construction.

The three apartments reunited under a solid and strict frame are designed and financed by the designer Alfred N. Beadle and the firm Dailey Associates, extending and reviving the classic style of the CSH. The apartments open themselves widely with their large bays, which constitute a system of patios and circulation. The pontoons float above the natural flooring, which is vegetal and usually arid, and they slip in between the structural frames. All of this contributes to a feeling of infinity. The Cartesian frame extends the perspectives and vanishing points, reducing limits and the notion of space in this ensemble. Glass and Formica panels reflect the views and accentuate the palatial effect of trick mirrors found at fairgrounds.

The built proposition is closer to an architectural object than an urbanistic one; its spatial equilibrium is driven by the sparse number of apartments. We are in effect quite far from the initial plan that envisaged its eighty blocks modulating in a check pattern until the horizon, like innumerable and unkempt cells reminiscent of motels and the myths of pioneer towns.

In the shade of the patios covered with nylon canvas, the intimacy of the three blocks seems to recede into the cool gardens and their wide leaves, along with the profiles of the typical cacti. The spare apartments made themselves known in 1964, horizontal and spread out like the city that does not cease to spill over on the ever-flat ground between the mountains that are now isolated by the creeping ocean of the suburbs.

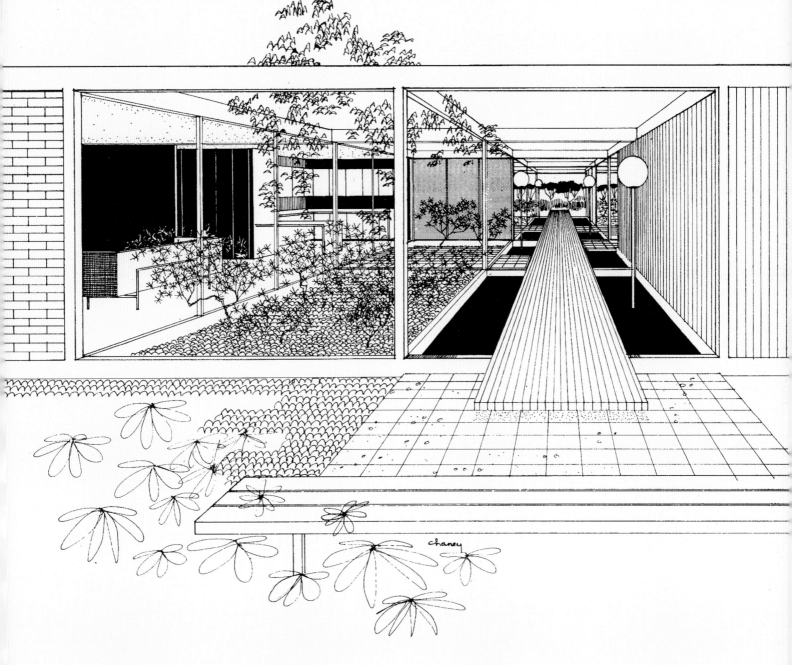

chaney

CSA#1, Alfred Beadle, Allan Dailey,
Arts & Architecture, November 1963

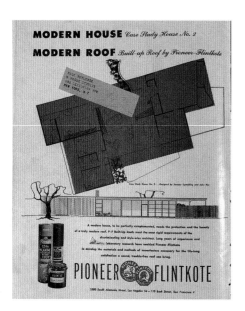

Flat roof

McCarthyism takes effect during the years of hysteria, leading towards the depreciation of the International Style. By its name, this style denotes the interchangeable quality of openness and of exchange, affirming its world leanings. Beyond its formal appearance, this architecture encourages a greater number of people to find accommodation in adequate sanitary conditions, emphasizing cost-effectiveness and large-scale construction; as such, it is recognized as a social architecture coming from Europe. In the fifties, the publisher of *House Beautiful*[28] would declare that modern architecture, due to its purged characteristics, had subversive virtues and encouraged the growth of Communism!

During the rise of Nazism in Germany, there were similar precedents, lending the pretext that the physiognomy of flat-roofed architecture was degenerate and "anti-German."[29] The argumentation used by the National Socialist movement – as much as the extremes enacted under the aegis of xenophobia – condemns modern architecture and stipulates the flight of those architects concerned, such as Mies, Gropius, Breuer... The post-war anti-Communist American argumentation becomes an amalgam between architecture and ideology, also condemning flat-roof architecture and crystallizing the conflict anew on formal grounds.

More so than Los Angeles, Phoenix is a flow of urban lava in ceaseless activity, provoking the desert at every instant now and tomorrow, pushing back its limits along with the horizon. An insidious urban tide, it gains ground and exerts itself where the cactus has been renounced, spreading at random. Los Angeles' little sister, Phoenix's inhabitants have often left the city of angels – at times perturbed by the earthquakes – to join this urban mirage that cannibalizes the void in which it revels.

CSA #1 is fed by this horizontality, by this absence of limits and by the desire for shade and serenity, a Pioneer program on arid Pioneer land. An urban model for expansive cities and a model inspired by the first season of the program, CSA #1 shreds the classical and noble aesthetic references of its program sisters in order to affirm its legitimacy, but its own objective above all is economic and financial.

This first experience with apartments brings us to the saying by Raymond Loewy that one should not leave "well enough" alone. This saying is terse, and contains the promise of high sales assured by the beautiful, which is liberated by the Pandora's box of visionary advertising. Nevertheless, beauty without inventiveness is reduced to an aesthetic of the simulacrum, the latter so strongly elaborated and fought over in the pages of the postwar magazine.

As in the sequels to a successful film, the new editorial team calls on a sure bet, the architect Edward Killingsworth, whose sketches for CSH #26 Esther McCoy unveils for us in her cult book.[55] A modular project *par excellence*, it is abandoned and never published in the pages of *Arts & Architecture*. With CSA #2 designed by the same architect re-staging a reference of his caliber, the production team of the magazine cannot go wrong, and reconfirms its research and investigative action in this new field. This project in Los Angeles is announced in the article of September 1964 and viewed as the confirmation of a triumphant launch of the program.

The classically minded architect designs a vast composition on an angled site. A service bar in the rear isolates the property from the street, while in the front, two plots come together to

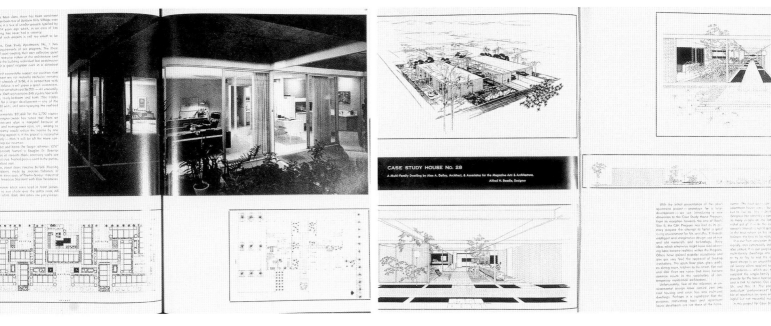

surround a central court around a pool, escaping the rectangle outlined by the U-shaped
buildings. These latter buildings, all two-storey, offer vertical façades open onto the private
gardens, extending the housing units. These cells are conceived according to two models: In
the bar, the vertical units make themselves comfortable amongst each other, whereas with
the plots, two apartments superimpose each other. The architect develops the ivestigations
that were conducted in the first program, polishes them up and regroups them. Fireplaces
adorn the glazed façades of the horizontal units recalling the Triad project, while the vertical units
recycle the plan of CSH #25, with a patio at their extremity. Raised a few paces above the
road, the pool at the center of the composition accentuates the generous invitation to enter the
complex, which is perfectly integrated with the city and responds to the rules of urbanism.

The parking located under the bar, along with the double height void over the gardens reveals
a desire for innovation above and beyond the simple will for a masterly and elegant staging of
the ensemble. The private as well as the shared circulations of the apartments, the great,
undulating stairways for the plots, as well as the distribution between common and private
spaces, also demonstrate the preoccupation with forming a communal model, where everyone
can lay claim to his privacy, and to the elementary and indispensable animation of the
centered composition.

Despite the promises of the study, the CSA quest for a model seems to be a bit tardy relative
to the existing and already more innovative projects. Craig Ellwood's courtyard apartments,
which were revealed in 1954 to the architecture world in São Paolo, include numerous formal
and structural inventions that in Killingsworth's project seem a bit stale.

Killingsworth would not build his delicately designed steel, concrete, glass and wood *opus*,
leaving an unfinished taste to the apartment program – a lacking of built experience, which is
the condition of claimed success.

The renaissance of the program would not really take place, and CSA #3 would never see the
light of day, due partly to a lack of conviction, and certainly to the program running out of
breath; perhaps also because this desire for modernity within the multi-family program would

207

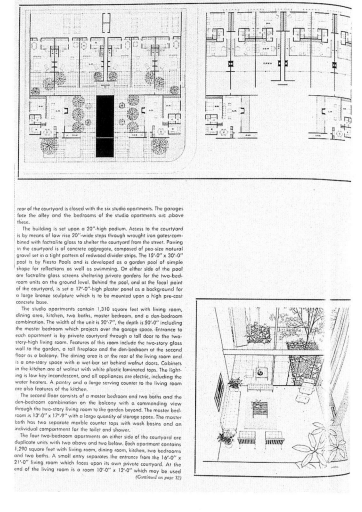

rear of the courtyard is closed with the six studio apartments. The garages face the alley and the bedrooms of the studio apartments are above these.

The building is set upon a 20"-high podium. Access to the courtyard is by means of low rise 20"-wide steps through wrought iron gates/combined with factrolite glass to shelter the courtyard from the street. Paving in the courtyard is of concrete aggregate, composed of pea-size natural gravel set in a tight pattern of redwood divider strips. The 15'-0" x 30'-0" pool is by Fiesta Pools and is developed as a garden pool of simple shape for reflections as well as swimming. On either side of the pool are factrolite glass screens sheltering private gardens for the two-bedroom units on the ground level. Behind the pool, and at the focal point of the courtyard, is set a 17'-0"-high plaster panel as a background for a large bronze sculpture which is to be mounted upon a high pre-cast concrete base.

The studio apartments contain 1,310 square feet with living room, dining area, kitchen, two baths, master bedroom, and a den-bedroom combination. The width of the unit is 20'-7", the depth is 50'-0" including the master bedroom which projects over the garage space. Entrance to each apartment is by private courtyard through a tall door to the two-story-high living room. Features of this room include the two-story glass wall to the garden, a tall fireplace and the den-bedroom at the second floor as a balcony. The dining area is at the rear of the living room and is a one-story space with a wet-bar set behind walnut doors. Cabinets in the kitchen are of walnut with white plastic laminated tops. The lighting is low key incandescent, and all appliances are electric, including the water heaters. A pantry and a large serving counter to the living room are also features of the kitchen.

The second floor consists of a master bedroom and two baths and the den-bedroom combination on the balcony with a commanding view through the two-story living room to the garden beyond. The master bedroom is 13'-0" x 17'-9" with a large quantity of storage space. The master bath has two separate marble counter tops with wash basins and an individual compartment for the toilet and shower.

The four two-bedroom apartments on either side of the courtyard are duplicate units with two above and two below. Each apartment contains 1,290 square feet with living room, dining room, kitchen, two bedrooms and two baths. A small entry separates the entrance from the 16'-0" x 21'-0" living room which faces upon its own private courtyard. At the end of the living room is a room 10'-0" x 12'-0" which may be used
(Continued on page 32)

CSA#2, Edward Killingsworth, Jules Brady et associés,
Arts & Architecture, May 1964

collide with the reality of some existing apartment models designed by the likes of Craig Ellwood and others, namely Richard Neutra, Rudolph Schindler, Raphael Soriano, Raymond Kappe and John Lautner. The projects of the CSA program are too few amidst this multitude, which still haunts Los Angeles and its hills in the shade of the eucalyptus.

Among other projects, in 1937 Richard Neutra would build the Landfair and Strathmore Apartments, in which the Eames couple and John Entenza would establish their residences. These projects extend the work of Rudolph Schindler by definitively breaking off from the European housing model, to which the latter too had contributed in 1927 with his Jardinette Apartments.

The Californian architects then explore this type of housing demand through the conglomeration of small houses within often-sculptural compositions hugging the slopes. Others direct their research to projects that are inspired by Hispanic forms, arranged around patios that are planted with orange trees and flowers and widespread throughout Los Angeles and notably in Hollywood; these are urban and flat communities. The historicist apartment model inspired by Spanish colonial forms is set aside in the post-atomic years for more aerial and technical projects. The pools are substituted for gardens and paths that flourish to distribute two, three, and four-storey apartments and studio buildings.

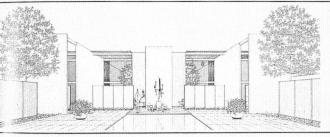

CASE STUDY APARTMENTS NO. 2 BY KILLINGSWORTH-BRADY AND ASSOCIATE, ARCHITECTS

OF THE MAGAZINE, ARTS & ARCHITECTURE, IN ASSOCIATION WITH SHERMAN WHITMORE, OWNER-DEVELOPER

ARTHUR L. HOSKINSON, GENERAL CONTRACTOR

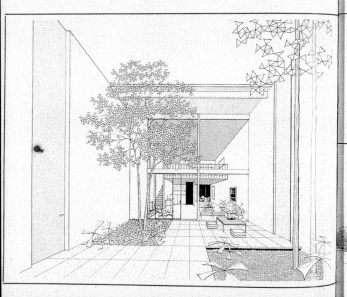

Editor's note: While waiting impatiently for construction on Case Study Apartments No. 1 (formerly Case Study House No. 28, A&A November, 1963) to reach a sufficiently photogenic stage of construction to warrant publication, we here present our second excursion into multi-family residential architecture.

The site of the project is a corner property 129'-0" x 142'-0" located on the upper mesa of Newport Beach, California. One street is the primary traffic artery for the general area, the other is a typical street of a better residential neighborhood. At the rear of the property is a 20'-0" alley which provides for service. There is a 20'-0" building setback on the primary street and the sideyard requirements are 4'0". However, at the side street there is an easement for underground utilities, which requires a building setback of 10'-0".

Zoning restrictions would have allowed 12 units on this parcel of land. The owner preferred to develop only 10, thereby allowing larger units and added amenities. Four of the apartments are two-bedroom units. The other six are two-bedroom, two-story studio type. The general plan has been developed as a balanced composition around a courtyard with a 15'-0" x 30'-0" swimming pool fronting on the principal street. On each side of the courtyard two two-bedroom apartments are stacked. The

(Continued on next page)

209

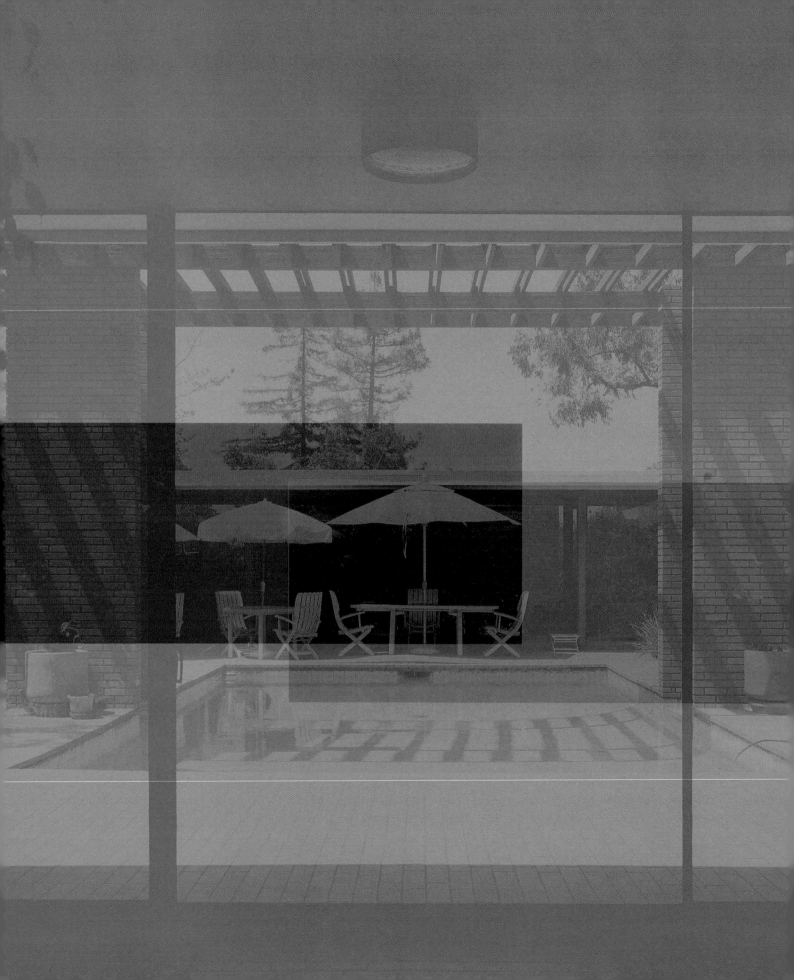

THE BUNKER OF THE LAST GUNSHOT

CSH #28

The CSH logo, disappeared and then replaced, resurfaces like an old crooner who reappears under the neon lights of Broadway for one last tour, after the farewell concert of a few years back, and of course at the behest of his loyal fans.

With nearly no text, the generous photos in the pages of the magazine, much like this final CSH, present a stylized carcass devoid of meaning and filled with a profusion of textures and carpets that saturate the space with a surface of a typical décor that is submerged in the sixties. Beige, chestnut, shag and leather in the interior adorn the magazine advertisements from May 1966. A jumbled interior with bricks throughout the exterior cover this modern mausoleum designed by the architects of CSH #20, Buff, Straub and Hensman. A decorator staged the interiors, signaling the end of the program, as if good design no longer sufficed but rather necessitated a final re-animation. We are offered an infinite mirroring of everyday objects, where the sometimes annoying flavor is soon enhanced by a saccharin sweet and anesthetic beige décor definitely the taste of condiments.

An interior and exterior brick sauce – generic elements of a housing development – are this time used towards constructive and innovative ends, nonetheless still managing to drown the pure lines in a thick and omnipresent bonding agent. Sponsored by a corporation and a brick manufacturer, it is designed as a backdrop through the lens of promoting this material.

Enormous and folding back on itself, looking at itself while renouncing the natural surroundings, CSH #28 hides away in a corner of Thousand Oaks, one hour north of the city of angels, in a private sanctuary of residences for a well-to-do bourgeoisie, indeed in a ghetto where money replaces the distinction of skin color. It is like at Bel Air, where one has to enter with heavy limousines that move sluggishly in the direction of the sunny hills. The lawns follow one another, with sometimes an address number engraved on a stone lying there like others dispose of their gnomes on their green surfaces all quasi similar to their neighbors – in a word, perfect. As one passes from one lawn similar to the next with groves groomed like docile poodles, a thick and flat slab floats above the identically trimmed shrubs in the shade

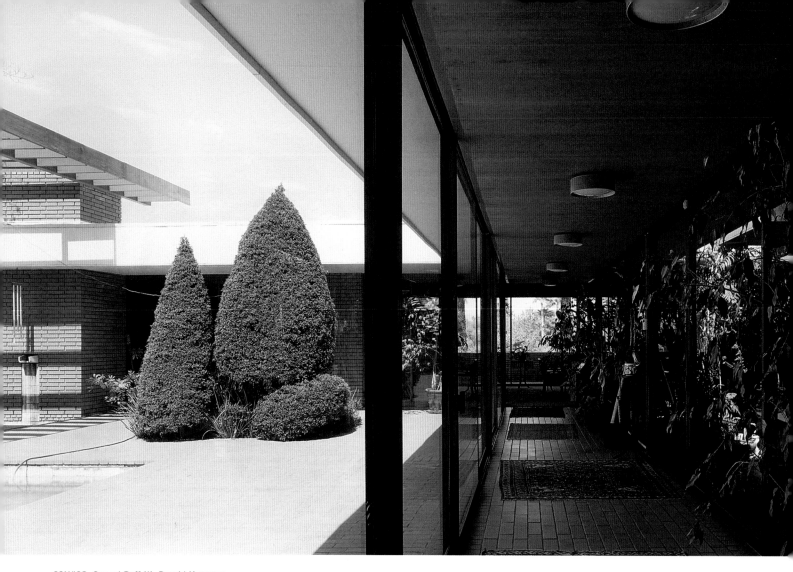

CSH#28, Conrad Buff III, Donald Hensman

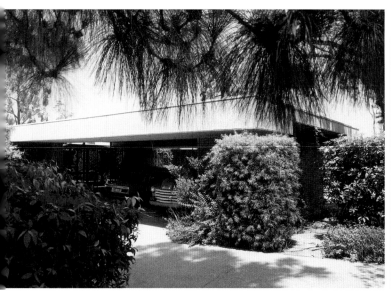
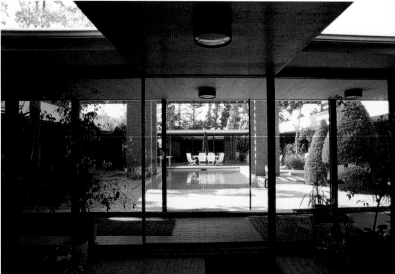

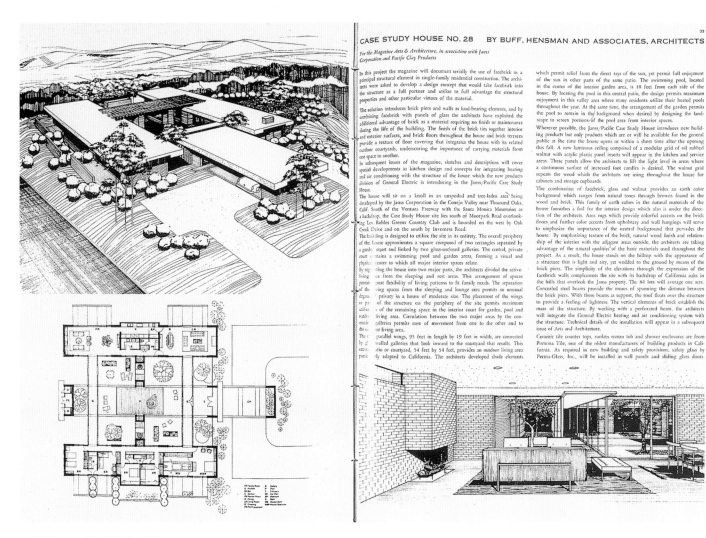

CSH#28, Conrad Buff III, Donald Hensman,
Arts & Architecture, July 1965

of the large pines within the over-refined décor. There is no more the large overhanging roof and the façade exposing with surety a window onto the good taste of today. An immense porch stretches out under a slab as thick as it is white, slicing the omnipresent green and blue. The concrete roof also floats above the bushes and solid brick walls, concealing the privacy of a family behind their impeccable rows. The materials of this project differ completely from those exploited in CSH #20; only the impression and the desire of spreading out and conquering the site remains. An incredible fluidity appears in this large masonry rectangle open at the center – a fluidity that is extended in the glass corridors that cross from one side of the sprawling edifice to the other. An excessive way of life moves away from the first investigations and publications crowned by innovations and precision. Julius Shulman photographs a top model straight out of *Vogue* magazine in this model, whose careful hairstyle and elegant dress echo the saturated and refined environment. CSH #28 is for sale like the young woman's dress promoted in the glossy pages of the magazine. The house unveils itself around a patio, which the two bars of the house program face. These two arms accommodate day and night activities, both oriented towards this ideal center, the pool reserved for leisure activities.

The swimming pool defines the size of the model, much like a Tatami mat, arranged in staggered rows, while also echoing the framing of the brick. Barbecuing, swimming, and reading, perhaps doing nothing. CSH # 28 thus offers itself as a fortress with nothing to defend but the

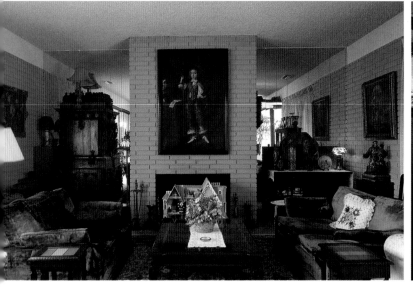
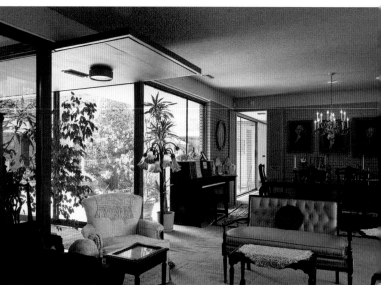

214 CSH#28, Conrad Buff III, Donald Hensman

ultimate luxury of its central void. I am swallowed up by this shaft of light and energy. Vast, the rooms follow one another and define the center, leaving the eye to wander to the balcony of the master bedroom, which is on axis with the glazed corridor. The image from the magazine comes back to me, and is akin to a classical drawing and to the constructed perspectives of the Renaissance with the addition of a top model, but minus the Italian sky.

Two piles of overscaled and monumental brick encroach on the pool, approaching a scale in itself Wrightian and strange in this introverted space. This feeling of excess, of waste, and of heroic creation occurs like a malady that has set in after the initial wonderment of the site has passed. I had a hangover after the intoxication of this mausoleum's discovery, there amidst a mediocrity displayed and pronounced like a conventional manifesto of the go-getter American bourgeoisie having arrived in this subdivision – what wonderment and surprise to see a suddenly desirable object situated among not much.

The program's breathlessness and the empty idling of a machine are the causes of this production to be washed up on the reefs of time and decorum. The bunker's last gasp folds in on itself by proposing a way of life that had become artificial. The weight of the materials and of the time win over the lightness of the program and its ambitions, which establish the best and the quest as pathways of freedom, development and invention and at the same time the desire for the future and for progress as driving forces of creation.

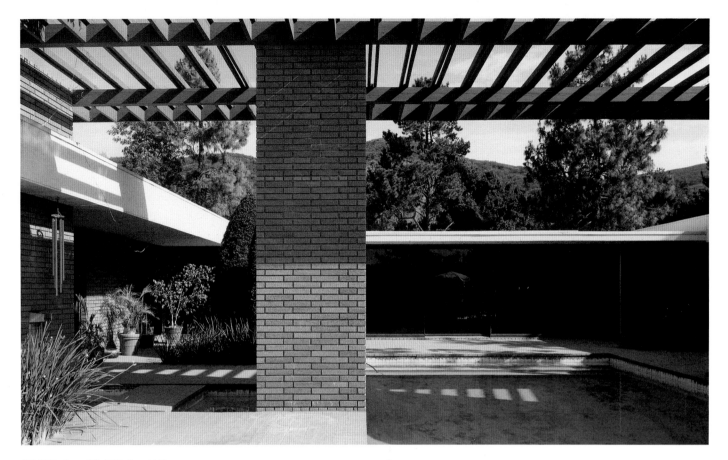

CSH#28, Conrad Buff III, Donald Hensman

We are far from the open projects inviting nature's wealth to enter and dissolve within the uncertain limits of the model home's contours. The brutalism omnipresent in the second half of the sixties no longer has the same magical presence of the first semi-industrial and industrial objects of the postwar period.

The CSH program seems to be nervous around this last void, about the impossibility of inventing a new model of life inspired by its manifesto of January 1945. It is frozen in a modern style that is no longer capable of regenerating and opening itself up to contemporary American society.

Without a doubt, the program is at odds with the societal project to which Americans aspired in 1966. The societal project contained in the writings of John Entenza no longer exists, absorbed by other desires and other inventions like the television, since almost none of the projects would take into account this latter phenomenon as a popular aspiration for family leisure. The elitism would remain a reduced format of distribution and a narrow framework for militancy, despite the great paths of reflection and design displayed in the pages of the magazine.

Folded in this mausoleum, the program buries itself; no more publications, and no other project follows this folding, this state of siege of an imploding fortress, certainly of intoxicating form, but of abandoned content.

Top-model model

I go back to Los Angeles bitter. Slowly the freeway ribbons of the city of angels excite the senses and become this euphoric drug for the driver. The flowing character of the drive affects the obscure and Californian side lying dormant in every European. I think of Jean Nouvel describing during a conference the intoxication of the driver on these freeways of pleasure. Immediately, Wolf Prix would condemn this romantic aspiration, opposing it to the idea of listening to a song by the Rolling Stones, the latter a more sexy kind of intoxication. Great romantic of a tarnished myth, Prix had no doubt forgotten that the group existed prior to the howlers, all of whom had committed suicide, roaring in a thunderous way on the radio in my Japanese car, suddenly a white rocket on the black band of asphalt; surely it was the romanticism of the freeway, as well as of the top-model houses.

Nevertheless I could not help myself but think of my interview with Pierre Koenig. He had not regretted the disappearance of the CSH. To him they were models, and their international influence had succeeded in contaminating the production of postwar single-family homes for more than twenty years. Yet contrary to their influence, the copy was not valid, intervening everywhere with a dose of homeopathy, and making an indelible mark on global production. Luxury top-models stimulate the desire of consumers and readers of the slender and elegant *Arts & Architecture*, not unlike the contemporary top models in fashion magazines – a desire of changing and changing oneself, a desire of the senses and of images, of a dream glazed over the beautiful pages in black and white.

A model of life that is nonetheless accessible breaks this mirror logic; only the desire and the mechanisms of seduction merge in the images made by architects, photographers, and sorcerers – graphic designers.

One can love the houses for what they were, for what they embodied, and for what they are today: At times sad and scratched-up by time, sometimes gleaming like sumptuous race cars, other times non-existent but on paper, an aspiration abandoned by men. I love them for their faint dream-like scent, those machines of war meant to gently transform mankind.

PRICE 35 CENTS

architecture

JULY 1945—CASE STUDY HOUSE #3—IN

PAPER ARCHITECTURE

"I hope that it is clear that the architects of this century have always actively engaged in an interdisciplinary discourse that uses the media to blur the line between high and low culture, art and commerce, and that the house is their polemical vehicle. To think about the architecture of the twentieth century will be to rethink the house/media interface." [56]

Beatriz Colomina

Since its announcement in the magazine in January 1945 and to this day, the Case Study House program remains perennial in its planning and its style, above and beyond its creation of a historical undertaking. Thanks to the national and international publication and circulation of its models, which affirmed during those years projects that were anchored in a contemporary modernism, the stylistic refinement of the Case Study Houses still enforces the program today as an important architectural reference of the past century, in fact never ceasing to illustrate the subtlety of the magazine's influence.

ROLE PLAY

We deduce that this unique experiment was born out of editorial will. Through the "live" 225
publications of the houses and by the program's longevity, [57] *Arts & Architecture* and its
publisher John Entenza participated actively in the elaboration and fabrication of a series of
houses promoting "good living."

Since Entenza took an active part in the praising of architecture, he openly inaugurated the
role of the publisher in architectural production with the Case Study House program. He
made of the house his favorite field of investigation, joining it with a moral and philanthropic
act, namely that of making available and possible a place for living to anyone in search of
accommodation and flourishment. He declared that the house was the most satisfying and
liberating typology of the architect's production.

From the announcement of the program, the magazine served as a charismatic client. In pre-
establishing this new order, this announcement defined a whole series of game rules, by
setting the parameters of this architectural universe set by this command. The first consequence
was revealed with the manipulation of the houses that were disclosed in the pages of *Arts &
Architecture* throughout their designs and completions, as much as in the popular picture
books of the time. This vision of domestic space was shared and enriched by all the participants
that gravitated around the magazine, from the publisher himself to the manufacturers and
entrepreneurs.

The houses became the pretext and the principal support for numerous advertisements in
the columns of the magazine. Mediatized before even being designed or built, they were the
tools and instruments of an idealized vision. Then, as they were visited and thus subjected to
public scrutiny, they rapidly acquired the equivocal status of model homes.

Since in English a scaled study is called a "model," and a sample built to scale is a "model
home," we notice an amusing linguistic parallel referring to the architectural short cut
between the house and its miniaturized version.

Client

"Architects will be responsible to no one but the magazine, which having put on a long white beard, will pose as 'client'." [58] Without ambiguity, this title personalized the magazine that was presented as the client, a thinking body managing and dictating the impending procedures of the adventure. The traditional client would no longer be the future inhabitant of the house, as such altering the usual relationship between the architect's work and the user.

"A program announcement" in January 1945 restricted the field of architecture to a minimum, interesting itself in nothing but the domestic space of the single-family home. It put in place specific architectural and aesthetic criteria elaborating the principle or concept of the "postwar house," which responded to contemporary aspirations. While the procedures that were derived from military techniques and the recycling of materials in their production were essential in Entenza's eyes, they would have to be at the service of a quality of life underlining the promise of a better life, in which the environment would be shaped by the design.

In January 1945, the choice of the eight initial architects who were invited for the design and construction opened the project with a furnished house, filled with objects chosen and put into place. The principle of a finished house with key in hand entered into development. Taking on the measure of responsibility for the architectural production, the publisher gave the designer a fundamental role, to manage the design of the house in a continuous and global way, assuring the supervision of choosing interior objects as well as the work of the landscape architect.

Entenza's ambition had been to give a sense of reality to architectural thought. The magazine proposed "eight houses, each to fulfill the specifications of a special living problem in the southern California area." [59] In addition to the climate in Los Angeles, reference was made to an ideal of life, an environment in which the Californians were predestined to live outdoors, bringing back to current tastes a forgotten tradition of hygienics.

At the time of his departure in 1962, Entenza would relate that "Our first intention, of course, was to offer the architect a maximum opportunity with a minimum of restriction; and in most cases, I think those opportunities were rather fully realized." [60]

While guaranteeing the artistic direction of the program, *Arts & Architecture* concretized the venture by inviting entrepreneurs and material suppliers to participate as sponsors in exchange for publicity. Without explicitly stating it, they also invited all those readers interested in purchasing this CSH to give notice in order to acquire a house at a lower cost. This commitment went hand in hand with the magazine's right to exploit through media the object of desire in its pages. Despite the numerous participants who joined in the mastery of the projects, the magazine remained the "client," the direct and sole respondent to the architect, having to react to constraints of publication and sign-off dates.

A plot was supposed to be acquired in La Cañada, Los Angeles, in order for the Case Study Houses to be built there; it was envisaged as an exhibition park, a plot awaiting infrastructure. After many attempts and numerous promises, only CSH #15 was built there, leaving aside the never built CSH #5, [61] #6, and #13, while #1 and #3, which were foreseen, migrated to other destinations. The site situated in Pacific Palisades was more of a success. Bought by the Eames couple and by Entenza and then divided into lots, it accommodated four CSH not counting CSH #19, which was later abandoned, then rejected by the program. One would have to wait until 1948 before the first CSH, namely #18 and #20 would be built there, followed closely by #8 and #9.

228

the case study house program

Because most opinion, both profound and light-headed, in terms of post war housing is nothing but speculation in the form of talk and reams of paper, it occurs to us that it might be a good idea to get down to cases and at least make a beginning in the gathering of that mass of material that must eventually result in what we know as "house—post war".

Agreeing that the whole matter is surrounded by conditions over which few of us have any control, certainly we can develop a point of view and do some organized thinking which might come to a practical end. It is with that in mind that we now announce the project we have called THE "CASE STUDY" HOUSE PROGRAM.

The magazine has undertaken to supply an answer insofar as it is possible to correlate the facts and point them in the direction of an end result. We are, within the limits of uncontrollable factors, proposing to begin immediately the study, planning, actual design and construction of eight houses, each to fulfil the specifications of a special living problem in the Southern California area. Eight nationally known architects, chosen not only for their obvious talents, but for their ability to evaluate realistically housing in terms of need, have been commissioned to take a plot of God's green earth and create "good" living conditions for eight American families. They will be free to choose or reject, on a merit basis, the products of national manufacturers offering either old or new materials considered best for the purpose by each architect in his attempt to create contemporary dwelling units. We are quite aware that the meaning of "contemporary" changes by the minute and it is conceivable that each architect might wish to change his idea or a part of his idea when time for actual building arrives. In that case he will, within reason, be permitted to do so. (Incidentally, the eight men have been chosen for, among other things, reasonableness, which they have consistently maintained at a very high level.)

We will try and arrange the over-all plan so that it will make

fairly good sense, despite the fact that building even one house has been known to throw a client off balance for years. Briefly, then, we will begin on the problem as posed to the architect, with the analysis of land in relation to work, schools, neighborhood conditions and individual family need. Each house will be designed within a specified budget, subject, of course, to the dictates of price fluctuation. It will be a natural part of the problem however to work as closely as possible within this budget or give very good reasons for not being able to do so.

Beginning with the February issue of the magazine and for eight months or longer thereafter, each house will make its appearance with the comments of the architect—his reasons for his solution and his choice of specific materials to be used. All this predicated on the basis of a house that he knows can be built when restrictions are lifted or as soon as practicable thereafter.

Architects will be responsible to no one but the magazine, which having put on a long white beard, will pose as "client". It is to be clearly understood that every consideration will be given to new materials and new techniques in house construction. And we must repeat again that these materials will be selected on a purely merit basis by the architects themselves. We have been promised fullest cooperation by manufacturers of products and appliances who have agreed to place in the hands of the architects the full results of research on the products they intend to offer the public. No attempt will be made to use a material merely because it is new or tricky. On the other hand, neither will there be any hesitation in discarding old materials and techniques if their only value is that they have been generally regarded as "safe".

Each architect takes upon himself the responsibility of designing a house which would, under all ordinary conditions be subject to the usual (and sometimes regrettable) building restrictions. The house must be capable of duplication and in no sense be an individual "performance".

All eight houses will be opened to the public for a period of from six to eight weeks and thereafter an attempt will be made to secure and report upon tenancy studies to see how successfully the job has been done. Each house will be completely furnished under a working arrangement between the architect, the designer and the furniture manufacturer, either to the architect's specifications or under his supervision.

This, then, is an attempt to find out on the most practical basis known to us, the facts (and we hope the figures) which will be available to the general public when it is once more possible to build houses.

It is important that the best materials available be used in the best possible way in order to arrive at a "good" solution of each problem, which in the over-all program will be general enough to be of practical assistance to the average American in search of a home in which he can afford to live.

We can only promise our best efforts in the midst of the confusions and contradictions that confront every man who is now thinking about his post war home. We expect to report as honestly and directly as we know how the conclusions which must inevitably be drawn from the mass of material that these very words will loose about our heads. Therefore, while the objective is very firm, the means and the methods must of necessity remain fluid in order that the general plan can be accommodated to changing conditions and conceptions.

We hope to be able to resolve some part of that controversy now raging between those who believe in miracles and those who are dead set against them. For average prospective house owners the choice between the hysterics who hope to solve housing problems by magic alone and those who attempt to ride into the future piggy back on the status quo, the situation is confusing and discouraging. Therefore it occurs to us that the only way in which any of us can find out anything will be to pose specific problems in a specific program on a put-up-or-shut-up basis. We hope that a fairly good answer will be the result of our efforts.

For ourselves, we will remain noncommital until all the facts are in. Of course we have opinions but they remain to be proved. That building, whether immediate or far distant, is likely to begin again where it left off, is something we frankly do not believe. Not only in very practical changes of materials and techniques but in the distribution and financing of those materials lie factors that are likely to expand considerably the definition of what we mean when we now say the word "house". How long it will take for the inevitable social and economic changes brought about by the war years to affect our living standards, no one can say. But, that ideas and attitudes will continue to change drastically in terms of man's need and man's ability to satisfy that need, is inevitable.

Perhaps we will cling longest to the symbol of "house" as we have known it, or perhaps we will realize that in accommodating ourselves to a new world the most important step in avoiding retrogression into the old, is a willingness to understand and to accept contemporary ideas in the creation of environment that is responsible for shaping the largest part of our living and thinking.

A good result of all this then, would, among other things, be a practical point of view based on available facts that can lead to a measurement of the average man's living standards in terms of the house he will be able to build when restrictions are lifted.

We of course assume that the shape and form of post war living is of primary importance to a great many Americans, and that is our reason for attempting to find at least enough of an answer to give some direction to current thinking on the matter. Whether that answer is to be the "miracle" house remains to be seen, but it is our guess that after all of the witches have stirred up the broth, the house that will come out of the vapors will be conceived within the spirit of our time, using as far as is practicable, many war-born techniques and materials best suited to the expression of man's life in the modern world.

What man has learned about himself in the last five years will, we are sure, express itself in the way in which he will want to be housed in the future. Only one thing will stop the realization of that wish and that is the tenacity with which man clings to old forms because he does not yet understand the new.

It becomes the obligation of all those who serve and profit through man's wish to live well, to take the mysteries and the black magic out of the hard facts that go into the building of "house".

This can be and, to the best of our ability, will be an attempt to perform some part of that service. But this program is not being undertaken in the spirit of the "neatest trick of the week." We hope it will be understood and accepted as a sincere attempt not merely to preview, but to assist in giving some direction to the creative thinking on housing being done by good architects and good manufacturers whose joint objective is good housing. —THE EDITOR.

John Entenza

Entenza commissioned two houses that were engaged with their time. Passionate about modern regional architecture, he found in them the qualities and potential indispensable to the demands of people, whose demands competed with the high technology of those tools manipulated during the war: "The house is to be a simple and straightforward expression of the living demand of modern-minded people wishing to cope with their living problems on a contemporary basis." [62] Entenza questioned the attachment "to the symbol of 'house'," as we know it, and dismantled the "old forms" connected to this idea. He suggested that it was important for the new world to accept contemporary ideas that would be "responsible for shaping the largest part of our living and thinking," and considered that the house produced would be "conceived within the spirit of our time." He concluded as follows: "What man has learned about himself in the last five years will, we are sure, express itself in the way in which he will want to be housed in the future."

His attraction for the single-family house appeared distinctly in the monthly programming of his magazine, constituting the majority of architectural projects published. He published few small-scale projects other than domestic ones, and no large-scale architecture whatsoever. Furthermore, equipment and urbanism were hardly mentioned. We should remember that the place and interest given to the single-family house in the United States are fundamental in a context such as Los Angeles, where the architecture is essentially suburban.

Arts & Architecture was neither completely oriented towards a female public, nor did it specialize exclusively in the technique of building, or as an art journal. In the pages, one could skim past varied themes dealing exclusively with contemporary production in film, literature, music, architecture, and industrial design. Through these media, the contents of the magazine summarized in a coherent way Entenza's preoccupations that interested and enriched his life. Construction was treated with the same refinement, and became the pretext for turning ideas into concrete results. Among the different subjects tackled, the house as common denominator took on a critical and active place. At once collective and individual, the domestic

space was fascinating because it was easily adaptable. The publisher used the adjective "good" in order to promote vigilance and quality as irreducible values, and "on housing being done by good architects and good manufactures whose joint objective is good housing."

Owning a home, savoring it and taking advantage of it; this was not only a dream, but could become reality and a source of coveted happiness. Like a skin that one would inhabit or clothing that one would wear, the design rapidly became an enunciation of signs and of will. Entenza spoke then of a behavior of identification, recalling his house, CSH #9, and others belonging to the program: "This house like the other (which is a part of the same overall project) is, among other things, the statement of an attitude."[63]

Can one speak of a founding act? Are thirty-six designed houses representative of a heroic step, since in this same period some architects like Richard Neutra, Frank Lloyd Wright or Le Corbusier accumulated hundreds of house projects? In light of their exemplary work, can one really put into perspective the modest scale of production of the Case Study House Program? This strange comparison emerges out of a rebellious desire to respond by means of other slightly insolent questions, drawing nearer to the reaction of an only child, and to the enunciation of even finer points.

How many clients had thirty-six houses designed, of which twenty-six were built? How many clients would repeat the experience like an obsession, an altruistic and didactic mission to improve the built universe of the American family within the "minimal house," indeed minimal? How many clients would use media via so many angles without becoming slaves to them, responding to the current rules in order to promote a better life for all within a better environment? How many magazines would assume the role of a critic in such a way, rejecting commercial criteria in favor of the experience of life? How many architects would participate over a period of twenty years, and would have the opportunity to ask the same questions and to respond to them differently, in tying them together, in rediscovering them, and in finding their way around them? How many programs would open as many doors to themes inciting exploration and production that are still today sources of research? How many clients would

succeed in reaching an international public to this day, lavished with a sense of architectural ethics, influencing a way of life, and indeed a way of behavior? How many magazines would take such a personal stance and would make such a persistent and enduring impact on the architectural production of the single-family house?

If the program's stakes can assume commercial realities, its ideological dimension explains its longevity. For seventeen years Entenza answered for, and led the magazine the way he led the construction of the houses. The coherence of the "movement" was due to the coherence of this man's thought of his time and of his aesthetic universe, which he knew to shape and establish with rigor. The role of the publisher was not solely that of an instigator-builder, but also that of a promoter of knowledge of, and appreciation for, an art of good design that was close to the user and to architecture. His first studies in diplomacy and his communication abilities drove him to be an energetic emissary of modern architecture. His studies then prepared him to fulfill the functions of director at the Graham Foundation for Advanced Studies in the Fine Arts.

After his departure from the journal in 1962, he would remark: "On the whole I feel that 'Arts & Architecture' has been a good client. At least a patient client, and in some cases a long suffering one." [64] He would add that the role of the Case Study Houses was to influence global architectural production: "(The) Case Study House program continues to enrich the broad field of domestic architecture where the architect most often gets his most personal and important opportunities to try his talent." [65] Through the design and construction of the houses, Entenza was the architectural catalyst, the publisher of architectural talents, and thus participated in the writing of a page in the history of architecture. The integration of the houses with media from the time of their conception – emphasized today by the constant publication of photographs – renders the program fervently present in our imagination and participates in the construction of our contemporary memory.

Yours ...GREATER FREEDOM OF DESIGN
WITH **MODERNFOLD** FOLDING DOORS

Smooth-operating Modernfold Doors—
the *only* accordion-type folding doors
with balanced pantograph hinge
construction—give architects and builders
the really practical solution to design
problems for maximum space use.
Modernfold Doors eliminate unsightly
and wasteful "door swing" areas . . .
act as ingenious room dividers
when used as folding walls.

Vertical steel rods extend from
the top row hinge plates through
intermediate hinges to bottom
hinge plates—*welded to each!*
Completely integrated pantograph
frame operates with smooth center
line pull—resists side sway.

In homes, schools, offices and factories—
wherever there's a need for folding
walls or doors—there's a place for
Modernfold. Write today for booklet
illustrating the uses of Modernfold
Folding Doors.

only **MODERNFOLD** *gives you*
all these exclusive features

Pairs of hinge plates of
equal size interlaced to
form an "X" double
hinge.

Three track sizes, engi-
neered for specific door
size.

Trolleys attached at
hinge intersection for
easier operation.

No cornice needed—
fabric hides hinges,
track and trolleys.

More insulating air
space between door sur-
faces. Sound insulating
liner optional.

Washable vinyl-coated
fabric covering in wide
range of decorator
colors.

More vertical steel rods
than any other door.
Welded, not crimped, to
hinges.

Same number of project-
ing folds on both sides.
Perfectly centered be-
tween jambs.

modernfold
DOORS

spacemaster line
custom line

MODERNFOLD DOORS, INC.
3836 E. Foothill Blvd.
Pasadena 8, Calif.
RYan 1-5185

MEDIA HOUSE

The Case Study House knew to place itself at the center of publications, beating to the rhythm of serials, retracing each step of its transformation, covering its conception and construction until its delivery. Once completed, it was open to the public for six to eight weeks. For the first time, the drawings and then the photographs played a fundamental role in the perception of archiitecture: The house became a living catalogue, a space that was both intelligent and enlivened. Each detail was treated with respect to different media, thereby accentuating and favoring one point of view above others in order to emphasize Entenza's objectives and to promulgate his vision of modern architecture and its role.

House as manifesto

Loaded with a pedagogical mission, the house projects are not solely functional or decorative. Their ideological content poses them as critical, social, political, and economic references. The houses deploy, expose, and open themselves to the gaze of the reader, then the visitor. They produce the materialization of a critical reflection on the single-family house and on the family, as well as on postwar society.

The houses encourage the activities of family members, thanks to an ease of house maintenance. The spaces in open plan, where the kitchen is open to the sitting room, no longer isolate the wife to an autonomous room. Each room has access to the garden, allowing relays between interior and exterior, thereby making of the garden a living room within the hygienic tradition of the benefits of sunshine and in light of the emergence of a leisure culture. The houses question and reveal the space of the rooms among each other, of the rapport of night and day spaces, and of the relationship between the garage and the kitchen. They impose the modernism of the flat (or almost flat) roof; Entenza did not explicitly state this criterion, but did build the program as an alternative to eclectic, "traditional" housing models. The Case Study Houses stress the integration of advancing media and technology and participate in the electrification of modern domestic life.

They interrogate the place of the car, ask questions regarding the post-atomic family, postwar American modernism, the war, the "minimal house" and standardization, while evoking still other themes. They concentrate on the notion of good living, they lay out the "California way of life" by integrating leisure activities in the house's plan, while absorbing the principles of functionalist architecture contained in Mies' adage: "Less is more."

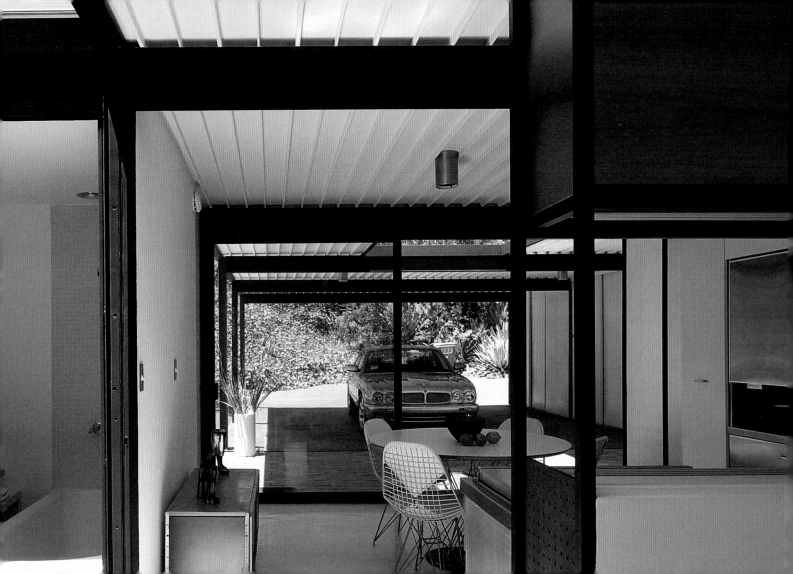

OBJECTS SELECTED FOR THE 1950 CASE STUDY HOUSE BY RAPHAEL SORIANO, ARCHITECT

X-Ray house

238 CSH#1950, Raphael Soriano, *Arts & Architecture*,
 October 1950

With the passing of the months, the issues devoted to a single house were worthy of a detective novel, where each detail was passed through with a fine-toothed comb – a sort of investigation or ultrasound of construction, a revelation of intimacy. The house was treated as an object of desire, whose genesis the magazine recounted by revealing little by little the project's progress. We note that the explanatory texts gradually gave way to the drawings and photos during the course of the projects' completion. The photographic reporting also covered the assembly of the work site and of chosen implementations, and turned its attention towards the efficiency of one technique or another.

The magazine shows and unveils; it fabricates the myth of the modern house, and participates in the disclosure of its principles. The house is also modern because it is produced through the eyes of media that encourage a particular reading characteristic of its time, showing the coveted object in a chosen light. In her article entitled "The Media House," Beatriz Colomina [66] discusses the architecture of the single-family house in the twentieth century as being a vehicle of outstanding architectural ideas of this century, thanks to its exploitation by the media. She writes that the media used by the architect are no longer solely his or her traditional tools (plans, sections, and models), but rather modes of representation that borrow their vocabulary from popular culture: Through its representation, the house acquired the status of a model home, constructed at one-to-one scale, and had been introduced from the turn-of-the-century in expos and fairs; it went as far as to be joined with the space of the museum (MOMA in New York, 1949), and also had its introduction in department stores. Simultaneously, the life-size house [67] was highlighted by photography and took its place among womens' magazines; it was the object of advertisements, of films, and of television.

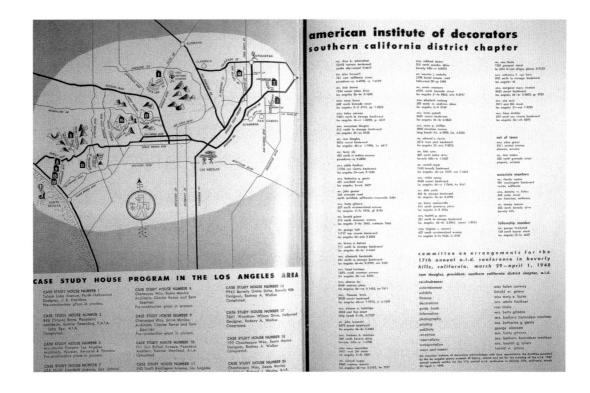

Arts & Architecture, March 1948

Sample house

"All eight houses will be opened to the public for a period of from six to eight weeks and thereafter an attempt will be made to secure and report upon tenancy studies to see how successfully the job has been done. Each will be completely furnished under a working arrangement between the architect, the designer and the furniture manufacturer, either to the architect's specifications or under his supervision." [68]

Entenza borrowed the vocabulary of the life-size house in order to share his vision of the ideal home with the public. He embarked on an adventure of the prototype at one-to-one scale, with the assistance of the architect, hoping that these high quality architectural examples would convince the real estate developers of the benefits of modern architecture. He combined this notion of prototype with the interior space and furnishings, making of this unity a dynamic element of the house that generated the plan rather than submitting to it. In contrast to examples previously mentioned, the Case Study Houses were built on specific sites; they were inspired by their contexts that in turn modified their foundations and orientation.

The very first house that was visited, CSH #11 designed by Julius Ralph Davidson, could boast receiving 55,000 people who rushed in to see the home defined as a "GI house." Built in 1946, it was associated with the title CSH #1, since it was the first of the program houses to break ground. Each house knew the same fate – that is, the same success; each was visited by crowds who were fond of the dream and of the new images created.

Six months after the public's visit, the magazine's "tenancy study" board – officially established at the time of the program launch – gathered commentaries from the inhabitants that noted the errors and successes of the architect and builder. The occupants of CSH #11 replied to the journal's request in the March 1947 [69] issue and revealed certain problems such as the excessive presence of the ventilation, the humming of the fluorescent tubes, or the vibration of the front window frames, from which a leakage of water was noticeable. The board was coolly provocative in terms of its "reality show" quality, presenting an anti-commercial, even politically incorrect dimension. If this experience found its end point here and was never

repeated, that single published testimony informs us today of the occupation of the projects, and of their inhabitants' every day life.

Beyond the means utilized, Entenza maintained a sober and elegant distance, never showing images of the visits in the magazine nor divulging the fact of them being met with success, as if he was almost embarrassed by this publicity effort. He put a kind of mailbox at the disposal of the architects, builders, and readers of his magazine, like a center where only the sites and dates of visitation were announced at the very end of the photographic coverage of the completed houses.

Although the houses were meant to be inhabited, Dolores Hayden [70] writes that the houses were built more to be seen than to be bought. The number of visitors received for the first six houses visited was 368,554 [71] – a remarkable performance if one takes into account that the houses were open for the most part only on the weekends. In the same spirit, Hayden adds that Entenza chose a trilingual secretary of European languages in order to maintain a foreign connection, preferring international fame to publicity among local developers.

In this context, the creation and sale of the houses through the magazine as intermediary redefined the traditional order of the data. By toppling the traditional relationship between project manager and client, this mediated phenomenon undoubtedly contributed in profoundly transforming the rapport between architecture and assignment and their connection to the image – to the point where one may wonder if the very nature of domestic architecture itself was transformed.

CASE STUDY HOUSE 17

DESIGNED BY CRAIG ELLWOOD

Some time ago we announced two new Case Study Houses, No. 17 and No. 18, both to be done by Craig Ellwood. Despite the usual assortment of vapours and excursions, alarms and frustrations, including a strangulating rock and gravel strike in the area, which held up construction for months, the first of this pair, Case Study House 17, is now open for public inspection Saturdays and Sundays from 2 until 5 p.m., through March 4, 1956.

We consider it certainly one of the handsomest of this long series of building ventures and hope for a general agreement that it sustains the high quality of creative thinking we have tried to bring

to this continuing program. We have, since 1945, attempted to give reality to progressive and provocative ideas in modern domestic architecture. Since its inception, No. 17 has been opened to the inspection of an interested public as a continuing demonstration of fresh approaches to structural techniques and use of materials in the contemporary house. A full photographic treatment of the project will appear in our March, 1956, issue.

The following pages show plan and elevations of the second and smaller of the two houses. It is planned to go into construction as soon as it is practical to do so.

CASE STUDY HOUSE 17
LOCATION: 9554 HIDDEN VALLEY ROAD, BEVERLY HILLS
OPEN TO THE PUBLIC SATURDAYS AND SUNDAYS FROM 2 TO 5 P.M.,
THROUGH MARCH 4, 1956

SPONSORS

The relays between the magazine, photography, advertising, materials and techniques present a stream of media forms and as many angles of vision, such that one wonders in what scale the media forms dominate the object.

Arts & Architecture did its own advertising for the CSH program. This self-promotion was followed by that of the manufacturers eager to participate in the experience that they sponsored and de facto co-produced. Over the course of time, the CSH program became on its own the principal support and source of the magazine's promotion. [72] "Merit Specified" assumed the label of quality endorsed by the magazine. This designation was a guarantee, present in the pages under the form of material or product descriptions used in the construction and composition of the house.

Recycling

"The house … will be conceived within the spirit of our time, using as far as is practicable, many war-born techniques and materials best suited to the expression of man's life in the modern world."

Anticipating the lifting of restrictions, in January 1945 Entenza placed his program in a strategic position. He centered experimental research on materials born out of the military industry that he would divert from their original role, thereby substituting a military role with a civilian one. This notion was not devoid of a pacifist leaning, and in fact contributed to the fabrication of happiness. It participated in the widespread recycling campaign in the United States, anticipating the postwar years and the reorganization of the country. Entenza encouraged architects to experiment with new materials and techniques brought to the market. In this context, Edward Killingsworth likes to recount that the door he designed for CSH #25 was assembled following the materials and principles of an airplane wing. [73]

Its three ton stomach
started with a window screen

When the CG4A Glider disgorges men and materials on a new air held front, give a service ribbon to Ceco metal window screens.

For from the engineering and manufacturing skill absorbed in the manufacture of this lightweight, rugged, metal frame screen came hundreds of glider fuselages for the Army Air Forces.

The fabrication of gliders requires the full use of Ceco's engineering skill and experience with lightweight metals. And depend on it—the additional skills learned in the fabrication of this remarkably tough, serviceable Glider will produce an even finer CECO screen for every type opening after the war.

No job, no opening, too difficult for CECO to screen

Ceco became the largest manufacturer of custom made screens in the world because Ceco brought to the making of screens the designing ability and precision workmanship of an engineering company. Ceco has solved the most difficult screening problems through better engineering, often redesigning and rebuilding openings before screen installation.

The large proportion of CECO screens in government buildings . . . over 500 U. S. post offices from coast to coast, veterans' hospitals, Federal court houses, Treasury Department offices, etc., is proof for architects of the outstanding quality of this Ceco product.

7 reasons why you should specify Ceco Screens!

1. Greater strength and rigidity . . . all Ceco metal frame screens are made from cold rolled light gauge metal or extruded sections, all corners expertly welded for additional strength.

2. Your choice of steel, aluminum, bronze, or copper frames finished in any color specified . . . paint always baked on. Choice of any screen cloth, including Koolshade.

3. Ceco screens are rustproofed. Ceco steel frame screens are given a special protective bonderizing treatment.

4. No warping, shrinking, or swelling with Ceco metal frame screens. Assured ease of operation, installation and removal.

5. No storing problem with Ceco metal frame screens. Easy to stack . . . no danger of breakage.

6. Ceco metal frame screens are lifetime screens. Wearproof, termite proof and rustproof.

7. Ceco screens cost no more . . . cut maintenance cost to minimum, providing substantial savings over a several year period.

CECO STEEL PRODUCTS CORPORATION
General Offices: Omaha, Nebraska
Manufacturing Division: 5701 W. 26th St., Chicago, Ill.

(Ceco screen shown to the Ceco residential casement window . . . a sun maximum window of proven adaptability to all types of architecture in the residential and apartment field.)

OTHER CECO ENGINEERED PRODUCTS: All types of metal residential and industrial windows, all types of steel doors, metal lath, metal weatherstrips, steel joists, steel roof deck. Meyer Steelforms, adjustable shores and clamps, concrete reinforcing bars, and welded fabric.

ENGINEERING MAKES THE BIG DIFFERENCE IN CECO CONSTRUCTION PRODUCTS

The label "Merit Specified"

In proposing to disclose the description of the materials chosen by the architect of each CSH in the pages of the magazine, Entenza invests in the market above demand and takes very profound action on the prices of materials. These materials would be destined for the building shells and secondary work, and would mix a whole range of industrial products. Everything from kitchen accessories, to furnishings, to the toaster, cupboards, dishes, ventilation, wall clocks, dryer and the pool – indeed a swarm of products would appear in a jumble. Among the products selected for Rodney Walker's CSH #16, cosmetics made of essential avocado oil occupied a space of their own next to the shower doors or dishwasher. [74]

"Merit Specified" became the label of quality stamped on the products used for the construction of the house and on the implementation of techniques, highlighting the businesses that carried out the work. The spectacular advertisement "One rubber stamp that does mean something" [75] seals the label that, issued through *Arts & Architecture*, in its four years of existence "has become one of America's most trusted buying guides…" [76] This label, which was validated by the architect, guaranteed the aesthetics and the quality of the products as much as the availability of materials. [77]

Arts & Architecture, January 1945

Advertising

Arts & Architecture, October 1948

Like an honest author, the publisher controlled as much the magazine, its graphics, and content like an object as the built architecture. He also controlled the graphics for publicity news flashes that were used to get to know his program and to assure the promotion of the houses. An analysis of the *Arts & Architecture* issue from January 1945 reveals a magazine that is finely structured and that demonstrates the fundamental role of advertising. After an accounting of the pages and their contents – 56 in total – one notices that as many pages are used for advertising (23) as are dedicated to articles. Two dividers are found in each issue: The first – the summary page [78] – describes the contents of the magazine and the members of its editorial board, while the second [79] comprises Entenza's serial column, which covers news and social reflections, but rarely architecture. Graphically, these dividers are always doubled by an advertisement, in which the carefully chosen graphics are designed to favor the meaning of the text and seem to correspond with it. A similar parallel (with other issues) shows that, for several years, the fourth page was reserved for Klearflax carpeting advertisements. A formal choice to conclude the magazine can be interpreted as a nod to the surface and the texture of the cover. Entenza chose with care those advertisements that yielded to the times, intertwining texts and ads with a harmony that was strict and sensual, regulating with authority the choreography of these two worlds. [80] It is known that the publisher refused certain advertisements, or modified them such that they would respond to the general character of the publication, thus losing both money and sponsors. Color in the magazine on the whole was used frugally, in flat blocks and in an essentially primary palette; rarely did advertisements use colored photo illustrations, which were en vogue in the womens' press.

KLEARFLAX LINEN LOOMS—DULUTH, MINNESOTA

showrooms

New York
295 Fifth Ave.

Chicago
8436 Merchandise Mart

Los Angeles
812 West 8th Street

San Francisco
372 Merchandise Mart

It's **reversible**

KLEARFLAX

Sponsors

Behind the part of "client," Entenza and the contributors to the magazine acted patiently, independent and free from the support of a financial group. While the manufacturing and industrial sponsors were an important part of this independence, they appeared in the first years of the CSH Program at the service of the client. As the years progressed, the signs of their influence revealed themselves overtly. The manufacturers – also invited to participate in the program in exchange for their offer of materials and services – benefited from publicity in the magazine. In return, the architect was no longer so free to act, since he depended on the sponsors and their presence became evident through the use of certain materials.

In 1960, CSH #20 suffered from the conditions imposed by the sponsor, the California Redwood Association, who wished for the natural treatment of wood while the architect wanted to paint it grey. [81] CSH #26 was a study completely sponsored by Bethlehem Steel, who hoped to promote metal in houses. Sponsored by the Janss Corporation and Pacific Clay Products, CSH #28 was completely faced in brick. The houses were no longer attributable to an owner, but to the materials or technique that defined their identities.

Not only in very practical changes of materials and techniques but in the distribution and financing of those materials lie factors that are likely to expand considerably the definition of what we mean when we now say the word 'house'." [82] From 1945 on, Entenza knew from the outset that the relationship to a command structure was in the process of change, and that the parameters for buying would lead to accelerating the transformation of architecture. He also knew that the "definition" of the way of living would be dependent on these changes. However, he did not use his magazine as a promotional tool and did not present the retailer side of the venture, rather maintaining a modest distance vis-à-vis the building economy.

Here's how houses should be built...with steel

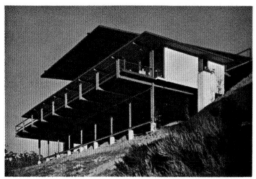

You can buy a house like this at Marin Bay. Contact the builder, 20th Century Homes. Architect: David Thorne; consulting structural engineer: Don Moyer. Steelwork by Solano Steel Corp.

*Steel for **Strength***

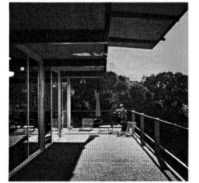

Consider the award-winning Harrison House, at Marin Bay in San Rafael, California. It is completely framed in steel. Steel for spaciousness, to replace the usual clutter of wood studs and bulky timbers. Steel for strength and *permanence*. This house can shrug off an earthquake, and didn't shudder when a helicopter landed on the roof.

Of course, it took time to put up the steel frame —nearly eight hours. Compare *that* with an ordinary frame house!

Wherever you live, your new home can be framed with strong, indestructible steel. If you'd like to see some examples, ask for our booklet, "The Steel-Framed House." Write Bethlehem Steel Company, Pacific Coast Division, Box 3494, Rincon Annex Station, San Francisco 19.

BETHLEHEM STEEL

project were selected by the designer on a "Merit Specified" basis.

Designed by Craig Ellwood
Consulting Engineers—
Mackintosh and Mackintosh
General Contractors—
David E. Harper

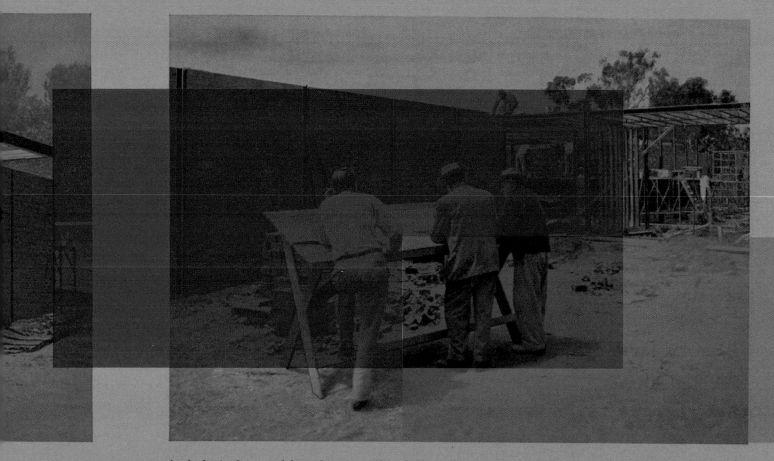

As the basic element of the architecture, all steel columns are exposed—giving a consistency to the design expression. 6″ terra cotta clay blocks contrast nicely with black-painted columns. Columbia-Geneva Steel Division, United States Steel Corporation, supplied steel for the project through Drake Steel Supply Co., Los Angeles. Fabrication by Raymond Welding and Equipment Company.

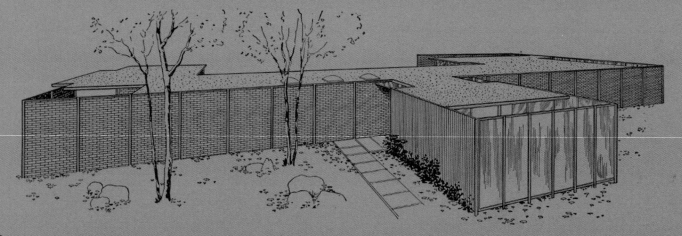

Western homes of the future are now building with steel... **UNITED STATES STEEL**

ARCHAEOLOGY

The archaeology studied here is that of the image, and in particular that of the published image. This iconography belongs to the public realm and participates in the memory of this period.[83] As shown, the images in *Arts & Architecture* became part of the reader's life. They influenced his environment in a daily way, such that he adopted the role of buyer and purchased furnishings represented in the images, or ventured into building a house.

SEDUCTIVE IMAGES

The drawings

The drawings published in the magazine appeared as an opportunity for the architect to express himself and, in some cases, to add humor, rigor and discipline. The graphic investigations seem to hold to the technical features of the publication and printing. Most of the time, the published drawings are rendered in ink, which favored duplication and guaranteed precision and legibility. They are simplified, thus allowing them to be scaled down for the magazine page. While the drawings appear in ink, this practice is actually less common in the United States, where they are generally done in pencil.

The lines of the plans are enhanced with varying weights, entailing the frames to be conveyed in different grey tones and different materials. Sometimes, they are accompanied by a flat color, which gives a rhythm to the black and white pages of the magazine. It would seem that the representation would go in tandem with the architecture. By the choice of an open plan, the spaces are integrated with each other without separating walls, and in fact appear to overlap. While the plans are geometric in their composition, they also present pictorial characteristics, scenic environments and the treatment of the exteriors and interiors that are in keeping with the principles of abstract painting, which excel in their textural and material investigations.

The drawings explore different techniques of traditional architectural representation – plan, section, and elevation – while the axonometric is often abandoned in favor of perspectives. They illustrate and give life to the architects' proposals. Similar in style to the sketches of Le Corbusier, they are sometimes funny, as in the case of CSH #4 and CSH #3, simple in their message as in CSH #21, and efficient for CSH #16. Masterful, prolific and in pencil in Neutra's hand, they are sometimes constructed with three vanishing points in which the two that are located on the horizon line are very close together, thus accentuating the dynamism of the perspectives – characteristic of views through a wide angle lens. The bird's-eye perspectives recall the views from an airplane, echoing a still-present war economy.

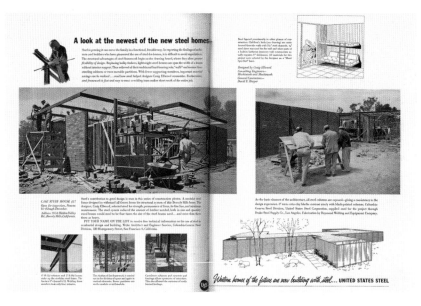

The photographs

With few exceptions, the photographs published in *Arts & Architecture* are in black and white. They seem not only to respond to the technical aspects of publication and to the difficulties and cost of four-color printing, but also to the aesthetic tradition of architectural photography, rejecting the stammering debut of color photography. The photos are varied, and several types retrace the CSH adventure. The photos of the models are taken in the studio with an artificial, meticulous light. Then, the photos that report the progress on the site are taken for the most part "live." Animated with characters like the builders and architects, they show their creation and assembly and present in detail the architectural invisible, that is, the construction techniques that unveil audacious designs.

Taken at the end of the building process, the portfolios respond to a totally different formal photographic vocabulary. While the sketch perspectives explore those views that can approach accentuated and distorted perspectives, the published prints for the portfolios in *Arts & Architecture* remain very influenced by the stability of traditional architectural photos. They scrupulously reproduce the verticals of the building, testifying for the most part to the architect's intentions while underlining the simplicity of the structure. This freezing of time fixes the view onto the era, authenticating an architectural technique, biased by the use of light and composition. The rigor of the image making apparently shares in the concern to conserve a vision and a heritage. The question of the photo was openly discussed in the pages of the magazine; *Arts & Architecture* took the position against an image that was too simple, against a photogenic architecture, and stated the conditions such that the physical space was at the heart of research carried out. Experience was firmly defended by the editorial team, who opposed the sale of architecture solely through its image and was wary of the aesthetic universe of certain magazines illustrated in color superimposed over the compositions of existing photos. In the March 1948 issue of *Arts & Architecture*, Alfred Auerbach defined the modern movement as one of protest, in opposition to the manipulatory commercial system of marketing. He criticized the use of the camera and denounced the dependence of architecture on its photogenic quality: "Kodak is modern... everything that they design is undertaken with an eye for the camera. Is it photogenic? Will it look well in *House Beautiful* or *House and Garden*?" [84]

Orchestrated as such, the architectural production can enter into the composition of the pages of *Arts & Architecture*, in which the photographs of the houses respond to the rules of current taste, at times testifying to an austere sobriety.

THE RULES OF THE GAME

Julius Shulman

From 1938, Julius Shulman worked[85] for *Arts & Architecture* and, in 1942, was part of its editorial team, covering the reporting of eighteen of the CSH. Passionate about modern architecture, Shulman remained one of its most fervent defenders for more than sixty years, as is revealed today by the continuous publication of his work. Because of his longevity and personality, Shulman took on, little by little, the role of witness to the era. As Joseph Rosa explains in his biography devoted to Shulman,[86] his mission, more than capturing architecture through photographs, was to transmit the modern image. In fact, he stopped taking photographs with the emergence of post-modern architecture, refusing to capture in photographs what he called "bad buildings."[87] Born in 1910 in Brooklyn to a Jewish family of Russian immigrants, he found his second home in Connecticut before coming to live in California with his family. In 1933, he received a camera, a Kodak "Vest Pocket," which sustained his escapades and his photos, receiving with one such shot a photo prize.[88] Yet, while he spent his long years at university, there is nothing in his biography that indicates his specialty, and curiously enough his photo courses date back only to his high school years; this also indicates that he was a self-taught photographer.[89] Upon his return to Los Angeles after a holiday in Berkeley where he had sold his photographs on campus, he met Richard Neutra in 1936 through a project manager friend. He visited the building site of the Kun house and took photographs; the prints were sent to the architect. Neutra then met Shulman – a decisive encounter and indeed a point of departure for what would be an incessant collaboration. He was requested by renowned architects, and in less than a year acquired a reputation along with a remarkable address book. He participated in seminars on modern architecture[90] and was overcome by its elegant aesthetic, centered on a restrained way of living. After the war, he started his own agency in Los Angeles. An amateur and admirer of contemporary architecture, he asked Raphael Soriano in 1950 to design a house for him with a studio. The luck and the talent had met.

In my meeting with him, I was fascinated by his loyalty to modern architecture, to the point of refusing all other mistresses. In his cabin located in the city's hilltops, Shulman loved to be precise in his spatial description of such and such element, of the tension that was created between two spaces through an opening or a closure. He elaborated on the quality of light upon entering his house, and its incessant journeys throughout the course of a day, yet he refused to let me take a picture of his house. Continuing his monologue, he confided to me about how Entenza had managed to insert this house into the program: Comfort and elegance emanated from all corners of the site. While his photographic activity is rich and knew an unflagging rhythm, the publications of the photographs strike us as more and more contemporary, retaining all along the sparkling gaze of their odd photographer.

Architecture under the influence

An almost solemn relationship exists between the photographer and the architect. To think that the latter is the sole creator of a journey, and the photographer merely the agent of patrimony would be reductive in a society conscious of its image. A relay operates between the work of the architect and the work of the photographer, and this dialectic influences the two professions to their mutual benefit.

Richard Neutra participated in numerous shots of his buildings, working in tandem with Shulman. The architect loved to use the photo since its reduction of the building's scale offered a critical review of the basic concepts of his architecture. [91] The photo promulgated the modern and international character of his architecture. [92] Let us remember that during the years of shortage, the architect painted the wood joinery in a metal color, knowing that the photos would outlive him as much as his architecture.

For Neutra, the photos summarized his architecture, and had the power to reveal their relationship to the site. The compositions were most often shot from the inside revealing the landscape. Joseph Rosa would say of Neutra that he appreciated Shulman's photos because they integrated the landscape, the sky and the shadows, as well as bringing a contextual dimension in opposition to that of European photographic aesthetics. The integration of landscape into modern American architecture is obvious, and distinguishes it from other countries. Shulman celebrated this dynamic symbiosis, revealing a domestication of large spaces. "Shulman's photographs created the 'American image'." [93] Their long collaboration translated into Shulman's photographic coverage of ninety percent of Neutra's projects. [94] One can easily imagine that the loyal collaboration constituted a permanent apprenticeship even though it sometimes felt burdensome. [95] He learned from Rudolph Schindler to preoccupy himself with the natural light of interiors. One day, when they together looked at a group of photos that Shulman had just taken of the Daugherty house in Santa Monica, he understood the importance of light's diversity and density in the comprehension of the volume. He subsequently used lighting to distinguish the walls from each other and to avoid uniformity. [96]

Neutra was legendary in the promotion of his work, and in fact, Shulman benefited from the reputation of the famous architect. As a result, other less well-known architects called Shulman, who in return advertised their work to editors who liked his photography. [97] Julius Shulman sold a seductive image of a better life, "well aware of the dual role of the photographer as a seller of objects and as a visual recorder of history." [98]

Joseph Rosa concludes his biography of Shulman by putting an emphasis on Europe seen from an American point of view: "The major difference between modern architecture in Britain and the United States is that when the aesthetic arrived in America, it lost its political character and became a metaphor for a better life."

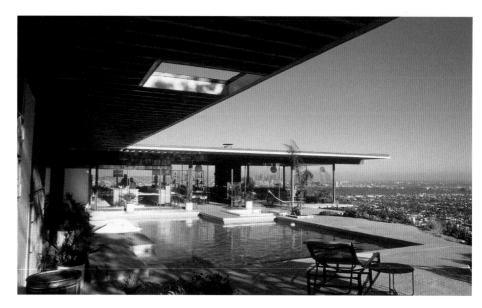

CSH#22, Pierre Koenig

Photos under the influence

In analyzing more precisely what makes a house photogenic and in taking into account the relationship between the photographic tool and its subject, possible architectural implications are visible from which multiple scenarios ensue: They would touch on the modification of the form of the domestic plan, and of its emphasis and attraction by the transparency in architecture.

The rapport to the site that supports the CSH and their setting on ground are determining factors in the photographic shot. The houses tend to use the site in its entirety, breaking as such with the usual placing of the house in the center. While the view of the house from the exterior tends to be more or less neutral, sometimes blind with the landing crossed, it presents an interior space that is frequently open and clear. Ellwood's plans for CSH #1950, #17, and #18 easily unfurl themselves and form bends that allow a sufficient retreat in order to plant one's foot. The L plans of Neutra's CSH #20, as well as Koenig's CSH #21 and #22 allow for dynamic shots created by the two parts of the house. Such layouts also recall those of film studios that, for the shooting of a scene, arrange the set with partitions to three sides or even without a ceiling.

Formal transformations are also accompanied by technical progress. The transparent façades – largely responsible for the architecture of the last century – were permitted by two givens: The dazzling progress of load resistance for large panes of glass that reduced the number of window mullions and made their price attractive, but also the availability of metal around 1950, which until then had been subjected to military restrictions. The surfaces of CSH #21 were erected with panes of sliding glass, thus allowing views from interior to exterior and vice versa, from virtually every room in the house, thereby making of each room a display window in a garden. While the façades appeared bare from the point of view of the photograph, the patios and the ceiling openings of #21, #23, and #25 allowed for apertures of light favorable to film exposure, and constituted a point of strength in the house's staging.

Structurally, the post-and-beam system supplants the interior partitions and renders visible the superpositioning of the house's programs. In this way, Koenig's CSH #21 presented the combined vision of dining room and garage, lending a mechanical quality to the house. The kitchen in CSH #22 opening onto the sitting room and in turn onto the city of Los Angeles superimposed the vision of contrasting scales – a metaphor of cinematic montage. A radical transparency was one of the obvious elements of modernist architecture in the fifties, [99] and it was a privileged photographic site.

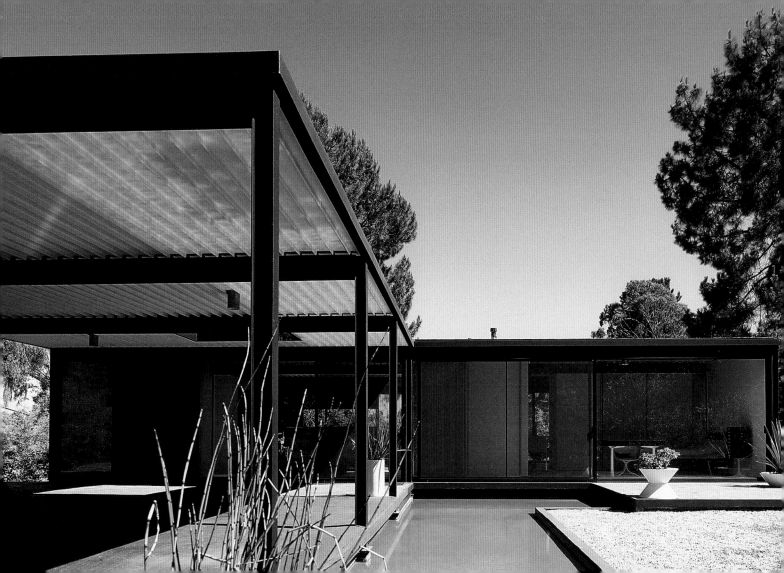

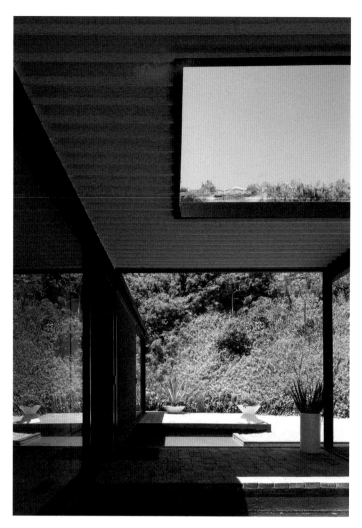

CSH#21, Pierre Koenig

Twilight

Beyond the transparency of the spaces, the reflective qualities of the materials exacerbate the photogenic aspect of the views. Present in CSH #21, the water, the transparent or translucent glass, the resin on the floor, and the lamination are staged, and thus contribute to the depth and the vibration of the medium.

Added to this is the abstraction of the sculptural photographic compositions, where the subtle balance of masses and volumes, plus the choice of black and white have from then on a full aesthetic motivation. Julius Shulman would say of black and white that it was more honest, [100] that he preferred it to color, and used infrared filters to heighten the contrasts. [101]

These effects lent an altogether distinctive presence to the sky, which became dramatic. He worked intensely in his darkroom. He would work on the shadows with a minute observation that was essential to the understanding of architecture. He loved the longer shadows that were cast since they showed off the volumetrics of the building, introducing suspense and a sense of facticity. Joseph Rosa would remark that "In Shulman's photographs there is a marked difference between shade, which illustrates the form as well as the massing of a building, and shadow, which reveals texture." [102]

The structural lines of the house, as with the post positioned in the center of the image cutting it into two verticals (CSH #21), or even a horizontal composition line situated in the center of the image, confirm Shulman's conviction that the photograph duplicates architecture. He emphasizes this view by using a horizontal or vertical "reduplication," [103] which stresses the photographic composition by the reflection of its surfaces. On the other hand, the view camera has a frosted glass panel [104] that shows the image inverted in all the planes, top/bottom, left/right. The photographs seem to be connected to the constraints of the tool, favoring a composition in the form of a cross. Shulman had taken courses on modern architecture and probably knew the experiences of the modernists who would love to invert the reading of architectural design so as to permutate the meaning of the section cuts, or even to attribute the reading of a plan to a section cut and vica versa. We know that the photographer loved to test the framing of the shot by inverting it. [105]

The view camera is a malleable tool but constrained by its size, its weight, and by the use of a tripod. It is a world behind and inside of which one regulates the composition and clarity. Hidden by a veil, light there is feeble, one cannot always see the angles of the image, especially in low light. The exposure time is variable and can be very long, making of photographers minute observers. The work conducted by Shulman on the mirror and the multiplication and composition in the form of a cross make me believe in a hypothesis of interpretation that reveals architecture as a metaphor for the camera.

While the cast shadows [106] enliven the photo and corroborate the composition, Shulman attributes a limitless source of inspiration to the light and its movement. The photographer did not use an electronic eye; he possessed a visual acuity that knew the journey of the light taken over time. During exterior shots he preferred the twilight to all other forms of light, since it allowed for a natural lighting of the exteriors, while making visible the interiors by electric light. [107] While photographing Neutra's Kaufman House in Palm Springs, the photographer captured the diminishing light, and made this technique a strong point of his art. The surrounding landscape took on an animate, even supernatural presence. The view taken of the exterior from the interior of the house doubled the view in reverse, favoring once again the transparency and the multiplication of the vertical planes. This same ambiguity was accentuated with the interior shots, by the artificial lighting in daylight that revealed the sculptural and domestic side of the garden.

By manipulating the artificial and natural light, the waiting times and the infrared filters, Shulman toyed with the photographic medium, all the while staging the scenic elements. The abstraction of architecture and of photography contributed to manufacturing a serene domestic landscape in which the ideology created was fond of a minimalist theme or of the aesthetic of *tabula rasa*; hygienic and ecological, his photographs showed a modern life without excess, near to its existing or fabricated landscape.

Beyond a sober rigor, the manufacturing of a media-based material probably influenced the design, and maybe even transformed it, by guiding it to respond to its environment.

A MODEL OF GRANDEUR

The model more true than nature itself

While *Arts & Architecture* published Shulman's photographs between 1945 and 1966, the images chosen for publication – sober and often without figures – differed from those that made the photographer famous to this day. Were the latter also manipulated, moving too far away from the strict philosophy of elitist good taste, indeed too close for the publisher's taste to the commercial criteria of pop culture?

Neglected by Entenza, this series of house photographs contributed to the paralleling of architectural photography with fashion photography. The banality of everyday life was transfigured with a serene and measured staging. The principle stand-ins of this sale through the image were related to the houses: Indeed, they were the unwitting precursors of today's reality shows. Pierre Koenig counts among those who appeared in his own design, CSH #21, while Edward Killingsworth's wife posed in CSH #23. Shulman staged the characters, not only out of a concern for scale, but also to inspire life into the space and to inspire a model of behavior for the readers: "The photographs were intended to show the orderliness of modern living, with the architecture as the key to a new lifestyle. People who live in a house can experience it, but the photographs show them, as well as others, how to 'see' it." [108]

In a sense, Julius Shulman was capable of aligning two tendencies: He lent a modern image while integrating both the vocabulary and the principle of advertising at that time.

Dressed appearances

The houses are furnished photographs, filled with domestic electrical appliances [109] and accessories. The décor comes to life with a set table. Inspired by the commercial techniques of consumer magazines for which he had worked, like *Life*, *House and Garden*, *Ladies' Home Journal*, and *Good Housekeeping*, [110] Julius Shulman staged his photographs by introducing filmic extras. He had the idea of selling [111] the houses as a finished product, keys in hand, to promote as such "good design." From Neutra [112] he had learned not to burden himself with those elements that were displeasing, and he came to certain project sites with the furnishings, plants, and objects that suited him. Since the CSH were completely furnished, he simply lit them. In rearranging the interior, he redefined the space where the action would take place, and accompanied it with a presence, comparing photography to film, and the photo studio to a film set. [113] The kitchen benefited from considerable technical progress that, by means of the shots, was shown to the entire world through images. The kitchen endured a spatial revolution that was recognizable in its layout, its size, and its technology. It exposed itself to the heart of the house, and offered itself to family members from the foyer, setting aside the role of the servants. Shulman very quickly realized that the kitchen was one of the consumer's privileged sites because of its possible identification with an object that was very susceptible to carrying symbolic worth.

263

Rest on the image: A woman is about to peel an orange, or to heat a meal. Immobile, the extras pause a few seconds in order to respond to the technical rigors of the light cell. Shulman argues that good design should be sold inhabited, animated by the history with which it goes. By his stagings, he allows the reader to participate as if he were in the room at the same moment, and not as a voyeur. The emergent television, which through its advertising clips guaranteed the public an appetite for a triumphant consumer society, defined the audiovisual climate present in the consumer's imaginary. Contrary to Oscar winning films, television chose actors for its advertisements and serials who were agreeable to watch and to hear. These characters were not like Hollywood stars, stars that referred to a sacred universe far away from little, everyday problems. The public could be able to identify itself with the actors who resembled them in life as on television. In making his compositions and in looking after his foregrounds, Julius Shulman pushed the limits of his camera's technical abilities. The view camera allows adjustment for the foreground's clarity as with the distance to infinity. It allows also for its turning to one side in order to force the frame of the photograph to be parallel with the verticals, and authorizes off-centering in order to catch up with the vanishing lines of the perspectives. Julius Shulman says of the view camera that it can help in the understanding of architecture, in manipulating the perspective, as well as in restoring it. [114]

MODEL HOMES OR CASE STUDY?

After having being announced in the magazine, the house represented in the form of drawings, plans, sections, models, and finally photographs, became in the end the object for the reader to visit. Passing from two dimensions to three and from the surface of the paper to a spatial volume, private domestic space was from then on a result of the magazine's linear public space; then it went on a journey only imagined before.

The ambiguity between what was the most private – the house – and what was the most public – the magazine – was crystallized during the visits by the readers. Besides, were they really experimenting with what they had before their eyes, or was it the specter of the progression of images from the magazine that they had in their memory?

The staging was successful. We can easily imagine the couples coming to visit the house, miniaturizing and reflecting it as a flashback onto their everyday lives. To whom was it of interest? To young married couples and families, but also to housing professionals. The voyeurism was heightened to a level of excitation, perhaps exacerbated by the fact that the houses that were dedicated to private use were exposed to the eyes of all. It was written in the initial advertisement that "The house must be capable of duplication and in no sense be an individual 'performance'." [115]

Although even the houses themselves looked to simplify construction details as well as to streamline the implementation of materials, within the goal of accommodating the constraints of multiplication, few of the houses were duplicated. Only CSH #11 was reproduced, with which CSH #15 prides itself the right of descent. Cloned again in three copies, CSH #11 was then constructed by a builder. Neither John Entenza nor Davidson, its designer would make a note of it in *Arts & Architecture*, perhaps releasing themselves from a paternity not assumed. Can one then back up the argument that the houses presented to the public responded with difficulty to the role of the model home? Moreover, Entenza seems to have avoided the designation "model home," since the experimental character of the CSH did not seem to fit the term, failing duplication without regret.

The complexity of the program was shown in the following ways: Between the house of the property developer and that of the architect, between the prototype of a series and a unique house, between the model home that one visited and one that would be sold untouched, between a future owner who ordered a house to live in it, and an architecture magazine that completed a house in order to publish it. When I met Julius Shulman, he confessed that Entenza had the houses built solely to publish them in his magazine. [116]

GRADE WISE IS PROFIT WISE...

"I SAVED OVER $250 per home

with the proper use of Utility grade West Coast framing lumber." - says Larry Koch, builder of custom homes.

Like builder Larry Koch, you, too, can find important economies in materials costs . . . with no reduction of quality . . . by using the right grades of framing lumber. "Utility" grade West Coast dimension lumber and boards are profit builders for One and Two Living Units, when used in accordance with FHA standards. Equally important, you have the traditional advantages of quality when you build with West Coast lumber.

Use West Coast "Utility" grade lumber for: solid roof boards*, sheathing*, rafters*, ceiling joists*, floor joists*, bridging*, studs* for single-story or top level of multi-story construction.

 ✱ *When used in accordance with FHA Minimum Property Standards for One and Two Living Units, FHA Bulletin No. 300.*

CHECK THESE USES

for "Utility" grade West Coast Lumber (in accordance with FHA Minimum Property Standards):

RAFTERS FOR LIGHT ROOFING (Roof slope over 3 in 12) (Weighing less than 4 lbs. per sq. ft. in place)

Douglas Fir Size	West Coast Hemlock Spacing	Maximum Span
2x6	16" o.c.	9'-8"
2x8	16" o.c.	14'-4"
2x10	16" o.c.	19'-8"

FLAT ROOF JOISTS supporting finished ceiling (Roof slope 3 in 12 or less)

2x6	16" o.c.	7'-8"
2x8	16" o.c.	11'-6"
2x10	16" o.c.	15'-8"
2x12	16" o.c.	18'-2"

CEILING JOISTS (no attic storage)

2x6	16" o.c.	11'-8"
2x8	16" o.c.	17'-6"

FLOOR JOISTS

		30 lb. live load*	40 lb. live load†
2x6	16" o.c.	7'-2"	6'-4"
2x8	16" o.c.	10'-8"	9'-6"
2x10	16" o.c.	14'-8"	13'-0"
2x12	16" o.c.	7'-0"	15'-4"

*sleeping rooms only
†other than sleeping rooms

BOARDS. Ample strength and satisfactory coverage make "Utility" boards a primary material for sub-floors, wall sheathing and solid roof boarding in permanent construction. This grade is widely used for light concrete forms.

WEST COAST LUMBERMEN'S ASSOCIATION

1410 S. W. Morrison Street, Portland 5, Oregon

GET THE FACTS

For detailed information about correct span tables for each dimension, write for your free copy of "WHERE TO USE 'UTILITY GRADE' " today!

TODAY

The CSH program has appeared and still remains an unparalleled case study in itself. The program is unique, in terms of concept and production, in demonstrating and analyzing the most private space, the domestic space of a house. If it may seem banal today, when architecture has become indistinguishable from its media image, it raises some questions that we want to look into: questions about the possible consequences of this promotion and veritable sale through the image, about highlighting architecture in an architectural magazine and beyond that, about the possible consequences of such a program on the American family structures, and last but not least whether the middle class family actually was the target of this project or not.

PAST OWNERS

It is known from the advertisements that the past owners were not in control of the specifications that were dictated by the magazine and orchestrated by the architect. They were defined more by their behavior than by their formal aspirations; as the architect of CSH #7, Thornton Abel, writes: "The plan is developed with the kind of family in mind who does not want a modern house for its shape or pattern alone but who has a philosophy that modern living and planning are one, each the reflection of the other." [117]

Following these criteria, the inhabitants of the houses were fabricated without flexibility. CSH #1 [118] was attributed to Mr. and Mrs. X, defined as a typical American family, in which the two adults had a professional activity and an already adolescent daughter. The families Alpha (CSH #6) and Omega (CSH #13) consisted of two sisters whose respective families wanted to be on adjoining lots. With talent and romanticism, Neutra recounted in the magazine his imagined and invented interaction between these last two houses. It is interesting to observe through the course of the readings that the architect [119] became an author, scriptwriter, and director of a future life.

Other houses, other scenarios: Soriano's CSH #1950 proposed a prototype that adapted itself to all sites with a post-and-beam construction mounted on a strict framework; the ideal tool for his architectural act. While it was stated that the typical family consisted of four people in 1950, CSH #1950 was built for three, or even a couple, who were in fact never personalized. Did it really exist?

Some houses (CSH #3 and CSH #7) did not have at the beginning of construction a site or an owner, and went in search of both. Thus flexible, these houses were conceived in such a way as to anticipate the changes appropriate to the site, were re-examined at the request of the owner and largely praised by the publisher. [120] Then, purchased at last, the individual traits of the owners would mark the form of the plan.

The CSH families expressed their modes of life through the houses. For CSH #3, the inhabitants were supposed to leave home together every morning for work, while CSH #8, CSH #9, Neutra's CSH #21, and Hensman's CSH #20 were designed for users working at home, in which certain rooms responded to their demands.

Going further back in the genealogical tree of the owners, I discovered the journal's lineage. In reconstituting it, the actors unveiled themselves one by one, showing off the will of a group who respected one another and fought for a common cause. Turning to the page that listed the directory of clients, the first house built, CSH #11, was inhabited by an associate [121] of the publisher, Robert Cron, the magazine's director of advertising. He was essentially in charge of sponsorship, and pitched the label of "GI House" for CSH #11, thus obtaining numerous donations.

Arts & Architecture, December 1945

The architect Davidson gave up one end of his property to build it, where he designed his architectural practice and house.

CSH #7 finally found itself acquired by the employees of Flintkote Company,[122] who participated in sponsoring the roofing materials in exchange for publicity; the house was on the fourth cover of *Arts & Architecture*.[123]

In continuing the list of subscribers, while the first publication with graphics by Ray Eames proposed an insight into the key personalities among the clients, we are speaking here of two atypical clients: The owners of CSH #8 and CSH #9 were none other than the actors of the program. Going hand in hand, these houses are indissociable from another; they have a central role, revealing an impeccable dialectic of layout and landscape, of private and public life. One can ponder the fact that Entenza quickly left his house and put it up for sale repeatedly; it lost value and was eventually transformed. I learned since then that Entenza did not like his house; "too much glass," his confidant and friend Killingsworth told me. The troubling message that Julius Shulman had whispered to me had found in the history of this house a certain accuracy difficult to admit.

Certain owners transformed their houses and played with their professional influence. We have the example of Saul Bass who, knowing the editor, successfully tried to make his house into a CSH, which took on the number 20. Himself an industrial designer, Bass actively participated in its conception, and he appeared in the publications in partnership with the architects; it was a unique case in the history of the CSH where the future owner intervened over the visualization of his house.

Two houses – #1950 and #25 – would take the step above the architects' intentions, by their transformation into a living catalogue, a commercial production in which the plan, as an echo, testified to its characteristics. Before even being designed, CSH #1950 created a thunderous advertisement stream of ready-mades, conferring an identity based on its content. On the other hand, CSH #25 became just like a display window. Its owner Edward Frank was a partner in the Frank Brothers Company, a contemporary furnishings and interior architecture firm in Los Angeles, and chose the house in order to display furniture by the Eames, Mies van der Rohe, Giedeon Kramer, Harry Bertoia. The built side opens onto an interior court and is therefore visible from the panoramic view appearing as a theater of private life, a projection of the architect, allowing the gaze to stroll from one room to another, to appreciate the arrangements of the furnishings and the life that takes place there.

CURRENT OWNERS

Having returned to the sites a few years later in order to take photographs and to complete my research, I understood the essential role of the current owners. The fate of these buildings and the memory that has been passed down – so important – depends on the choice of inhabitants, of their acceptance of the house as it is, the desire whether or not to transform or to maintain it, of putting in furniture of their own choice, to live there according to the model promised to everyone in the magazine, or to transform the rooms completely or even to destroy them.

Through the interviews taken and visits made, I could grasp not only the rhythm of the houses, but also the intimate sounds of all the machines that worked; to catch a glimpse of the life of their inhabitants, to rouse me of the humanity that was not only on paper, but perpetuated by life and by the ensuing generations. Standing still, timed as if by a stop watch by the shots of the technical room, the long day perusing and documenting the houses silently, almost forgetting everything else, the Case Study Houses appeared or disappeared before me favoring what they were at the time. The photos taken by Julius Shulman were done so before delivery of the houses, houses that were sometimes not even completed. Were these images truly real? In my viewfinder, I admired the tensed line, always on the lookout for a vanishing detail, behind a Marie Antoinette sofa or a Regency Style chest... More than before, I noticed that the rooms were no longer used as they had been intended. Certain modes of life, like the use of the garden, the passage from inside to outside had been destroyed in most cases due to the introduction of air conditioning closing the house which had thus become impervious. Continuing the analysis of new zoning that I attributed to the siting of the television and to the kitchen the role as catalyst for activity where the rest of life unfolded – the same kitchen that was often criticized because it was perceived as being too small. The fireplace had lost its role as extra heating; it was no more than decoration now. But where then was the time of the parties, of the dancing soirees offering themselves up to the spasmodic frivolity of Rock and Roll?

I noticed spaces cluttered with objects and the owners often complained of a lack of storage space; did they know that the society of consumption had caught up with them? Some found in the monastic aspect of their house an intellectual pleasure, confessing to me that they felt at its service, and sometimes as its slave.

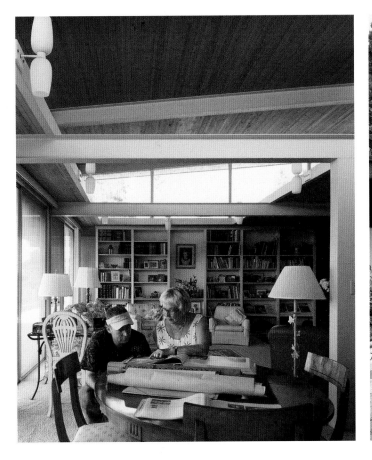
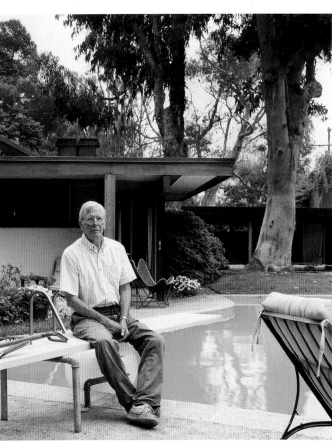

I knew different owners, some of whom were elated by my visit, others embarrassed, sometimes uninterested in the CSH Program, but never indifferent and for the most part filled with pride and charged with a task that awaited them, proud to possess a history inscribed in their property and thus in them. Listening to them recall the memories of their own lives, letting me be guided by their story, I would sometimes hear the noise of the children, or smell the exhalations of the barbeque, projecting myself mentally and losing myself in the meanderings of the plans and lives and the destiny of the houses traversed. Four important witnesses of this period are the owners from the beginning of the program who did not move. The owners of Neutra's CSH #20 (1948), and Koenig's CSH #20 (1960) had their houses built, chose their architects with authority, and participated in the program in order to benefit from the attractive prices and the benefits. Mr Bailey, a dinosaur from the first period of the program and owner of CSH #20, kept it from not being only a memory, but always transmitted that memory with grace, recounting numerous anecdotes about Neutra and Charles and Ray Eames. More than whatever story told, the visit to his house combined with the landscape is an honorable example and needs no other explanation.

Of the other two owners, Ellwood's CSH #16 (1958) and Beverley David Thorne's CSH #26 (1963) bought the houses at the time they were built, by the desire to taste this architecture and this mode of life, and also for the happy implantation of their house in the ground. It was still not long ago that the owner of CSH #26 recalled to me that she had lived in this house for thirty-eight years. Every bit as much as the houses, the architects, or the magazines, these owners have that memory of the program, which was related to the everyday.

Some more recent owners like the producer Dan Cracchiolo [124] who lived in CSH #21, were also moved by modern architecture and its image, and went in search of the ideal object. Cracchiolo would note in an article by Thomas Hines, "it is my life as a film-maker, and my love for photography that has brought me to this place. As I collected prints, I discovered Julius Shulman and architectural photography, and then later I came to love the houses on their own merits." These observations convinced him to renovate the house. Pierre Koenig spent twice as much time restoring than conceiving this project. Since then, the house was re-sold and bought by a young fashion designer; a passionate and meticulous collector, he equipped his house with furniture of the era. There is a concept of image floating in the air, and how can one not be sensitive to it here in Los Angeles?

The astonishing Eames House is a unique case of conversion. Open to visits from the garden side only and inhabited by the Eames daughter during the visits, the house oscillates between a museum, a home and Demetrios Eames' office. This grandson contributed to the promotion of the couple's work, employing up to four people full-time in the studio and the bookstore situated in the heart of Venice, devoting himself to the re-issuing of the furniture, the objects, and the books.

Another house, another example: Originally designed by Neutra, CSH #19 was so modified by its owner in the course of construction that Entenza never recognized it as being part of the program, and Neutra refused it of his paternity. Having since been renovated with taste and within the rules of art, the house is occupied by a television producer and his wife, an interior designer. Both researched extensively on their house and are delighted to live there; they collect furniture from this period and it was from them that I learned about its dramatic provenance.

Another source of destitution just as unsuspected, I met the architect Rodney Walker's son who built himself a house following the plans of CSH #16 – the house in which he grew up.

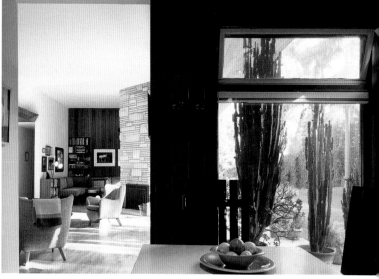

CSH#19, Richard Neutra

Still feeling a need to understand what had come earlier when I knocked on the doors of the houses, other owners learned to their surprise that they had a Case Study House, a fact unknown to them at the time of purchase.

What will become of these houses when the older and more loyal guardians leave? Doctor Bailey, lucid regarding the possible fate of his house, discusses with me the phenomenon of "mansionizing," a kind of enlargement in cardboard chateau form, necessitating the buy-back and re-absorption of the house, the digestion then rejection of a large hollow home and of unspeakable styles. The reality of the housing market in the City of Angels weighs on the land prices, but the houses simply don't measure up.

Aside from the passionate collector of modern myth rather wishing he were wealthy, or the inhabitant of a house-as-museum, who would accept to live in an outdated house today? To talk about these houses, to get them known – the press and the media are an efficient shield against the shock of the times and the low selling prices for these little jewels under-appreciated by all.

280

THE CASE STUDY HOUSES AS MEDIA TARGETS

Alfa Romeo advertisement

Inspired by the Case Study Houses for his *A Bigger Splash* of 1967, David Hockney [125] also participated in the creation of Californian myth that propelled everyone's imaginary into a better life, one that was lighter and less serious. The houses become estranged from their initial use and become décor, crowned symbols of a democratic, social, and radical attitude, their eyes full of hope for what modernity could offer.

Today media targets cultivate the myth, and it is not rare to fall into one of those advertisements that use a Case Study House as background. They are used in the movies and for fashion photography, and on television for the Renault *L'Espace* commercial, and so on.

Beatriz Colomina writes: "In fact, one can repeatedly see a shift through the century from the representation of modern architecture in the media to its use as a prop for the media. Once the famous Shulman photographs of the Pierre Koenig Case Study House presented an ideal image of modern domestic life, the house became the stage set for over a hundred movies." The owners of CSH #22, Mr. and Mrs. Stahl benefited from some revenue from renting their house as décor and film set. They had chosen to participate in the program, attracted by the sponsors but more seduced by the formal possibilities of a modern house that had the view at its disposal while being able to hide from it. This house has achieved the status of icon, one that, being endlessly reabsorbed by the media, lives on its own image. The aerial site of the house where the water from the pool blends with the sky, favors a succession of collages. Personalities wearing high fashion and donning objects are suspended above the city like a photomontage. This surrealistic image is exaggerated by the staging of domestic space, which itself is in levitation. The famous house exhibits not only a radical plan against the background of an imposing landscape, but it is dressed in a sublime frame of important encounters that are surrounded by an immutable theatricality.

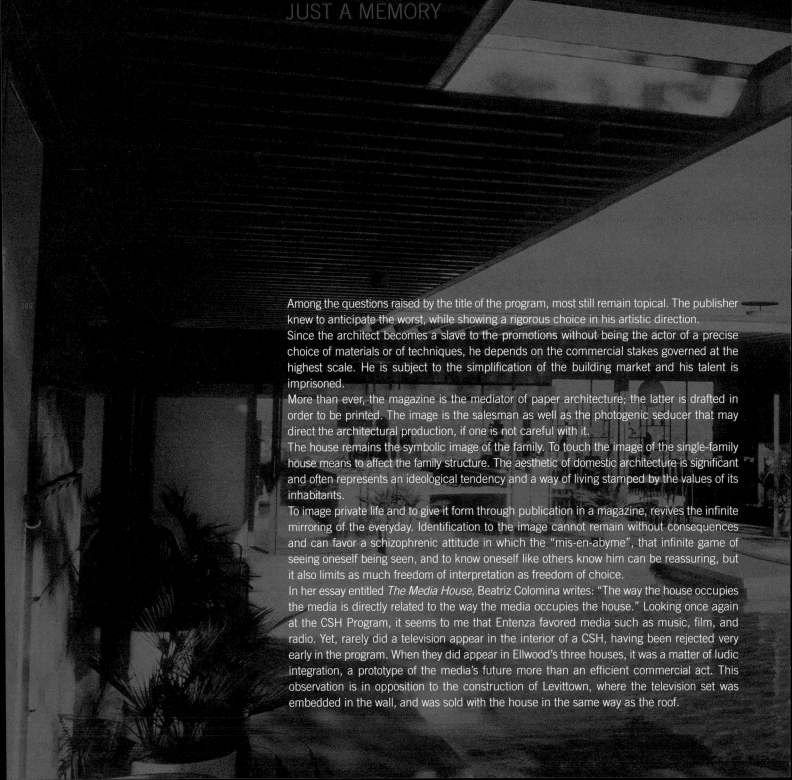

Among the questions raised by the title of the program, most still remain topical. The publisher knew to anticipate the worst, while showing a rigorous choice in his artistic direction.

Since the architect becomes a slave to the promotions without being the actor of a precise choice of materials or of techniques, he depends on the commercial stakes governed at the highest scale. He is subject to the simplification of the building market and his talent is imprisoned.

More than ever, the magazine is the mediator of paper architecture; the latter is drafted in order to be printed. The image is the salesman as well as the photogenic seducer that may direct the architectural production, if one is not careful with it.

The house remains the symbolic image of the family. To touch the image of the single-family house means to affect the family structure. The aesthetic of domestic architecture is significant and often represents an ideological tendency and a way of living stamped by the values of its inhabitants.

To image private life and to give it form through publication in a magazine, revives the infinite mirroring of the everyday. Identification to the image cannot remain without consequences and can favor a schizophrenic attitude in which the "mis-en-abyme", that infinite game of seeing oneself being seen, and to know oneself like others know him can be reassuring, but it also limits as much freedom of interpretation as freedom of choice.

In her essay entitled *The Media House*, Beatriz Colomina writes: "The way the house occupies the media is directly related to the way the media occupies the house." Looking once again at the CSH Program, it seems to me that Entenza favored media such as music, film, and radio. Yet, rarely did a television appear in the interior of a CSH, having been rejected very early in the program. When they did appear in Ellwood's three houses, it was a matter of ludic integration, a prototype of the media's future more than an efficient commercial act. This observation is in opposition to the construction of Levittown, where the television set was embedded in the wall, and was sold with the house in the same way as the roof.

Paul Virilio told me that mental images are today put in check by the ready-made images of television, film, and video games. [126] It is certainly difficult to escape from the images of our time, but with television, the task is even more arduous since the reflexes are conditioned from a very young age. Can I dare to proclaim that the decline of the house's formal imaginary coincides with the widespread use of television in the home? Must one see in it a foreboding date anticipating the difficulty of interesting a greater number of people in questions relating to the diversification of single-family housing, which in fact announces the end of the program?

To all this, the publisher presented an alternative in preventing the drama of mass-produced architecture, of the surge in residential suburbs, and of the inadequacy of progress-bound quality. He introduced the label of quality, elevating the level of construction.

He imagined the CSH for a modern family that was active and cultivated. The notion of leisure integrated itself in the house plan, and one found it through patios bathed in sunlight. If the woman worked, she was independent, and domestic tasks were lessened and shared. Entenza's relentlessness and his work ethic made of this program a successful example of paper architecture that exceeded the framework and status of the publication. This generous example responds on a higher level to the problems of today, and provides us with lasting solutions.

Entenza placed himself as a publisher of concrete production of architectural ideas; he split the role of the client in his magazine and held onto his independent and free vision. This example of architecture illustrates the role of the client in architectural production, where, more than ever before, this example of architecture would make him king.

Notes

1. Esther McCoy, *The Case Study Houses, 1945-1962*, Los Angeles: Hennessey Ingalls Publishers. The first edition of 1962 appeared under the title: *Modern California Houses*.

2. Esther McCoy, *The Second Generation*, Salt Lake City: Gibbs and Smith Inc. Publishers, 1984.

3. The Hennessey Ingalls Bookstore is also the publisher of Esther McCoy's anthology of the Case Study Program, *Modern California Houses*.

4. The word "domesticity" in English refers to domestic life, to the private lives of individuals that correspond to the world of the house. This understanding of the term is one that we intend, and should not be confused with the French word "domesticité," which relates to domestic servants.

5. The eight architects chosen were: J. R. Davidson, Charles Eames, Eero Saarinen, Richard Neutra, Ralph Rapson, Sumner Spaulding, Whitney R. Smith, William Wilson Wurster.

6. *Arts & Architecture*, April 1945, p. 26.

7. *Ibid.*, p. 29.

8. *Ibid.*

9. *Arts & Architecture*, June 1945, p. 27.

10. *Ibid.*

11. *Ibid.*

12. Elizabeth T. Smith, "The Thirty-Six Case Study Projects," published in Elizabeth Smith Ed., *Blueprints For Modern Living – History and Legacy of the Case Study Houses*, Los Angeles: MOCA, 1989, pp. 46-47.

13. *Arts & Architecture*, September 1945.

14. Richard Neutra reporting the reaction of client Omega in *Arts & Architecture*, October 1945, p. 34.

15. The Cranbrook Academy of Art was restored by Eliel Saarinen, who also became the school's dean and director. Still in operation today, this academy seeks to reunite the decorative arts.

16. Eames and Saarinen won two prizes at the Museum of Modern Art's "Organic Design Competition."

17. *Arts & Architecture*, March 1948, p. 40.

18. *Id.*, December 1945, p. 42.

19. Beatriz Colomina, "Reflections on the Eames House," published in *The Work of Charles and Ray Eames – A Legacy of Invention*, New York: Harry N. Abrams Inc. Publishers, 1997, p. 142.

20. *op. cit., Modern California Houses*, p. 57.

21. *Arts & Architecture*, August 1946, p. 40.

22. *Id.*, February 1947, p. 40.

23. 1" = 1 inch = 2.5588 cm

24. 1' = 1 foot = 30.3666 cm

25. *Arts & Architecture*, November 1947, p. 39.

26. *Id.*, May 1947, p. 32.

27. David Gebhard and Robert Winter, *Los Angeles, An Architectural Guide*, Salt Lake City: Gibbs and Smith Publishers, 1994, p. 18.

28. *op. cit., Modern California Houses*, p. 73: "The leap from the early Case Studies to Raphael Soriano's street pavilion was a leap from the personal to the impersonal, from the isolated case to the prototype."

29. *op. cit.*, "The Thirty-Six Case Study Projects," p. 61.

30. Craig Ellwood would also participate in the building of CSH by Neutra, Harwell Harris, Wurster and Bernardi, for the accounts of Lamport Cafer Salzman who was a promoter for war veterans.

31. *Arts & Architecture*, July 1954, p. 12.

32. *Id.*, June 1953, p. 24.

33. See note 24.

34. See note 23.

35. Neil Jackson, *The Modern Style House*, London: E. & F. N. Spon Publishers, 1996, p. 88. According to the author's research, Doctor Hoffman, not Doctor Field, is the owner of CSH #17. Doctor Field is the owner of CSH #18.

36. *Arts & Architecture*, March 1955, p. 18.

37. *Id.*, June 1955, p. 18.

38. *Arts & Architecture*, February 1956, p. 20. See also *Modern California Houses*, p. 105, *op. cit.*

39. *Arts & Architecture*, February 1956, p. 20.

40. *Id.*, April 1957, p. 18.

41. *Id.*, November 1957, p. 35.

42. *op. cit.*, "The Thirty-Six Case Study Projects," p. 66.

43. *Arts & Architecture*, June 1958, p. 25.

44. *Id.*, September 1957, p. 23.

45. *Id.*, August 1957, p. 15.

46. Ethel Buisson, interview with the architect Don Hensman, July 1995.

47. The plywood sections are 8'x4', the frame is 8 feet on center. The range is 16 feet.

48. Berkeley Plywood Company and Fir Plywood.

49. *Arts & Architecture*, July 1958, p. 31.

50. *op. cit.*, Neil Jackson, p. 96.

51. Interview with the architect, July 1995.

52. Ethel Buisson, "The media house" interview with the architect Edward Killingsworth, June 2002.

53. 1 acre = 4,047 m^2

54. Los Angeles City Council's Committee on Zoning.

55. *op. cit., Modern California Houses*.

56. Beatriz Colomina, "The media house," *Assemblage* #27, 1995.

57. From 1945 to 1966, if one counts the post-Entenza years.

58. "Announcement of the Case Study House Program," *Arts & Architecture*, January 1945.

59. *Ibid.*

60. *op. cit.*, John Entenza, in *Modern California Houses*, p. 204.

61. *op. cit.*, "The Thirty-Six Case Study Projects," p. 48.

62. John Entenza, *Arts & Architecture*, February 1945, p. 43.

63. *Arts & Architecture*, July 1950, p. 28.

64. *op. cit.*, John Entenza, in *Modern California Houses*, p. 204.

65. John Entenza, *Ibid.*

66. *op. cit.*, Beatriz Colomina, "The Media House," *Assemblage* #27, 1995.

67. The scale of the drawings and the size of the house are one-to-one; the house is designed or constructed in real size.

68. *Ibid.*

69. *Arts & Architecture*, March 1947, p. 37.

70. *op. cit.*, Dolores Hayden, "Model Houses for the Millions," in *Blueprints for Modern Living*, p. 210.

71. *op. cit.*, Esther McCoy, p. 204.

72. Beatriz Colomina, "Publicity," in *Privacy and Publicity*, Cambridge: MIT Press, 1994, p. 156. In this text, Colomina analyzes the role of the media industry in understanding Le Corbusier's architecture from the 1920's.

73. Ethel Buisson, interview with Edward Killingsworth, Summer 1995.

74. *Arts & Architecture*, February 1947, p. 43.

75. *Id.*, March 1950, p. 38.

76. *Ibid.*

77. *Arts & Architecture*, March 1945, p. 47.

78. *Id.*, January 1945, "Contents for January," p. 13.

79. *Ibid.*, "Notes in Passing," p. 27.

80. The reconciliation and collaboration of the worlds of industry and university research after the war contribute to the founding myth of power on the part of the United States. See Olivier Zunz, *Le Siècle Américain*, Paris: Éditions Fayard, 2000, pp. 23-25.

81. Ethel Buisson, interview with Edward Killingsworth, July 1995.

82. *Arts & Architecture*, January 1945, "Announcement."

83. Today, one can consult copies of *Arts & Architecture* in almost all American libraries. These journals constitute a precious collection for librarians.

84. *Arts & Architecture*, March 1948, "Kodak is modern… everything that they design is undertaken with an eye for the camera. Is it photogenic? Will it look well in *House Beautiful* or *House & Garden*?"

85. Joseph Rosa, *A Constructed View: The Architectural Photography of Julius Shulman*, New York: Rizzoli, 1994, p. 52.

86. *Ibid.*, p. 88.

87. *Ibid.*, p. 67.

88. *Ibid.*, p. 38.

89. *Ibid.*

90. *Ibid.*, p. 44.

91. *Ibid.*, p. 214.

92. *Ibid.*, p. 47.

93. *Ibid.*, p. 49.

94. *Ibid.*, p. 47.

95. *Ibid.*, p. 49.

96. Julius Shulman, *Architecture and its Photography*, Cologne: Taschen, 2000.

97. *op. cit.*, *A Constructed View: The Architectural Photography of Julius Shulman*, p. 57.

98. *Ibid.*, p. 88.

99. The transparency here is relative, since the walls of the residences often control it.

100. *op. cit.*, *A Constructed View: The Architectural Photography of Julius Shulman*, p. 215.

101. *Ibid.*, p. 65.

102. *Ibid.*, p. 70.

103. *Ibid.*, p. 77.

104. The frosted glass on which the image is reflected is squared, in order to align the verticals of the building with the verticality of the image.

105. *op. cit.*, *A Constructed View: The Architectural Photography of Julius Shulman*, p. 69.

106. *Ibid.*

107. So that *twilight* regains its original meaning of "two lights".

108. *op. cit.*, Julius Shulman, in *A Constructed View: The Architectural Photography of Julius Shulman*, p. 88.

109. *Arts & Architecture*. At the end of the descriptions of the CSH, a breakdown of all the products used in the house would appear.

110. *Ibid.*, p. 54.

111. *op. cit.*, *A Constructed View: The Architectural Photography of Julius Shulman*, p. 88.

112. *Ibid.*, Neutra "readjusting the furniture," p. 51.

113. *The Photography of Architecture and Design*, p. 36. (Also cited in Rosa.)

114. *op. cit.*, Julius Shulman, *Architecture and its Photography, p. 243*.

115. *Arts & Architecture*, January 1945, "Announcement".

116. Ethel Buisson, interview with Julius Shulman, July 1995.

117. *Arts & Architecture*, November 1945, p. 40.

118. *Id.*, February 1945, p. 43.

119. *Id.*, October 1945, CSH #6 by Richard Neutra, p. 33.

120. *Id.*, April 1947.

121. *op. cit.*, "The Thirty-Six Case Study Projects," p. 56.

122. *Ibid.*, p. 50.

123. *Ibid.*, p. 51.

124. Thomas Hines, *Architectural Digest*, June 2000, p. 113.

125. Ibid., p. 113: "In David Hockney's 'A Bigger Splash'(1967), a low-lying house in glass and stucco, topped by a flat roof, stands out against the brilliant sky outlined by palm trees. When asked about his sources, Hockney acknowledged that he was inspired by the Case Study Houses."

126. Interview with Paul Virilio, 18 July 2001.

Background Notes

1. David Halberstam, *Fifties*, New York: Random House, 1996, p. 89-99.

2. *Ibid.*, p. 58-66.

3. Gwendolyn Wright, *Building the Dream, A Social History of Housing in America*, Cambridge and London: MIT Press, 1981, p. 241. In 1934, it was put in place by the FHA (Federal Housing Administration) and the NHA (National Housing Act) – both of which were dependent on the state to stimulate the market for single-family homes at moderate prices.

4. *Ibid.*, p. 242.

5. *Ibid.*, p. 249.

6. See for exemple the *Petit Robert* regarding the United States of America.

7. *op. cit.*, *Building the Dream, A Social History of Housing in America*, p. 242.

8. *Ibid.*, p. 243.

9. *Ibid.*, p. 247.

10. Leonard and Dale Pitt, *Los Angeles A to Z*, Berkeley and Los Angeles: University of California Press, 2000, p. 403.

11. Alain Masson, "La Première Machine de Diffusion," in Alain Masson, ed., *Hollywood 1927-1941. La Propagande par les Rêves ou le Triomphe du Modèle Américain*, Paris: Éditions Autrement, 1991, part of a series entitled "Memoires" #9, p. 11.

12. Mike Davis, "Hollywood et Los Angeles: un Mariage Difficile," *ibid.*, p. 16.

13. Phillipe Paraire, *Le Cinéma de Hollywood*, Paris: Éditions Bordas, 1989, part of a collection entitled "Les Compacts." Paragraph written according to the information provided on pages 20-31.

14. The present module is based on the research and writing of Jean Castex, copied for his course entitled: "Cours d'Histoire d'Architecture. Un Siècle d'Amérique de 1860-1960,"research laboratory, architectural and urban history, School of Architecture, Versailles, November 1999. The lecture was entitled: "Le Quadrillage du Territoire: La Land Ordinance de Jefferson de 1785," p. 6.

15. *op. cit.*, "Le Quadrillage du Territoire: La Land Ordinance de Jefferson de 1785," p. 80.

16. The state made a gift of land to the iron industry in order to construct rail lines. Today this land represents an asset.

17. Frederick Law Olmstead, *The Papers of Frederick Law Olmstead*, Volume VI, London 1865-1874, Baltimore: Johns Hopkins University Press, 1977-1992, p. 273-295.

18. Olivier Zunz, *Le Siècle Américain*, Paris: Éditions Fayard, 2000, p. 130.

19. Dolores Hayden, "Model houses for the millions," in *Blueprints for Modern Living*, Cambridge: MIT Press, p. 198.

20. Albert G. H.Dietz, *Industrialized Building Systems for Housing*, Cambridge: MIT Press, 1971, p. 178.

21. Helen Searing, "Case Study Houses in the Grand Modern Tradition," in *Blueprints for Modern Living*, p. 248. 41,000 miles have been constructed, connecting the major cities.

22. *Ibid.*, p. 107-108.

23. Lesley Jackson, "Decorations and Fittings," in *"Contemporary" Architecture and Interiors of the 1950's*, London: Phaidon, 1994 ,p. 107-141, 4.

24. *op. cit.*, *Fifties*, p. 123.

25. Francis D. K. Ching, *Building Contsruction Illustrated*, Second Edition, New York: Van Nostrand Reinhold, 1991.

26. Villas Savoye and Garches by Le Corbusier, and the Barcelona Pavilion by Mies van der Rohe.

27. Colin Rowe, *The Mathematics of the Ideal Villa and Other Essays*, Cambridge: MIT Press paperback edition, 1982, p. 132.

28. *op. cit.*, Joseph Rosa, *A Constructed View: The Architectural Photography of Julius Shulman*, New York: Rizzoli, 1994, p. 57, 59.

29. Barbara Miller Lane, *Architecture and Politics in Germany 1918-1945*, Cambridge: Harvard University Press, 1968, p. 138.

CATALOGUE

0' 1' 5' 10' 20'

scale in feet

0 1 5 10 20

scale in meters

CSH#1

1945-1948
Julius Ralph Davidson

10152 TOLUCA LAKE AVE.,
NORTH HOLLYWOOD, CA

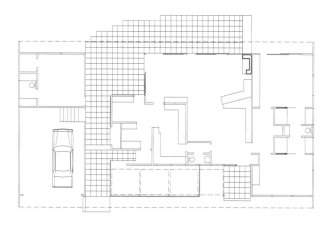

CSH#2

1945-1947
Summer Spaulding and John Rex

857 CHAPEA ROAD,
CHAPMAN WOODS
PASSADENA, CA 91107

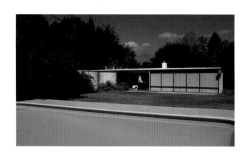

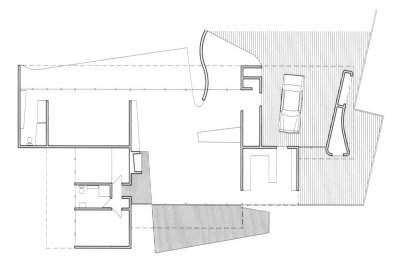

CSH#3

1945-1949
William Wilson Wurster
and Theodore Bernardi

13187 CHALON ROAD,
BRENTWOOD, CA 90049

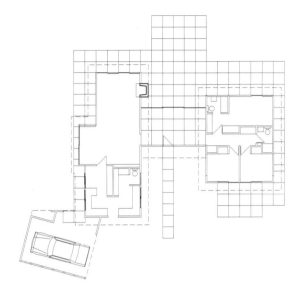

CSH#4

Greenbelt House
1945
Ralph Rapson

NOT BUILT

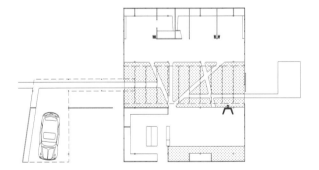

CSH#5
Loggia House
1945
Whitney R. Smith

NOT BUILT

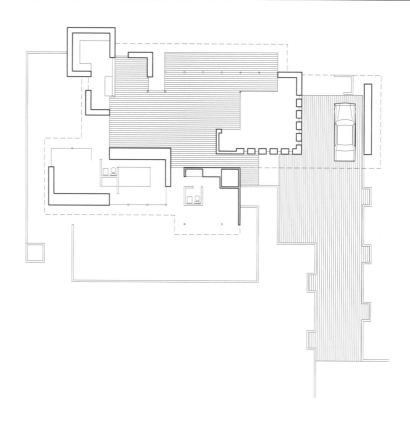

CSH#6
Omega
1945
Richard Neutra

NOT BUILT

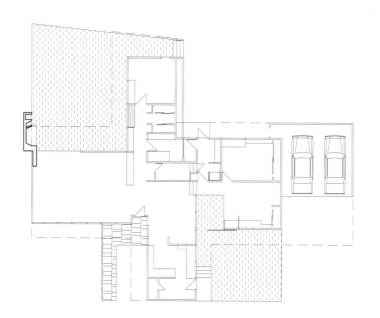

CSH#7

1945-1948
Thornton Abell

634 NORTH DEERFIELD AVE.,
SAN GABRIEL, CA 91775

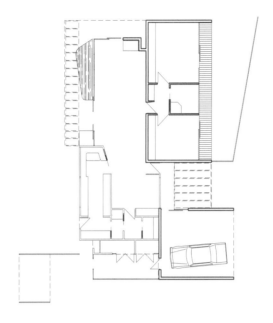

CSH#8

1945-1949
Charles and Ray Eames

203 CHAUTAUQUA BLVD,
PACIFIC PALISADES, CA 90272

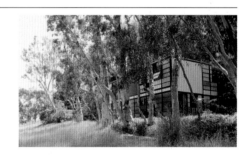

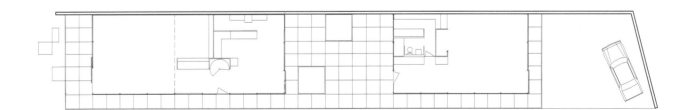

CSH#9

Entenza House

1945-1949

Charles Eames and Eero Saarinen

205 CHAUTAUQUA BLVD,
PACIFIC PALISADES, CA

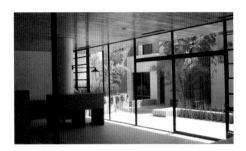

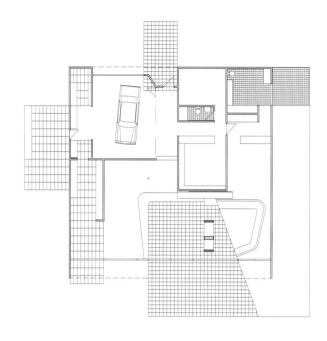

CSH#10

1945-1947

Kemper Nomland and Kemper Nomland, Jr.

711 SOUTH SAN RAPHAEL AVE.,
PASADENA, CA 91105

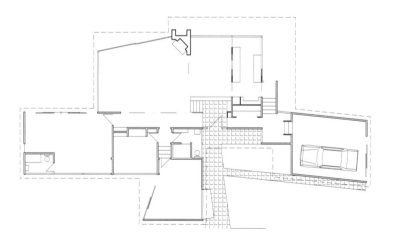

CSH#11

1946
Julius Ralph Davidson

540 SOUTH BARRINGTON AVE.,
LOS ANGELES, CA

DESTROYED

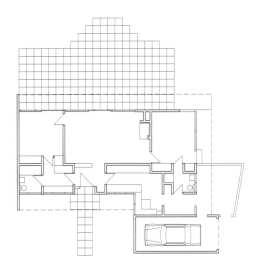

CSH#12

1946
Whitney R. Smith

NOT BUILT

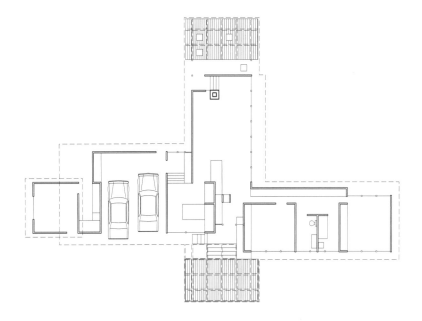

CSH#13

Alpha

1946
Richard Neutra

NOT BUILT

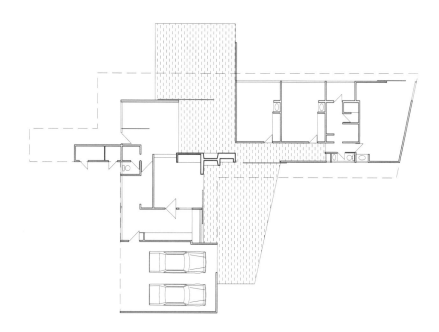

CSH#15

similar to CSH#11, 1946-1947
Julius Ralph Davidson

4755 LASHEART DR.,
LA CAÑADA FLINTRIDGE, CA 91011

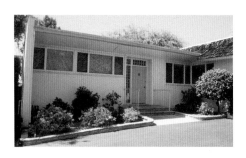

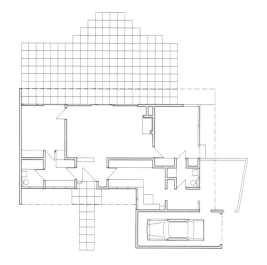

CSH#16

1946-1947
Rodney Walker

9945 BEVERLY GROVE DR.,
BEVERLY HILLS, CA 90210

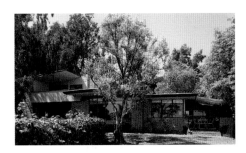

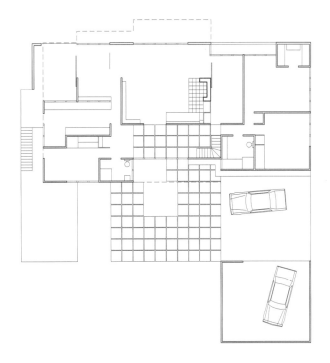

CSH#17

1947
Rodney Walker

7861 WOODROW WILSON DR.,
LOS ANGELES, CA

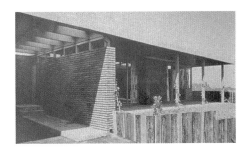

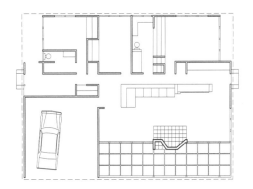

CSH#18

1947-1948
Rodney Walker

MAP 631B7
199 CHAUTAUQUA BLVD,
PACIFIC PALISADES, CA 90272

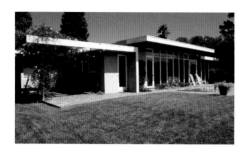

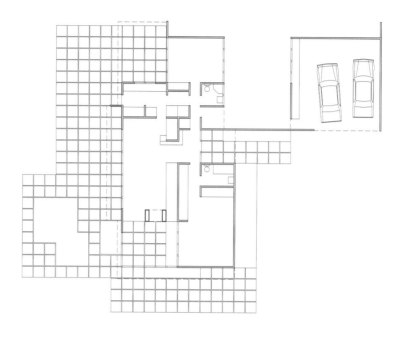

CSH#19

1947-1948
Richard Neutra

201 CHAUTAUQUA BLVD,
PACIFIC PALISADES, CA 90272

BUILT AND ALTERED

REFUSED

CSH#20
Bailey House
1947-1948
Richard Neutra

219 CHAUTAUQUA BLVD,
PACIFIC PALISADES, CA 90272

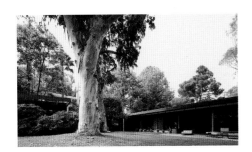

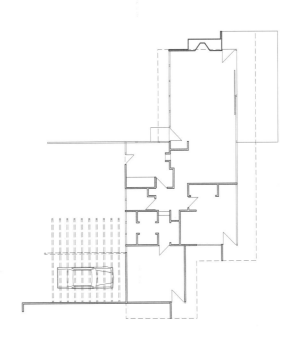

CSH#21
1947
Richard Neutra

NOT BUILT

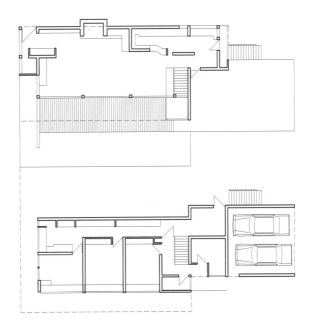

CSH#1950

1950
Raphael Soriano

1080 RAVOLI DR.,
PACIFIC PALISADES, CA

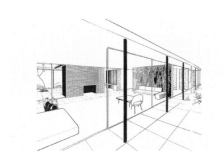

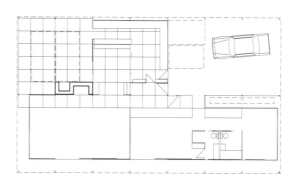

CSH#16

1952-1953
Craig Ellwood

1811 BEL AIR ROAD,
LOS ANGELES, CA 90077

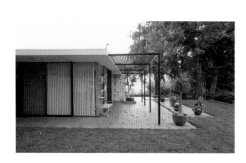

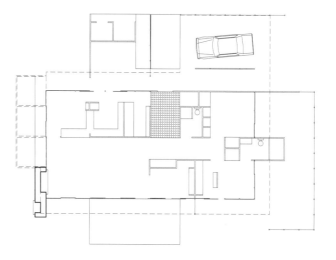

CSH#17

1954-1955
Craig Ellwood

9554 HIDDEN VALLEY ROAD,
BEVERLY HILLS, CA

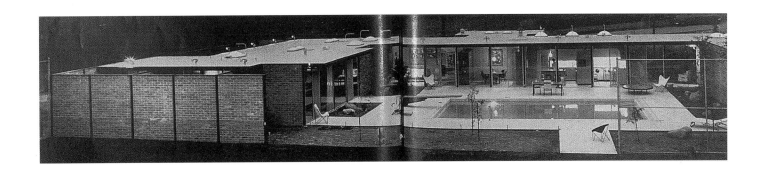

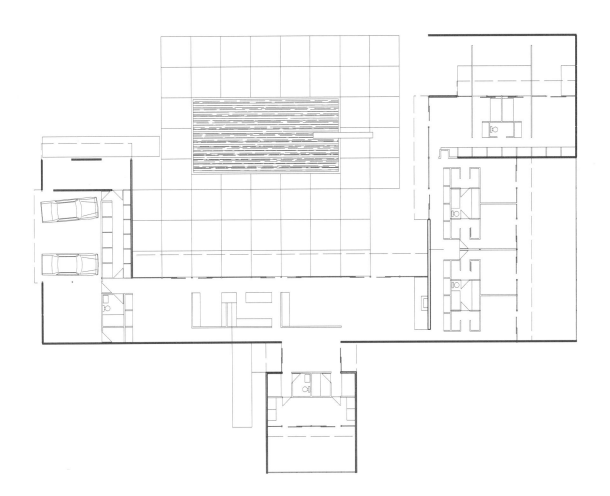

CSH#18

1956-1958
Craig Ellwood

1129 MIRADERO ROAD,
BEVERLY HILLS, CA

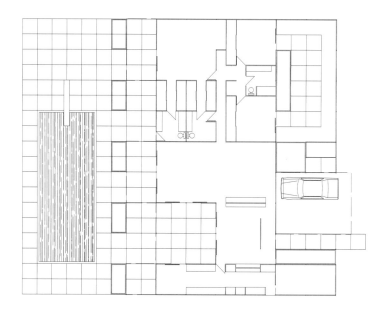

CSH#19

Garret Eckbo

1957
Don Knorr

NEAR SAN FRANCISCO, CA

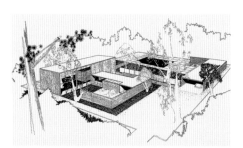

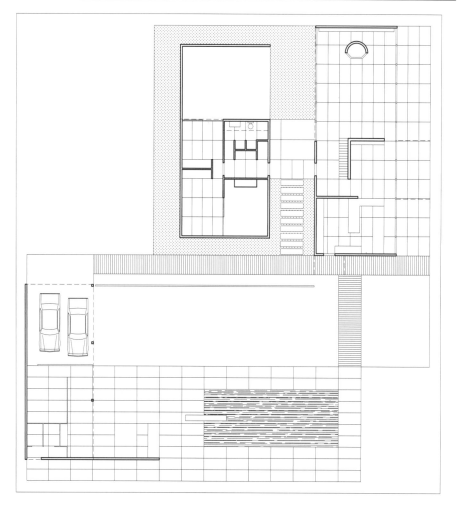

CSH#20

Bass House

1958
Conrad Buff III, Calvin Straub
& Donald Hensman

2275 SANTA ROSA AVE.,
ALTADENA, CA 91001

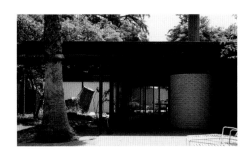

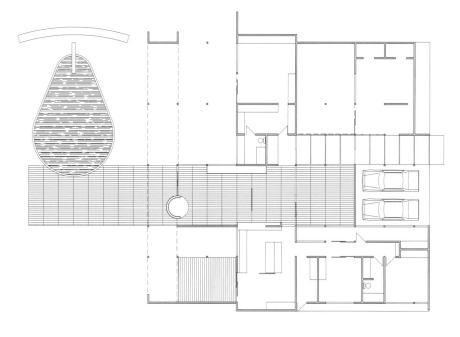

CSH#21

1958
Pierre Koenig

9038 WONDERLAND PARK AVE.,
LOS ANGELES, CA 90046

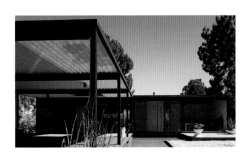

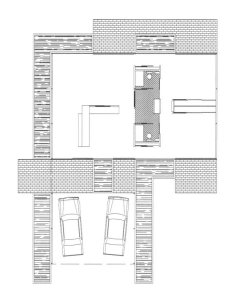

CSH#22

1959-1960
Pierre Koenig

1635 WOODS DR.,
LOS ANGELES, CA 90069-1633

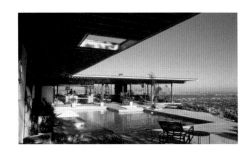

CSH#23 – Triad

House A
1959-1960
Edward Killingsworth, Jules Brady
& Waugh Smith

RUE DE ANN,
LA JOLLA, CA

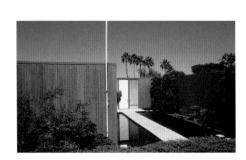

CSH#23 – Triad
House B
1959-1960
Edward Killingsworth, Jules Brady
& Waugh Smith

RUE DE ANN,
LA JOLLA, CA

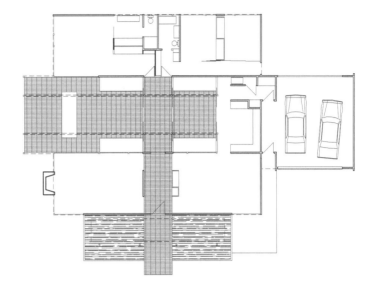

CSH#23 – Triad
House C
1959-1960
Edward Killingsworth, Jules Brady
& Waugh Smith

RUE DE ANN,
LA JOLLA, CA

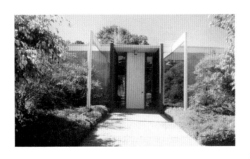

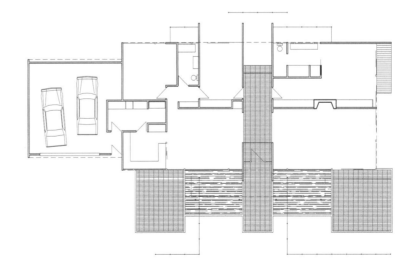

CSH#24

1961
Quincy Jones & Frederick E. Emmons

NOT BUILT

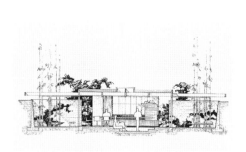
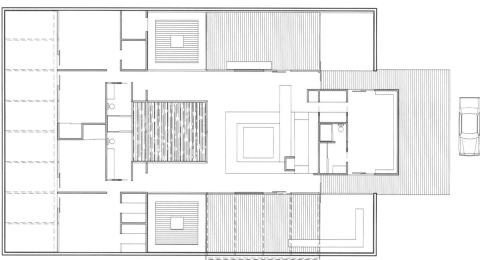

CSH#25

1962
Edward Killingsworth, Jules Brady
& Waugh Smith

82 RIVO ALTO CANAL,
LONG BEACH, CA 90803

CSH#26*

1962
Edward Killingsworth, Jules Brady
& Waugh Smith

NOT BUILT

CSH#26

1962-1963
Beverley David Thorne

177 SAN MARINO DR.,
SAN RAFAEL, CA 94 901-1537

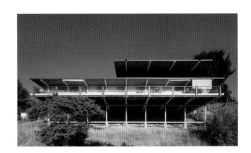

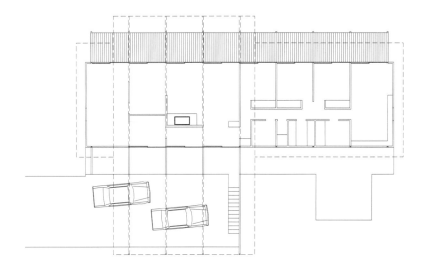

CSH#27

1963
John Carden Campbell, Worley Wong
& Allen Don Fong

NOT BUILT
PLANNED FOR THE EAST COAST

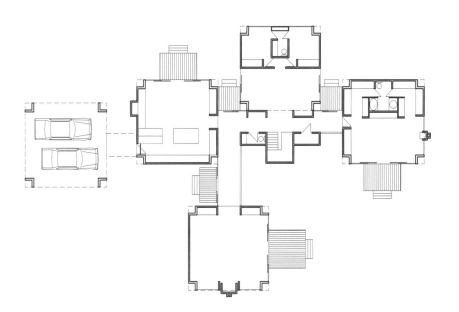

CSA#1

1963 -1964
Alfred Beadle & Allan Dailey

4402 28TH STREET,
PHOENIX, AZ

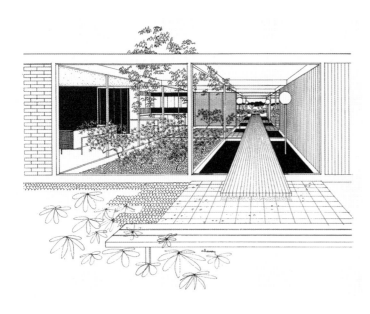

CSA#2

1964
Edward Killingsworth, Jules Brady
& Associés

NOT BUILT

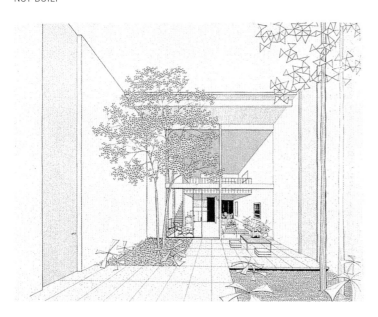

CSH#28

1965-1966
Conrad Buff III & Donald Hensman

91 INVERNESS ROAD,
THOUSAND OAKS, CA 91361

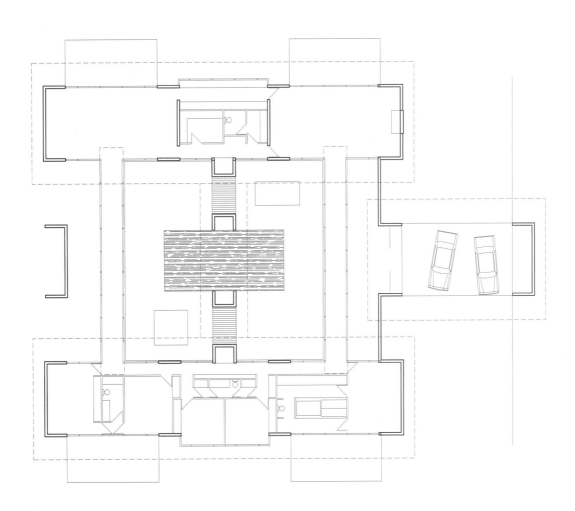

	#1	#2	#3	#4	#5	#6	#7	#8	#9	#10	#11	#12	#13		#15	#16	#17	#18	#19
1945																			
1946																			
1947																			
1948																			
1949																			
1950																			
1951																			
1952																			
1953																			
1954																			
1955																			
1956																			
1957																			
1958																			
1959																			
1960																			
1961																			
1962																			
1963																			
1964																			
1965																			
1966																			

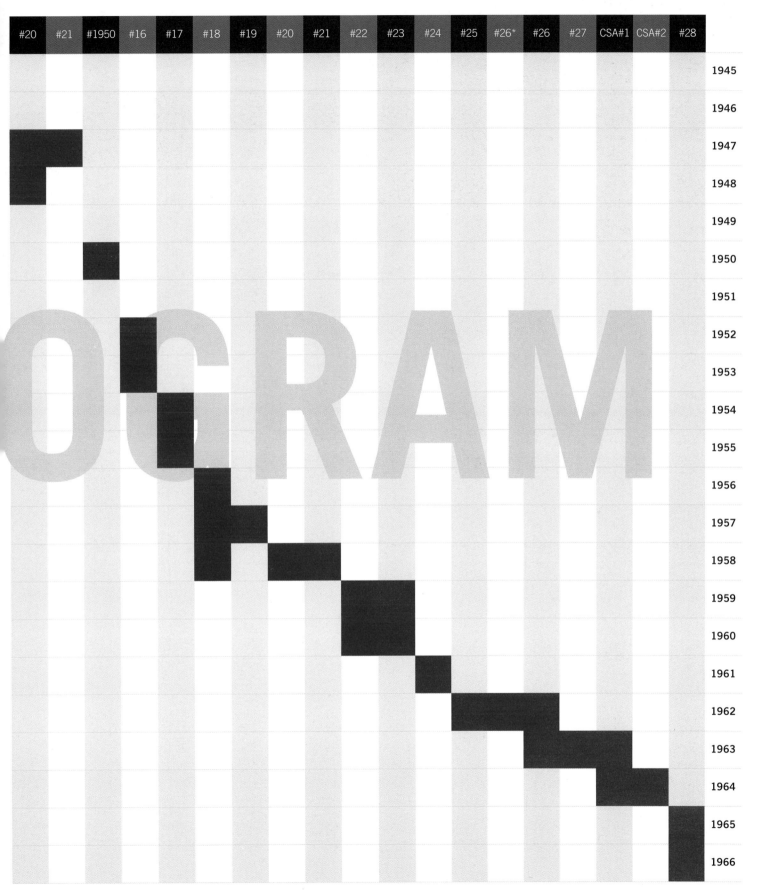

| #20 | #21 | #1950 | #16 | #17 | #18 | #19 | #20 | #21 | #22 | #23 | #24 | #25 | #26* | #26 | #27 | CSA#1 | CSA#2 | #28 |

1945
1946
1947
1948
1949
1950
1951
1952
1953
1954
1955
1956
1957
1958
1959
1960
1961
1962
1963
1964
1965
1966

OCTOBER 1945 · CASE STUDY HOUSE NO. 6

Illustration credits

Graphic design and layout: Philippe David, with Mélanie Bourgoin and Antoine Olivier, Paris

Translated from the French by Jasmine Benyamin, California / Berlin

Editorial coordination: Emmanuelle Passerieux, Paris

Sub-editing for the English edition: Christian Rochow, Berlin

Production: Néo Typo, Besançon

The French edition was published by

LES ÉDITIONS DE L'IMPRIMEUR

Richard Edwards, publisher
Néo Typo, printing house
1c, rue Lavoisier, F – 25000 Besançon
Tel.: + 33 3 81 53 41 67 – Fax: + 33 3 81 53 16 14
In Paris:
27, rue Étienne-Marcel, F – 75001 Paris
Tel.: + 33 1 44 76 81 26 – Fax: + 33 1 44 76 09 99
E-mail: leseditionsdelimprimeur@wanadoo.fr
Website: www.leseditionsdelimprimeur.com
© 2004 Les Éditions de l'Imprimeur for the French edition
© 2004 Ethel Buisson and Thomas Billard for the contemporary photography

A CIP catalogue record for this book is available from the Library of Congress, Washington D.C., USA

Bibliographic information published by Die Deutsche Bibliothek
Die Deutsche Bibliothek lists this publication in the Deutsche Nationalbibliografie; detailed bibliographic data is available in the Internet at <http://dnb.ddb.de>.

BIRKHÄUSER V/A

© 2004 Birkhäuser – Publishers for Architecture
P.O.Box 133, CH-4010 Basel, Switzerland
Part of Springer Science + Business Media
Printed on acid-free paper produced from chlorine-free pulp. TCF ∞
Printed in France
www.birkhauser.ch

ISBN 3-7643-7118-8

9 8 7 6 5 4 3 2 1

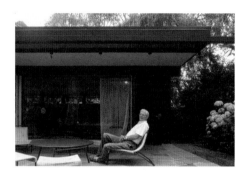